The
NATIONAL
GALLERY OF ART
of Washington and Its Paintings

Edited by
MIA CINOTTI

With a foreword by
J. CARTER BROWN

JOHN BARTHOLOMEW & SON LIMITED: Edinburgh

Great Galleries of the World

Collection directed by
ETTORE CAMESASCA

Editing and Graphics
CLAUDIA GIAN FERRARI
SERGIO TRAGNI
GIANFRANCO CHIMINELLO

Picture collection
CARLA VIAZZOLI

Secretaries
MARISA CINGOLANI
VERA SALVAGO

Graphic and Technical Adviser
PIERO RAGGI

Printing and Binding
ALEX CAMBISSA
CARLO PRADA
LUCIO FOSSATI

Color editing
FIORENZO BERNAZZANI
FELICE PANZA

Foreign editions
FRANCESCO TATÒ
FRANCA SIRONI

Editorial Committee
MILTON GLADSTONE
DAVID GOODNOUGH
JOHN SHILLINGFORD
ANDREA RIZZOLI
MARIO SPAGNOL
J. A. NOGUER
JOSÉ PARDO

Contents

Photographic sources

Color plates and black and white illustrations: National Gallery of Art, Washington.

First published in Great Britain 1975 by
JOHN BARTHOLOMEW AND SON LTD.
12 Duncan Street, Edinburgh, EH9 1TA
and at 216 High Street, Bromley, BR1 1PW
Copyright © by Rizzoli Editore, Milano, 1975

ALL RIGHTS RESERVED
ISBN 0-85152-928-3

PRINTED IN ITALY

The Pursuit of
a Universal Culture

After the Second World War there was a sudden upsurge in interest in the arts throughout the United States, and historians are still wondering why this should have taken place at this time. Certainly the early Protestant traditions of the United States were not favorable to the arts. In the first boats bringing pilgrims, dissenters, and indentured servants to America there were no paintings, images, and only very occasionally someone whose training would qualify him as an artist. Some observers noting this recent change in the climate of opinion have seen it as the result of more leisure time, and more education about art at all levels from the high schools to the universities. Others have seen it as the result of being surrounded by such a plethora of machine-made products that we are tired of uniformity, and rejoice in the unique creations of the artist. Another reason may be because we are so often and brutally reminded of how fast the world we live in is changing, and we are beginning to treasure the past with new appreciation. A more cynical view is that American art appreciation is linked to the soft rustle of the check book. Certainly phenomenal prices are being paid for masterpieces almost every week. Frequently there are newspaper stories about some lucky collector who finds a painting worth a fortune in his attic. Whatever the reasons, art museums are springing up like exotic flowers in the hitherto bleak artistic landscape of the United States, and the local art exhibit is becoming very much a feature of the American way of life.

I am very proud that the National Gallery has been able in such a short space of time to contribute to this cultural growth. This is the golden age of collecting in America, and we can only hope that our good fortune will continue. In the Spring of 1971 work began on an additional building for the Gallery in Washington. This will double the area available to the National Gallery and will create the space for a research center for advanced study of the Visual Arts, which will be the first such undertaking of its kind in a museum framework.

I am pleased and honored that the Rizzoli Company of Milan, Italy, was the moving force behind this project, because from the American viewpoint, Italy, more than any other country, is and always has been the artistic heartland of Western civilization. About one third of the exhibition areas in the main part of this gallery are devoted to Italian art, from Cimabue to Modigliani, and this preponderance is a just tribute to the fact that Italian genius has provided the guiding light for civilization for longer periods than any other.

The first art of which there is any mention in Washington is of Italian vendors selling statues, such as miniature replicas of the Apollo Belvedere, in the streets of the newly founded capital during the early 1800's. The first true fresco paintings in America were painted around the dome of Washington's Capitol by Constantine Brumidi, an Italian immigrant artist.

We hope that these traditional links through the arts between our two countries will never weaken, and that we will continue to be able to exhibit and preserve so many artistic ambassadors from such a creative country.

J. CARTER BROWN
Director of the National Gallery of Art

History of the Gallery and Its Paintings

The National Gallery of Art in Washington is one of the youngest state museums in the world, and owes its existence largely to the bringing together of four great private collections: the Mellon, Widener, Kress and Dale collections.

Other important collections, such as those of Ralph and Mary Booth of Detroit and Lillian S. Timken of New York, have been presented to the Gallery from time to time, and a certain number of works have been purchased with the aid of special funds supplied by the donors of the main collections and others. These include the Mellon Fund, the Ailsa Mellon Bruce Fund and the Chester Dale Fund.

The Mellon Collection. Andrew Mellon of Pittsburgh was a banker and steel, coal and oil magnate whose collection consists of works of art bought over a period stretching from the late nineteenth century to his death in 1937. With encouragement from his friend Henry Clay Frick, he first purchased paintings for his own pleasure, and concentrated his interest on seventeenth century Dutch and eighteenth century English art. These early preferences remained with him throughout his life, even after he had broadened his horizons, and they are responsible for the presence in the Gallery of nine of its twenty-four Rembrandts, six of its eight works by Frans Hals, and three of Vermeer's rare paintings. English works acquired in the same way include six Gainsboroughs, three Reynolds, three Raeburns, a masterpiece by Constable and two by Turner. Together they form an excellent collection of Dutch and English paintings.

Mellon's appointment as Secretary of the Treasury in Washington in 1921 caused him to reconsider the nature and purpose of his art collection. From then on his purchases were governed by a new and enlightened policy. He decided to form a collection representing the best in European art from the early Byzantine period to the eighteenth century. In 1927 he told his adviser David E. Finley (who was to become the first Director of the National Gallery) that his specific aim was to provide the capital of the United States with the great national gallery it lacked — on the model of the National Gallery in London, which Mellon admired and frequently visited. He deliberately — and with striking foresight — chose to limit his purchases to the period stretching from the "Primitives" to the precursors of modern art, for he rightly supposed that the existence of many rich collections of Impressionist and Post-Impressionist art already in the United States would sooner or later result in donations to the National Gallery.

During and after the period 1932-33, when he was United States ambassador in London, Mellon made more important purchases, and he extended his interest to Italian Renaissance sculpture. During the latter part of his life, Mellon was also concerned to provide the future art gallery with an extensive collection of American art, and so he purchased the entire Thomas B. Clarke collection of historical portraits, most of which were later transferred to the National Portrait Gallery, founded in 1968. At the time of this purchase, Mellon already had in mind the possible future creation of such a portrait gallery. Nevertheless, the portraits of greatest artistic value went to the National Gallery, with the result that it received from the Mellon Collection (through the A. W. Mellon Educational and Charitable Trust, which came into operation after Mellon's death), and from a special Mellon Fund for purchases, 130 portraits and selected works by American artists, covering the period from the pioneers to Duveneck.

As founder of the National Gallery, Mellon thus provided it with a nucleus of works of art: nearly three hundred paintings from his own collection, together with twenty-four pieces of sculpture, most of which were examples of Italian Renaissance work.

The Widener Collection. Peter A. B. Widener of Philadelphia, a banker and railway magnate, began this collection at the end of the nineteenth century, and it was added to after his death in 1915 by his son Joseph E. Widener on the understanding that it should be given to a museum in Philadelphia, New York or Washington, or sold for the benefit of the Widener family if the donation to a museum should prove impossible.

The Wideners had a particular predilection for the Italian Renaissance, which is represented in their collection by a number of masterpieces belonging principally to the golden age of the sixteenth century.

The Wideners' predilection for "golden ages" in art also accounts for the presence of many eighteenth century English works in their collection, including portraits of the nobility by Reynolds, Gainsborough, Raeburn, Romey, Hoppner and Lawrence, and fine landscapes by Constable and Turner. But if we remember that the bulk of the Wideners' collection, unlike the others described in this book, consists of works purchased before 1920, it will be realized that the Wideners also showed a surprisingly early liking for works painted in a modern and revolutionary idiom, and so purchased works by artists who were then generally little understood or appreciated.

However, their interest in painting, though dominant, was not exclusive. Like Mellon, they assembled a valuable collection of Italian Renaissance sculpture, and they also collected eighteenth century French sculpture and that rare and "difficult" type of sculpture, the small bronze.

The Wideners also presented to the National Gallery a magnificent collection of Chinese porcelain, furniture, tapestries (including the famous Flemish Mazzarino tapestry), ceramics, jewelry and masterpieces of medieval goldware such as *The Chalice of Abbot Suger*, named after the founder of Saint-Denis. The collection is completed by some particularly fine examples of eighteenth century French prints, books and decorative objects, with the result that, taken together with the Kress bronzes, it has enabled the National Gallery to become a museum in the wider sense of the word, rather than just a picture gallery.

The Kress Collection. This famous American collection was assembled more recently than the National Gallery's other basic collections, but thanks to a large number of additional gifts made since the original donation, it has in fact provided more works of art than any of the others. At present the paintings alone occupy more than a third of the Gallery's main floor. Furthermore, donations and loans from the Kress Collection are still being made, not only to the National Gallery in Washington and the great galleries of New York and Philadelphia, but also to eighteen museums in various American states, as well as to twenty or more scholastic and other institutions (see *History*, 1961).

The Kress Collection was created by Samuel Henry Kress, a native of Pennsylvania, like Mellon and Widener. In his youth he had been a schoolteacher, but he subsequently purchased a small stationery shop not far from where he was born, and finally became the owner of a chain of 265 large stores stretching across thirty different states. He spent part of his fortune on cultural and philanthropic works, creating the Samuel H. Kress Foundation for this purpose in 1929. In 1940, his brother Claude's estate swelled the Foundation's assets, and when Samuel Kress died in 1955, paralyzed since the age of eighty-two, their younger brother Rush Harrison Kress became the new president of the Foundation. He gave further impulse to the Foundation's artistic activities, which were now placed under the direction of Guy Emerson, with Mario Modestini in charge of restoration services (see *History*, 1945, 1946 and 1947).

Samuel Kress was nearly sixty when he became keenly interested in art. His earliest purchases were from Count Alessandro Contini Bonacossi, a Florentine collector, whom he had first met in Rome about 1920, during one of his regular holidays in Europe. Later on he became friendly with the famous art critic Bernard Berenson in Florence, and consequently concentrated his purchases on works of the Italian Renaissance. Later, however, he widened his interest to include the other great schools of European art, and hence inevitably concerned himself with periods later than the sixteenth century; but he excluded modern and contemporary artists from his collection. The most modern artist represented in it is Ingres.

The criteria on which he based his choice of works were, however, quite different from those applied by other art collectors. His aim was not merely to assemble works by the greatest masters, but also to collect examples of the work of minor artists and schools, so that his collection should be not so much an anthology of masterpieces as a historical and critical survey, providing evidence of the development of schools and periods of painting. Hence his original intention of housing both a "permanent collection" and a "study collection" in Washington was modified by a decision to decentralize the "study collection." Works already available were mostly distributed amongst institutions of higher education, and additional purchases were made in order to fill gaps in the art collections of provincial galleries.

Until it was presented to the National Gallery in Washington, the bulk of the Kress Collection was housed in Samuel Kress's home (subsequently Rush Kress's home) at 1020 Fifth Avenue, in New York City.

The period when the Kress Collection was assembled can be divided into three parts, during the first two of which Samuel Kress himself was responsible for purchases. The first stretches from 1929-30 to 1939 (when he presented the Collection to the National Gallery, around the outbreak of the Second World War), and the second from the beginning of the war until 1945. The third coincides with Rush Kress's presidency of the Kress Foundation. He had already been assisting his brother Samuel, and his acceptance of the direction of the Foundation in 1945 was marked by the purchase of the magnificent Dreyfus Collection of Renaissance medals, plaquettes and small bronzes (see *History*, 1957 and page 15). Purchases reached their height during the period 1946-56, when more than twenty-five million dollars were spent on works of art, some of which went to the National Gallery in Washington.

In 1945, Samuel Kress laid the foundations of his important collection of

French paintings, with the result that the National Gallery was then able to devote two rooms to the French School (see *History*, 1946). These purchases broadened the scope of the Collection considerably.

When the last donations were made (see *History*, 1961), the Kress Collection had reached its final form. Now it is undertaking the task of cataloguing this huge mass of works of art, part of which is in the National Gallery in Washington and part in various other museums.

The Dale Collection. Chester Dale was a New York banker who, with his first wife Maud, was well known for his keen interest in modern art. Maud Dale was herself a painter and art critic and a friend of many artists of the "Ecole de Paris"; she was responsible for shaping her husband's initial artistic tastes. Until her death in 1953, she gave him valuable assistance in finding paintings to buy. The Dale Collection was largely assembled in the period 1920-30, though important additions were made in subsequent years, for Chester Dale's passion for art did not cease with the death of his wife, and his keen interest in the National Gallery in Washington also continued, especially since he had become a Trustee in 1943 and President of the Board of Trustees in 1955. The Dale Collection first came to the National Gallery in the form of extensive loans (see *History*, 1943 and 1954) and a few donations. On the death of Chester Dale, however, the entire collection was left to the National Gallery, including those works which were still at his home (see *History*, 1962).

The Dale Collection is devoted to the splendors of modern French painting. Its 250 works make it one of the world's greatest collections of modern and contemporary French painting, from David, Delacroix and Corot to the Impressionists, Fauves and Cubists. And

at the same time it has a section devoted to modern American painting and another devoted to artists such as Boucher, Chardin, Tintoretto, El Greco, Rubens and Zurbarán, who may in some sense be considered precursors of modern art.

It is striking that it would be possible to fill an exhibition room with contemporary art just by bringing together the portraits of themselves which the Dales commisisoned from their favorite artists: portraits of Chester Dale by Bellows (1922), Lurçat (1928) and the great Mexican artist Diego Rivera (1945); portraits of Maud Dale by Bellows (1919), Lurçat (1928) and Léger (1935), as well as by the sculptor Despiau, who immortalized her in a striking bronze in 1931.

The other paintings collected by the Dales also have this particular characteristic of reflecting an intimate and personal relationship between painting and collector.

The Dale Collection boasts some fine examples of nineteenth century American painting, such as the portraits of Lord and Lady Liston (Lord Liston was British Ambassador in Washington) by the celebrated Gilbert Stuart, Morse's *Portrait of a Lady*, and works by the Impressionists Whistler and Mary Cassatt. But the most impressive part of the American collection is the blunt and terse description of "the American Scene" by Bellows and Du Bois.

Thanks to the existence of the special Dale Fund for purchases, the Dale Collection has continued to grow even since Chester Dale's death. Purchases made in this way have strictly adhered to the spirit of the Collection as a whole, so that there still remains the possibility of further developing it along its own specialized lines.

1836. The Washington Museum was opened as the first public museum in the city, but it had only two rooms.

Like other nineteenth century museums, it was largely devoted to the history of science, since that was the principal interest of the age. The few pictures it contained were of mediocre quality.

1840. The Washington Museum was merged with the National Institute, which had been created in this year and was under the Direction of the Hon. Joel R. Poinsett, Secretary of War and an art enthusiast. It was America's first "national museum", and paintings here began to hold a position of some importance beside objects illustrating natural history.

1846. Congress set up the Smithsonian Institution thanks to the substantial sum of money (five hundred and fifty thousand gold dollars) which it received in 1835 under the will of the English scientist James Smithson, illegitimate son of the Duke of Northumberland, who had died in Genoa in 1829. Smithson was bitter at his difficult situation in English society, and in spite of the fact that he had never been to the United States, he left his entire estate to the United States government "to increase and diffuse knowledge among men." The new Smithsonian Institution set up a science museum in which art collections gradually came to have a certain importance.

1862. The Smithsonian Institution took over the National Institute (see the year 1840).

1865. Fire destroyed a large part of the art collections in the Smithsonian Institution.

1869. The Corcoran Gallery was created from private funds. It was the first museum in Washington to be wholly devoted to painting and sculpture.

1891. Franklin Webster Smith published a plan for the creation of a colossal park of culture in the area to the south west of the Washington Monument in Washington. It was to contain reproductions of famous Western buildings and works of art and was to be supplied with automatic moving seats to facilitate the movement of visitors. Smith was a hardware merchant whose hobby was making models of the famous buildings and places he had visited on his travels, and for a while his extravagant idea found some credit both in the United States and abroad. In any case, it reflected increasing consciousness of the need for a national gallery of European art.

1906. The art collections in the Smithsonian Institution were enhanced by the arrival of Harriet Lane Johnston's valuable collection, plus a number of other donations and bequests. In view of the particular nature of the Institution, this meant that a step had now been taken towards the formation of a national gallery.

1923. Charles Lang Freer, a Detroit banker and a great patron of the American artist Whistler, offered the nation both his art collections and a building to house them. The Freer Gallery was therefore set up, but it was limited to oriental art and to a few chosen works by American artists.

1936. On December 22, Andrew Mellon wrote a letter to President Roosevelt offering not only to give the American nation his own magnificent collection of paintings and sculpture but also to build a suitable building to house the collection and to set up a fund for the creation of a great national gallery of art in Washington, D.C. His collection was worth thirty-one million dollars. One condition stipulated by Mellon was that Congress should guarantee the necessary funds for the maintenance of the gallery, and he expressed

the hope that future donations from other American citizens would serve to enrich it. Roosevelt replied expressing his pleasure on December 26. Mellon's offer at last made it possible to fill the longfelt want of a national gallery in Washington, for important public collections had already been set up in Boston, New York, Philadelphia, Chicago, Cleveland and Detroit. These other galleries however, belonged to individual cities, and states, so that the Washington gallery would be the only national gallery in the United States to be devoted exclusively to the figurative arts.

1937. On March 24 Congress formally accepted Mellon's gift of his collection. It set up the National Gallery of Art as a section of the Smithsonian Institution, guaranteed to maintain it, and appointed as a governing body a Board of Trustees consisting of four ex officio members (the Chief Justice, the Secretary of State, the Secretary of the Treasury and the Secretary of the Smithsonian Institution) and five private citizens. David E. Finley, Mellon's artistic

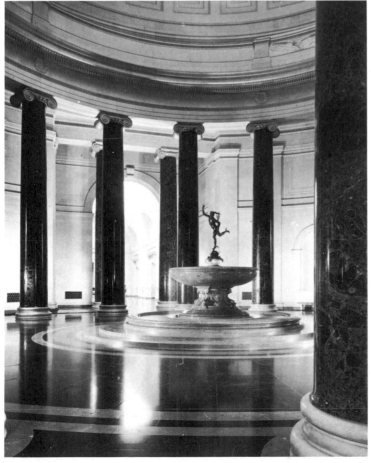

The Gallery's entrance hall. In the center is a fountain surmounted by Giovanni Bologna's bronze Mercury.

adviser, was appointed as the first Director. A site was chosen for the Gallery building between the Capitol and the Washington Monument, and work on the foundation was begun in June of this year. The well-known architect John Russell Pope had been chosen by Mellon to design the building. It was to be an imposing neoclassical edifice, in keeping both with the neo-Palladian and Graeco-Roman taste which then held sway in Washington, and also with Mellon's desire to create an American counterpart to the National Gallery in London. Andrew Mellon died two months after work on the building was begun, and John Russell Pope also died in 1937, so the building was completed by Pope's associates Otto R. Egger and Daniel Paul Higgins.

When the Mellon Collection was transferred to the National Gallery, it consisted of 111 paintings and 22 pieces of sculpture. The most striking paintings were Duccio's *Nativity*, Botticelli's *Portrait of a Youth*, the *Portrait of a Youth* in similar vein by Filippino Lippi, Giovanni Bellini's *Portrait of a Young Man in Red*, Cima da Conegliano's *Madonna and Child with Saints Jerome and John the Baptist*, Raphael's *The Niccolini-Cowper Madonna* and *The Alba Madonna* and Titian's *Venus with a Mirror*. Flemish and Dutch works included Jan van Eyck's *The Annunciation*, Van der Weyden's *Portrait of a Lady*, Memling's *Portrait of a Man with an Arrow*, and, from the seventeenth century, a number of works by Hals, Rembrandt, De Hooch, Maes, Metsu, Ter Borch, Cuyp and Hobbema. German and Spanish works were few in number but of high quality, and included two portraits by Holbein, two El Grecos, Velazquez's *The Needlewoman* and four portraits by Goya. The glories of eighteenth century art were represented by works of French and English artists.

1938. By the summer of this year, the foundations of the Gallery had been excavated, and the gigantic size of the building about to be erected seemed out of all proportion to the size of the Mellon Collection which it was to house. But those in charge of the Gallery kept in mind the possibility of fulfilling Mellon's wish concerning future donations. For many yers, Jeremiah O'Connor, Curator of Painting at the Corcoran Gallery, and Herbert Friedmann, Curator of Birds at the Smithsonian Insitution, had devoted some of their time to looking at private collections, and in the winter of 1938 they paid a visit to one of the most outstanding collections in America, the Kress Collection in New York. On his return to Washington, O'Connor wrote to Samuel Kress urging him to give his collection to the new National Gallery, where it would be safeguarded for all time, since the future of the Gallery had been guaranteed by the government.

1939. On April 18th O'Connor passed on to Finley, the Director of the National Gallery, an invitation to visit Samuel Kress in New York. The visit lasted for seven hours, during which Finley pleaded the case of the Gallery with such persuasion that Kress decided to give up his plan for a private museum, although a site was already under option on Fifth Avenue, in New York, and designs had been prepared. Instead, he decided to give the major part of his treasures to the new National Gallery. Finley and Walker, respectively Director and Curator of the National Gallery, were given permission to choose the best of what Kress had purchased up to that time, a total of 416 paintings and 35 pieces of sculpture. All were examples of Italian schools of art and were intended partly to form a representative collection in the Gallery and partly to constitute a study collection for specialists and students. Thus the Kress Collection brought to

the Gallery many very fine Renaissance and eighteenth century paintings. Outstanding among Renaissance works were those from the Contini Bonacossi Collection, including Agnolo Gaddi's *The Coronation of the Virgin*, Gentile da Fabriano's *A Miracle of Saint Nicholas*, Perugino's *The Annunciation*, Giovanni Bellini's *Portrait of a Young Man* 293, Lotto's *Saint Catherine* and Dosso's *Scene from a Legend*. From British collections and dealers came Carpaccio's *Madonna and Child*, Giovanni Bellini's *Portrait of a Condottiere* and *Portrait of a Venetian Gentleman*, Simone Martini's *The Angel of the Annunciation* and Lotto's *A Maiden's Dream*.

1940. On the instructions of the Mellon Trust, which administered Mellon's estate, four European paintings (Rembrandt's *A Turk*, one of a group of masterpieces acquired from the Hermitage in Leningrad, Hals' *A Young Man in a Large Hat*, Van Dyck's *Portrait of a Flemish Lady* and Cuyp's *The Maas at Dordrecht*) and eleven American paintings were added to the Mellon Collection.

1941. In spite of the Second World War, the *National Gallery of Art* in Washington was opened on March 17, and in the meantime three more paintings had been donated to it. Duncan Phillips gave Daumier's *Advice to a Young Artist*; the widow of Felix M. Warburg gave a triptych signed by Pietro Lorenzetti as well as Domenico Morone's *A Dominican Preaching* (more recently attributed to Agnolo degli Erri) in memory of her husband. The Gallery catalogue listed a total of 591 works — 540 paintings and 51 pieces of sculpture. But a number of works on loan from the Kress Collection did not appear in it.

1942. Exhibition rooms were being prepared for the Widener Collection, which had recently been presented to the Gallery and was in the process of being moved there. Joseph Widener had donated his collection on three conditions: firstly, that it should be kept as a unit; secondly, that all the examples of the lesser arts should be accepted and exhibited; and thirdly, that the gift should be exempt from taxes. The third condition was the most difficult to fulfill, because Pennsylvania had the right to levy a five per cent tax on bequests going outside the state boundaries. Being the beneficiary, the United States government would have to pay the tax, but thanks to direct intervention by President Roosevelt, Congress agreed to recognize the debt without the sum being specified, since the amount of the tax would be assessed only when the collection had been valued. Hence the government signed a blank check for the first time in its history.

The Widener Collection brought to the Gallery not only a rich series of objects from the minor arts which were exhibited on the ground floor (see page 17), but also 99 paintings of various centuries and schools, and 41 pieces of sculpture. The most interesting works were the *Portrait of a Lady* by the Sienese artist Neroccio, a *Self-Portrait* attributed to Lorenzo di Credi, Mantegna's *Judith and Holofernes* 638, Raphael's *The Small Cowper Madonna*, Titian's *Venus and Adonis*, Bronzino's *A Young Woman and Her Little Boy*, Rembrandt's *Philemon and Baucis*, *Portrait of a Man in a Tall Hat* and *Portrait of a Lady with an Ostrich-Feather Fan*, and some excellent modern paintings including Degas' *The Races* and *Before the Ballet* and Renoir's early *The Dancer*.

In this same year some American paintings were given to the Gallery by Mrs. Gordon Dexter and Mr. and Mrs. George W. Davison.

1943. The famous Rosenwald Collection of prints, drawings and watercolors was presented to the National Gallery (see page 17). Seventy-one paintings and 26 pieces of sculpture were added to the Kress Colection, including Raphael's *Bindo Altoviti* (now better attributed to Giulio Romano), and Guardi's *A Seaport and Classical Ruins in Italy*; and among works which had previously been on loan but were now to be considered gifts were Beccafumi's *The Holy Family with Angels*, Giovanni Bellini's *Madonna and Child with Saints*, Filippo Lippi's *The Annunciation* and Magnasco's *Christ at the Sea of Galilee*. And for the first time a Kress donation included seventeenth and eighteenth century French works.

A first group of modern paintings from the Dale Colection reached the Gallery this year. Seventy-two nineteenth century paintings were on loan, and a number of works by "precursors" of modern painting were presented to the Gallery, including Boucher's magnificent *Venus Consoling Love*, two Chardins, a study for a head by Rubens, El Greco's expressionistic *Saint Jerome* and Zurbarán's *Saint Lucy*. American paintings given to the Gallery included Morse's fine *Portrait of a Lady*. Other important acquisitions this year were Corot's *The Eel Gatherers*, which was presented by Mr. and Mrs. Frelinghuysen, and Homer's *Breezing Up*, presented by the W. L. and Mary T. Mellon Foundation.

1944. Blake's *Job and his Daughters* was added to the Rosenwald Collection. Bellow's masterly *Both Members of This Club* came from the Dale Collection as an important addition to the Gallery's Americar. art.

1945. Samuel Kress, now eighty-two years old, was struck down by paralysis and remained paralyzed until his death ten years later. The last purchase for which he was responsible was El Greco's great *Laocoön*. Meanwhile, his brother Rush had purchased Gustave Dreyfus' famous collection of 1,306 Renaissance bronzes. Among works presented to the Gallery this year were two important Canalettos given by Barbara Hutton, *The Square of Saint Marks* and *The Waterfront by the Piazzetta*, also two companion preces by Ch.-A.-Ph. Van Loo depicting *The Magic Lantern* and *Soap Bubbles*, and Raeburn's family portrait of *John Johnstone of Alva, his Sister and his Niece*. (The last three of these were presented by Mrs. Robert W. Schuette.) Further additions to the Gallery's coliection of American paintings were Bellows' two portraits of Mr. and Mrs. Dale.

1946. Rush Kress became President of the Kress Foundation, and in January began to negotiate the donation to the National Gallery of 100 paintings and 10 pieces of sculpture purchased by Samuel Kress during the preceding two years. Among the paintings were a sufficient number of seventeenth and eighteenth century French works to justify their amalgamation with others previously presented to the Gallery (see the year 1943), and so the first two exhibition rooms devoted to French paintings from the Kress Collection were opened. The new donation included Poussin's *The Baptism of Christ*, Watteau's *Italian Comedians*, Boucher's magnificent *Madame Bergeret*, two companion pieces by Fragonard depicting *The Swing* and *The Gold Cushion* and one of Ingres' finest portraits, *Madame Moitessier*. A very interesting addition to the Mellon Collection this year was the American artist Ryder's *Siegfried and the Rhine Maidens*.

1947. An important group of works from the Ralph and Mary Booth Col-

lection came to the Gallery. They included Giovanni Bellini's *Madonna and Child* 894, two fine portraits of *A Prince of Saxony* and *A Princess of Saxony* by Cranach the Elder, other German portraits by Strigel and Kremer, and a Tintoretto. The arrival of two paintings by Legros marked the beginning of the transfer to the Gallery of the George Matthew Adams Collection, which was devoted to the work of Legros. In this year Guy Emerson became Director of the artistic program of the Kress Foundation.

1948. An important exhibition of "Masterpieces from the Berlin Museum" was held in the Gallery. It consisted of works of art recovered in the American Zone of Germany after the war, and was also seen in 1948 and 1949 at art galleries in Detrot, Cleveland, Minneapolis, San Francisco, Los Angeles, St. Louis, Pittsburgh and Toledo, before being returned to Germany. Among works presented to the Gallery this year were Murillo's *The Return of the Prodigal Son* (gift of the Avalon Foundation), Raeburn's *Captain Patrick Miller* (gift of Pauline Sabin Davis), Renoir's *Head of a Young Girl* (gift of Vladimir Horowitz) and Sargent's very fine *Repose* (gift of Curt H. Reisinger).

1949. The Gallery organized an important exhibition of treasures from Viennese collections found in the American Zone after the war. During this and the next year it was to travel to the Metropolitan Museum in New York, the Art Institute of Chicago and the M. H. De Young Memorial Museum in San Francisco. Additions to the Gallery's collections this year included a magnificent Byzantine *Enthroned Madonna and Child* 1048 (presented by Mrs. Otto Kahn) and some landscapes presented by R. Horace Gallatin, including Guardi's *The Rialto Bridge* 1038, Corot's *River View* and Daubigny's *Landscape with Figures*.

1951. An important exhibition of the Kress Collection was held to celebrate the National Gallery's tenth anniversary. It consisted of works purchased during the preceding six years, including French and Italian paintings, a large number of paintings of northern schools, French sculpture and some Italian sculpture. Works presented to the Gallery this year included Turner's *The Rape of Proserpine* (gift of Mrs. Watson B. Dickermann), Corot's *Gypsy Girl with Mandolin* (gift of Count Cecil Pecci-Blunt), Renoir's *Oarsmen at Chatou* and *Woman with a Cat*, Gauguin's *The Bathers* and Degas' fine portrait of *Madame Dietz-Monin* (gift of Mrs. Albert J. Beveridge).

1952. Some of the Kress Collection pictures and sculptures which had been exhibited in the Gallery the previous year were now presented to the Gallery, as had been hoped. The Gallery thus acquired a number of Italian Renaissance masterpieces, including Giovanni Bellini's *An Episode from the Life of Publius Cornelius Scipio*, Crivelli's *Madonna and Child Enthroned with Donor*, Mantegna's *Portrait of a Man*, as well as Benozzo Gozzoli's *The Dance of Salome* and Tintoretto's *Christ at the Sea of Galilee*. American collections provided a number of important additions to the Gallery's fourteenth century works, such as Bernardo Daddi's *Madonna and Child with Saints and Angels* and Paolo Veneziano's *The Coronation of the Virgin*. Annibale Carracci's *Landscape* was added to the seventeenth century collection, while Tiepolo's *Apollo Pursuing Daphne* and *A Young Lady in Dominio and Tricorne* joined the eighteenth century collection.

The representation of the northern

European schools in the Kress Collection was greatly enhanced by the arrival of a number of German and Flemish masterpieces, such as *The Death of Saint Clare* by the Master of Heiligenkreuz, Dürer's *Madonna and Child*, Altdorfer's *The Fall of Man*, as well as *Mary, Queen of Heaven* by the Master of the Saint Lucy Legend, Memling's *Saint Veronica* and Bosch's *Death and the Miser*. The Gallery's French collection gained the most, however, with works from the studio of Simon Marmion and the Master of Saint Gilles, and above all with a number of seventeenth century masterpieces by artists ranging from Le Nain to Poussin. Additions to the eighteenth century French collection included a Lancret and three Chardins, while nineteenth century French painting gained two magnificent works by Ingres: his portrait of *Monsieur Marcotte* and *Pope Pius VII in the Sistine Chapel* (commisisoned by Marcotte when Ingres was in Rome).

1953. Chester Dale loaned a large part of his collection to the National Gallery, where it was to remain under the terms of his will (see page 7 and the year 1962).

The most important event of the year was the arrival of the Garbisch Collection of American primitives and of a first group of miniatures, watercolors and pastels (see page 11). The most attractive aspect of the collection was its fresh and simple description of American life and history during the great century when the American nation was created.

Other additions this year included Eakins' masterly *The Biglen Brothers Racing* (gift of Mr. Cornelius Vanderbilt), Fuller's portraits of *Mrs. Stephen Higginson* and *Violet* (gift of Mrs. Augustus Vincent Tack) and landscapes by Haseltine and Kensett, presented by Mrs. Rogers H. Plowden and Frederick Sturges Jr.

1954. Blake's *Last Supper* joined the Rosenwald Collection. Additions to the Gallery's collection of modern European paintings included Corot's *Italian Girl* (gift of the Avalon Foundation) and *The Bullfight*, attributed to Goya (gift of Arthur Sachs). A number of excellent paintings by American artists were added to the Dale Collection, such as Blakelock's *The Artist's Garden*, Henri's *Snow in New York*, Luks' *The Miner* and Weir's *Moonlight*.

1955. Samuel H. Kress died at the age of ninety-two. Chester Dale became President of the National Gallery. Donations to the Gallery included Corot's *Ville d'Avray* (gift of Count Cecil Pecci-Blunt) and Pater's *On the Terrace* (gift of William D. Vogel). Another group of American primitives from the Garbisch Collection arrived in the Gallery.

1956. A new exhibition of the latest additions to the Kress Collection was held to celebrate the Gallery's fifteenth anniversary. The year's most important gift was Manet's *Gare Saint-Lazare*, presented by Horace Havemeyer. Two new Renoirs, *Girl with a Basket of Fish* and *Girl with a Basket of Oranges* were presented by William Robertson Coe, Goya's portrait of the young *Victor Guye* was presented by William Nelson Cromwell and Guardi's *Castel Sant'Angelo* was presented by Howard Sturges.

Thirteen more primitives from the Galbisch Collection were added to the Gallery's collection of American art. John Walker became Director of the Gallery.

1957. The most interesting gift from the Kress Foundation this year was the Dreyfus Collection of medals, plaquettes and small bronzes (see the year 1945). Cranach's *The Nymph of the Spring* was presented by Clarence Y. Palitz and Courbet's powerful *La Grotte de la Loue* was presented by Charles L. Lindemann. One of Stuart's finest portraits — that of *Sir Robert Liston* — was added to the Dale Collection (see the year 1960 for its companion). The most important event of the year was an exhibition of "The Art of William Blake," held to celebrate the bicentenary of his birth. It consisted of 95 works, including oil paintings, watercolors, drawings, engravings and decorated books from the Rosenwald Collection and other outside sources, and it offered a complete survey of the work of an artist whose highly imaginative art looks forward both to the Expressionists and the Surrealists. Also of interest was the traveling retrospective exhibition of George Bellows.

1958. Cézanne's important *Le Château Noir* and *Vase of Flowers* were presented to the Gallery by Eugene and Agnes Mayer, and Rubens' *The Meeting of Abraham and Melchizedek* was presented by Syma Busiel. Another 15 American primitives were added to the Gallery's Garbisch Collection, including two attractive paintings of ships by Leila T. Bauman, Bradley's *Little Girl in Lavender* and Chambers' *Mount Auburn Cementery*. A traveling retrospective exhibition of the work of Winslow Homer was opened in November.

1959. The Kress Foundation made another donation of works of art to the Gallery, including el Greco's *The Holy Family* (possibly a sketch for the equally famous painting of the same subject in the Prado at Madrid), an altarpiece by the Master of Flémalle and assistants, and two fine portraits of a man and his wife by Cranach. Another important gift was that of the Timken Collection, most of the 23 paintings of which were eighteenth century European works. Outstanding among them were Tiepolo's *Bacchus and Ariadne*, Boucher's *The Love Letter*, some English portraits by Lely and Romney, and Turner's *The Evening of the Deluge*. The Gallery's collection of Impressionist works was greatly enhanced both by Edith Stuyvesant Gerry's gift of Manet's *The Tragedian* and Whistler's self-portrait, and by Eugene and Agnes Meyer's gift of Cézanne's important *The Sailor* and *Still Life with Apples and Peaches*. The Gallery also organized an exhibition of "Masterpieces of Impressionist and Post-Impressionist Painting," consisting of works from private collections. A large number of them were from the Dale Collection and subsequently became the property of the Gallery.

1960. Manet's *Still Life with Melon and Peaches* was presented by Eugene and Agnes Meyer, and a landscape by Ruisdael was presented by Rupert L. Joseph. Stuart's portrait of *Lady Liston* (see the year 1957) was added to the Dale Collection. A Smithsonian Institution traveling exhibition, "Italian Drawings, Masterpieces of Five Centuries," was seen in the National Gallery in Washington as well as in Chicago, Boston and New York. It was organized by the Department of Prints in the Uffizi Gallery in Florence, and the catalogue was prepared by Giulia Sinibaldi.

1961. Another important exhibition of works from the Kress Collection, entitled "Art Treasures for America" was held to celebrate the Gallery's twentieth anniversary. It enabled the public to see works which had recently been donated but not hitherto exhibited, such as Canaletto's *The Portello and the Brenta canal at Padua*, Luini's *The Magdalen* and Rubens' *Marchesa Brigida Spinola Doria*. This exhibition, together with some last donations made on December 9, marked the Kress Foundation's final distribution of its immense treasures. The National Gallery retained 377 of about 600 paintings which had been gradually amassed during the preceding years, together with

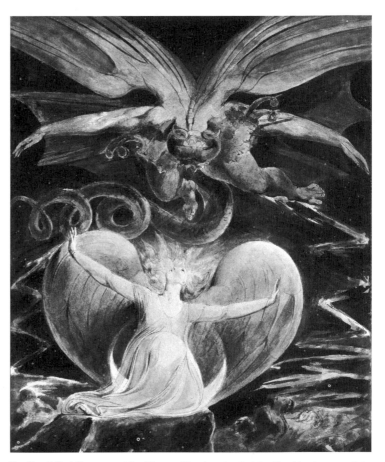

The Great Red Dragon and the Woman Wearing the Sun for Her Mantle, *one of the most hallucinatory paintings by Blake. The work was on view at the exhibition arranged in 1957 by the Gallery to mark the bicentennial anniversary of the painter's birth.*

82 pieces of sculpture and all the small bronzes. The Kress Collection now occupied 34 rooms in the Gallery.

Apart from the works already mentioned in connection with the exhibition, further donations this year included a *Madonna and Child* by Ghirlandaio, Giovanni Bellini's *The Infant Bacchus*, Cima da Conegliano's *Saint Helena*, Correggio's *"Salvator Mundi,"* two mannerist portraits — Pontormo's *Monsignor Della Casa* and Bronzino's *Eleanor of Toledo* — Titian's *Doge Andrea Gritti*, Annibale Carracci's *Venus Adorned by The Graces* and Tiepolo's *A Scene from Roman History*.

The fact that the Gallery celebrated its twentieth anniversary this year resulted in many donations, quite apart from those from the Kress Foundation. Ailsa Mellon Bruce presented Fragonard's masterly *A Young Girl Reading*; De Heem's *Vase of Flowers* and the American artist Copley's *The Copley Family* were purchased from the Mellon Fund; the Coe Foundation presented Gainsborough's portrait of *William Yelverton Davenport* as well as paintings by Miereveld and Beechey; the Fuller Foundation presented Turner's *The Dogana and Santa Maria della Salute, Venice* as well as Gainsborough's *Master John Heathcote* and Reynolds' *Squire Musters*.

Three more important exhibitions were organized by the Gallery this year. One was entitled "The Civil War" and marked the centenary of the American Civil War by bringing together eye-witness accounts in the form of drawings by artists known as "specials," who accompanied the armed forces. A traveling exhibition of "Tiepolo Drawings from the Victoria and Albert Museum, London" was held under the auspices of the Smithsonian Institution, and there was also a retrospective exhibition of the work of Thomas Eakins.

1962. Harry Waldrom Havemeyer and Horace Havemeyer Jr. gave the Gallery Vermeer's magnificent *A Lady Writing.* Van Cleve's portraits of Toris W. Vezeler and his wife were purchased with money from the Mellon Fund, Orazio Gentileschi's *The Lute Player* was purchased from the Ailsa Mellon Bruce Fund, and Manet's *Oysters* was purchased from the Adele R. Levy Fund. Chester Dale died, leaving the Dale Collection to the Gallery in his will. This meant that, in addition to the Impressionist and modern French paintings, the Gallery acquired works by artists ranging in time from David, Géricault, Gérard, Gros, Ingres, Delacroix, Daumier, Courbet, Millet, Monticelli and Puvis de Chavannes up to Fantin Latour and the minor Impressionists.

The Gallery's American collection gained Sargent's *Street in Venice* (gift of the Avalon Foundation) and his *Miss Grace Woodhouse* (gift of Olga Roosevelt Craves), as well as Inness' *Lake Albano, Sunset* (gift of Alice Dodge). An exhibition entitled "John Gadsby Chapman, Painter and Illustrator" was held from December 16 until the end of January 1963. Chapman illustrated many nineteenth century American books.

1963. From January 10 to February, the Gallery exhibited Leonardo da Vinci's *La Gioconda*, which had been lent by the French government to the President and people of the United States. Hundreds of thousands of Americans from all parts of the country filed past the painting. Donations to the Gallery this year included Poussin's *The Assumption of the Virgin* (gift of Ailsa Mellon Bruce), Rubens' *Tiberius and Agrippina* (from the Mellon Fund), Goya's *The Duke of Wellington* and *The Bookseller's Wife* (gift of Mrs. P. H. B. Frelinghuysen) and the famous painting of *Watson and the Shark* by the American artist Copley (from the Ferdinand Lammont Belin Fund). Rush H. Kress, the extremely active President

9

(From the top) The complicated framework which underlies the ceiling of the Gallery and into which the lighting system is installed. This system provides for day-lighting through skylights. (Below) The steam-room where the pressure valves in connection with heating and air-conditioning are installed.

from the series of more than a thousand in the Garbisch Collection at the Metropolitan Museum in New York.

1967. This year's report detailed the number of people who visited the Gallery (a million and a half, plus more than one million seven hundred thousand schoolchildren), and new acquisitions. These included three quite outstanding works obtained through the Ailsa Mellon Bruce Fund: Leonardo da Vinci's *Ginevra de' Benci* (purchased from the Liechtenstein Collection), an Avercam and a portrait by Mabuse. It was announced in November of this year that Mellon's son and daughter, Paul and Ailsa, had offered funds for the construction of a new building near the Gallery (to be designed by the Chinese architect I. M. Pei). Its purpose was to house a Center for Advanced Study of the Visual Arts, with a library, archives and an electronic center for the rapid finding of documents. Work was begun on the building in 1970 and should be completed by 1975. The architect's model shows the building to be a complex structure with a trapezoidal plan, divided diagonally into two complementary triangles, each of which will have its own specific function. One allows space for services, and also has an area designated for temporary exhibitions, special events in the visual arts and a photographic archive (which had been under discussion for some time but not yet set up — see the year 1970). The other trianglar area is to house the study center itself.

American paintings acquired this year included a Cole (through the Mellon Fund), a Moran (gift of the Avalon Foundation), a Feininger (gift of Julia Feininger) and 8 primitives from the Garbisch Collection, among which were Chamber's *The Hudson Valley, Sunset*, an amusing work by Mark and an anonymous *A City of Fantasy*. But the most important event of the year as regards American painting was the large exhibition: "Gilbert Stuart, Portraitist of the Young Republic."

1968. The National Portrait Gallery was founded, and Charles Nagel was appointed as its first Director. Acquisitions this year included a Van der Heyden, Pannini's *Interior of Saint Peter's, Rome*, Juan de Flandes' *The Temptation of Christ* (all three purchased through the Ailsa Mellon Bruce Fund), two paintings by the American artist Kuhn (gift of the Avalon Foundation and Brenda Kuhn), a lakeside view by Kensett (gift of Mrs. Sigourney Thayer), and three primitives from the Garbisch Collection, including Bradshaw's *Plains Indian*. An exhibition entitled "Painter of Rural America, William Sidney Mount 1807-1868" was held this year.

1969. An exhibition of "American Naive Paintings of the 18th and 19th Centuries" from the Garbisch Collection had now returned from a tour of Europe and was shown in the Gallery during the summer. The Gallery acquired Claude Lorrain's *The Judgment of Paris* and *Portrait of a Man* by Jordaens through the Ailsa Mellon Bruce Fund.

1970. J. Carter Brown was appointed Director of the National Gallery. A spring exhibition entitled "The Reality of Appearance. The Trompe l'Oeil Tradition in American Painting" surveyed work from James Peale to the moderns, and the catalogue included an introduction by Alfred Frankenstein. Cézanne's important early *The Artist's Father* was presented to the Gallery by Paul Mellon.

It was officially announced that a National Photo Archive for Art Historians, Architects and Environmentalists was to be set up, and that its Director would be the art historian Alessandro Contini-Bonacossi. The Archive now possesses more than 200,000 negatives of paintings, sculpture and architecture, which are the property of the National Gallery. The collection will be added to, on the basis of specific criteria of selection, and will occupy one third of the area set aside for the new Center for Advanced Study in the Visual Arts which is now under construction to the east of the National Gallery, between Pennsylvania Avenue and Madison Drive (see the year 1967).

Description of the Gallery

The National Gallery in Washington is one of the most imposing modern neoclassical buildings in America, as well as the largest marble construction in the world. It is situated in the central part of the city, between the Capitol and the Washington Monument, occupying a vast site on what was previously a piece of marshland called Tiber Creek.

John Russell Pope was chosen as architect. He had studied at the American Academy in Rome and had designed the Baltimore art gallery as well as a number of other public buildings in the United States. His brand of neoclassicism did not have the purist approach of the neo-Greek architects, but sought inspiration instead in the noble relationships of rotundas, galleries and porticos found in the splendid and dramatic architecture of Imperial Rome. The prime coordinating feature of the whole National Gallery building is the central rotunda with its huge coffered dome, reminiscent of the Pantheon. The two internal courtyards with their colonnades recall the atria of Roman houses at Pompeii, while the exterior, with its niches, pilasters and monumental porticos, was influenced by one of the most important neoclassical buildings in Washington: George Hadfield's Old District Court House of 1820.

Pope died when he was just sixty-three, in the very year that work on the National Gallery began (1937), but his partners Otto R. Eggers and Daniel Paul Higgins carried out his design to perfection, creating a building on two floors with an exhibition area of about 498,000 square feet and façade about 780 feet long. It measures 305 feet at its widest point. The building consists basically of a huge rotunda with colonnade and dome from which two long galleries extend to East and West, each one ending in a colonnaded garden court. The exhibition areas are arranged around this central structure in such a way that a plan of the building consists of an east-west rectangle (containing the rotunda) terminating at each end in a cross (containing the two garden courts). The two principal entrances are on the long north and south sides, the most important being on the south side, facing the Mall. It consists of a double Ionic portico with an imposing flight of steps up to the main floor and the rotunda. The north entrance looks onto Constitution Avenue. It has an Ionic portico and gives access to the ground floor, which can also be reached through the imposing east and west entrances, facing Fourth and Seventh Avenues respectively. On the ground floor, directly below the rotunda, is a spacious lobby with pilasters. A number of staircases and lifts between the two floors enable the large number of visitors who come to the Gallery to circulate without difficulty.

Both the outside and inside of the building are made of highly prized marbles. The main structure is made of precious pink Tennessee marble, the blocks being carefully arranged so that

of the Kress Foundation, died at the age of eighty-six.

1964. Paul Mellon presented the Gallery with an interesting pair of *Caprices* by Canaletto which had formerly been in the Bryant Collection in England. And through the Ailsa Mellon Bruce Fund the Gallery acquired two rare paintings by Gian Antonio and Francesco Guardi, as well as Largillière's *Elizabeth Throckmorton*. American paintings by Homer, Trumbull and Sargent were presented by John W. Beatty, Patrick T. Jackson and Ernest Iselin.

1965. Many more works were acquired by the Gallery. With the aid of the Ailsa Mellon Bruce Fund it gained a painting by Corneille de Lyon, another by Sithium, a small work by Roberti and Rubens' *Daniel in the Lions' Den*. The Bay Foundation presented a group portrait by Vigée-Lebrun. The Gallery's American collection received a substantial donation from Paul Mellon of 351 paintings (mostly watercolors) of Indian subjects by George Catlin, while the Avalon Foundation presented Heade's *Rio de Janeiro Bay*. James C. Stotlar presented a charming Wyant, while eight "primitive" portraits by Earl, Field,

Sheffield and Theus joined the Garbisch Collection. An exhibition of "The Watercolor Drawings of John White from the British Museum" was held. For the first time outside England it was possible to see drawings illustrating three ill-starred expeditions to settle North America during the reign of Queen Elizabeth. An important retrospective exhibition of the work of John Singleton Copley was also held.

1966. A report on the various collections, donations, exhibitions and scholarly and educational activities of the Gallery was published to mark its twenty-fifth anniversary. A very important acquisition (through the Dale Fund) was Delacroix's *The Arab Tax*. Thanks to the Ailsa Mellon Bruce Fund, the Gallery also acquired Van der Weyden's *Saint George and the Dragon*, while its collection of American art gained portraits by Sully and Charles Willson Peale (gift of Countess Mona Bismarck and Morris Schapiro), a fine La Farge on a Tahitian subject (through the Caspar Miller Fund) and Feininger's *Zirchow VII* (gift of Julia Feininger). An exhibition of "101 American Primitive Water Colors and Pastels" was organized. The works exhibited were selected

the darkest are nearest to the ground and the lightest are highest up. Twenty-seven different shades are used in such a way as to give an effect of lightness and harmony to what is in reality an immensely heavy structure, consisting of 35,000 marble blocks. The columns of the dome are made of "imperial green" marble from a quarry near Lucca, the entablature is made of "fancy marble" from Tennessee, and the floors are made of green marble from Vermont. The walls of some of the rooms where Italian paintings are exhibited are made of Roman travertine, the staircase walls are made of Italian *botticino* (whereas the steps are of Hartville marble from France), and other Italian marbles (*venato istriano*, *rosso di Levanto* and *Tavernella chiaro*) and precious local marbles were used for the other walls, entablatures, doorways and floors. It is almost a miracle that this should have been possible, for the Gallery was built during the Second World War, when most of the Italian and other European marbles had to cross the Atlantic in the midst of hostilities.

The beauty of the building, however, was never allowed to overwhelm the works of art it contains. They remain the focus of attention when one is inside the Gallery. Finley, the first Director, and Walker, the Chief Curator (who was to succeed Finley as Director), applied the principle that all the works of art (and especially the paintings) would be appreciated best if they were kept apart from one another. Each was therefore given a large amount of clearly defined wall space (the amount of wall space available was greatly increased by the use of partitions), and references to their histories were kept in the background. Only in the cornices, door surrounds and wall coverings is there a reflection of the age to which the paintings belong. In a few cases, works of art have been used in a more special way. Thus the fountain at the center of the rotunda is embellished with Giambologna's bronze *Mercury*, and those in the middle of the two garden courts have two lead sculptures of sporting *putti*, by the French sculptors Legros and Tubi, which once stood in the gardens at Versailles.

The works of art are protected and preserved by a complete air-conditioning system within the Gallery, which maintains temperature and humidity at a constant level and filters the outside air in order to remove any harmful atmospheric agents. In addition, the windows are fitted with plastic filters to prevent ultraviolet rays from causing the paintings to fade. Maintenance and preservation of the works of art is the responsibility of the restoration department, and at the same time special scientific research, primarily concerned with the yellowing of varnishes and the use of synthetic varnishes, has been going on for nearly thirty years at the Mellon Institute in Pittsburgh, thanks to funds provided by the Dominion and Avalon Foundations.

While continuing this work of preservation, the National Gallery tries to maintain close ties bween the public and the works of art on exhibition, so that visitors may enjoy them to the full. Hence, in addition to the careful arrangement of the works themselves, every attempt is made to see that the interior of the Gallery is pleasant. There are plenty of seats and places for resting as well as a cafeteria, and changing exhibitions of rare flowers are continuously displayed in the garden courts. Orchestral concerts under the baton of a conductor-composer are also held in one of the garden courts, thus enabling the public to listen to a unique musical ensemble which often plays new compositions.

The Gallery's Educational Department is responsible for its various cultural activities. Guided tours of the Gallery are given by expert art historians, visitors can hire portable tape recorders

with individual headphones and listen to talks about the works of art in thirty-one exhibition rooms, free leaflets containing explanatory commentaries are available in individual exhibition rooms, Sunday lectures are provided, and there is an annual series of A. W. Mellon lectures. A special section of the Department is responsible for extension services and supplies every state in the Union with travelling exhibitions, Gallery films and slide lecture sets. Also available to the public are a well-equipped library and the Index of American Design, which contains watercolor facsimiles of American decorative arts and crafts from the seventeenth to the end of the nineteenth century. Six hundred and sixty artists were commissioned to paint them by the government during the Depression.

All the above services are on the ground floor of the Gallery, which also houses minor arts of the Middle Ages and Renaissance (1-3), decorative arts and Chinese porcelain from the Widener Collection (4-6), contemporary French painting from the Dale Collection (9-15), French decorative arts of the eighteenth century (16-18), prints and drawings (19), Renaissance bronzes from the Kress Collection (21) and a room for temporary exhibitions (22). About a thousand paintings are exhibited on the main floor, as follows:

Paintings

a) Italian School Primitives, Renaissance painting in Tuscany and Umbria	Rooms 1-15
Renaissance painting in Venice and Northern Italy	Rooms 19-29
Seventeenth and Eighteenth Centuries	Rooms 33-36
b) Spanish School	Rooms 30, 50, 51
c) Flemish and German Schools	Rooms 35-43
d) Dutch School	Rooms 45-49
e) French School Seventeenth and Eighteenth Centuries	Rooms 52-56
Nineteenth Century	Rooms 69-72, 76-77, 83-93
f) British School	Rooms 57-59, 61
g) American School	Rooms 60A, 60B, 62, 64-68

The Gallery's sculpture collection is also exhibited on the main floor, in Rooms 2, 6, 11, 12, 16-18, 38 and 60.

Most of this book is primarily concerned with paintings. This is true of the *History of the Gallery and its Paintings* (see page 6) and subsequent sections, and the descriptive section on the Gallery's American collection, which is complete and comprehensive in itself. Nevertheless, the Gallery is so rich in all the other arts that they too deserve some attention.

American School

The Gallery's collection of American art consists of 827 paintings and five pieces of sculpture. It owes its existence primarily to the donation of 130 American portraits by the Mellon Trust, 42 modern and contemporary paintings from Chester Dale, 175 "primitive" paintings (the work of eighteenth and nineteenth century artists) from Edgar William and Bernice Chrysler Garbisch, and 351 of George Catlin's paintings of Indian Subjects from Paul Mellon, as well as to purchasing funds given by the Avalon Foundation, and gifts and funds from more than seventy other private individuals and foundations.

The Gallery's American collection is a broadly based one, and hence provides a complete panorama of the de-

velopment of American painting from the eighteenth century to the early decades of the twentieth century. From the point of view of artistic achievement, the first event of major significance in the history of American painting was the involvement of certain important American artists in the investigations of the French Impressionists. One of these was Whistler, who has nine paintings in the Gallery, including major works like *Chelsea Wharf Grey and Silver* and *The White Girl*. Another was Mary Cassatt, who settled in Paris and whose seven works in the Gallery include *The Loge* and the famous *The Boating Party*. Another group of American artists was also influenced by the latest devolpment in European art. Some of them can hence be related to Post-Impressionism and Neo-Impressionism (Henri, Hassam, Chase, Melchers, Blakelock, La Farge, Ranger, Frieseke and Weir), and others to Symbolism, Art Nouveau, Secession and Expressionism (Davies, Dearth and Luks). Outstanding among them is Ryder (*Siegfried and the Rhine Maidens*), whose paintings convey a forceful, mystical vision. All the above artists belong to the later nineteenth century and the early years of the twentieth century, when the refined art of Feininger, an artist of German extraction, stood out for its poetic interpretation of Cubism.

American art first asserted itself earlier than this, however, for an American school of portraiture grew up at a very early slage, and showed itself to be independent of ihe great British school of portraiture from which it derived. From its beginnings in the closing years of the eighteenth century and the early years of the nineteenth century, it produced work of high quality, thanks to important artists like Savage and Copley, and especially Stuart, a great painter whose task it was to bear witness to the young American Republic by depicting the influential members of its upper and middle classes. West, on the other hand, recorded the epic history of America in his paintings (e.g. *Colonel Guy Johnson* and *The Battle of La Hogue*). This fine tradition in portraiture continued throughout the nineteenth century. Morse was outstanding among the portrait painters of the time, and he was succeeded by such artists as Sully, Mather Brown,

Trumbull, Harding, Rembrandt Peale, Neagle, Fuller and Huntington, until one comes to the strikingly modern work of Duveneck. Among American painters of realist landscapes, the most important was Cole (one of the greatest members of the Hudson River School), and next to him come Inness, Kensett, Wyant and Moran. Special mention must also be made of the quite individual work of Homer, whose apparently uninhibited vigor nevertheless conveys a poetic feeling of immediacy. Sargent specialized in painting the portraits of the American upper classes. He was active at the turn of the nineteenth century and gave portraiture a slightly frivolous kind of elegance which nevertheless had its artistic value at times.

George Catlin's series of "Indian Cartoons" have a special place within the context of nineteenth century American painting. Some were on canvas, but most were watercolors, and they were divided into three groups: "North American Indians," "South American Indians" and "Voyages of Discovery by La Salle." This last group was probably commissioned by Louis Philippe of France to commemorate La Salle's voyages to North America in the period 1678-1687. Paintings of this kind inevitably have a descriptive precision of detail and a concern for documentary exactitude which produces facsimiles of real Indians, but these qualities are strangely accompanied in Catlin's work by a poetic breadth of vision in depicting the wide open spaces of the American landscape.

A third striking phenomenon in American art was the impression made by the "American scene" on the artistic imagination. Painters found a primitive kind of fascination in modern American life, with the rise of great financial empires, the ferment of political life and the sudden mushroom growth of cities. The two most outstanding examples of art inspired in this way are to be found in the violent works of Bellows and the elegant, satirical paintings of Du Bois, both of whom interpreted the modern life which had come to America from Europe with sardonic force and harsh creative power.

Another phenomenon peculiar to American art is that of "primitive" or "naive" painting by artists who had no formal training. Sometimes they were

11

One of the Gallery's storerooms.
All storerooms are air-conditioned and open to the public.

One of the main entrances to the Gallery, with the flight of steps facing the Mall leading into the Rotunda on the Main Floor.

professionals (especially the portrait painters) and sometimes amateurs who earned their living in some other way. This kind of art also exists in Europe, but in America it can be described as a school of art because it was so prolific for so long and provided a forceful and fresh description of a young nation in the process of growing up. This kind of painting is the expression of a pre-logical stage in human creativity, rather like that of children (naive simplification of forms, emphasis on whatever strikes the artist's imagination most, and lack of a rational organization of volumes, colors and three-dimensional space), and it was the principal and special function of the American primitives to supply in this way an image of the development of American society at middle class level. Their paintings describe the life and vicissitudes of the lower middle classes in rural areas and of the newly developing working classes. Like simple poet-minstrels, they provided a homely, familiar reflection of the heroic deeds of American history, as well as an array of modest but clearly delineated portraits of the leading personalities in what had not yet become a mass society.

This particular kind of art flourished from the early eighteenth century to the mid-nineteenth century, and was patiently colected, piece by piece, with expert discrimination, by Colonel Edgar William Garbisch and his wife Bernice Chrysler Garbisch.

Outstanding among portraitists in the eighteenth century were Badger, Wollaston, Winthrop Chandler and the unknown artists who painted *Jonathan Bentham* and *Catharine Hendrickson*, while in the nineteenth century the best portraits were produced by Ralph Earl, Eichholtz, Ralph E. W. Earl, Bundy, Field, Jennys, Hadock, Ammi Phillips, Powers, Skynner and Theus. Also worthy of mention among the nineteenth century portraitists are W. Chandler, Coe, Greenwood, Multhrop, Polk, Robinson, Sheffield and the unknown artists who painted *Sophia Burpee*, *Martha*, *Aphia Salisbury Rich and Baby Edward* and *Young Man Wearing White Vest*. Special mention must be made of the artists who painted children, such as Bradley, H. G. Chandler, Joshua Johnston, MacKay, Prior,

Sachs, Stock, Jordan, Walters and many other unidentified painters who produced a unique series of smart and self-composed little children.

All this portraiture provides a faithful reflection of a society struggling to assert itself. There are "snapshots" of large families, naively idealised portraits of husband and wife, individual portraits of men in the pride of their newly undertaken professions, and of those hard-faced women who struggled to bring up families in difficult circumstances in a country which their people had occupied only a few generations earlier. They wear starched lace like battle armour, and their curled bonnets give them the air of grand ladies.

There are other "primitive" paintings which provide a poetic interpretation of nature and man's environment, conveying a simple enthusiasm at the sight of a neighbor's fertile fields or a friend's farm or the civic dignity of the local village (Alexander, Hicks, Hofmann Zeliff, Lermond, Mader, Ropes, Chambers' sweeping views, and the unknown artists who painted *Leaving the Manor House*, *Mahantango Valley Farm*, *Mounting of the Guard*, *New England Village*, *Twenty-two Houses and a Church*, *Village by the River* and a modern dream entitled *A City of Fantasy*). Related to these landscapes are the proud paintings of American ships by Leila T. Bauman, Bard, Cooke, Hashagen, Mullen, Tanner, and the unknown artists who painted *Imaginary Regatta of America's Cup Winners* and a bird's eye view of a port entitled *Northwestern Town*.

There is also a whole series of "primitive" paintings reflecting the indelible memories of recent historical events and a deep attachment to new ideals of liberty (Kemmelmeyer, Lamb, and the unknown artists responsible for *Allegory of Freedom*, *Liberty*, *Burning of Old South Church*, *Bath, Maine*, *Civil War Battle* and *"We go for the Union"*), which is epitomized in *General Washington on a White Charger*.

The Gallery's collection of watercolors and pastels includes a large number by amateurs, among them many schoolgirls, in a freer, more intimate and immediate style. But the two most important groups of works in this medium are paintings by professional por-

traitists and a group of German manuscripts from Pennsylvania, called "Fraktur" because they are decorated with broken geometrical patterns which recall German "Fraktur" prints of the sixteenth century.

Taken as a whole, therefore, the collection is an important primary source for anyone wishing to study the various aspects of the American School of painting.

Sculpture

The National Gallery has over 250 items in its sculpture collection, thanks to important donations of works of the Italian Renaissance and the eighteenth century French school (see *The Gallery and its Paintings*: Mellon Collection, Widener Collection and Kress Collection), as well as to others of modern and contemporary French sculpture, such as the 50 Daumiers from the Rosenwald Collection, the 28 Rodins presented by Simpson, 7 items from the Dale Collection and others purchased through the Ailsa Mellon Bruce Fund, together with a number of other donated works of various periods and schools.

Thanks to contributions from the Kress Collection, an early stage in the development of Italian sculpture is exemplified by a very interesting group of fourteenth century works (Bonino da Campione, Tino di Camaino and a powerfully dramatic piece by Giovanni di Balduccio), which includes one outstanding masterpiece in the form of twin figures of the *Archangel Gabriel* and the *Madonna of the Annunciation* in polychrome and gilded wood. Their subtle Gothic rhythms identify them as the work of Nino Pisano.

The Italian Renaissance is particularly well represented, especially fifteenth century sculpture from Florence and central Italy. A whole series of fascinating works serves to demonstrate the immense variety of styles which flourished during this golden age. They range from the work of acopo della Quercia and Ghiberti, in classical style but with Gothic reminiscences, to the blunt vigor of Donatello, the delicate expressive charm of Desiderio da Settignano and Antonio Rossellino, the realism of portrait busts by Mino da Fiesole, Benedetto da Maiano and Verrocchio, elegant glazed terracottas, in classical style but with sources of inspiration in popular culture as well, by Luca and Andrea della Robbia, refined productions of the Humanist culture of Urbino, and a dramatic "unfinished" work in the manner of Michelangelo.

Examples of this Florentine and central Italian work are the problematical *David of the Casa Martelli*, attributed to Donatello, a terracotta *Madonna* probably by Ghiberti, a bust of Marietta Strozzi and an exquisite Renaissance *Tabernacle* by Desiderio da Settignano, two lovely figures of *Virtue* and a portrait of *Astorgio Manfredi* by Mino da Fiesole, a *Madonna* and a *Nativity* by Luca della Robbia, some versions of the *Adoration of the Child* by Andrea della Robbia, a *Princess of the House of Aragon* by Francesco Laurana of Urbino and a *Giuliano de' Medici* attributed to Verrocchio. The somewhat heterodox and gloomy atmosphere of the Renaissance in Lombardy at the time of the Sforzas, where Gothic influences remained, is reflected in some portraits of members of the Sforza family attributed to Amadeo and some reliefs which are similar in style to those at the Charterhouse near Pavia.

The richer and more dramatic art of the sixteenth century High Renaissance, with its interest in chiaroscuro effects, is exemplified in the bronze *Mercury* by the Italo-Flemish sculptor Giambologna and by a fine group of strikingly pictorial Venetian sculptures by Jacopo Sansovino and Alessandro

Vittoria. The elegantly detached and refined Mannerism of Milan is represented by busts in which the Imperial sculptor Leone Leoni shows all his skill as a goldsmith (*The Emperor Charles V*), and by a fine relief of *The Adoration of the Shepherds* by Annibale Fontana. The "small bronzes" in the Widener Collection display an impassioned kind of Renaissance refinement, as is particularly clear in the *Inkwell* by the Paduan artist Riccio, in Giambologna's *Hercules and the Erymanthian Boar*, and in the Mannerism of *Virtue and Vice* by the Dutch sculptor Adriaen de Vries, who worked in the Italian style.

Outstanding among the Baroque sculptures of the seventeenth century are a number of works by Bernini, the best being his marble bust of *Monsignor Francesco Barberini*, which belongs to a series of portrait busts made for members of the family of his patron, the Barberini Pope Urban VIII. The Gallery's most interesting seventeenth and eighteenth century sculpture, however, is that which reflects the magnificence of contemporary French society. Examples range from the elevated splendor of the work of portrait sculptors employed by Louis XIV (Desjardins, Coysevox and Jacques Pron the Younger), and the rather cold charm of sculptors who worked at Versailles (the Gallery has two groups of *Cherubim* made by Pierre Legros and Tubi for fountains at Versailles), to the new kind of pictorial sculpture produced by Le Lorrain. His work led to the limpid elegance which held absolute sway among the artists employed by Louis XV and Madame de Pompadour (e.g. Jean-Louis Lemoyne, Bouchardon and Falconet), and finally to the neopaganism and scientism of the age of Louis XVI and the Encyclopaedists, which was reflected in the realist sculpture of Pajou, the precociously neoclassical compositions of Clodion and the uncompromising portraits of Houdon.

Neapolitan Fisher Boy and *Girl with a Shell* are two magnificent companion pieces by Carpeaux which bring us right up to late nineteenth century naturalism. This direct approach to reality, however, had already been implicitly superceded by Daumier. His series of bronzes connected with the July Revolution (a series of portraits of *Deputies*) and the 1848 Revolution (*Ratapoil*) reveals a new interpretation of

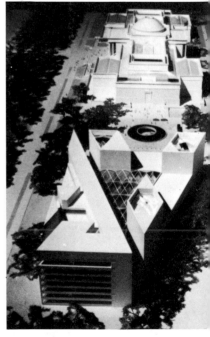

Plastic model of the new building which will house the Center for Advanced Study in the Visual Arts.

reality involving a synthesis of what the eye sees and an acceptance of the value of sensibility, and on this basis he develops his implacable social and political satire. What is implicit in Daumier is developed to an extreme degree in Rodin's interpretation of Impressionism in sculptural terms, as one can see in the National Gallery's magnificent collection of small signed sculptures of his (6 terracottas, 7 bronzes, 4 works in marble and 11 in gesso). Renoir also developed Daumier's ideas in his sculpture. Although primarily a painter, his sculpture (the National Gallery has two bronze heads of his small son *Coco*, both dating to 1908) was more than just an occasional activity. He came to sculpture, in fact, in his later years, in a attempt to keep at bay the crippling arthritis from which he suffered, and worked by giving instructions to a young pupil of Maillol. Another painter who sculpted was Gauguin. The National Gallery has his realistic *Pair of Shoes* as well as a wooden fetish entitled *Père Paillard*, inspired by his surroundings at Tahiti, where he had been able to express his primitive symbolism in sculpture. This primitive spirit can also be seen in Modigliani's *Head of a Woman* (in limestone), where it is combined with new ideas related to Cubism, the basic source of inspiration being the concentrated expressionism of negro sculpture.

To these examples of the principal trends in modern sculpture must be added the work of the Anglo-American artist Epstein (the National Gallery has his *American Soldier* of 1917) with its suggestions of Futurism. However, there is a reaction against the Impressionist attempt to dissolve reality in the rich, classical harmonies of Maillol's nudes (the National Gallery has *Venus*, *Summer* and *Bather with Arms Raised*) and of Despiau's figures (the National Gallery has a portrait of *Maud Dale*), as well as in the spiritualized rhythms of the work of the German sculptor Lehmbruck (*Standing Woman*, 1910).

The Gallery's sculpture collection also includes works in quite different styles and from different periods. There are, for example, some Greek sculptures (a classical *Head of a Youth* dating from the 4th century B. C. and a second century Hellenistic *Eagle*), a refined *Bronze Cockerel* from the school of great Negro metal sculptors of the Kingdom of Benin who specialized in casting with the *cire perdue* technique, two English sculptures in alabaster dating from the fourteenth or fifteenth centuries (*The Trinity* and *Saint George*), and a wooden figure of *Saint Burchard* by Tilman Riemenschneider, a late Gothic German realist. The presence of works like these, however, does not alter the fact that the Gallery's collection serves primarily to document three great periods in the history of sculpture: the Renaissance, the eighteenth century, and the nineteenth and twentieth centuries.

Renaissance Bronzes from the Kress Collection

The Gallery's collection of small Renaissance bronzes, medals and plaquettes from Italy and other parts of Europe contains 1306 items (459 reliefs and plaquettes, 130 statuettes and miscellaneous utensils, and more than 700 medals), and bears witness to an art form in which the Renaissance expressed with utter conviction and a refined aesthetic sense its belief in its own ability to recreate the classical spirit. For Greek and Roman society had used small bronzes, portrait medallions and ornamental plaquettes as a highly refined expression of classical ideals in a form derived from the coins, small ex voto figures and plaquettes used as ornaments or amulets, which had developed over thousands of years

GENERAL INFORMATION

Organization – The Gallery's staff consists of about 375 persons, headed by a President and a Director, in addition to different heads of departments and assistants.

Institutions Connected with the Gallery – The Gallery is provided with a Photographic Laboratory, a rich Photographic Archive, a Scientific Department to carry out chemical and X-ray researches, a Restoration Studio and a Publications Department to provide for publications and updated pamphlets on pictures, in addition to the Gallery's yearly Report.

Lighting and Air-conditioning – The exhibition rooms are lit by natural light supplemented, when necessary, by artificial lighting (tungsten lights and neon). Air-conditioning is held at 72° F with a relative humidity of 51%.

Security Services – There is an anti-theft system involving an automatic alarm, closed circuit TV cameras and hidden photo cameras. The anti-fire service is carried out by an electronic system. Radio communications with the police are constantly held. The guard force consists of 131 officers and men.

Admission – The Gallery is open to visitors on weekdays from 10 a.m. to 5 p.m. in winter, and from 10 a.m. to 9 p.m. in summer; on Sundays, from 12 noon to 9 p.m. The Gallery is closed on Christmas Day and New Year's Day. Admission is free at all times. There are frequent guided tours by staff members.

Cultural Services to the Public – Visitors can attend the library and avail themselves of the photo archive. Yearly reports on the Gallery's activity and catalogues of some collections and special exhibitions are available.

Services to the Public – There is one cafeteria type restaurant with a capacity of about 240 persons.

Subsidiary Exhibitions – The Gallery arranges on the average of four major special exhibitions of material from outside the Gallery per annum, and about eight minor exhibitions per annum.

CHARACTERISTIC

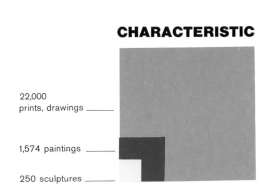

22,000 prints, drawings

1,574 paintings

250 sculptures

VISITORS

	1st quar.
	2nd quar.
	3rd quar.
	4th quar.

200.000 400.000 600.000

RELATIVE IMPORTANCE OF THE SCHOOLS REPRESENTED IN THE MUSEUM

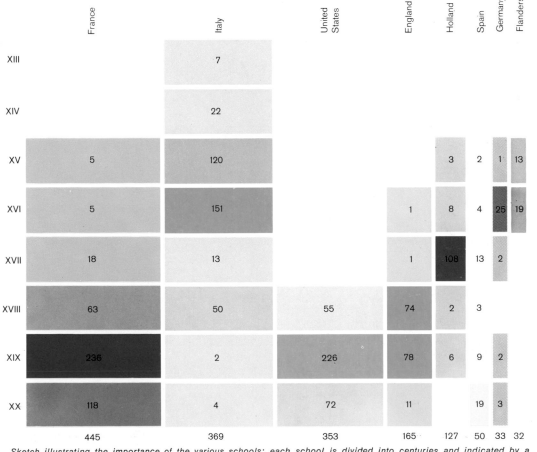

	France	Italy	United States	England	Holland	Spain	Germany	Flanders
XIII		7						
XIV		22						
XV	5	120			3	2	1	13
XVI	5	151		1	8	4	25	19
XVII	18	13		1	108	13	2	
XVIII	63	50	55	74	2	3		
XIX	236	2	226	78	6	9	2	
XX	118	4	72	11			19	3
	445	369	353	165	127	50	33	32

Sketch illustrating the importance of the various schools: each school is divided into centuries and indicated by a different color; the length of the strips is proportional to the number of paintings belonging to each school with regard to the other schools; the color intensity is proportional, within each school, to the importance of the paintings for each century. The figures referring to the paintings have been indicated with the nearest possible approximation.

14

Main floor

Ground floor

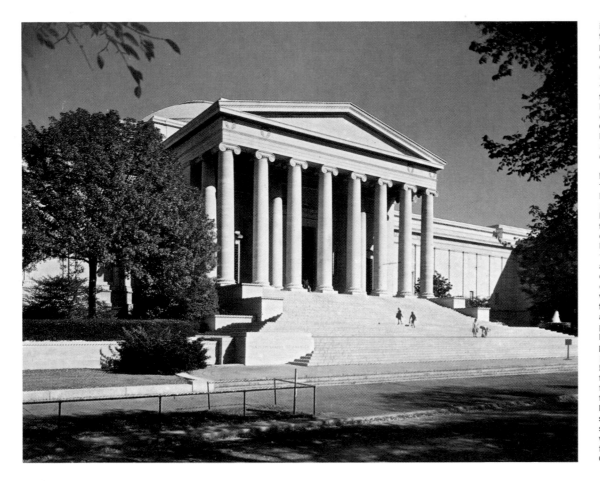

in the Mediterranean area. But since this particular art form makes it comparatively easy to obtain cast copies of original works and to imitate ancient alloys and patinas, forgers have applied their skill in this field to a very considerable extent. Consequently the National Gallery's bronzes from the Kress Collection, most of which are outstanding items from the Dreyfus Collection (see *History*, 1945 and 1957), have that much greater a rarity value and constitute one of the world's finest collections of Renaissance bronzes.

The collection was originally assembled in Paris by Gustave Dreyfus (1837-1914), who devoted practically the whole of his life to collecting Renaissance masterpieces. When he was thirty-five, he made his first purchase by securing the fine collection of Italian Renaissance paintings, sculpture and bronzes known as the "little Paris Bargello," which was being sold by the painter and connoisseur Charles Timbal because of the difficult situation in France at the time of the Franco-Prussian war of 1870 and the Commune. From this time onwards Dreyfus concentrated almost exclusively on purchasing two particular forms of art which the Timbal collection lacked and which he was particularly interested in: medals and plaquettes with scenes in relief. The latter had been used in Renaissance times as ornaments on furniture and furnishings or as pendants, and the former had been revived during the Renaissance by the Veronese artist Pisanello as a highly personal form of souvenir, commissioned by the person whose features appeared on the medal for himself, or as a gift for his friends. On the reverse side would be represen-

15

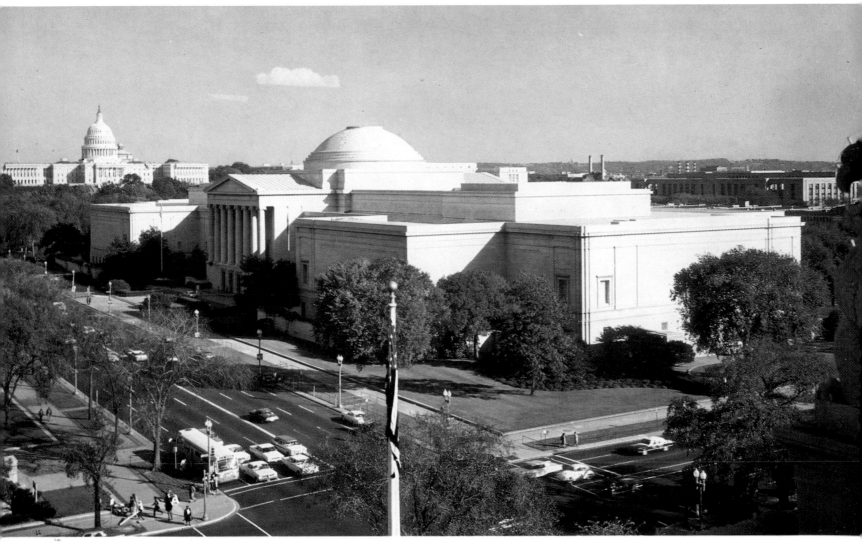

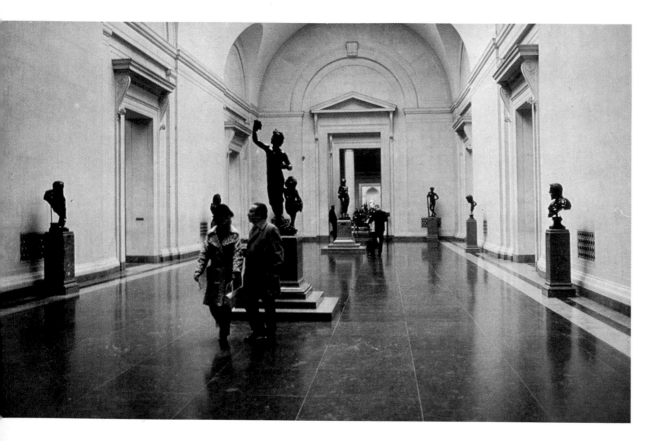

(Top) The wide corridor linking the painting rooms.
Bronze sculptures are on exhibit in it. (Below) One of the two garden courts
in the Gallery. In the center is a fountain, once in the gardens
of Versailles, decorated with a small lead group of putti. Afternoon concerts of
classical music are given in both garden courts.

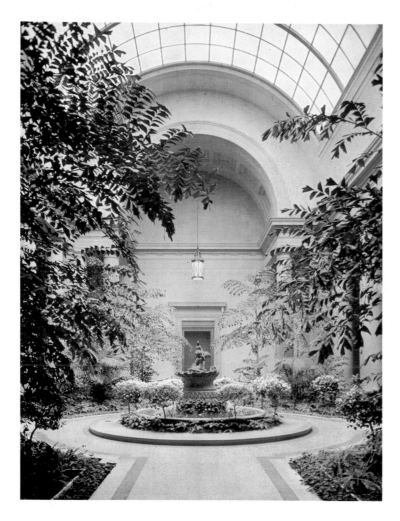

was influenced by Bramante, but also the Emilian artist Enzola, the Venetian artist Camelio and the very prolific Moderno. Bellano, an assistant of Moderno, was responsible for *The Dead Christ and Two Angels*, a plaquette rather in the style of Donatello. Another plaquette bears a portrait of *Aristotle* and gives the impression of being an antique piece which circulated among sculptors of the time as a model. And in addition, there is a whole group of works involving the engraving of precious stones, and including a series of plaquettes copied from antique cameos.

The most refined of all these sculptors of plaquettes was the famous Riccio (Andrea Briosco), whose Paduan brand of Humanism was fertilized by contact with the sculpture of Donatello. Outstanding among his many plaquettes are the magnificent *Deposition of Christ* and the *Family of Satyrs*; and he was also responsible for the best of the small bronzes. There are also a few masterpieces from outside Italy, such as the superlatively beautiful plaquette depicting *Orpheus and Eurydice* by Peter Vischer the Younger who, together with Peter Flötner, exemplifies the Renaissance art of Nuremberg under the influence of Dürer.

Among the medals are some examples of the magnificent, monumental realism of Antonio Pisano, known as Pisanello. They include one made for *Leonello d'Este* (with an allusion to his wedding on the reverse side in the form of a cupid teaching a lion — Leonello's emblem — to sing), and others made for *Sigismondo Pandolfo Malatesta, Filippo Maria Visconti* and *Don Iñigo d'Avalos*, an official at the Aragonese court. The serenely elegant medals of Matteo de' Pasti (who built the Tempio Malatestiano to Alberti's design) are nearly as beautiful as those of Pisanello, and the Gallery possesses those he made for *Guarino* (a Veronese humanist who became tutor to Leonello d'Este), *Sigismondo Pandolfo Malatesta* and Sigismondo's wife *Isotta degli Atti*. (The elephant on the reverse side is the emblem of the Malatesta family and symbolises magnanimity.) The second half of the fifteenth century produced a large number of medallists, including Enzola, Melioli, Antico, Francesco Laurana, Candida, Cavino, the very popular Sperandio of Mantua and Boldù, a Venetian artist who imitated the Greek style. Outstanding among the Gallery's medals of this period are Giancristoforo Romano's portraits of ladies of the House of Este and Aragon, some forceful portraits (e.g. *Alfonso I d'Este*) by Niccolò Fiorentino, the best of the Florentine medallists, and Caradosso's medal for Pope Julius II (with a view of St. Peter's, as in the design which the Pope commissioned from Bramante, on the reverse side).

In the sixteenth century, the art of the medal was dominated by the technique of striking, and the most important medallist of the time was the famous Milanese sculptor and goldsmith, Leone Leoni, whose work is represented in the Gallery by a medal made for *Andrea Doria*, who had had him released from the papal prisons (there is a portrait of Leoni surrounded by a convict's chain on the reverse side), another for *Pietro Aretino*, whose whiplash tongue was the most feared of his day (the medal bears the motto "Veritas odium parit"), and a third for Michelangelo. Other outstanding medals of the Milanese school are those by Pompeo Leoni, Jacopo da Trezzo and Annibale Fontana. The most elegant female portraits appear on medals by Ruspagiari and the Sienese artist Pastorino.

The fine work of Antonio Abbondio of Trento (the Gallery has a medal he made for *Maximilian II and Maria*) takes us across the northern frontiers of Italy, since he worked for the Austrian

ted something — perhaps an emblem — connected with the person who commissioned the medal. Plaquettes and medals have in common the fact that they were made by casting from a wax model, as were small bronzes as well. In the sixteenth century, however, medals were struck rather than cast, with the result that they were made as small as coins, and could no longer be regarded as fascinating miniature sculptures. It was the goldsmith's technique of striking rather than the sculptor's technique of casting which was chiefly imitated in other parts of Europe.

The National Gallery is fortunate in possessing the whole of this collection as well as the small bronzes, for in 1930 Dreyfus' heirs sold it to Lord Joseph Duveen, and in 1945 it passed from him to Rush Kress. The few other pieces of sculpture which came to the Gallery from the Kress Collection but not from Dreyfus include not only the beautiful fifteenth or sixteenth century bronze *She-Wolf*, which is a copy of the famous Etruscan she-wolf in Rome and was acquired in 1945 from the Castiglioni Collection in Vienna, but also the refined *Female Figure with Cornucopia* attributed to the fifteenth century Sienese artist Vecchietta. It had formerly been in the Kaiser Friedrich Museum in Berlin and was acquired by the National Gallery in 1955.

One outstanding masterpiece among the plaquettes and reliefs is a *Self-Portrait* by Leon Battista Alberti, the great fifteenth century Florentine architect and theorist, who can be described as one of the founders of the Renaissance. It bears the winged eye used by Alberti as his emblem, since it alluded to his mastery of the science of optics, perspective and proportion. Another particularly fine work is the *Saint Jerome*, in pictorial style, which was made about 1475-85 by Francesco di Giorgio, an architect, sculptor and painter from Siena. All the other best known makers of plaquettes and medals are represented in the Gallery's collection, including not only Antico of Mantua, whose art, like that of Alessandro Leopardi of Padua, derives from Mantegna, and the Milanese goldsmith and metalworker Caradosso, who was active at the time of the Sforzas and

royal family after a period of activity in Milan, and he had a profound influence on the art of the medal in Germany, where the usual technique was not to cast from wax but from carved wood or stone models. The most important center for metalwork in Germany was Augsburg, where Hans Schwarz founded the German school of medal making. He and Hagenauer (another Augsburg artist), as well as the sculptor Deschler (the Gallery has his magnificent portrait of *Hieronymus Paumgartner*), Gebel and Reinhardt the Elder of Nuremberg produced portrait medals of uncompromising vigor, leaving the reverse sides blank. It is very doubtful, on the other hand, whether Dürer — who dominated the art of Nuremberg — in fact supplied the design for the medal of *Charles V*.

Flanders is represented in the Gallery's collection by a whole series of medals by that prolific artist Jonghelinck, as well as by a magnificent single medal (with the head of *Erasmus*) by the painter Quentin Metsys. The Gallery's French medals are more interesting. Earliest in time, and displaying late Gothic echoes, is a delightful medal made for *Louis XII and Anne of Brittany* (with a background of lilies) by Nicolas Leclerc and Jean de Saint-Priest (1499). The great medals which Guillaume Dupré made for *Henry IV and Marie de' Medici, Duke Francesco V Gonzaga* of Mantua (1612) and the Superintendent of Finances *Pierre Jeannin* are of a quite different kind, for they display a rich Renaissance style and a refined virtuosity. It was Francis I who brought Renaissance art to France, and in works such as those mentioned above the Renaissance style reached its maturity, though, as so often happened outside Italy, it later became exaggerated.

The Gallery's collection of bronzes also includes an unusual group of fifteenth century Italian mortars which is unique for its high quality and its refined classical reliefs of grotesques, sphinxes, garlands and vine leaves.

The Graphic Arts - The Rosenwald Collection

The graphic arts are a specialised branch of art collecting, and the National Gallery is fortunate in possessing about 22,000 prints, drawings and watercolors, largely thanks to the gift of the Rosenwald Collection. It now boasts one of the most important collections of the graphic arts in the world. The man who created it over a period of thirty years was Lessing J. Rosenwald, a retired businessman from Philadelphia (i.e. he was a Pennsylvanian like Mellon, Widener and Kress). He had been Chairman of a chain of department stores, and his dedicated enthusiasm as a collector gradually made him an expert in a field which demands not merely a knowledge of art history but also an exceptional sensitivity to those subtle qualities, such as brilliance of impression, paper quality, margins and inks, which contribute to the creation of a good print.

Rosenwald was discriminating in his purchases and adhered to a careful system of selection. He followed the most important auctions throughout the world, and took advantage of the sale of great specialized private collections like that of Count Harrach of Vienna, with the result that he was able to present to the Gallery one of the finest existing collections of fifteenth century wood and copper engravings (a specialized field much prized by connoisseurs), consisting of over seven hundred items. The collection also includes some exceptionally rare and fine items by great artists from northern Europe, such as Masters E.S., Schongauer, Dürer, the Dutch artist Lucas van Leyden and Nanteuil. The quality and quantity of this material is such

as to enable one to trace the whole history of engraving through them. The earliest German and Italian wood engravings, with their strong, hard quality, and the earliest Florentine copper engravings in the "fine manner" (with close cross-hatching) led both to the freer and more plastic "broad manner" with its broad, parallel lines of shading and distinctly differentiated depths of line (Mantegna produced masterly engravings of this kind), and to the bold freedom of the multiple lines which Masters E. S. and Schongauer introduced into Germany and which led to the wood and copper engravings of Dürer. Subsequently one comes to the "pictorial" manner of sixteenth century engravings, with lines and dots, then to the refined achivements of etching and chiaroscuro woodcuts obtained by means of successive impressions from different blocks, and finally to the refinement of the various eighteenth century French styles of color and "facsimile" engraving.

Rosenwald also assembled a fine collection of watercolors and a certain number of paintings by artists who interested him on account of their work in the graphic arts. A case in point is that of the English artist William Blake, who created a series of highly imaginative illustrations to Dante's *Divine Comedy*. The Rosenwald Collection is housed in a specially built small museum near Philadelphia. It is at the disposal of the National Gallery in Washington, and is continually brought to the attention of the public by means of traveling exhibitions throughout the United States. A certain number of rooms for exhibition and study purposes are reserved for it in the National Gallery in Washington and, like the Kress Colection, it is continually growing, for its funds have more than doubled since the donation was first made.

Particularly worthy of mention among other examples of the graphic arts in the National Gallery are the eighteenth century French prints, books and illustrations from the Widener Collection, and the drawings and watercolors from the Dale Collection. The latter include three Daumiers and Raoul Dufy's *View of Fez*. And finally, the miniatures, watercolors and pastels by American primitives in the Garbisch Collection (see pages 11 and 12) also deserve separate mention.

The Decorative Arts

The examples of the decorative arts in the National Gallery belong almost entirely to the Widener Collection (see page 6), and are divided into a number of sections. The Medieval section includes the priceless *Chalice of Abbot Suger*, various ciboria in enameled copper and a gilt copper reliquary in the form of an Arab's head, while the Renaissance is represented by enameled ware from Limoges and exquisitely engraved rock crystal and jewelry, most of which are examples of sixteenth century Italian jewel engraving and gold work. There is also an important collection of rare pieces of Italian majolica, consisting of 38 outstanding items from Siena, Cafaggiolo, Deruta, Gubbio, Urbino and Faenza. Almost all of them date to the early sixteenth century.

The Gallery also possesses an important collection of furniture, consisting of Renaissance chests, chairs, stools and tables, as well as eighteenth century French work, including some very rare Louis XV and Louis XVI furniture.

Among the Gallery's tapestries and carpets are some more outstanding items, such as the tapestry of *The Triumph of Christ* designed by Mazzarino.

It is nevertheless the collection of Chinese porcelain which takes pride of place among the minor arts, both for its extent and its quality.

Masterpieces
in the National Gallery of Art

ITALIAN ARTISTS

The great collectors who founded the National Gallery had a considerable enthusiasm for the golden age of Italian painting, with the result that the Gallery can display to the visitor one of the world's most magnificent collections of Italian pictorial art from the Primitives to the Renaissance, including works ranging in time from Giotto and Duccio di Buoninsegna to Raphael, Giorgione and Titian. The history of Italian painting then continues with important eighteenth century works by Tiepolo, Canaletto and Guardi, and comes up to present day with works by artists such as Modigliani and De Chirico.

1. Three centuries after his death, Margarito di Magnano da Arezzo was referred to in Giorgio Vasari's *Lives of the Artists* (Vasari was a fellow-citizen of Arezzo) as **Margaritone**, to emphasize his importance. Though active in the mid-thirteenth century, he remained insensitive to the new Gothic art, and continued to paint bulky Romanesque figures. This *Madonna and Child Enthroned* is an early work, dating to about 1270, when Margarito's figures were flat – without spatial depth. He painted within the Byzantine tradition which then held sway in Italy, but without the stylistic refinement of the Byzantine capital at Constantinople. His work reflects rather the rough expressiveness of the art of the Roman provinces in Syria, where the style of the earliest centuries A. D. – reminiscent of European Romanesque – still persisted. Nevertheless, there is a Byzantine elegance about the stately immobility of the figures and the intensely linear treatment of the folds in the draperies, as well as charming suggestions of provincial backwardness in the old-fashioned, backless throne and the Madonna's rich crown.

2 – 3. Duccio di Buoninsegna represents the refined culture of the city of Siena in

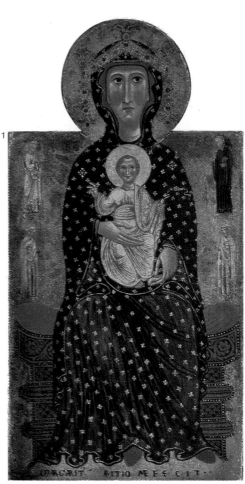

MARGARITONE, MADONNA AND CHILD ENTHRONED

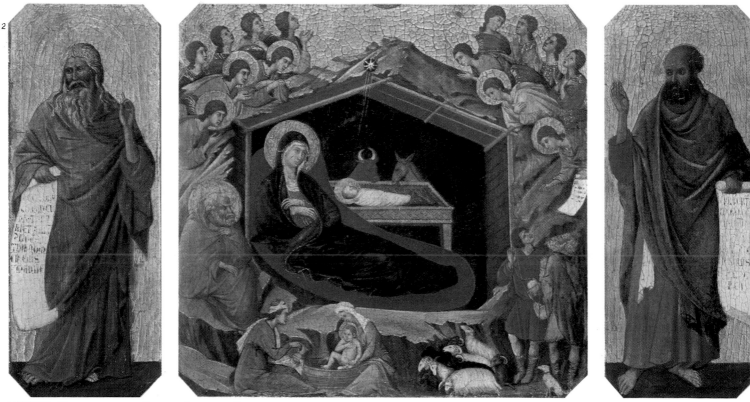

DUCCIO NATIVITY WITH THE PROPHETS ISAIAH AND EZEKIEL

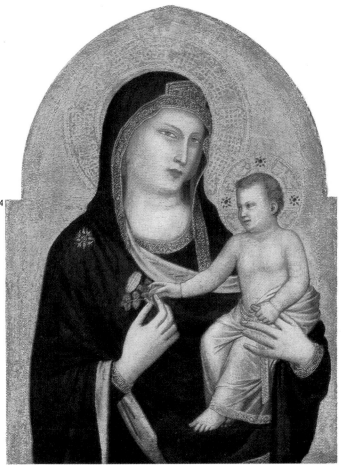

GIOTTO Madonna and Child

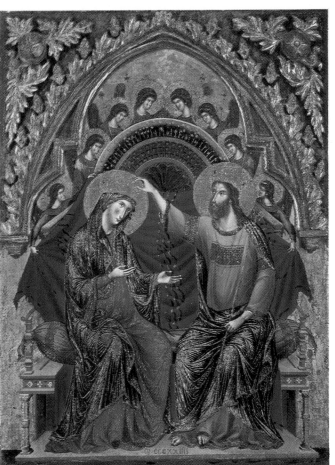

PAOLO VENEZIANO The Coronation of the Virgin

19

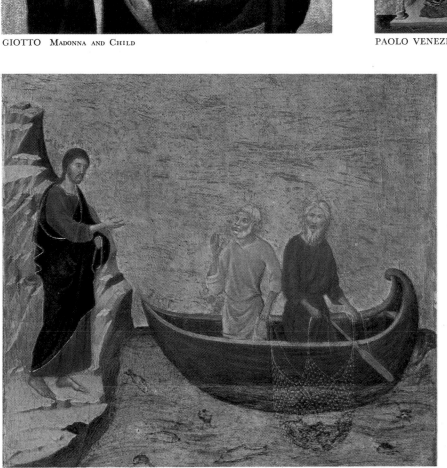

DUCCIO The Calling of the Apostles Peter and Andrew

Tuscany. It was an important center of Italian Gothic art, and still possesses the masterpiece of the century in Duccio's colossal *Maestà* altarpiece. The triptych of the *Nativity with the Prophets Isaiah and Ezekiel* comes from the front predella, while from the rear predella comes *The Calling of the Apostles Peter and Andrew*. Although there are signs of the new times in the realism of facial features and gestures, Duccio still remains essentially faithful to the Gothic style. At the same time, moreover, there is evidence of his allegiance to the Byzantine tradition in the gold background and the lack of spatial depth.

4. **Giotto** is still Romanesque in spirit, but he has an amazing ability to render mass and volume, as one can see in this *Madonna and Child*. His ability to render the human figure as a harmonious combination of psysical and spiritual attributes makes him a precursor by more than a hundred years of Masaccio's revolutionary art and "Humanist" view of life. It is thanks to Giotto, in other words, that Florence became the cradle of the Renaissance at so early a point in time. He did not reject the contemporary Byzantine tradition, however, for it is reflected in the stately nobility of the painting as a whole as well as in the gold background. But the two figures are placed against the flat background in such a way as to make one conscious of the space separating them from it, while the white thornless rose in the Virgin's hand is painted in perfect perspective.

5. The subject of *The Coronation of the Virgin* came into fashion in Italy at the end of the thirteenth century, and proved particularly popular in Venice. This panel was in fact painted in 1324 by a Venetian artist, **Paolo Veneziano**, who followed the Byzantine tradition.

GADDI The Coronation of the Virgin

GENTILE DA FABRIANO A Miracle of Saint Nicholas

20

6. Agnolo **Gaddi** was the son of Taddeo Gaddi, Giotto's favorite pupil, and was Giotto's last disciple in Florence. His painting of *The Coronation of the Virgin* dates from about 1370 and shows reminiscences of Giotto in the facial features, and of Gothic art in the undulations of the draperies.

7. **Gentile da Fabriano** was an artist from The Marches whose art is between the so-called "International Gothic" style — that over-rich final flowering of Gothic art which swept the courts of Europe — and the new art of the Renaissance. Two years before his death in 1427, he painted this predella panel of *A Miracle of Saint Nicholas* as part of a polyptych commissioned by the Quaratesi family of Florence for a church of St. Nicholas. He was living in Florence at the time, and his painting was influenced by the latest ideas in art, as one can see from the solidity of his figures and the sense of depth in the well-defined architectural space. It is thought that the crypt seen here represents the original form of that in the church of St. Nicholas at Bari, where the saint's relics had been taken from Asia Minor in the eleventh century. The five predella scenes, including this one (on the extreme right), can be seen as though reflected in a mirror in the apse, under the mosaic of Christ flanked by the Virgin and St. Nicholas. Predella panels were used to depict scenes from the life of the saint to whom the altarpiece was devoted, and thus we see here sick and crippled pilgrims touching the tomb of St. Nicholas.

8. **Fra Angelico** was a friar and painter in the Dominican Convent of St. Mark in Florence. *The Healing of Palladia by Saint Cos-*

FRA ANGELICO The Healing of Palladia by Saint Cosmas and Saint Damian

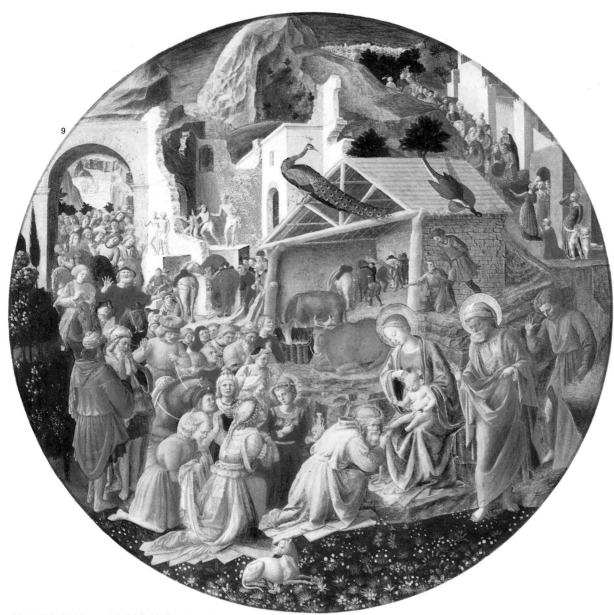

FRA ANGELICO AND FILIPPO LIPPI THE ADORATION OF THE MAGI

mas and Saint Damian is a fully mature work of about 1440 which he painted as a predella panel for an altarpiece to decorate the high altar in the convent church. St. Cosmas and St. Damian were two Arab healers who carried out their deeds of Mercy among the sick without thought of gain or distinction of nationality or religion, and the increasing frequency with which they appeared in Florentine altarpieces results from the fact that St. Cosmas was the patron saint of Cosimo de' Medici, the great "healer" of Florence's ills. On the left-hand side of the panel Palladia is seen being healed, while on the right St. Cosmas is upset by the attempted offer of a reward. Fra Angelico's handling of volume in the human figures and the architecture is evidence of his own original interpretation of those new Renaissance ideas which Masaccio had offered to Florence in his famous frescoes in the Carmine church.

9 – 10. Filippo **Lippi** was another friar-artist. He took his vows (though he later renounced them) in the very Carmine convent whose proud boast was Masaccio's frescoes, and he learned the painter's craft among Masaccio's very active following. He painted the tondo of *The Adoration of the Magi* in collaboration with **Fra Angelico**, having come close to the latter's style in his maturity. Fra Angelico must have been responsible for the composition, and must have begun the painting about 1445, before he left for Rome. His style is apparent in the substantial and gentle figure of the Madonna with her Child, and in the women making their way up the road on the right. Lippi was responsible for completing the remainder of the painting. He introduced not only the forceful realism and portraiture which are typical of his work, but also an early taste for genre scenes, such as one finds in the group of figures in the stable. There is in fact a wonderful blend of old and new in his work. His use of perspective, and the foreshortened views of horses are reminiscent of Paolo Uccello's famous battle scenes; the treatment of the nude in the bodies of the young athletes balancing on top of the ruins (in the middle of the background) looks forward to later studies of anatomy in Mature Renaissance artists like Antonio Pollaiuolo or Verrocchio; and at the same time the use of symbols (e.g. the peacock of immortality on the stable roof) has its roots in the Middle Ages. At about the time he and Fra Angelico worked on the tondo, Lippi also painted this *Madonna and Child*, in which the figures are set in a classical shell niche. It was painted entirely by him and is typical of his work.

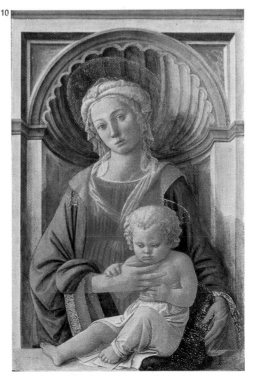

FILIPPO LIPPI MADONNA AND CHILD

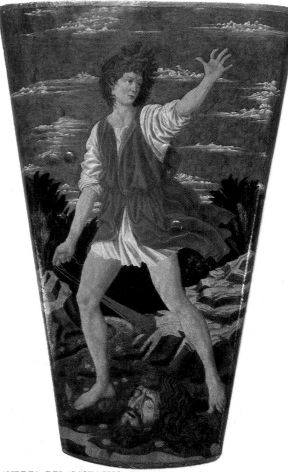

ANDREA DEL CASTAGNO The Youthful David

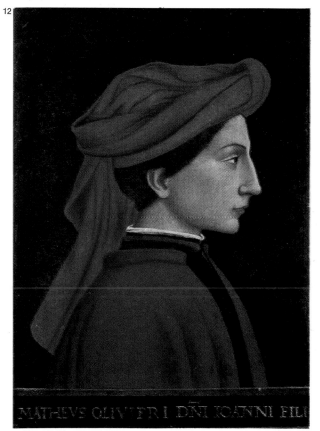

DOMENICO VENEZIANO Matteo Olivieri

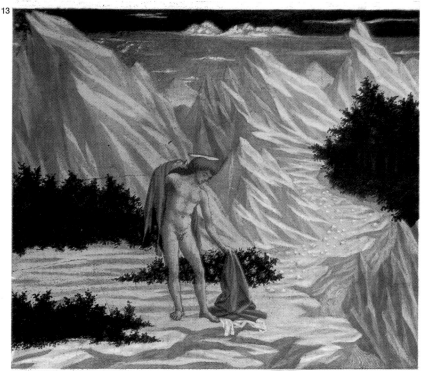

DOMENICO VENEZIANO Saint John in the Desert

11. Andrea del Castagno's figures transform the monumental solidity of early Florentine Renaissance art into dynamic energy, for they pulse with life. His original and tempestuous use of line was to leave its mark on Florentine art of the later fifteenth century, and was to reach as far north as Padua and Ferrara as a result of Castagno's early visit to Venice. In *The Youthful David* we see a young man who has just released from his sling the stone which was to stun Goliath and so enable him to cut off the giant's head. David personifies the type of hero most admired by Humanist culture, for he combines the ancient mythological concept of the ideal warrior with the political ideal of the victor over tyranny. The figure was painted about 1450 on a leather shield which was probably used as an ornament in processions held before tournaments.

12 – 13. Domenico Veneziano trained as an artist in the Gothic and Renaissance atmosphere of Venice, with the result that he blends the soft tones and rhythms of Venetian art with the constructive use of geometry found in the new art of Florence, where he went to live until his death in 1461. This portrait of *Matteo Olivieri*, a Florentine, is usually attributed to Domenico Veneziano (though sometimes to Paolo Uccello), and is one of the most striking examples of Humanist portraiture. The turban with one corner hanging down over the wearer's shoulder was a favorite form of headgear of that period. It appears in the gallery of Florentines whom Masaccio introduced into the frescoes in the Carmine church, and in many portraits attributed to Domenico Veneziano, Paolo Uccello and even Masaccio himself, where the profile view allows the artist to define his subject's features with a refined use of line as well as with a forceful plasticity. This predella panel of *Saint John in the Desert* is a mature work by Domenico Veneziano dating approximately to 1445. It shows how the artist has succeeded in going beyond a scientific study of the real world and has transfigured it by bathing every object in light. Thus the sparkling rocky landscape is metaphysical rather than realistic, and the geometrical shapes are broken down into diffused light. St. John is depicted in accordance with the new classical ideals. He is shown at the moment when he throws down his worldly clothes in order to put on the camel-hair garb required by his new ascetic life, and this becomes a pretext for the portrayal of a naked athlete, as pure in form as a Greek Apollo, even though he has the halo of a Christian saint. Domenico Veneziano is the only artist to have depicted this moment in St. John the Baptist's life. The panel was originally part of a large altarpiece painted for the church of Santa Lucia de' Magnoli in Florence. The whole work depicted the Virgin surrounded by St. John the Baptist and other saints. The predella was subsequently dismembered, however, and the fragment illustrated here came to America from the Berenson Collection, having been sold without attribution for a modest sum. It was subsequently recognized as the work of Domenico Veneziano and bought by Samuel Kress.

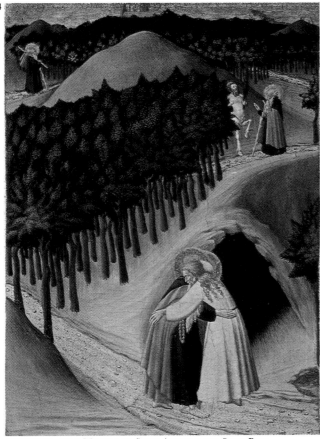

14. While Florence was an art center where new ideas tended to overthrow tradition, Siena was skilful in modifying its Gothic past by transforming Florentine mastery of plastic and spatial qualities into narrative charm and delightful shapes and colors. *The Meeting of Saint Anthony and Saint Paul* is one of four predella panels in the National Gallery from a St. Anthony Abbot altarpiece which is usually held to be the work of that most poetic of the Sienese narrative painters, Stefano di Giovanni, known as **Sassetta**, but is sometimes attributed to the Master of the Osservanza, a follower of Sassetta. Sassetta is thought to have painted it with an assistant about 1440. Although the artist does pay attention to the plasticity of his figures, he puts a simple trust in the efficacy the story he has to tell, and achieves his effect by means of the simple poetry of the characters and the setting in the countryside near Siena. The landscape is arranged vertically, and three episodes are taking place simultaneously, in accordance with the medieval system of multiple narration. In the upper left-hand corner St. Anthony is setting off in search of another hermit. On the way he converts a centaur (a symbol of paganism), and at the bottom of the picture he embraces St. Paul in front of the cave in which the latter lives. Their embrace is rendered in the medieval manner, without spatial depth and without any attempt to suggest the separateness of the two bodies.

15. In painting this predella panel of *The Annunciation*, **Giovanni di Paolo** – another Sienese artist – tackles the problem of space and perspective, but fails to find a completely satisfactory solution. His attempt to apply the principles of perspective shows a good deal of hesitation and a naive insistence on using the "tapestry approach" to space. Thus the vaulted roof seems to curve backwards rather than forwards, the lines of perspective recede towards a point whose whereabouts is uncertain, and the architectural features of the scene remain isolated from the human figures, which themselves seem separate from the background. The scene is set in the Gothic garden of the Earthly Paradise, where two pairs of rabbits act as symbols of the perils of the flesh, and the expulsion of Adam and Eve can be seen taking place. There are unusual features about the iconography of this painting. The idea of juxtaposing the Fall of Man with its own remedy (the Annunciation presupposes salvation) derives from Fra Angelico's Annunciations.

23

SASSETTA THE MEETING OF SAINT ANTHONY AND SAINT PAUL

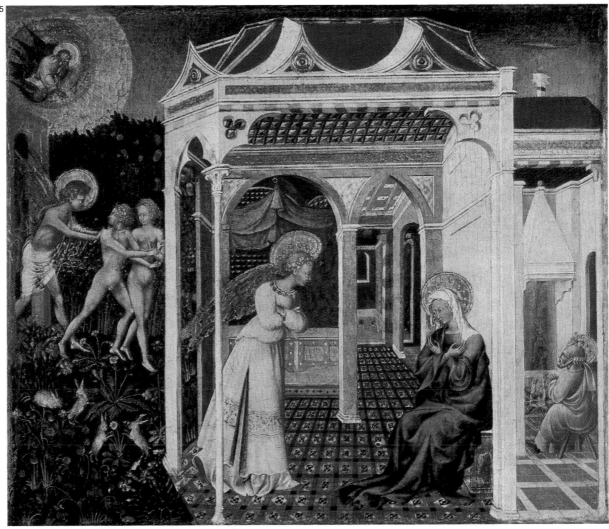

GIOVANNI DI PAOLO THE ANNUNCIATION

24

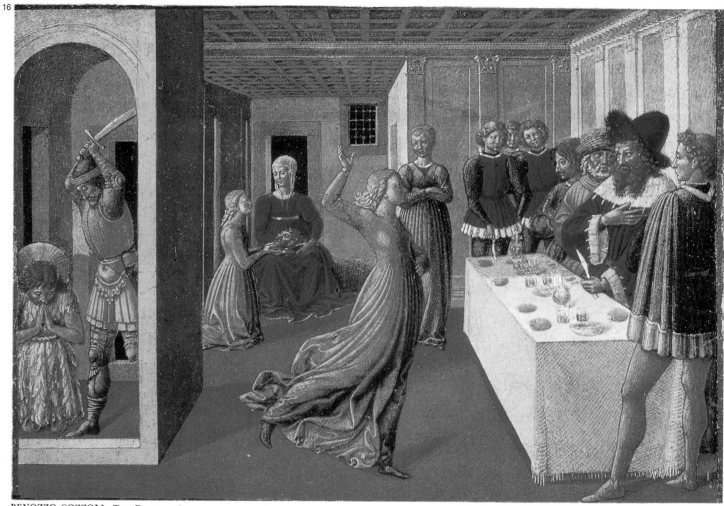

BENOZZO GOZZOLI The Dance of Salome

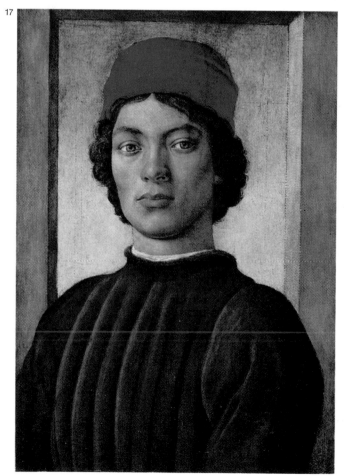

FILIPPINO LIPPI Portrait of a Youth

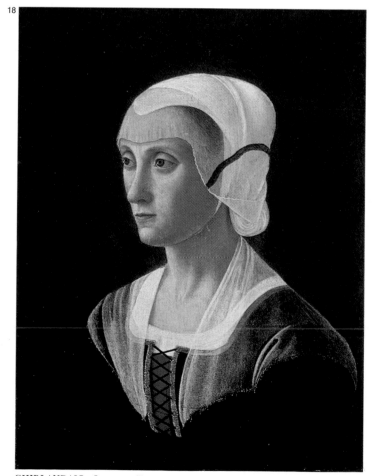

GHIRLANDAIO Lucrezia Tornabuoni

16. **Benozzo** of Lese was called Gozzoli by Vasari in his *Lives of the Artists*. His "narrative" paintings are characterized by a dynamic treatment of form which he derived from the innovations of Andrea del Castagno, Antonio Pollaiuolo and Botticelli. *The Dance of Salome* comes from the predella of an altarpiece which he painted in 1461-62 at the age of forty-one. It is a masterpiece of subtle narration in which Benozzo transforms the biblical episode of cruelty and filial love into a review of the bustling contemporary world and the refined fashions of Florence. The three scenes (young Salome dancing before Herod to obtain the head of St. John the Baptist as a reward; the beheading of St. John; and the severed head being offered to Salome's mother Herodias) are presented simultaneously within a triple architectural setting which is nevertheless treated as a single unit from the point of view of perspective.

17 – 18. The National Gallery possesses two fine examples of Florentine portraiture from the second half of the fifteenth century: *Portrait of a Youth* and the supposed portrait of *Lucrezia Tornabuoni*. The first of these was once attributed to Botticelli, but is now thought to be by Filippino **Lippi**, son of Filippo, and probably dates to about 1485, when the refined art of Botticelli was influential among young Florentine painters. The second portrait was painted by Domenico **Ghirlandaio** about 1475, and is thought to depict Lorenzo the Magnificent's mother at the age of about fifty.

19 – 20. Sandro **Botticelli** was the artist who best interpreted the Florence of Lorenzo the Magnificent, with its new concept of beauty based on the reconciliation of pagan and Christian ideals. He had been a pupil of Filippo Lippi, but was also influenced by the new dynamic quality of Pollaiuolo and Verrocchio. He was the favorite artist of the Medici family, and painted *The Adoration of the Magi* when he was about thirty-five – probably during his visit to Rome in 1480-81. The scene is set in a broad landscape, with the stable in the form of a classical ruin, symbolizing that Christianity was founded on the ruins of the pagan world. In the center of the picture sits the Virgin, represented as a slightly melancholy but sophisticated noblewoman, and all the figures in the picture have vibrant, flowing forms which convey a sense of ebbing vitality. The crowd is made up of persons of high social rank who may be members of the Della Rovere family (the family emblem, a young oak-tree, can be seen on the right of the picture) Botticelli also painted this portrait of Lorenzo the Magnicent's younger brother *Giuliano de' Medici*. It is probably a posthumous portrait, painted after Giuliano had been assassinated in the Pazzi Conspiracy of 1478. The half-open door and the turtle dove perching on a dead branch are classical symbols revived in the Renaissance to signify death and constancy in mourning.

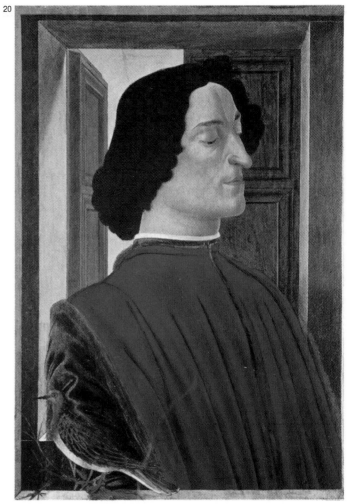

20

BOTTICELLI Giuliano de' Medici

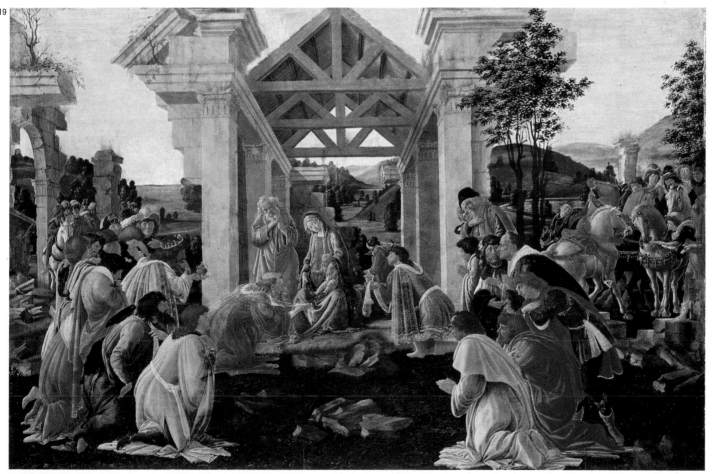

19

BOTTICELLI The Adoration of the Magi

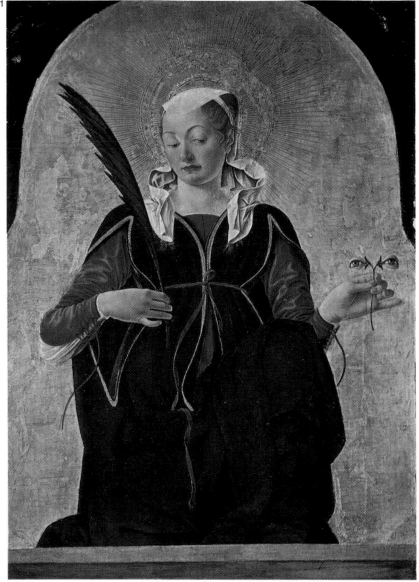

COSSA SAINT LUCY

21. This magnificent panel dipicting *Saint Lucy* is one of three surviving panels (the other two are also in the National Gallery) from a polyptych painted by Francesco del **Cossa** about 1470 for the church of San Petronio in Bologna. He was a favorite artist at the court of Borso d'Este in Ferrara, and the figure of St. Lucy has a typically Ferrarese hardness of texture, combined with a certain monumentality which derives from the plastic qualities of Piero della Francesca and Mantegna. It was Cossa, too, who painted the important frescoes of the "Months" in Palazzo Schifanoia in 1470, at the age of about thirty-five, thus providing us with a masterpiece of Ferrarese art and precious evidence of that court life which is also reflected in his interpretation of St. Lucy. For though St. Lucy was a virgin martyr from Syracuse who became the patron saint of sight – as we are reminded by the splendor of her halo – Cossa has turned her into a sophisticated noblewoman from the Ferrarese court. His typically Ferrarese surrealist imagination can also be seen, for example, in the eyes, which become a sort of elegant accessory, thanks to the lorgnette-like handle to which they are attached. This particular panel must have been placed high up within the altarpiece, for the figure of St. Lucy is foreshortened, as she gazes down on the congregation.

22. This expressionistic *Madonna and Child in a Garden* is striking for the compositional value of the curling, metallic folds of the draperies, for the intensely emaciated forms and for the jewel-like brilliance of the colors. It was painted about 1455 by Cosimo **Tura**, the founder of the Ferrarese school of painting. Renaissance art in Ferrara was very different from that of Florence in that it paid far more attention to the harsh energy of northern European art, which it had come to know partly through German engravings and the work of the Flemish painter Van der Weyden, and partly through contemporary art from Padua. Not only was Donatello now active in Padua, but the work of Aandrea del Castagno was influential, and Paduan artists were working toward the hard plasticity of Mantegna. The figure of the Virgin seems almost sculpted rather than painted, and the setting is reminiscent of certain late Gothic "Madonnas of the Rose Garden" from the Rhine. But the way in which the Virgin is situated in space belongs entirely to the Renaissance. The body of the Child is solid and geometrically formed; his position is unusual, for the appears to be sus-

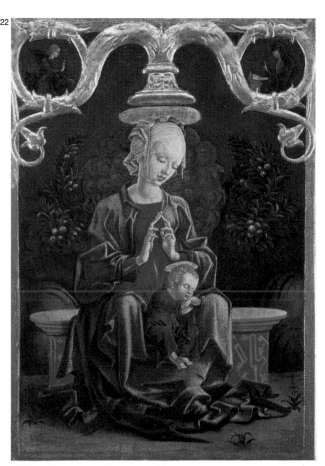

TURA MADONNA AND CHILD IN A GARDEN

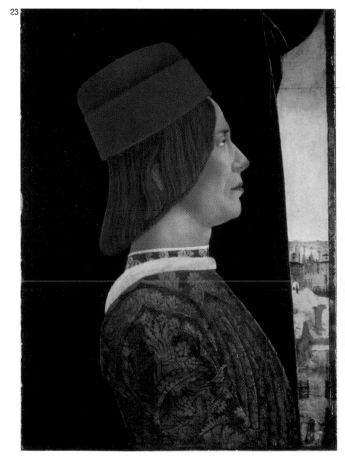

ERCOLE DE' ROBERTI GIOVANNI II BENTIVOGLIO

pended, asleep, between his mother's knees. At the top corners of the painting are what remains of the original frame in the form of two typically Ferrarese Gothic stucco volutes which together form Mary's initial in the middle, and enclose two tondos depicting the two figures involved in the Annunciation.

23 – 24. Ercole de' **Roberti** is the third great figure of the Ferrarese School. More than that of his fellow artists, his work displays an architectural, monumental interpretation of form, in which northern influences are less deeply felt, and it thus offers the most complete expression of Ferrarese Humanism. Like his master, Cossa, he worked in Bologna as well as at Ferrara, and it was in the former city that he painted the portraits of its rulers: *Giovanni II Bentivoglio* and *Ginevra Bentivoglio*. The two pictures can be dated approximately 1480. Their atmosphere is a serene, almost idyllic one, suggesting that we are in the presence of two beneficent rulers, but the historical facts are different, for Giovanni and Ginevra left behind them in Bologna somber memories of their cruelty.

25. Carlo **Crivelli** was a Venetian artist, but he painted this *Madonna and Child* in The Marches about thirty years after he had left Venice. He adopted the so-called "hard style" which northern artists had practiced in their attempt to produce paintings with hard, jewel-like properties, as pure and indestructible as a precious stone. Crivelli was behind the times, however, for he blends a knowledge of Renaissance achievements in rendering volume and space with a refined use of line and color which harks back to Gothic art. He is influenced not only by Mantegna's expressionistic use of volume, but especially by the trompe l'oeil charm of the garlands of flowers and fruit which festoon his great altarpieces. Thus the trompe l'oeil apple and pear at the top of the picture derive from Mantegna's particular kind of naturalism, but Crivelli has produced an even more sophisticated illusion of reality.

26. The hard plasticity of form found in the work of Andrea **Mantegna**, a Paduan artist, retains its incisive splendor even in a panel as small as this *Judith and Holofernes*. Art historians are almost unanimous in attributing it to Mantegna as a late work, dated about 1495, when he was about sixty years old. By then he had left Padua and been working for some time at the court of the Gonzagas in Mantua. The treatment of the subject is quite classical. Judith has the appearance of a draped statue, and displays that sublime calm and detachment from events which one expects to find in figures from classical reliefs. As a young man working in the studio of his master Squarcione in Padua, Mantegna had learned to look at antique sculpture carefully, but the hard plasticity of his figures was later softened by contact with Giovanni Bellini, his brother-in-law. There is something of Bellini's gentle female figures in the calm and thoughtful face of Judith, the heroine of Israel.

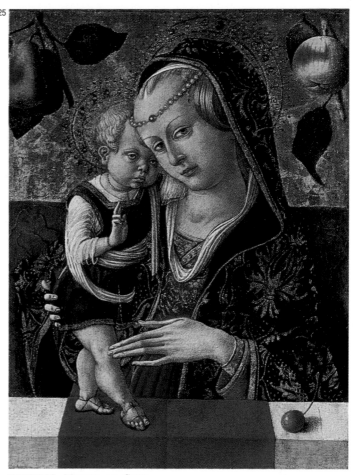

CRIVELLI Madonna and Child

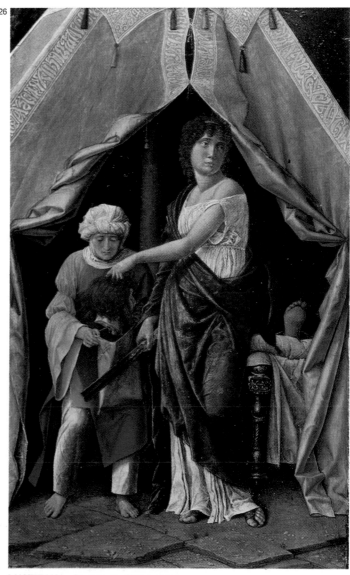

MANTEGNA Judith and Holofernes

ERCOLE DE' ROBERTI Ginevra Bentivoglio

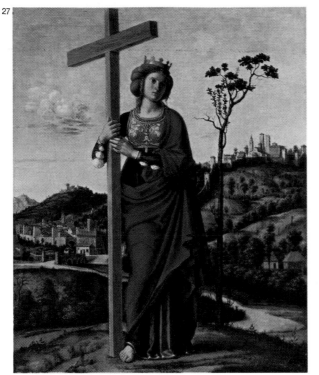

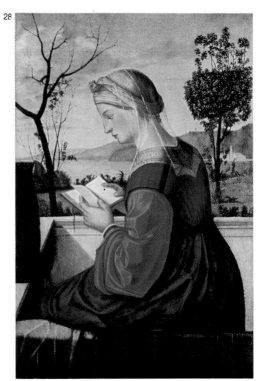

CIMA DA CONEGLIANO Saint Helena

CARPACCIO The Virgin Reading

27 – 28. The handling of color and light in this painting of *Saint Helena* make it a typically Venetian work. Giovan Battista **Cima da Conegliano**, a follower of Bellini, painted it shortly after his arrival in Venice at the age of thirty in 1492. St. Helena, mother of the Emperor Constantine, is seen leaning on the cross which she miraculously discovered in the Holy Land. She is dressed in elegant, aristocratic clothes, and stands calmly in a gentle landscape in the Venetian hinterland. This same handling of color tones leads from the brightly-lit works of Giovanni Bellini to the radiance of Titian and then to the dramatic effects of light and shade found in Tintoretto; and at a stage on the way one encounters the light-drenched compositions of Vittore **Carpaccio**, whose rich, poetic figures make him essentially a sixteenth century artist. His *The Virgin Reading* shows what we would certainly assume to be a rich Venetian lady, were it not for her delicate gold halo seen against the blue sky. It was painted about 1505, when Carpaccio was at his full maturity and had begun a series of narrative canvases for the Scuola degli Albanesi, one of which (now in the Accademia Carrara at Bergamo) includes a very similar female figure.

The panel is incomplete on the left-hand side: an arm and leg of the Christ Child were originally on the cushion lying on the parapet, but have subsequently been painted over.

29. This *Portrait of a Young Man in Red* is a mature work by the Venetian artist Giovanni **Bellini**, and was painted between 1480 and 1490. The composition displays a tempered classicism, and the young man's intelligent and gentle face is typical of Bellini, as are also the rich colors, accentuated by the new use of oil paints.

30. This *Madonna and Child* belongs to **Antonello da Messina**'s pre-Venetian period, for he painted it in his native Messina about 1475, when he was at least thirty-six. The poetic portrayal of the mother with a little child seeking her breast reflects the artist's apprenticeship in Naples, where Catalan, Flemish and Renaissance influences all interacted. The Madonna is a Catalan type; the use of thin surface layers of oil paint derives from Flemish art; while the clearly defined masses and solemn figures come from a Tuscan and a French artist: Piero della Francesca and Jean Fouquet, both of whom had worked in Naples.

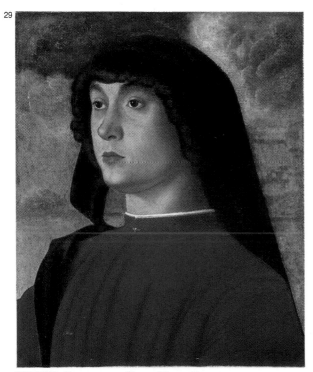

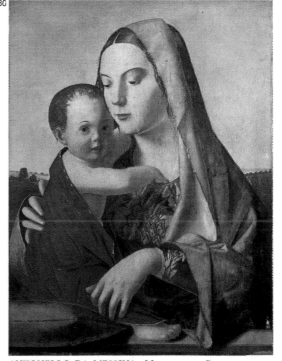

BELLINI Portrait of a Young Man in Red

ANTONELLO DA MESSINA Madonna and Child

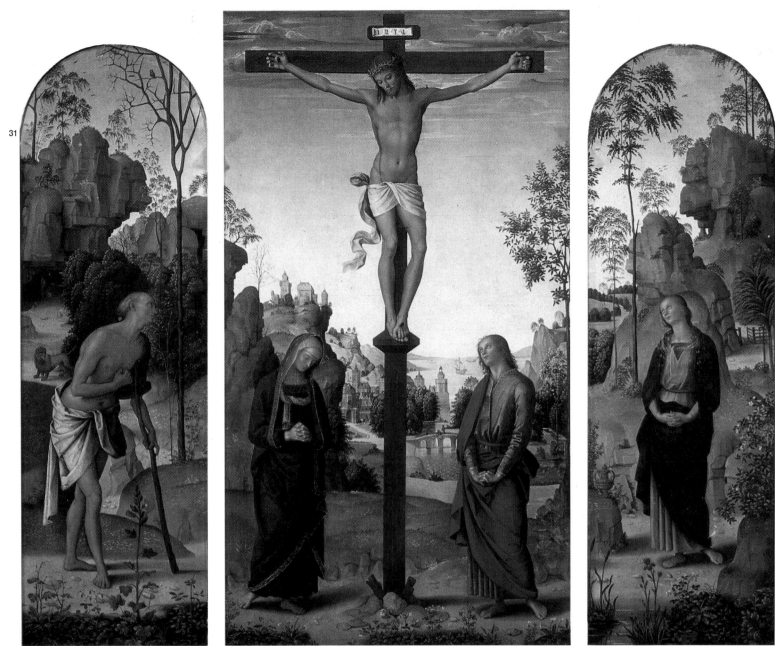

PERUGINO The Crucifixion with the Virgin, Saint John, Saint Jerome, and Saint Mary Magdalen

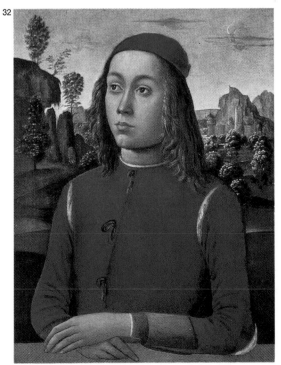

MASTER OF SANTO SPIRITO Portrait of a Youth

31. The ideals of the Umbrian School of painting, founded by Piero Vannucci – known as **Perugino** because he worked at Perugia for a long time – are to be found in the soft clarity of his images and the broad, clear spaces in which they are situated. He is sensitive to the Renaissance discoveries of Florence, but in his work Tuscan classical purity acquires a new sublimity of form, volume and atmosphere. This enormous triptych of *The Crucifixion* is a masterpiece of his early maturity. It was commissioned by Pope Alexander VI's confessor of the church of San Domenico at San Gimignano, and was painted about 1482 (i.e. at the period when he and Pintoricchio were painting frescoes on the walls of the Sistine Chapel in the Vatican). In the center is the figure of Christ on the Cross with the Virgin and St. John the Evangelist mourning over him. The left-hand panel shows St. Jerome in the desert (an allusion to the Early Fathers of the Church) with his symbolic lion, and the right-hand panel shows St. Mary Magdalene (an allusion to the repentance of sinners) with her special attribute: the jar of ointment (a classical amphora in this case) which she used to anoint Christ's feet during the supper in the house of Lazarus. Typical of Perugino are the calm religious feeling and tranquil composition, and there are also occasional touches of refined elegance resulting from recent contact with Pintoricchio. The triptych has had a checkered history. A copy was substituted in the church in San Gimignano during the Napoleonic occupation of Italy, and the original came into the hands of the Princes Galitzin in Moscow. Subsequently it found its way to the Hermitage in Leningrad, where it was acquired by the American collector Mellon, who presented it to the National Gallery in Washington.

32. This *Portrait of a Youth* is attributed to the **Master of Santo Spirito**, who was active in Tuscany in the late fifteenth century. Its refined elegance, tempered by a strong sense of form and color, is reminiscent of the Florentine School. The facial type recalls the figures in the altarpieces in the church of Santo Spirito in Florence by the same artist, while the attitude of the hands has been seen as inspired by Leonardo's famous *Gioconda*.

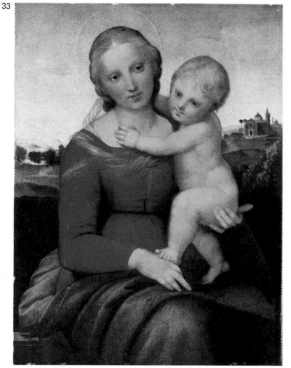

RAPHAEL The Small Cowper Madonna

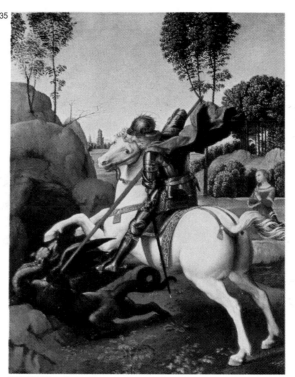

RAPHAEL Saint George and the Dragon

33. *The Small Cowper Madonna* is an early masterpiece by **Raphael**. The tranquil Umbrian style of composition which he learned from his master Perugino is here enriched by the pyramidal arrangement of the group, as well as by the broad areas of delicate color, the use of light in creating volume, and the ineffable sense of mystery which emanates from the Virgin's beautiful face. All these factors are indicative of the new influences which Raphael felt when he moved from Umbria to Florence in late 1504 at the age of twenty-one. Here he could see Michelangelo and Leonardo at work, and an echo of the latter is discernible in this picture, which he painted soon after arrival. There is a reminder of Raphael's native city, however: the Renaissance church of San Bernardino outside Urbino appears in the background on the right.

34. Raphael's *The Alba Madonna* is a mature work, painted about 1510-11. He had been in Rome since 1508, and had already painted his imposing compositions — crowned by the School of Athens — for the first of Julius II's *stanze* in the Vatican. Both the *stanze* paintings and this Madonna reveal the same Renaissance attempt to create an ideal blend of the Christian spirit and pagan grandeur. The classical serenity of the figures and the poetic charm of the landscape are here perfectly blended in the new, all-embracing sixteenth century view of things, thanks to the harmonious equilibrium of the masses within the monumental calm of the total composition. The painting takes its name from the Duke of Alba, who owned it in the eighteenth century. From Spain it passed to the Czar of Russia and thence to the Hermitage, where it was purchased by the American collector Mellon and presented to the National Gallery in Washington.

35. Raphael was in Florence when he painted *Saint George and the Dragon* (c 1505), but he still maintained contacts with his native Umbria. It is thought that this panel was commissioned by Guidobaldo da Montefeltro, Duke of Urbino, as a gift for King Henry VII of England, who had made Guidobaldo a Knight of the Garter. In fact, the first word of the motto of the Order of the Garter ("Honi soit qui mal y pense")

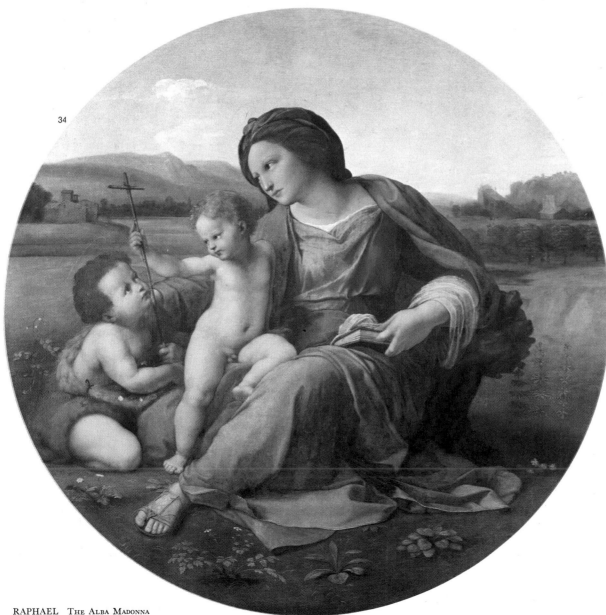

RAPHAEL The Alba Madonna

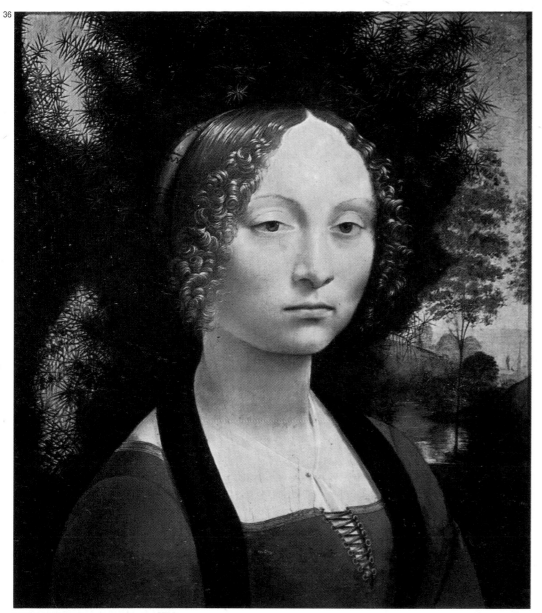

36

can be read on the garter round St. George's greave. There are reminiscences of Umbrian art both in the landscape, with its charming little trees, and in the figure of the princess; whereas the formal innovations of Florentine art are echoed in the forceful portrayal of the horse and the dragon, which recalls Leonardo's anatomical studies.

36. This portrait – thought to represent *Ginevra de' Benci* – is unanimously attributed to **Leonardo da Vinci**, and came to the National Gallery in 1967 from the Liechtenstein Collection in Vienna. The portrait was probably painted about 1474. Leonardo was then twenty-two and his style reflected something of the incisive, linear manner of his master Verrocchio, a Florentine painter who was also a sculptor and goldsmith. At the same time, however, there is something quite personal about the way he seeks to penetrate the mystery of his subject's personality by means of a style of painting which gently caresses but models with precision, using light and shade in such a way as to produce, even at this early stage in his career, that delicate poetic charm which was to prove so influential with his Lombard followers.

37 – 38. Bernardino **Luini** was a Lombard follower of Leonardo, whose style was also influenced by Raphael's tempered classicism, and who yet remains an artist with a very personal manner. His painting of *The Magdalen* with her jar of ointment is conceived as a portrait of an elegant Milanese lady whose mysterious smile derives from that of Leonardo's ladies. Luini also painted the so-called *Venus*. Here we have a chaste female nude painted in terms of pagan idealism and set in a romantically conceived lakeside landscape scattered with strange rocks, which also derive from Leonardo. Both these works were painted in the third decade of the sixteenth century, when Luini had fully developed his Renaissance attitude toward art.

LEONARDO Ginevra de' Benci (?)

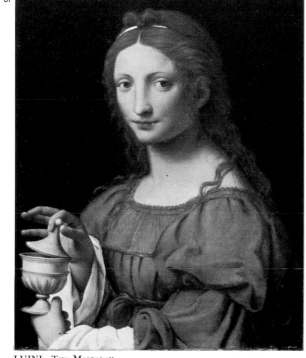

37

LUINI The Magdalen

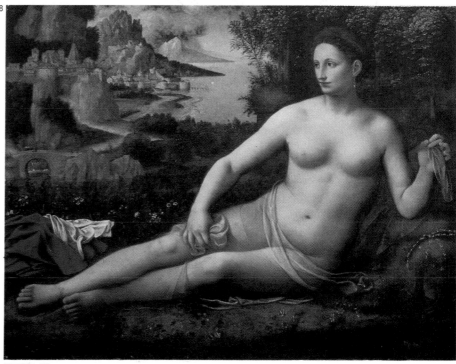

38

LUINI Venus

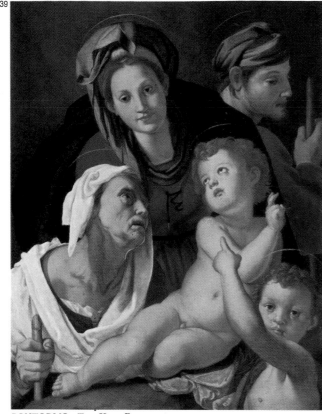

PONTORMO The Holy Family

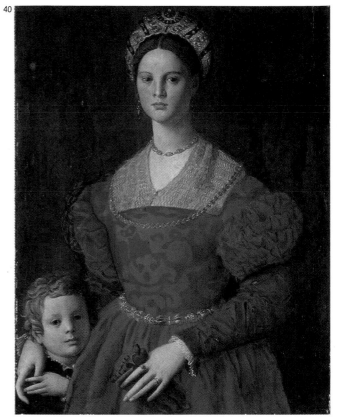

BRONZINO A Young Woman and Her Little Boy

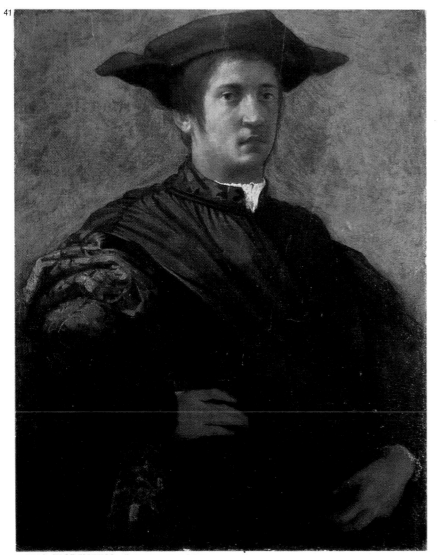

ROSSO FIORENTINO Portrait of a Man

39 – 42. In the second decade of the sixteenth century a more complex and agitated style of painting, known as Mannerism, developed out of the Renaissance "bella maniera" of Leonardo, Raphael and the later Michelangelo. It was the result of a lively reaction against the serene world of the classical artists, and found expression in more cerebral and at the same time more pathetic forms, which conveyed the artist's inner anxieties at the dangers which then threatened social and political life in Italy and culminated in the sack of Rome of 1527. The artist sought to withdraw from those toubled times and seek refuge in an untroubled artistic limbo. The four paintings illustrated here are excellent examples of Florentine Mannerism – and Florence was one of the most active centers of mannerist art. *The Holy Family* was painted about 1525 by Jacopo Carucci, known as **Pontormo** after the village where he was born (though it is sometimes attributed to Pontormo and his pupil Bronzino). It is influenced by the best work of Leonardo, Michelangelo and Andrea del Sarto, but modifies these influences by conveying a sublime melancholy and by organizing the painting in complicated and sophisticated compositional and volumetric harmonies. *A Young Woman and Her Little Boy* was painted about 1540 by Agnolo di Cosimo di Marino, known as **Bronzino** on account of the metallic, jewel-like glitter of his painting. One striking quality about it is the contrast between the disquiet expressed in the two faces and the calm splendor of the woman's dress. The *Portrait of a Man* (possiby a portrait of the Florentine composer Francesco dell'Ajolle) was painted by **Rosso Fiorentino** at about the same time as Bronzino's picture, and it accentuates in almost aggressive fashion the delicate melancholy of Raphael's last portraits. The fourth Florentine Mannerist painting, an *Allegorical Portrait of Dante*, is an unusual work, painted about 1530 by an unknown artist of the **Florentine School**. It conveys very well the essence of that intellectual distillation of form and color which was the basis of the Mannerist approach. In the background, behind the figure of Dante, are a number of allusions to the *Divine Comedy*. One can discern Cocytus, the lake of ice described as the circle of Hell where traitors are punished, as well as Mount Purgatory, with the Garden of Eden at the summit, and the celestial spheres of Paradise. In Dante's lap is a copy of the *Divine Comedy* open at a

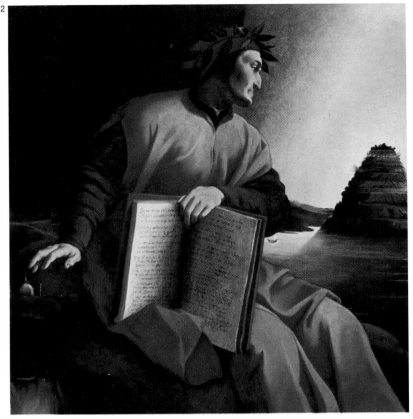

FLORENTINE SCHOOL Allegorical Portrait of Dante

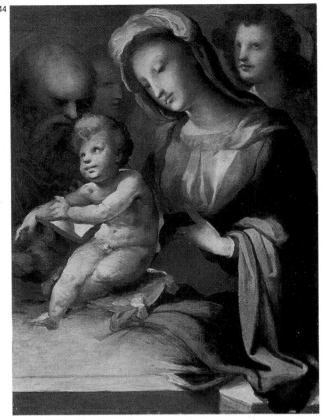

BECCAFUMI The Holy Family with Angels

passage in Canto XXV of *Paradise* in which he expresses the hope that he may return to Florence from exile and be crowned poet there in the Baptistery beside the cathedral, where he had been baptised; he stretches out his hand toward these two buildings, which float above the flames of Hell.

43. Characteristic of the Mannerist art of Siena is an extreme delicacy of feeling, as one can see in this version of the legend of *Saint George and the Dragon* by Giovannantonio Bazzi, known as **Sodoma**, an artist from Vercelli who settled in Siena. There is a dramatic pathos about this painting which constitues Sodoma's personal interpretation of the tranquillity of form and picturesque imaginativeness of Leonardo, Raphael and even Pintoricchio, whose famous Piccolomini Library frescoes could then be seen in Siena cathedral. The monstrous dragon and the horse derive from Leonardo (as is clear from a drawing of a horse on one of Leonardo's sketch sheets at Windsor), but although Sodoma was keen on horses and horse-racing and knew perfectly well what a horse looked like, he made St. George's steed as imaginary a beast as the dragon. The landscape background is also a highly imaginary invention, with traces of the influence of northern European art through some of those prints which made the bizarre late Gothic manner popular among the Mannerists. The feeling of pathos predominates in the figure of Princess Cleodolinda and is reflected in the human remains of the dragon's previous meal in the foreground. (This macabre detail was painted over in the nineteenth century with a flowering meadow, and was recently revealed when the painting was cleaned and restored). This "courtly" work was painted in 1518 at the request of Duke Alfonso I d'Este of Ferrara.

44. *The Holy Family with Angels* was painted about 1545 by the Sienese artist Domenico **Beccafumi**, who was influenced not only by Sodoma and Raphael but also by Flemish artists and Dürer. The delicate, languid feeling which this picture conveys is indicative of Mannerism at a more advanced stage of development, where subjects are projected into an atmosphere of unreality, figures are extremely elongated and thin in outline, colors are delicately soft, characters are not so much contemplative as introverted and dangerously cut off from life, and at the same time there is a feeling of movement which looks forward to the exuberance of Baroque art. Judging by the flowing brushwork and the freedom of expression, this must be one of Beccafumi's last paintings.

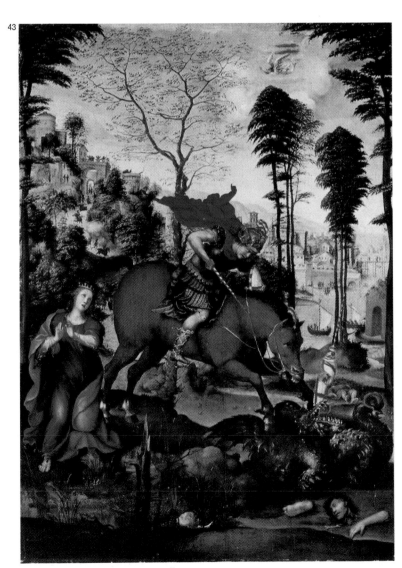

SODOMA Saint George and the Dragon

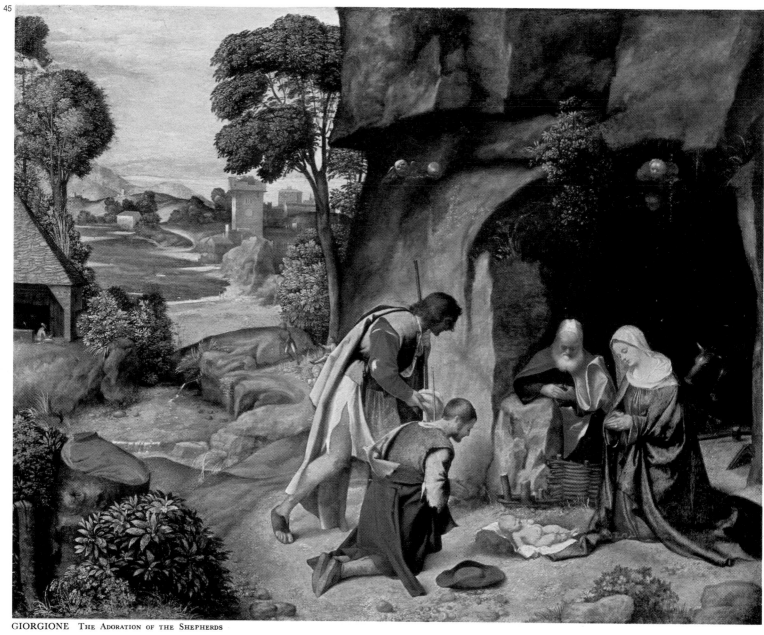

GIORGIONE The Adoration of the Shepherds

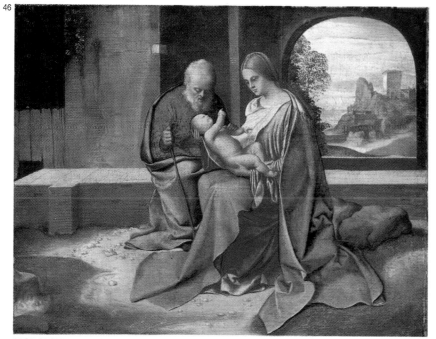

GIORGIONE The Holy Family

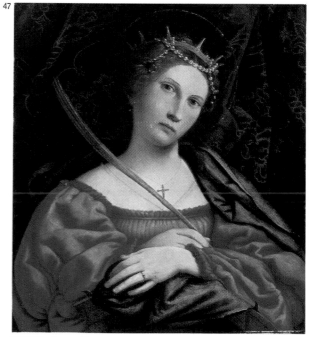

LOTTO Saint Catherine

45 – 46. Renaissance art reaches its full maturity in Venice with the tone poems of **Giorgione**. His name was in fact Giorgio da Castelfranco, but Vasari tells us in his *Lives of the Artists* that he acquired the augmentative suffix because of "his stature and greatness of mind." In his work color is not used to isolate objects and space with separate contours. Forms melt into one another under the effect of the light which falls on them, and figures merge with the life of nature. Giorgione's career was short, for he died of the plague in Venice in 1510 at the age of thirty-three; but he revolutionized Venetian art. Few of his works are known, but the National Gallery possesses two of them. *The Adoration of the Shepherds* is the more mature of the two, partly in its greater compositional sophistication and partly in the subtle transformation of the pastoral idyll (an aspect of his painting which has particularly attracted art collectors) into a philosophy of nature which sees man and the natural world in harmony. X-ray examinations have revealed a number of *pentimenti*, and it is thought that Titian, then a young man, may also have worked on the painting, since he was at that time assisting Giorgione on the frescoes for the Fondaco dei Tedeschi. The small painting of *The Holy Family* may be a fragment of a predella. It shows Giorgione's art at an early stage of development, with strong reminiscences of the physical types found in the work of Giovanni Bellini. Hence it must have been painted in the very early years of the sixteenth century.

47. The identity of this sophisticated and elegant *Saint Catherine* is clear from the inclusion of her martyr's wheel, and the signature and date "Laurentius Lotus 1522" tell us that it was painted by Lorenzo **Lotto** when he was about forty. Although Venetian, he worked chiefly in the inland territories of the Venetian Republic because the influence of German artists like Dürer in Venice contributed to the presence of an element of psychological tension in his art which was not popular in the city itself. In this painting he has created a delicately inward-looking image of St. Catherine. Everything that seems simple and spontaneous about her is in fact subtly complex, whether it be her pose, her glance or her hair style.

48. Duke Alfonso I d'Este and his wife Lucrezia Borgia were the chief cultural stimulus at the refined sixteenth century court of Ferrara, where the court poet was Ariosto and the court painter was Giovanni Luteri, known as **Dosso Dossi**. This *Scene from a Legend* is thought to illustrate the episode in the first book of Virgil's *Aeneid* in which Aeneas and Achates are shipwrecked on the shores of Libya as a result of a storm produced by Juno, and it is typical of the romantic subjects from literature which Dosso Dossi frequently painted for Alfonso d'Este, using Ariosto's *Orlando Furioso* or the classical epics as his sources. This particular work is thought to be one of a series depicting ten episodes from the *Aeneid* which Dosso Dossi painted between 1518 and 1521, when he was about thirty. They were intended to decorate Duke Alfonso's study in the castle, known as the "alabaster chamber." The canvas was probably twice its present size originally, for it is thought to have been cut down on the left-hand side. Dosso was particularly skilled at transforming the world of nature into that of romance; at this period he was still under the influence of Giorgione, as one can see in the idyllic treatment of the crowd of country people and the delicate color tones of the costumes and landscape.

49 – 50. The art of Brescia in the sixteenth century lies half way between the brilliance of Venetian painting and the somber tones of that of Lombardy, and it derives its troubled pathos and incisive linear style from northern European art, through the "Venetian Germans" (i.e. Dürer, Jacopo de' Barbari and Bartolomeo Veneto). This *Portrait of a Knight* was painted by **Savoldo**, and is typical of his work in that it is influenced by the rich art of Flanders, with which he had close ties through his Flemish wife. The *Pietà*, with the Virgin, St. John the Evangelist and St. Mary Magdalene, a masterpiece by Alessandro Bonvicino, known as **Moretto**, was painted in his early maturity, about 1520-30. Moretto was particularly skillful at expressing emotion with concentrated intensity, using cold color and silvery reflections.

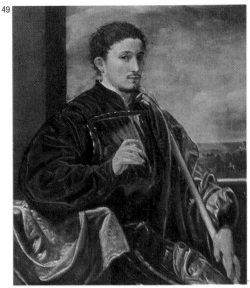

SAVOLDO PORTRAIT OF A KNIGHT

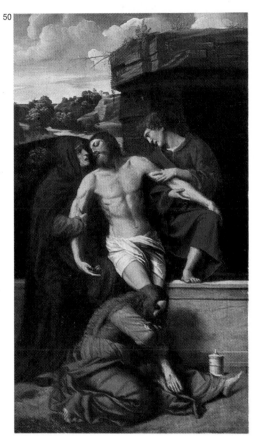

MORETTO PIETÀ

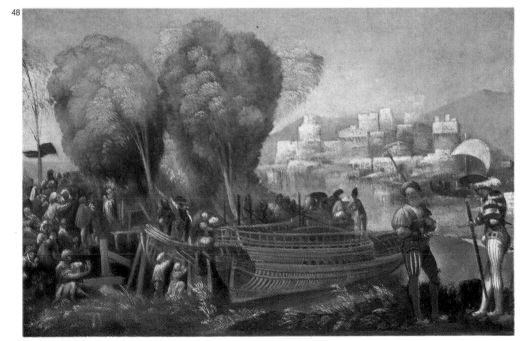

DOSSO DOSSI SCENE FROM A LEGEND

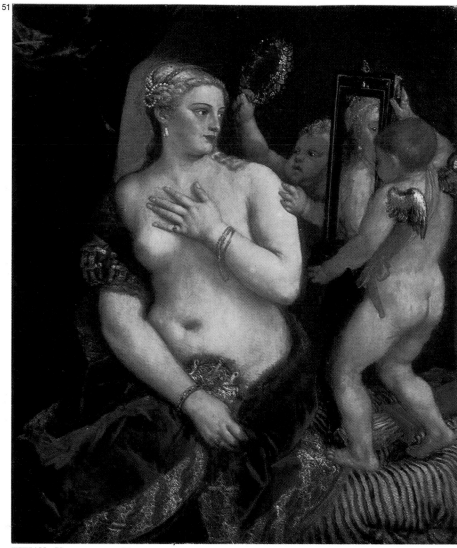

TITIAN Venus with a Mirror

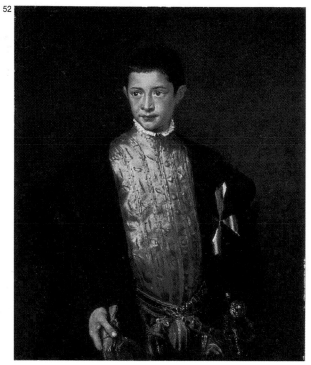

TITIAN Ranuccio Farnese

51. *Venus with a Mirror* is one of the few works which **Titian** painted without a specific commission. He may have painted it purely for his own pleasure, for it was found in his studio on his death in 1576, and subsequently made its way to the Hermitage in Leningrad, where it was bought by Mellon from the Soviet government and presented to the National Gallery. It was painted about 1555, and in it Titian has created a female nude who is both an ideal of immortal beauty and a richly sensual human figure. The delicate color tones of his master Giorgione have here given way to a stronger and more complex chromatic texture, thanks to his skill in handling oils and in superimposing layers of bright colors in order to render the splendor of flesh, hair and jewels. Titian's use of the mirror – a very popular object among Renaissance artists – is highly original. He causes it to direct the gaze of the goddesswoman straight at the spectator, who is consequently drawn into the mystery of her self-contemplation and into Titian's world of Olympian calm and divinely beautiful flesh.

52. Titian's considerable reputation as a portrait painter at the most important courts in Europe is thoroughly justified by this portrait of *Ranuccio Farnese*, the twelve-year-old son of Pier Luigi Farnese, Duke of Parma, who was himself the son of Pope Paul III. For Titian is able to combine a feeling of vitality, outward magnificence and forceful physical features with a sense of rank, psychological insight and an aristocratic pose. In spite of his youth, Ranuccio had been appointed Prior of San Giovanni dei Forlani in Venice, which belonged to the Knights of Malta, and he was painted by Titian in 1542 when staying in Venice. A letter written by Cardinal Alessandro Farnese to Ranuccio's brother in the same year reveals that the portrait was painted partly from life and partly in Ranuccio's absence.

53. A quite different style of portraiture is to be found in the work of **Sebastiano del Piombo**, a Venetian artist who acquired his nickname from the fact that he became keeper of the seals ("piombi") in the Papal Chancellery in 1531. By that time he had already been in Rome for 20 years, for the death of Giorgione and the attractions of the "grand manner" of Michelangelo and Raphael had caused him to move there from Venice. This *Portrait of a Humanist* was painted about 1520, when the artist was about thirty-five. It has all the solidity and powerful chiaroscuro of the work of Michelangelo, but here it is expressed in deep, cold color tones, and with that disenchanted mel-

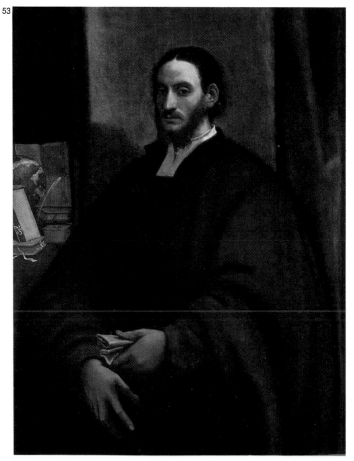

SEBASTIANO DEL PIOMBO Portrait of a Humanist

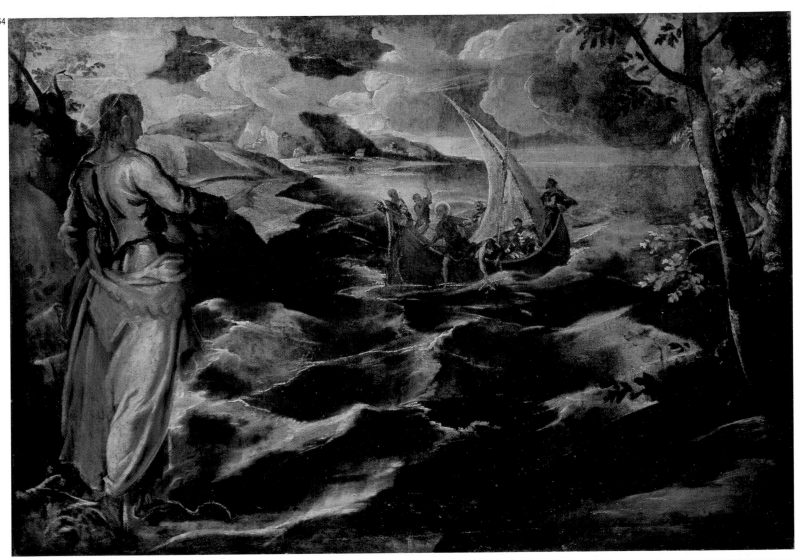

TINTORETTO Christ at the Sea of Galilee

ancholy that one finds in Raphael's late portraits. His melancholy, however, is more cerebral than that of Raphael, and already looks forward to certain features of Mannerism. The humanist depicted here must have been a geographer, judging by the objects in the delightful still life on the table. He stares out of the picture with a cold, clear gaze, as though he were alienated from life and had rejected the world.

54 – 55. This painting of *Christ at the Sea of Galilee* is attributed to Jacopo Robusti, known as **Tintoretto**, though it has also been identified as an early work by El Greco, who worked with Titian and Tintoretto in Venice at an early stage in his career, and was fond of painting ethereal figures like that of Christ in this scene. Here we see the risen Christ revealing himself to the Apostles, and granting them a miraculous catch of fish in the Sea of Galilee. The boat in fact contained seven Apostles, headed by Simon Peter (St. Peter), who leaped into the water to reach his master as soon as he saw him. The greens and blues in this painting, together with the dramatic effects of light and shade, are typical of Tintoretto's mature and late style, such as one finds in works painted by him between 1560 and 1590. His art is full of pathos, and while it contains elements of Mannerism, is also looks forward to the Baroque. The art of the Renaissance reaches a quite different kind of late development, however, in the work of Paolo Caliari, known as **Veronese**, for his paintings have different pre-Baroque qualities in the buoyancy of the figures and the gay, bright color harmonies. *The Finding of Moses* is a replica by Veronese of a work painted about 1580 and now in the Prado in Madrid. The biblical characters have been "modernized." What we are really witnessing are the latest celebrations in Venice after the victory over the Turks at Lepanto – just before Venice went into decline.

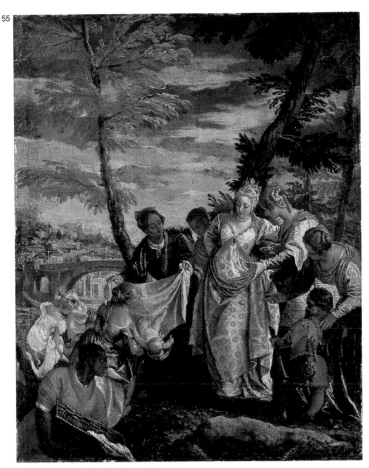

VERONESE The Finding of Moses

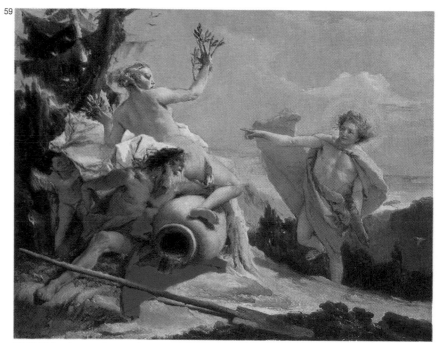

TIEPOLO Apollo Pursuing Daphne

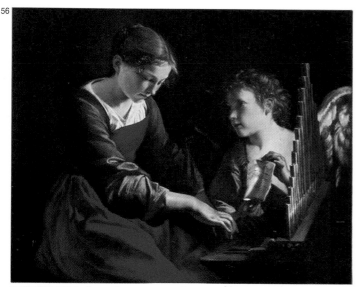

GENTILESCHI Saint Cecilia and an Angel

56. *Saint Cecilia and an Angel* was painted about 1610 by Orazio **Gentileschi**, who was born in Pisa but settled in Rome, where he produced realist painting in the style of Caravaggio, but with a certain classical purity. St. Cecilia had become very popular in Rome in the early years of the sixteenth century as the result of the discovery of her miraculously preserved body in the church of Santa Cecilia in Trastevere in 1599. An error in the transcription of ancient Latin writings about her made her appear to sing a hymn to God, and so she became the patron saint of musicians and singers.

57 – 58. The scintillating Rococo art of the eighteenth century took various forms. In Genoa, Alessandro **Magnasco** treated both landscape and figures in *The Baptism of Christ* in a highly dramatic and persuasive manner, while in Rome, Giovanni Paolo **Pannini** specialized in architectural compositions and so placed his busy crowd of people inside in *The Interior of the Pantheon*. Both works were painted about 1740, but Pannini used the Rococo style simply in order to produce a skillful souvenir scene, whereas Magnasco is a disturbing prophet of disasters yet to come, for his strange, spidery caprices express the nightmarish creaks and groans of a society in decay.

59 – 60. The mythological scene of *Apollo Pursuing Daphne* is an excellent example of the splendor of the work of the eighteenth century Venetian artist Giambattista **Tiepolo** at the height of his lyricism. The painting was originally intended to be used as an overdoor, and the scene is foreshortened and arranged

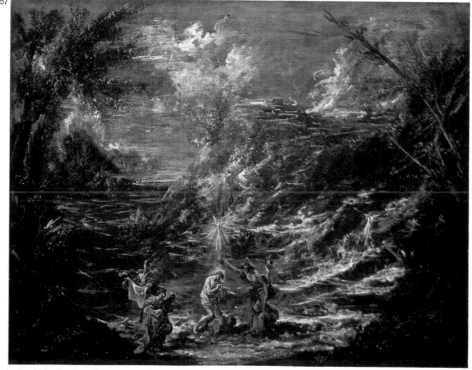

MAGNASCO The Baptism of Christ

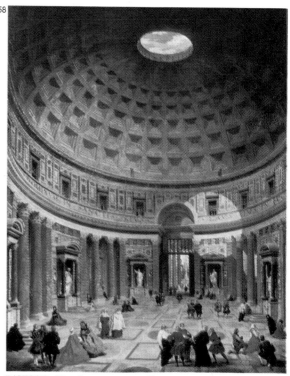

PANNINI The Interior of the Pantheon

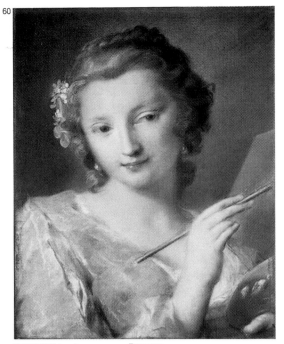

CARRIERA Allegory of Painting

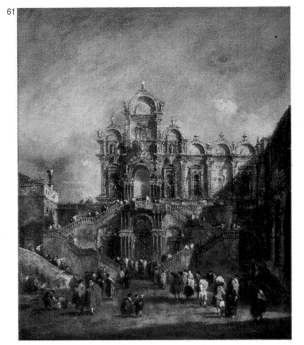

GUARDI Campo San Zanipolo

in a skillful diagonal composition. The figures of Apollo and Daphne display a blend of the sublime and the human, as well as a sophistication and an amazing ability to simplify which make Tiepolo's art an eighteenth century counterpart to the Renaissance art of Titian. Rosalba **Carriera**, another Venetian artist, was twenty years older than Tiepolo, but can be placed in the same category. Her *Allegory of Painting* gives the distinct impression of being an idealized self-portrait.

61. Francesco **Guardi** specialized in painting real and imaginary views, and his art represents a final stage in the development of Rococo. *Campo San Zanipolo* shows the Scuola di San Marco with a temporary staircase built in front of it for the visit of Pope Pius VI in 1782. The result here is a splendid piece of Rococo art in which the solid mass of the Scuola becomes a miraculously buoyant piece of architecture, and the gay Venetian crowd has a distinctly theatrical air.

62 – 63. The Rococo caprice was modified to produce the "ideal view" in the form of an imaginary landscape with ruins, while the scientific search for the truth led to the "view from nature," where the camera obscura was used to frame the required scene in perspective. A fine example of this kind of work is *The Portello and the Brenta Canal at Padua*, painted by Antonio Canal, known as **Canaletto**. He brought about a revolution by painting even his largest canvases in the open air, thus obtaining the kind of poetic naturalness which one sees in this view. Canaletto's nephew Bernardo **Bellotto** painted *The Castle of Nymphenburg* (near Munich), probably about 1761. The use of a ruling pen has here led to a certain rigidity of composition, and the almost obsessive clarity of vision suits the lucid northern landscapes which were his speciality, since he lived in Dresden, Vienna and Warsaw.

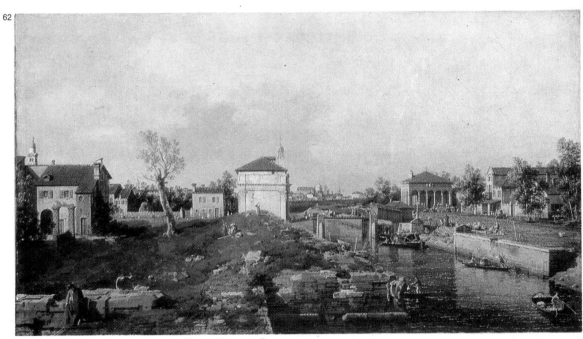

CANALETTO The Portello and the Brenta Canal at Padua

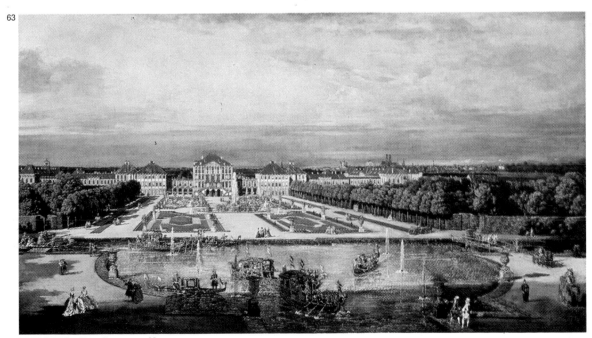

BELLOTTO The Castle of Nymphenburg

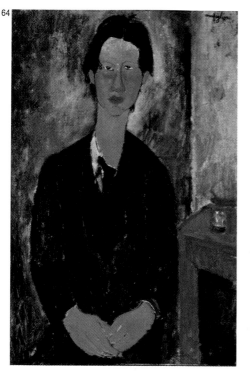

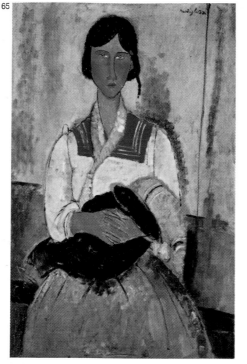

MODIGLIANI Chaim Soutine

MODIGLIANI Gypsy Woman with Baby

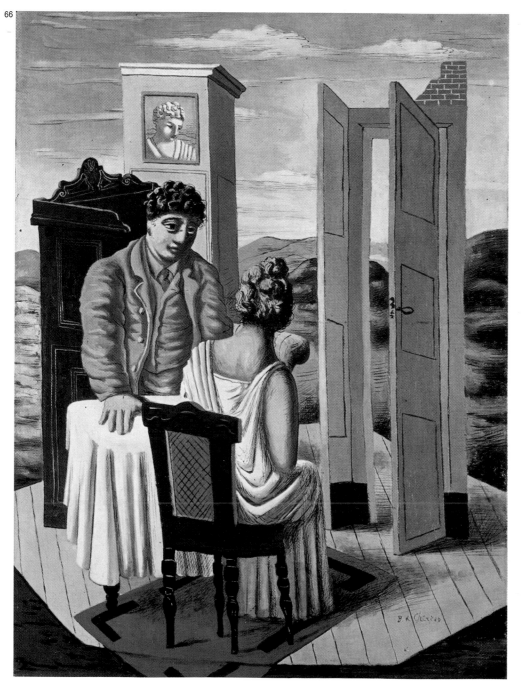

DE CHIRICO Conversation among the Ruins

64 – 65. Amedeo **Modigliani** was a Tuscan artist who went to Paris – then an important melting pot for artistic ideas – in 1906, at the age of twenty-two. There is great poetic vitality in his blend of a sensitive use of line, derived from early Sienese art and Botticelli, with a harshly modern use of basic geometrical masses and crudely intense colors, which he learned from studying negro sculpture and from meeting Cubist and Fauve artists. His portrait of *Chaim Soutine* (a well-known artist of Russian origin and a close friend of Modigliani) was painted in 1916 or 1917, not long before Modigliani's early death at the age of thirty-five. Chaim Soutine lived in a state of poverty and spiritual torment, which he tried to assuage by drinking. The frontal arrangement of the figure, with a long neck attached directly to the jaw, shows the influence of negro wood sculpture. *Gypsy Woman with Baby* was painted in 1918 or early 1919, when Modigliani and his faithful companion Jeanne Hébuterne were staying on the Côte d'Azur in order to avoid the danger of the bombardment of Paris. This is his only known painting of a mother and child, and it was painted when Jeanne gave birth to their daughter. As a result of his then being in a Mediterranean climate, his colors seem brighter than usual, and there is a new depth of charm in the melancholy poetry of the figures, which are elongated in a kind of arabesque rhythm.

66. Giorgio **De Chirico** (a living artist) is another Italian painter who lived in Paris in the early years of this century, although his sources of inspiration have always remained substantially Italian, for the classical mobility of the objects he paints derives from the antique world with which he was very familiar (he was born at Volos in Greece), and from the eager study of Renaissance painting. Nevertheless, as his art developed he moved away from the Latin world towards German Romanticism, where he discovered the disturbing fascination of the world of the imagination, and the metaphysical value of objects. His *Conversation among the Ruins* was painted in 1927, and is an example of the "metaphysical painting" which he invented and which looks forward to Surrealism. This particular work belongs to a series of "furniture in the valley" in which disturbing effects are achieved by placing mysteriously isolated pieces of furniture and architecture on a pedestal within a landscape inhabited by enigmatic human figures – in this case a modern man beside a woman in a classical robe.

FLEMISH AND DUTCH ARTISTS

67. This painting of *The Annunciation* is probably the left-hand wing of a lost triptych, and is an early work by Jan **van Eyck** of Bruges, the founder of the Flemish School of painting. It was painted before the famous Ghent altarpiece of 1432. Van Eyck's particular kind of analytical realism, which led him to examine animate and inanimate objects with the same loving care, since they all reflect the God who created them, is fully developed in this painting, but the lightness of the figures, the undulating rhythms and the elegantly elongated shapes all derive from the International Gothic style. Whether or not he really discovered oil painting, as tradition maintains, it is certainly true that he was the first to master oils as a means of expression, and he made use of the new possibilities they afforded him in the handling of light. He envelops his figures in the almost tangible light of the atmosphere, and his oil paint is laid over an opaque tempera surface in a way which allows him to produce subtle effects of translucency and reflection. Flemish artists in general were very sensitive to Christian symbolism, and van Eyck used it with masterly effect. He places the episode of the Annunciation (an event which separates the Old and New Testaments) and the three windows in the background (representing the Trinity) in bright light, while the frescoes and the stained-glass window depicting Jehovah high up on the church wall are enveloped in shadow. The words of the Angel's greeting are arranged in such a way that Mary's reply, written backwards from the spectator's point of view, can be read by the Holy Ghost as it swoops down the rays of light in the form of a dove.

68. This elegant *Profile Portait of a Lady*, with its flowing composition, flat treatment against a mat background, and refined costume, was formerly attributed to the International Gothic and Early Renaissance manner, but it is now thought to be by an unknown artist of the **Franco-Flemish School** and dated about 1410. This was the time when International Gothic art was enjoying its final fling at the courts of Burgundy and of the Duc de Berry, the former now united to Flanders as a result of the marriage of Philip the Bold of Burgundy and Margaret of Flanders.

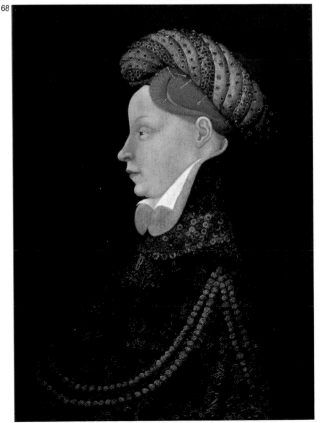

FRANCO-FLEMISH SCHOOL Profile Portrait of a Lady

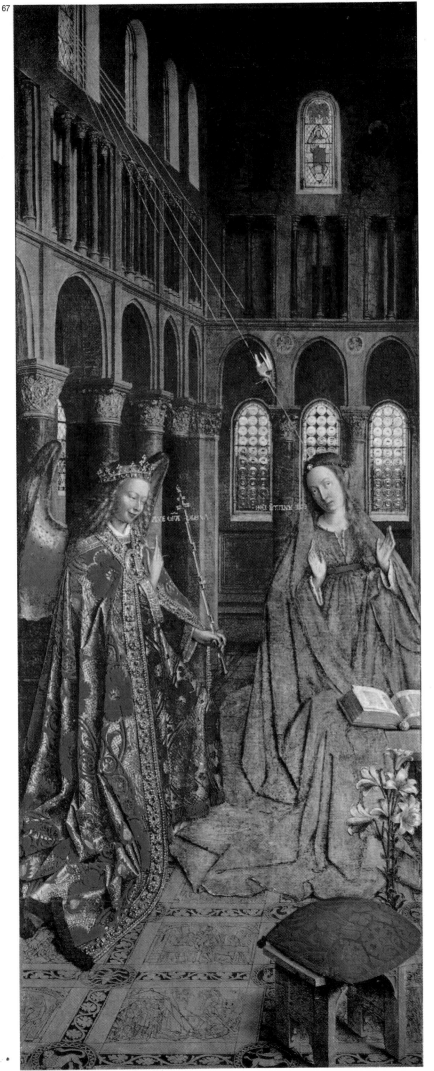

VAN EYCK The Annunciation

69

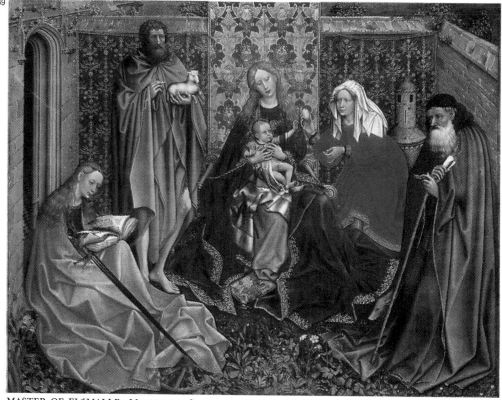

MASTER OF FLÉMALLE Madonna and Child with Saints in the Enclosed Garden

42

69. This *Madonna and Child with Saints in the Enclosed Garden* was painted by the **Master of Flémalle** and assistants. The saints surrounding the Madonna and Child are, from left to right, St. Catherine with her martyr's wheel and the sword of her faith, St. John the Baptist with the lamb, St. Barbara with the tower in which she was held prisoner, and St. Anthony the Hermit. The Master of Flémalle usually paints in a sculptural and expressive style, but in this case his work is more incisive and meticulous, with an almost obsessive care in rendering clearly the details of nature; there are reminiscences of the International Gothic style in the flowing rhythms of his closely interwoven forms.

70 – 71. The artists of the Flemish School were skillful portrait painters. This *Portrait of a Lady* (thought to represent Marie de Valengin, daughter of Philip the Good of Burgundy) was painted by Rogier **van der Weyden**, the greatest exponent of the Flemish expressionist manner. In this introspective portrait he has used his subject's physical features as a means of penetrating the stresses of her inner life. He painted it after his visit to Italy in 1450, which led him to develop a greater depth of human expression in his work.

70

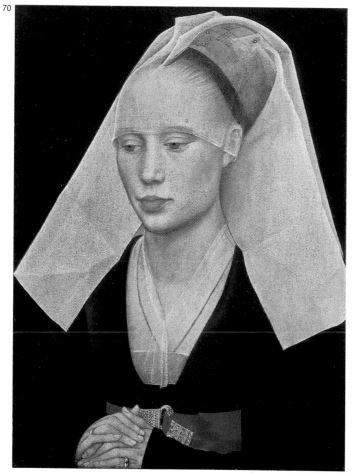

VAN DER WEYDEN Portrait of a Lady

71

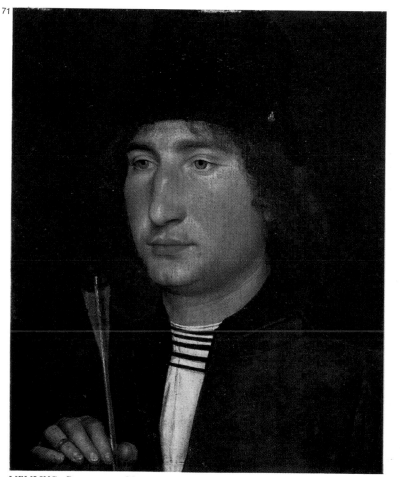

MEMLING Portrait of a Man with an Arrow

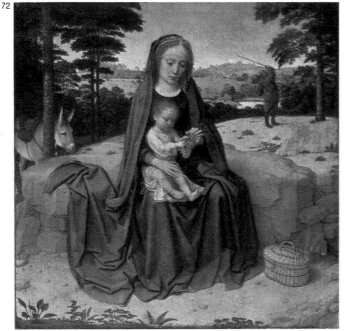

G. DAVID THE REST ON THE FLIGHT INTO EGYPT

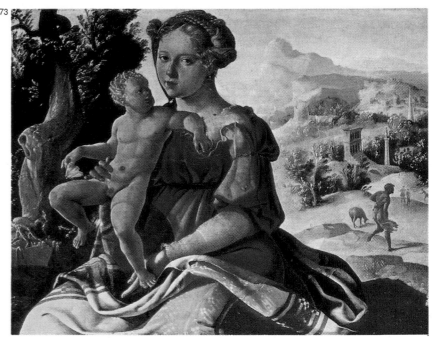

VAN SCOREL THE REST ON THE FLIGHT INTO EGYPT

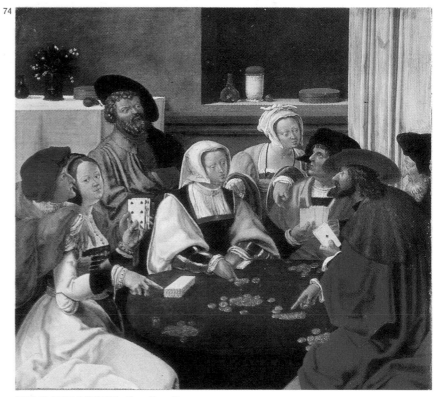

LUCAS VAN LEYDEN THE CARD PLAYERS

Hans **Memling**'s *Portrait of a Man with an Arrow* was painted twenty-five years or so later – about 1470. Memling dominated Flemish painting in the fifteenth century with his gift for expressing a balanced humanist point of view. He blends the intensity of expression of his master van der Weyden with the solemn calm of his great model van Eyck, in whose native city of Bruges he spent most of his working life. The portrait presumably depicts a member of a corporation of archers who has won some archery competition, his vistory being symbolized by the golden arrow.

72 – 73. These two quite different interpretations of *The Rest on the Flight into Egypt* are separated by an interval of only twenty years. The first is a mature work of about 1510 by Gerard **David**, a pupil of Memling. He was the last great painter of the Flemish School in Bruges, and here he succeeds in combining the expressive calm of Memling with a more directly Italian kind of idealism which he gained from a visit to Italy. His delight in conveying aspects of real life is evident in the simple actions of this family at mealtime, as St. Joseph beats some chestnuts from a tree and the Virgin gives her Child some grapes to eat. At the same time, however, he has an equally Flemish love of symbols. Thus the grapes denote the Eucharist and hence prefigure the Last Supper and the Passion of Christ, while the violets and cyclamen growing at the bottom of the picture are allusions to the humility and suffering of the Virgin Mary. David's preoccupation with form makes him a forerunner of Mannerism, but the Mannerist element in Jan **van Scorel**'s version of *The Rest on the Flight into Egypt* is much more evident. Van Scorel belonged to the Utrecht School of painters and practiced that Italianate form of Dutch art which found inspiration in the "grand manner" of the work of Raphael and Michelangelo in Rome. This painting can be dated about 1530. While the figure of the Child clutching a butterfly (a symbol of human frailty) is reminiscent of Michelangelo, the Virgin recalls the work of Raphael; but van Scorel has given added sophistication to his figures, with the result that the "grande maniera" has become a self-sufficient "bella maniera," in which there is a certain intrinsic melancholy. At the same time he gives a cold, jewel-like sheen to human flesh in a typically Mannerist way. In the background there are suggestions of a dream-like classical world which derived from van Scorel's stay in Rome from 1522 to 1524.

74. The most important sixteenth century Dutch artist to find inspiration in the Renaissance art of Rome was **Lucas van Leyden**. His paintings display a hyperbolic interpretation both of Renaissance forms and of the traditional Dutch realist treatment of genre scenes. *The Card Players* shows an incisive and meticulous concern for detail which is partly the result of the artist's work as an engraver.

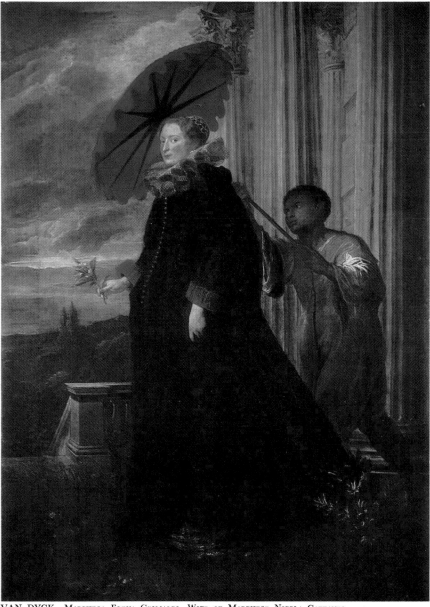

75 – 77. The two great representatives of seventeenth century Dutch Baroque art are Peter Paul **Rubens** and Anthonis **van Dyck**. Rubens had become strongly attracted to the Baroque during an early visit to Italy, and signed his letters "Pietro Paolo" in his enthusiasm for things Italian. His *The Meeting of Abraham and Melchizedek* is a mature work, dated about 1625. The consecration of bread and wine by the priest for the hero who has defeated the kidnappers of Lot is used as a prefiguration of the Eucharist. The painting is a richly imaginative work, exuberant in color and composition, and was executed for the Infanta Isabella, Regent of the Low Countries, as a model for one of a series of tapestries on the subject of the Eucharist which she commissioned him to design. It is a dramatic piece of Baroque theatre in the Roman manner, with infant angels to roll back the curtain. Van Dyck, on the other hand, shows that he is sensitive to Italian idealism as well as to the Baroque in these two portraits of *Marchesa Elena Grimaldi, Wife of Marchese Nicola Cattaneo* and her little daughter *Clelia Cattaneo*. They date from about 1623, when van Dyck was staying in Genoa, and originally hung in the Palazzo Grimaldi there. Van Dyck was then twenty-four years old, and had already very rapidly gained acceptance as official portrait painter to the nobility of the proud Republic of Genoa because of his ability to convey their sense of lofty pride at a time when Genoese society was at the height of its splendor. There is thus a supremely aristocratic feeling in his painting which keeps any Baroque exuberance under control.

VAN DYCK Marchesa Elena Grimaldi, Wife of Marchese Nicola Cattaneo

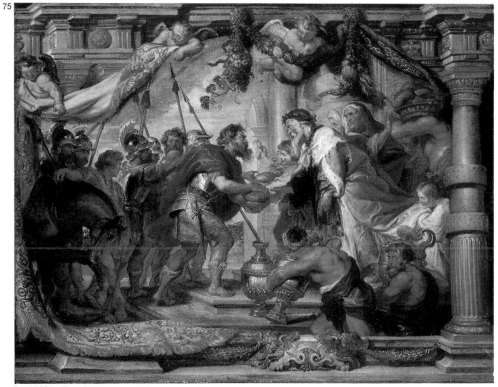

RUBENS The Meeting of Abraham and Melchizedek

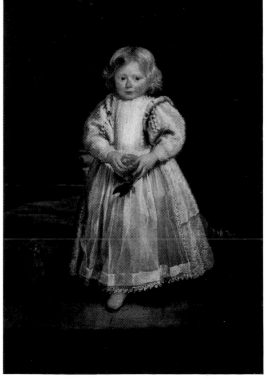

VAN DYCK Clelia Cattaneo, Daughter of Marchesa Elena Grimaldi

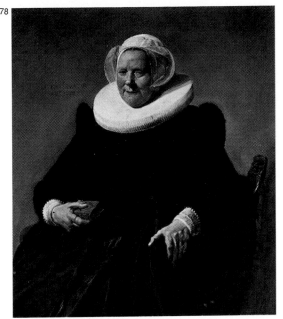

HALS Portrait of an Elderly Lady

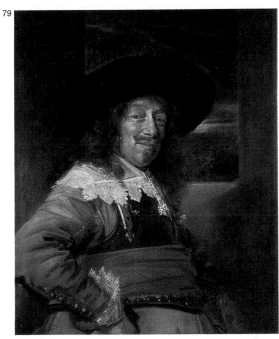

HALS Portrait of an Officer

78 – 79. Frans **Hals** was a Dutch portrait painter whose work is less refined than that of Flemish artists, but who had an impressive ability to grasp the external aspects of things, as though in a photographic snapshot, without making a penetrating psychological study of his subject. A few bold brush strokes allowed him to convey the reality of old age in his *Portrait of an Elderly Lady* of 1633, while the essence of the self-satisfied soldier is captured in his *Portrait of an Officer* of a few years later. The figure in the latter painting has much in common with those who appear in the famous group portraits of officials in which Hals excelled. We are reminded that Hals has been described as a "painter of smiles," and that his rapid, summary technique was admired by the Impressionists.

80 – 82. There appears to be a contrast between seventeenth century Baroque art and the meditation through images practiced by the Dutch painter Jan **Vermeer** of Delft, yet there is an echo of Baroque hyperbole even in the statuesque calm of his work, with its subtle relationships between light and form and between light and color. His figures are motionless but full of tension; light has the effect of removing the weight from solid objects; and his colors seem about to disintegrate. He manipulates natural light in such a way as to modify shapes. These two companion pieces entitled *The Girl with a Red Hat* and *Young Girl with a Flute* both have the same tapestried background and the same armchair with lions' heads. The effect of light on the colors is to give them a translucent sheen which reminds one of glazed porcelain. *A Woman Weighing Gold* was painted about 1657. The figure of the pregnant woman (probably the artist's wife) acquires a sense of mystery from the light which falls upon her, as she seems to weigh up the very meaning of life.

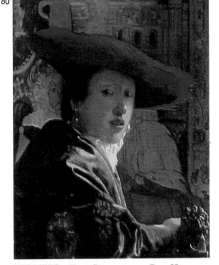

VERMEER The Girl with a Red Hat

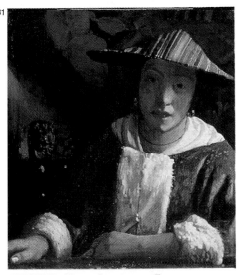

VERMEER Young Girl with a Flute

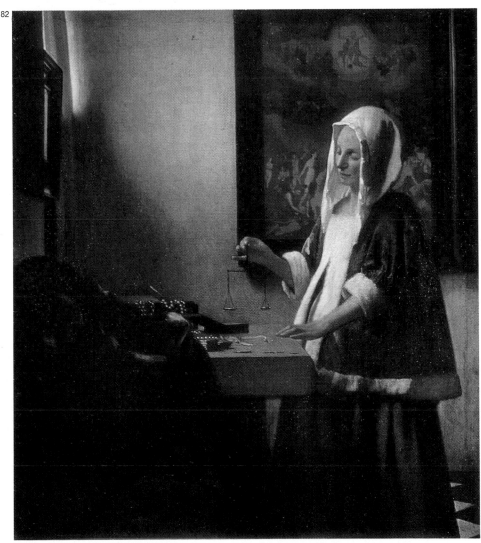

VERMEER A Woman Weighing Gold

REMBRANDT

The National Gallery's remarkable collection of works by Rembrandt Harmensz. van Rijn makes it possible to trace the development of his art. The essence of his painting, in fact, can be described as the material expression of human thought by means of the dematerialization of matter under the effect of light, used as an ingredient of color and handled in a wide variety of tones, from the brightest and most vibrant to the darkest shadow. Rembrandt worked in the important commercial port of Amsterdam, where the influential bourgeoisie were more interested in having their own recently acquired power extolled than in meditating on the meaning of life. The death of Rembrandt's wife Saskia in 1642 marks a turning point in his relationship with this flourishing society. Up to that time his resplendent paintings had succeeded in reconciling his dramatic effects of gold and shadow with the down-to-earth requirements of his patrons. From now on he concentrated more on probing the mystery of man and concerned himself less with the realities of everyday life. The paintings of the closing period of his life express the relationship between light and shade in the most basic terms.

83. *Joseph Accused by Potiphar's Wife* is thought to have been painted in 1655. Potiphar is wearing one of the exotic costumes that Rembrandt liked to give his characters, and the painting as a whole reveals those mysterious harmonies of bright light and deep shadow which are typical of his later work.

84 – 85. *Self-Portrait 72* shows a man who has prematurely aged as a result of his misfortunes, but remains unbowed and at the height of his analytical powers. *The Apostle Paul* also displays an introspective approach. He is not portrayed at the moment when a vision transformed his life, but is caught in deeply anxious meditation.

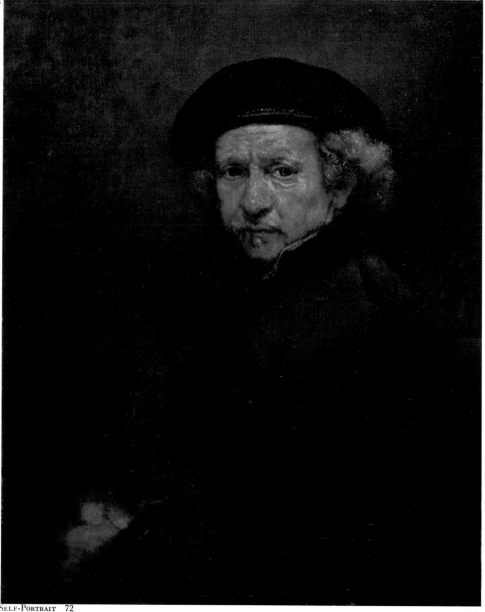

SELF-PORTRAIT 72

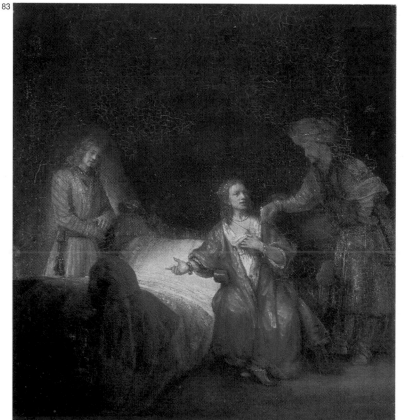

JOSEPH ACCUSED BY POTIPHAR'S WIFE

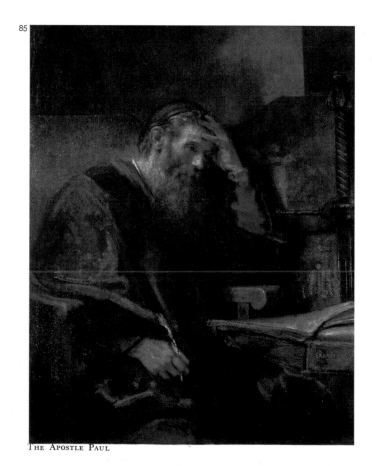

THE APOSTLE PAUL

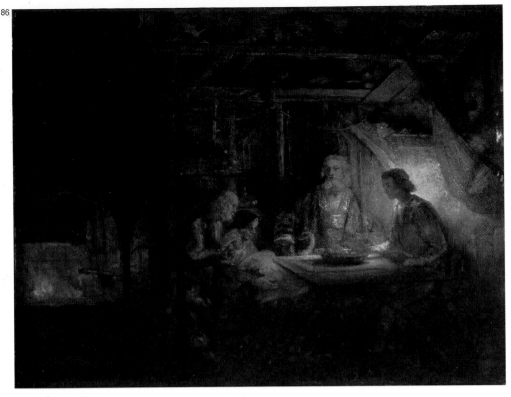

PHILEMON AND BAUCIS

86. The story of *Philemon and Baucis* is told by Ovid in the *Metamorphoses*. They are an elderly couple who symbolize the eternal nature of the love which governs the world, and are visited by Jupiter and Mercury. Rembrandt, however, has transformed the scene into something almost biblical, for Jupiter looks like an Old Testament high priest, or one of the artist's personal friends among Amsterdam's learned rabbis. Rembrandt has painted his visionary scene with a technique reminiscent of his own masterly etchings, and the serene pagan poetry of life and death is quite absent.

87 – 88. The *Portrait of a Gentleman with a Tall Hat and Gloves* and its companion *Portrait of a Lady with an Ostrich-Feather Fan* were painted about 1667, at a very late stage in Rembrandt's career. The two unidentified sitters emerge from the shadows with a dignity that transcends human nature, for Rembrandt has transformed a simple pair of portraits of husband and wife into a symbol of the mystery of the human life cycle. Both paintings belonged at one time to Prince Youssoupoff, an extremely wealthy Russian who refused to sell them to Peter A. B. Widener. But when the prince's son was living in poverty in London after the Russian revolution, he sold the paintings to Peter Widener's son Joseph, on the condition that the could buy them back if he became wealthy again. In due course he came to Widener with a check for one hundred thousand pounds, but it turned out that the funds had been supplied by one of Widener's rival collectors, and so Widener was able to keep the pictures and present them to the National Gallery in 1942.

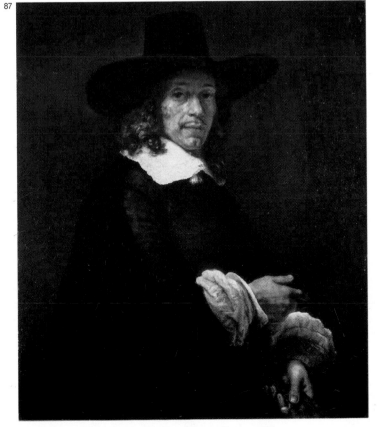

PORTRAIT OF A GENTLEMAN WITH A TALL HAT AND GLOVES 663

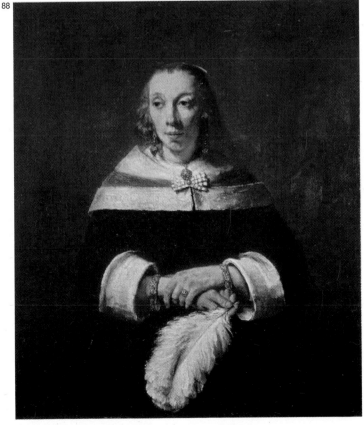

PORTRAIT OF A LADY WITH AN OSTRICH-FEATHER FAN

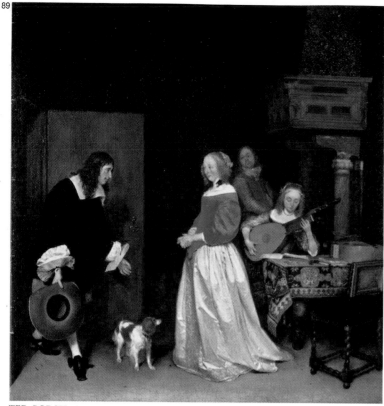

TER BORCH THE SUITOR'S VISIT

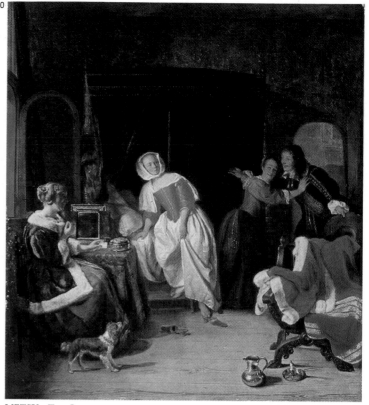

METSU THE INTRUDER

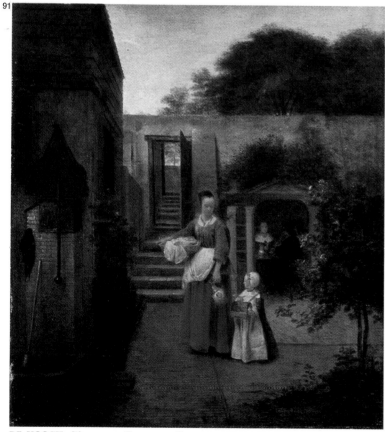

DE HOOCH WOMAN AND CHILD IN A COURTYARD

89 – 90. Aristocratic and gallant genre paintings were particularly popular in Holland, thanks both to Gerard **ter Borch**, who specialized in rendering the sort of shimmering cloths and exaggeratedly brilliant silks seen in *The Suitor's Visit* (c 1658), and to Gabriel **Metsu**. The dramatic scene of *The Intruder* was painted by Metsu when he was about thirty, two or three years after the preceding painting. In both works the Dutch liking for interiors is combined with elements of genre painting. This is clear in the first painting in the quizzical glance of the father in the background and the feigned concentration on her music of the friend (or sister?) of the fiancée. Similarly, we notice how, in Metsu's painting, the salacious atmosphere is *not* in fact counteracted by the old woman's empty gesture, for the attempt to repulse the intruder is feigned.

91. Pieter **de Hooch** is the most poetic of the Dutch painters of scenes of everday life. As in the case of *Woman and Child in a Courtyard* (c 1660), he succeeds in transforming open-air scenes into intimate interiors. Thus the courtyard seems like a room, and the light is handled as though it came through a window. Of all Dutch artists, de Hooch is the nearest to Vermeer in the vitality and tranquillity of his scenes, in the thoughtful investigation of color-light relationships, and in the clear, lucid atmosphere of his settings.

GERMAN ARTISTS

92. St. Clare was an ardent follower of St. Francis of Assisi and founded the Order of Poor Clares. *The Death of Saint Clare* is a diptych wing illustrating the miraculous event which contemporary biographers claimed to have occurred at the death. They tell how the Virgin Mary came to her bedside in the company of a number of virgin martyrs and supported her head while God appeared and received her soul (represented here in the traditional way as a small child in God's arms – a symbol of the return to a state of innocence). The virgin martyrs who accompany Mary are, from left to right, St. Margaret with a dragon, St. Dorothea with a basket of flowers, St. Barbara with her tower, St. Cecilia with a garland of roses, St. Catherine with her wheel, and St. Agnes with her lamb in front of the bed. (The prominence given to St. Agnes may be connected with the unknown person who commissioned the painting, or the monastery for which it was intended.) The painting clearly belongs to the International Gothic style which held sway in the courts of Europe at the turn of the fourteenth century, as one can see from the refined elegance of the costumes (suitable for court ladies in the early fifteenth century), and the sophisticated charm of the elongated figures, with their spidery fingers and swaying ballet-like motion. It was painted (together with its companion wing, now in the Cleveland Museum of Art) about 1410 for a monastery in northern Germany by the **Master of Heiligenkreuz**, a forceful exponent of the International Gothic style.

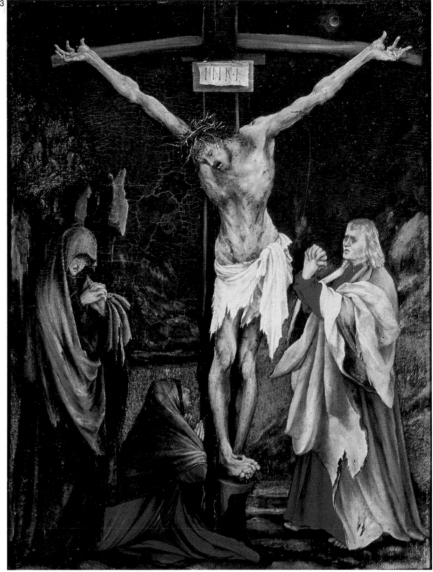

GRÜNEWALD THE SMALL CRUCIFIXION

93. Grünewald's *The Small Crucifixion* is a masterpiece of German painting and one of the greatest works in the National Gallery. Its title distinguishes it from a larger painting of the same subject which forms part of Grünewald's most famous work: the Isenheim polyptych. *The Small Crucifixion* was painted about 1510, rather earlier than the Isenheim polyptych, and the artist has here succeeded in using the limited dimensions of the panel to convey his interpretation of the tragedy of Christ's death with even greater effect. His intensity of expression is almost overwhelming, and his ability to synthesize the elements of his painting has something almost modern about it. The folds and creases of the draperies are still Gothic in treatment, and the landscape backround is reminiscent of a decorative Gothic garden, but there is something very German about the artist's disdain of formal beauty and his intentional distortion of the human figure in such a way as to make it as expressive as possible. It was this sort of approach which led to the grim power of German Expressionism in the early years of this century. The boldly shortened figure of the Virgin Mary, for example, could well have come from a modern Expressionist painting. Grünewald's painting was originally in the collection of Duke William V of Bavaria and his son Maximilian I, but the artist was then unidentified. However, the famous German art historian Sandrart saw it there in the seventeenth century and was able to identify it as a masterpiece by Grünewald. The painting subsequently disappeared for two centuries and was thought to have been destroyed, but it was found again in 1922 and was bought thirty years later by Rush Kress, who presented it to the National Gallery.

MASTER OF HEILIGENKREUZ THE DEATH OF SAINT CLARE

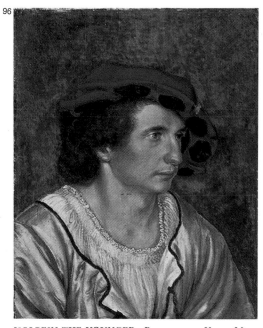

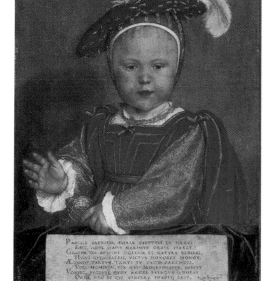

CRANACH THE ELDER Portrait of a Woman

HOLBEIN THE YOUNGER Portrait of a Young Man

HOLBEIN THE YOUNGER Edward VI as a Child

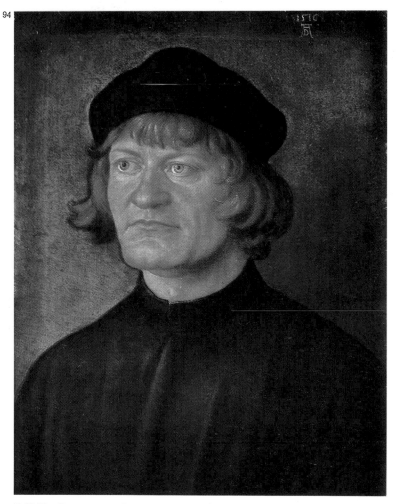

DÜRER Portrait of a Clergyman

94. The first great German Renaissance artist was Albrecht **Dürer.** He painted this powerful *Portrait of a Clergyman* (which may depict Johann Dorsch, a famous Lutheran preacher from Nuremberg) in 1516, but it reveals little of that idealization of man and search for a rational ideal of beauty which he learned as a young man in Italy. Its particular kind of psychological penetration is related rather to the purely German tradition of Holbein the Elder's portraits, but it does nevertheless reveal Dürer's passionate interest in a rational analysis of natural phenomena. He has noticed the reflection of his studio windowpanes in the iris of his sitter's eyes, and so he has painted them there; then he has painted a reversed image of them on the hollow of the pupils, since it is in fact the function of the pupil to reflect the image in this way. The painting is executed on parchment – an experimental support material which Dürer used on two other occasions in 1516.

95. Lucas **Cranach** the Elder was court painter at Wittenberg to Frederick the Wise, Elector of Saxony, and was of the same generation as Dürer, but his pictorial treatment of the real world displays a Mannerist refinement. His *Portrait of a Woman* was painted in 1522, and reveals subtly stylized rhythms in the outline of shoulder and hat, the design of the belt, and in the neck emerging from the collar.

96 – 97. The last of the great German portrait painters was Hans **Holbein** the Younger. His *Portrait of a Young Man* (c 1520) is an early work, related to Italian idealism and characterized by its freedom of pictorial synthesis. His portrait of *Edward VI as a Child*, on the other hand, is a mature work executed soon after his second arrival in England, when little Prince Edward, son of Henry VIII and the third of his six wives, was fourteen months old. The painting was presented to Henry VIII on New Year's Day 1539. These two paintings represent the two opposite poles of Holbein's career. At an early stage he worked with his father and brother Ambrosius at Basle, where Italian influence was strong, but his later career was spent largely in England. In this second portrait, little Prince Edward is in ceremonial dress and holds a gold rattle as though it were a scepter. Below him is written out the text of a poem by Cardinal Morrison urging him to emulate his illustrious father. This is a typical example of a type of courtly portraiture which English artists sought to emulate for almost a century.

SPANISH ARTISTS

98 – 99. These two paintings are among the most famous works of Domenikos Theotokópoulos, known as **El Greco** because he was born in Crete. *Saint Martin and the Beggar* was painted between 1597 and 1599 for the left-hand altar in the Chapel of San José in Toledo. (There is also a late replica of this painting in the National Gallery, and the paintings for the high altar and right-hand altar are still in situ in Toledo.) By now El Greco had reached his full maturity, and his spiritualized, elongated figures had become typical, but there are echoes of his early training in Venice in the treatment of the sky and the way he applies his greens and golds. The story of St. Martin sharing his cloak with a beggar was popular at the time of the Counter-Reformation, when it was used as a symbol of Christian charity. *Laocoön* was painted about 1610, four years before El Greco died. The closing years of his life were characterized by a new interest in the classical world and the nude, which is here blended with an increasingly rapid style, where pale colors are laid on in dramatic patches in an atmosphere of nightmarish tension. Stylistically, this represents the height of El Greco's achievement. The Graeco-Hellenistic sculpture group of Laocoön and his sons had been discovered in Rome in 1506 and the theme had subsequently become fashionable in art. El Greco must certainly have seen the Lacoön group during his visit to Rome in 1570, before he went to Spain. Lacoön was a Trojan priest of Apollo who angered Athena by hurling his spear at the wooden horse which the Trojans wished to bring into the city against his advice. (It was subsequently the cause of the city's destruction.) In El Greco's painting he is seen being killed with his sons by the sea serpents summoned to attack him by the angry gods. The two nude figures on the right represent two gods who are watching Lacoön's punishment. The wooden horse can be seen in the background outside the walls of a city which is not in fact Troy but Toledo, where El Greco worked for the rest of his life.

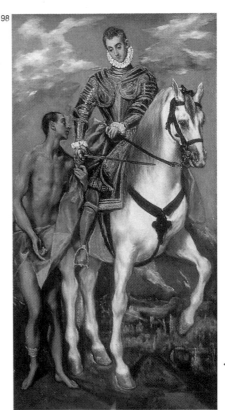

EL GRECO SAINT MARTIN AND THE BEGGAR

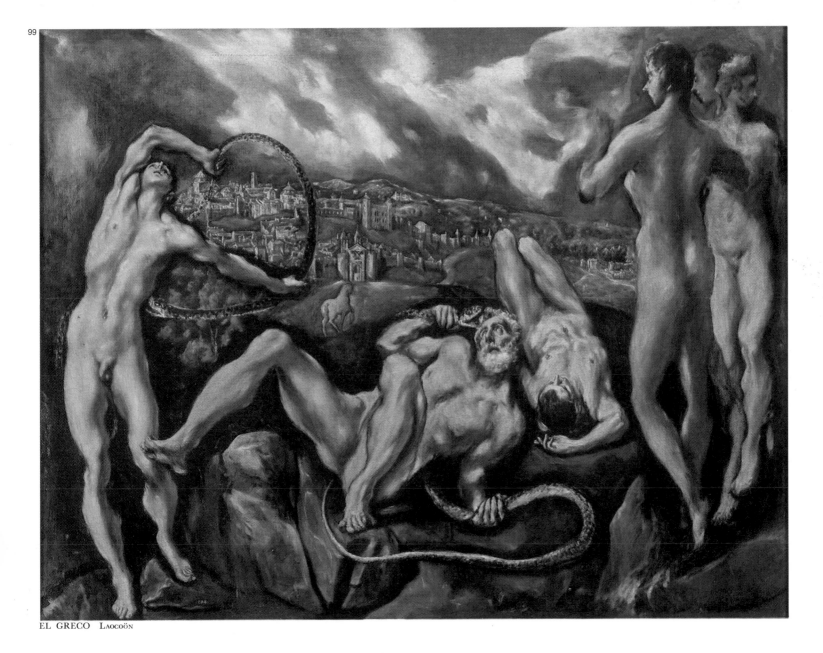

EL GRECO LAOCOÖN

100

VELÁZQUEZ The Needlewoman

101

MURILLO A Girl and Her Duenna

100 – 101. *The Needlewoman* by Diego **Velázquez** and *A Girl and Her Duenna* by Bartolomé Esteban **Murillo** represent the two opposite poles of Spanish art in the seventeenth century – the century of realism. The young woman bending over her needlework is probably Velázquez's eldest daughter Francisca, who was born in 1519 and would be about twenty in this painting. Velazquez uses an extremely rapid technique to convey the essence of reality, in a way which anticipates the pure pictorial values of modern art. Murillo's brand of realism, on the other hand, is uncompromising and has all the liveliness of the popular spirit. His painting is as intense and rapid as that of Velázquez, but at the same time he manages to emphasise the reality of what he is depicting. This particular work depicts two famous courtesans from Galicia at a window. (It was painted about 1670 and is sometimes known as *Las Gallegas*.) Murillo must frequently have seen such women as he walked through the streets of his native Seville.

102 – 103. The work of Francisco **Goya** brings the golden age of Spanish art to a close and heralds the arrival of modern art in Europe. Goya was about sixty when he painted *Señora Sabasa García* (c 1806-7), and by now his eighteenth century attitudes had given way to new kinds of inspiration which enabled him to render the warmth of human life even more effectively. One is conscious of the throb of human life in his subjects, of the blood flowing in their veins. In this portrait there is a feeling of sensuality and mystery which looks forward to Romanticism. It depicts the young niece of Don Evarista Pérez de Castro, ex-Prime Minister of Spain. Goya had seen her when he was painting her uncle, and had asked permission to record in paint the ephemeral beauty of this eighteen-year-old girl. He then presented the portrait to her as a gift. The portrait of *The Marquesa de Pontejos* was probably painted in 1786. The lady in question was one of the most influential beauties at the royal court in Madrid, and Goya's painting of her is in the elegant eighteenth century style. Her shepherdess's costume recalls the pastoral fashion which Marie Antoinette launched in France, and the setting is reminiscent of the tapestries which Goya himself designed for the royal tapestry workshops. But the fresh brushwork, and the enigmatic mask of the subject's face, with its two anxious eyes set in the middle, are typical of Goya's new and revolutionary art, in which his subjects become screens beyond which one glimpses a disturbing world.

102

GOYA Señora Sabasa García

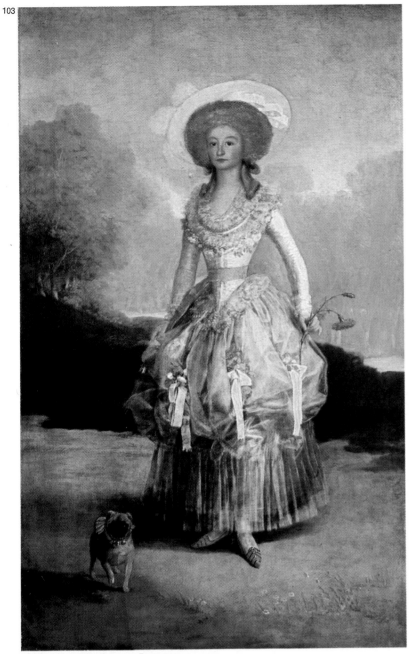

GOYA The Marquesa de Pontejos

104. The work of Ignacio **Zuloaga** is characterized by his outstanding ability to transform folklore and local color into the idiom of painting. He lived in the latter part of the nineteenth century and the early years of this century, and has proved to be the most popular of modern Spanish artists. He was born in 1870, and was just over forty when he painted this *Woman in Andalusian Dress*. The background is an emblematic representation of unrestrained nature, and the artist has succeeded in conveying all his subject's beauty with a minimum of brushstrokes and a range of very strong but sober colors.

105. *The Sacrament of the Last Supper* belongs to the most recent phase in the development of the celebrated Surrealist painter, Salvador **Dali**. He intensifies reality and creates supra-real phenomena in a lucid, obsessive and extreme world which has the quality of a dream and appears to be a projection of the fantasies of the unconscious. This work was painted in 1955 and belongs to a period when Dali was painting religious subjects as a tangible means of salvation in a world gone mad. The Gulf of Lligat on the Costa Brava, where Dali has his studio, can be seen in the background. The scene is set within a transparent dodecahedron – a symbol of heavenly perfection – above which the top half of a naked man, whose features resemble those of Dali himself, stands in a protective attitude. The face of Christ, and especially his eyes, recall the features of Dali's favorite model, his wife Gala; and the painting is signed "Gala Salvador Dali" in the bottom right-hand corner.

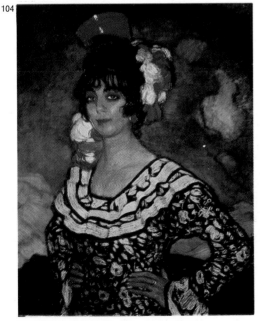

ZULOAGA Woman in Andalusian Dress

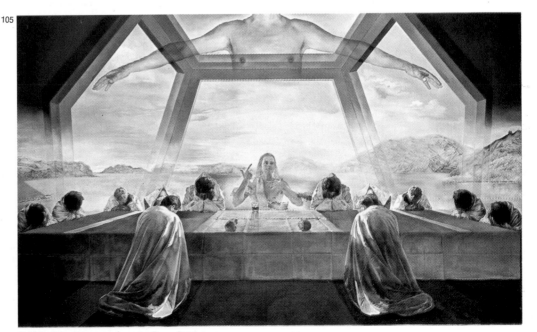

DALI The Sacrament of the Last Supper

FRENCH ARTISTS

106. The greatest French artists of the time of the Valois kings and the Court of Fontainebleau were Jean Clouet and his son François **Clouet**. Pictures of beautiful women at their bath were popular at the time, and this one was the work of François Clouet, court painter to Henry II. It is thought to depict *Diane de Poitiers*, Henry's mistress. She was twenty years older than Henry, but contemporary accounts say that she knew the secret of eternal youth and looked the same age as the king. Typical of Clouet's style are the delicate treatment of physical features and the clarity and balance of the composition, to which are added certain Flemish qualities in the wet-nurse, the maid servant in the background and the magnificent still life in the foreground, all of which look forward to the seventeenth century. If the painting does indeed depict Diane de Poitiers, it must have been painted before 1559 (since Henry died in that year), but it is thought by some to depict Marie Touchet, mistress of Charles IX, one of Henry's sons and successors.

107. *Omer Talon* was a celebrated "avocat général" of the Paris parliament and an energetic champion of its rights in relation to the crown. Here he is depicted in the magnificent robes of his profession by Philippe de **Champaigne**, the greatest portrait painter of the reign of Louis XIII and the regency of Mazarin. Champaigne was expert at combining Baroque splendor with a psychological investigation of his subject and a keen observation of detail. The date 1649 appears on the base of the column. This means that the sitter was fifty-four when the portrait was painted and had held his influential position for eighteen years.

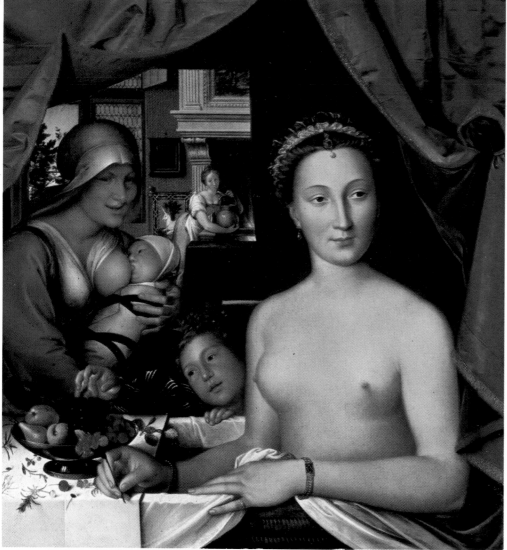

CLOUET Diane de Poitiers (?)

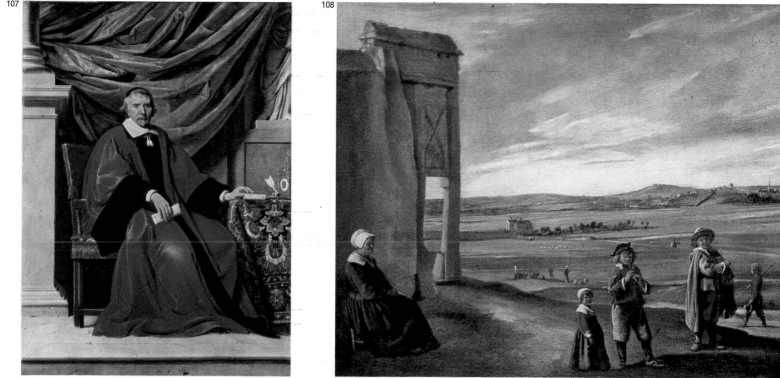

CHAMPAIGNE Omer Talon

LE NAIN Landscape with Peasants

108. This *Landscape with Peasants* was painted about 1640 by Louis **Le Nain**, and confirms his status as the most important exponent of the anti-academic manner, with its emphasis on informal subjects and intimate feelings, by contrast with the "grand manner" of classical artists like Poussin. Dutch art is an important source of inspiration in this painting, but it also reflects something of the realism of Caravaggio. However, there is something quite personal to Le Nain in the placid poetry of figures and landscape and in the clear definition of shapes and distances. The painting is thought to have belonged to the English artist Thomas Gainsborough and to have influenced his early landscapes.

109 – 110. Nicolas **Poussin** and Claude **Lorrain** represent the "grand manner" in seventeenth century art. Poussin achieved this by using elevated classical subjects and reviving the style of Raphael, while Claude Lorrain expressed a classical and lyrical interpretation of nature. Both spent most of their lives in Rome. Poussin was born in 1594, went to Rome at the age of twenty-nine, and immediately gained acceptance among the artistic élite at the Papal court. Claude Lorrain was born in 1600, and like

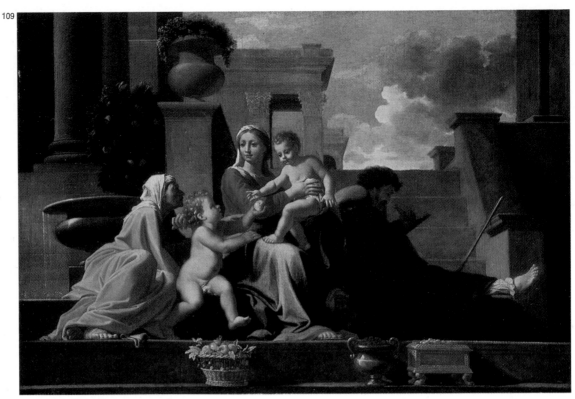

POUSSIN HOLY FAMILY ON THE STEPS

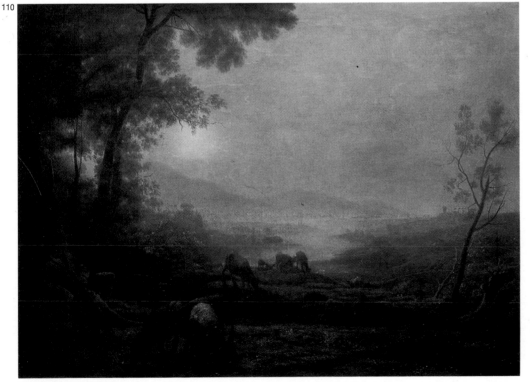

LORRAIN THE HERDSMAN

many of his compatriots from Lorraine, went to Rome as a boy to work as a pastrycook. The two artists often worked side by side, and the younger of the two was influenced by the other's work. The *Holy Family on the Steps* shows Poussin at the height of his ability to give his compositions an intellectual order by means of his absolute mastery of form, a compositional arrangement which is perfectly balanced in spite of its apparent asymmetry, and a sober use of color. The fact that The Madonna and Child are in the same attitude as in Raphael's *Madonna del pesce* and that St. Joseph looks like one of the philosophers in Raphael's fresco of *The School of Athens* in the Vatican *stanze*, shows that Poussin had studied Raphael's work with keen interest. But he did not imitate him. Poussin's world reveals a rich intellectual meditation on reality, quite different from Raphael's sublime human warmth. Claude Lorrain's *The Herdsman* displays a lyrical interpretation of the Roman Campagna, with effects of light and a concern to convey changes of time and season which make the artist a precursor of modern landscape painting.

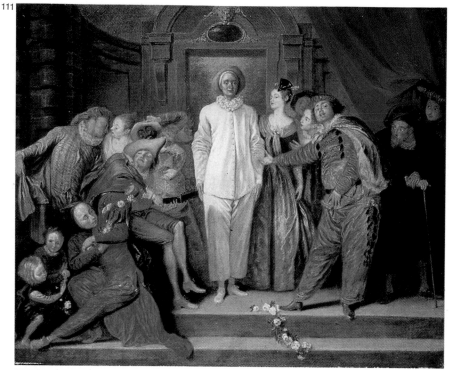

WATTEAU Italian Comedians

111. Antoine **Watteau** was the founder of the eighteenth century Rococo style, the essential characteristics of which are melancholy, frivolity, elegance and sensuality. The source of his inspiration was the *fêtes galantes* and theatre scenes of his own time, but he transformed reality into a charming kind of fantasy. *Italian Comedians* in usually identified as a picture he painted in 1720 (the year before he died) for Dr. Richard Mead, a leading London doctor whom he had gone to England to consult. The particular troupe of Italian actors immortalized in this painting had been disbanded in 1697 on the orders of Mme. de Maintenon, but had been welcomed in Paris again in 1716. It was disbanded again in 1719 when the Opéra Comique, the great rival of the Comédie Française, closed down. Gilles stands in the center, surrounded by his fellow actors. It appears, however, that the models for the painting were not the actors themselves, but some of Watteau's friends, and that the figure on the right is Dr. Mead.

112. The art of François **Boucher** contains the essence of Rococo – that artificial charm which lends the human figure the same whimsical curls and undulations that it uses in depicting nature. This mythological *Venus Consoling Love* was painted in 1751 for Madame de Pompadour, Louis XV's mistress, whose favorite painter was Boucher at that time. It has been said that Madame de Pompadour herself posed for the figure of Venus, at whose feet are the doves which are her symbol.

113 – 114. The intimate poetry of Jean-Baptiste Siméon **Chardin**'s paintings proved very attractive to Diderot, the creator of the *Encyclopédie*, a compilation which epitomized a century which had begun in frivolity and ended with a yearning for truth. *The House of Cards* and *The Young Governess* are two masterly examples of an art which uses the pure values of painting to give new life to a type of bourgeois realism whose sources are to be found in Flemish art. The undulating rhythms of Rococo art are

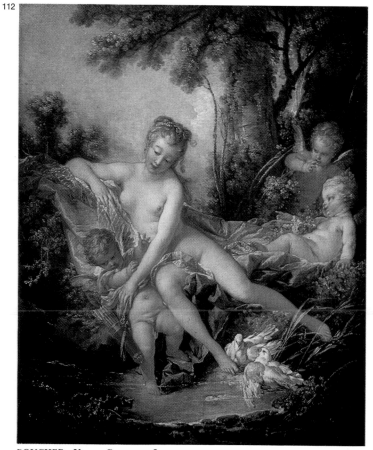

BOUCHER Venus Consoling Love

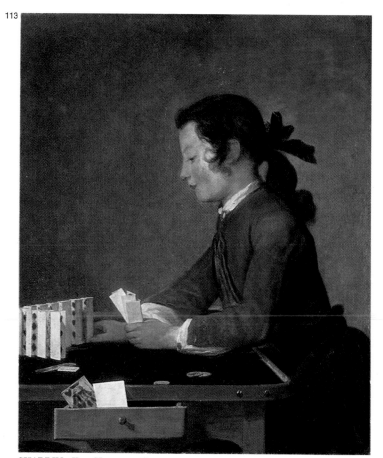

CHARDIN The House of Cards

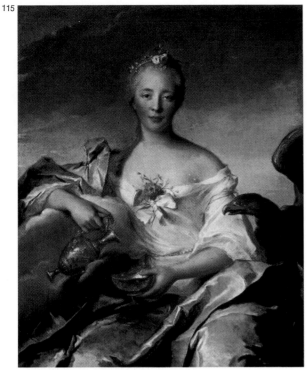

NATTIER Madame de Caumartin as Hebe

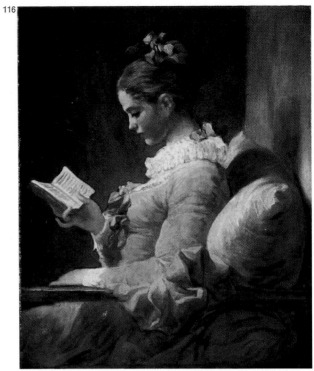

FRAGONARD A Young Girl Reading

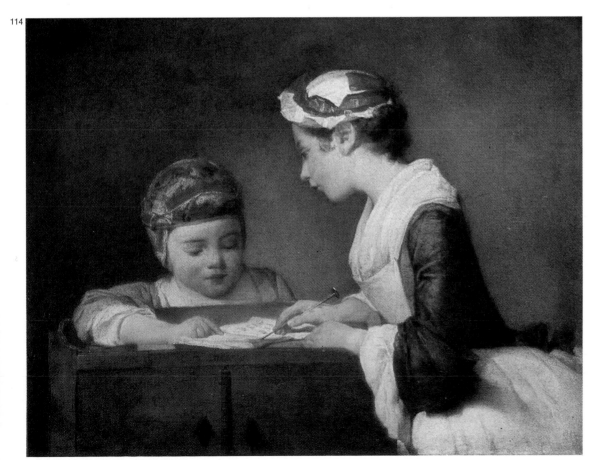

CHARDIN The Young Governess

now free of all artifice, and become a sober musical element within a kind of painting whose texture is sensitive to the new understanding of the effect of light upon color.

115. Jean-Marc **Nattier** was official portrait painter at the French court. His courtly portraits are given an allegorical or mythological form, as one sees in his delightful *Madame de Caumartin as Hebe* of 1753. Here is a case where the Rococo style has acquired a certain ritual dignity.

116. The forceful and yet refined paintings of Jean-Honoré **Fragonard** (1732-1806) bring the history of eighteenth century French art to a close, for he takes up the Rococo style at a late stage in its development and moves towards nineteenth century Romanticism. *A Young Girl Reading* was painted about 1776, when his creative ability was at its peak, and it is outstanding for its sensitivity to the pulse of life and for the gentle feeling of mystery which it lends to concrete objects. In spite of his achievements as an illustrator and painter, Fragonard never gained official recognition, and hence could often paint for himself. This the case with *A Young Girl Reading*. Its throbbing and curling rhythms belong to the last phase of the Rococo style, but there is something very modern about the rapid modeling of forms.

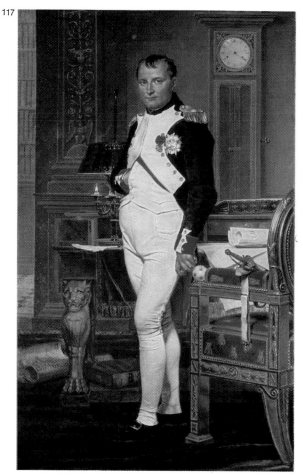

J.-L. DAVID Napoleon in his Study

117 – 118. It was not Napoleon who commissioned this portrait of *Napoleon in his Study*, but the eccentric Duke of Hamilton, who claimed the throne of Scotland and collected full-length portraits of all the crowned heads of Europe. For his portrait of Napoleon, he commissioned Jacques-Louis **David**, the most famous artist of his day. David had been the painter par excellence of the Greco-Roman revival known as Neoclassicism and of the austere French Republic, and had subsequently become official painter to Napoleon as First Consul and then as Emperor. This portrait is dated 1812, the year of Napoleon's disastrous retreat from Russia. Only the external trappings of Neoclassicism are to be found in it (the antique armchair, the desk leg in the form of a lion-headed sphynx and the candlestick standing out against the pilaster), whereas the style is essentially that of courtly Empire realism. Although painted only a year later, David's portrait of his wife *Madame David* is a quite different piece of work. It is a masterly example of the bourgeois realism typical of David's last period, and it looks forward to the artistic taste of the Restoration.

119. Jean-Auguste Dominique **Ingres** began this portrait of *Madame Moitessier* in 1844, but did not complete it until 1851. Ingre's ideals were strongly classical, and here he has blended Greek and Renaissance idealism with the contemporary view of man. Hence Madame Moitessier's flesh has a statuesque purity and the outline of her body has the grace of Raphael, whereas there is a sensual and Romantic charm about her accessoires. But the two different worlds are juxtaposed without actually being fused together, and this grand lady seems to aspire to the purity of the classical nudes on Greek vases in which Ingres found a source of inspiration.

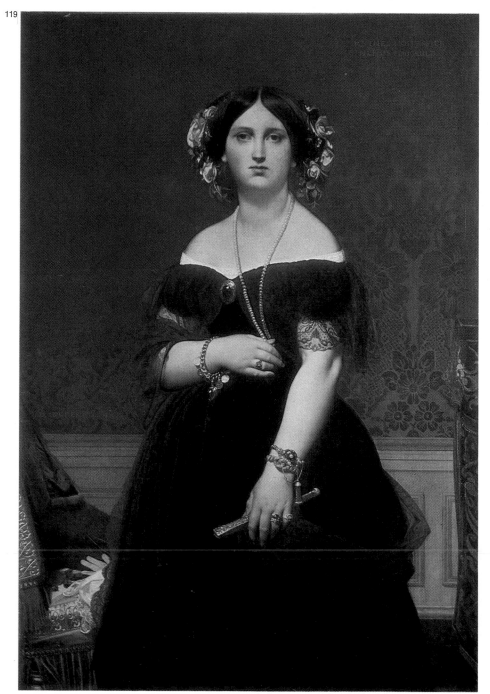

INGRES Madame Moitessier

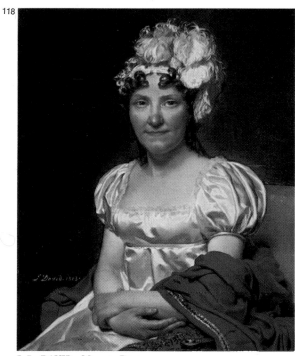

J.-L. DAVID Madame David

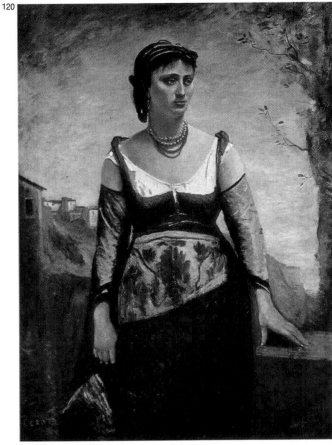

COROT Agostina

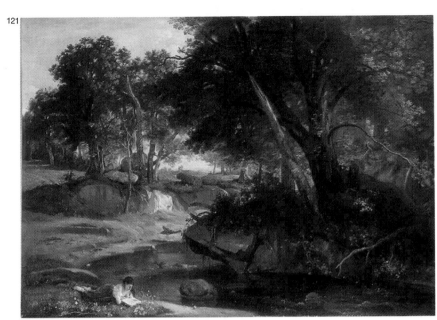

COROT Forest of Fontainebleau

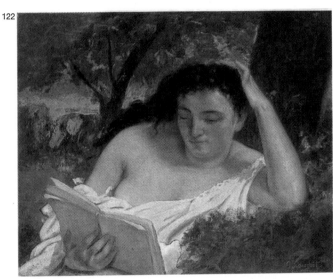

COURBET A Young Woman Reading

120 – 122. Jean-Baptiste Camille **Corot** probably painted *Agostina* in 1866. She is a country girl and was no doubt created from memories of the artist's long visit to Italy. Corot brought into being the Romantic landscape, and there is a clear indication of the treatment he chose to give such subjects even in his early *Forest of Fontainebleau* (c 1830). Gustave **Courbet**'s *A Young Woman Reading* is directly inspired by Corot's painting of a girl lying on some grass reading. Courbet was the greatest exponent of late ninteenth century Realism.

123. Eugène **Delacroix**, the champion of Romanticism, painted *The Arab Tax* in 1863, the year he died. He opposed the classical vision of Ingres and the unclouded realism of Courbet by extolling the power of the human imagination. This particular painting brings to a close both Delacroix's career and the age in which he lived. It is striking not only for its exuberance, but also for its proto-Impressionist use of color to break down forms, and its rediscovery of the Orient as a world of sensual vitality.

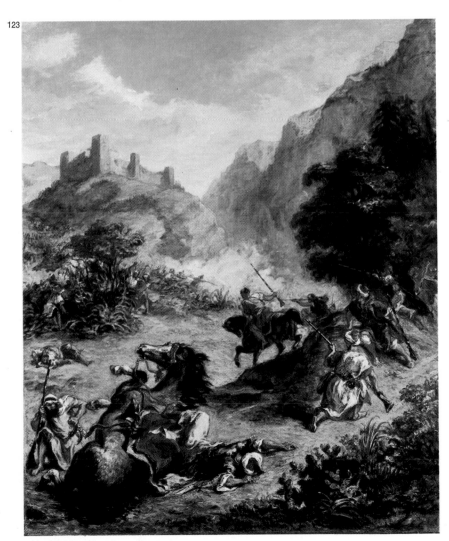

DELACROIX The Arab Tax

DAUMIER Advice to a Young Artist

124. *Advice to a Young Artist* is one of Honoré **Daumier**'s few paintings, for he was primarily a caricaturist. In his paintings, social commitment becomes a bitter poetry of life, conveyed in a rapid, pre-Impressionist manner, which is nevertheless Romantic in its color range and use of chiaroscuro. Daumier's closest friend was Corot, who bought him a cottage at Valmondois, where he retired for the closing years of his life. At this cottage he concentrated on his painting, although he was poverty stricken and threatened with blindness. He probably painted this picture there after 1860, and he gave it to Corot as a sign of his gratitude.

THE IMPRESSIONISTS

When Daumier died in 1879, Impressionism had already come into being. In fact there was a foretaste of it Manet's *Le Déjeuner sur l'Herbe*, a painting exhibited in 1863 at the Salon des Refusés. The Impressionist movement made its public début at an exhibition held in 1874 in rooms belonging to the photographer Nadar. Monet, Degas, Renoir, Pissarro and others who had been rejected by the most recent Salon exhibitions were represented there, as was Cézanne, now at the beginning of his career. Manet, however, was not involved in this exhibition, since he managed to show paintings at the Salon. It was Monet's painting entitled *Impression: soleil levant* which caused a journalist to decry these artists as "Impressionists." They rejected the realist technique of modeling in terms of light and shade, proposing instead to convey what the eye sees by mingling together the pure colors (now identified scientifically) which go to make up sunlight. They applied these colors freely, in such a way as to reconstitute on canvas the effect of strong sunshine in nature. They avoided the use of black and dark shadows, for they had discovered that even shadows have color. The shadow of each object, they found, has a color complementary to that of the object itself. Thus yellow objects have violet shadows, orange objects have blue shadows and red ones have green shadows. This technical revolution was accompanied by a choice of subject matter from contemporary life. The Impressionists, in other words, not only contemplated nature (hence the cult of "plein air" painting) but also the life around them, which they succeeded in catching in its fleeting moments.

125 – 127. Édouard **Manet** painted *Gare Saint-Lazare* in 1873, a year before the first Impressionist exhibition. It is a masterly example of Impressionism. The scene is framed as in a snapshot, the subject is taken from contemporary life, the handling of color takes into account recent research into the relationship between complementary colors and the presence of color in shadow, and at the same time Manet displays that independence of vision which he always showed in his relations with orthodox Impressionism. He painted this view in the garden of his friend Alphonse Hirsch in Paris, at the corner of the Rue de Rome and the Rue de Constantinople. The little girl seen from behind is Hirsch's daughter, and the lady is Victorine Meurent, Manet's favorite model. *The Dead Toreador* is a fragment of a picture of a bullfight which was exhibited at the Salon in 1864 and severely criticized. It belongs to Manet's pre-Impressionist period, when he painted famous works like *Le Déjeuner sur l'Herbe* and *Olympia*, in which he conveys a synthesis of the real world by means of free brush strokes used to model forms directly – something he had learned by studying the work of that great precursor of modern art, Velázquez. The fact that the subject is Spanish is related to the new fashion for things Spanish which flourished in Paris as a result of the arrival of Napoleon III's wife, Eugenia de Montijo. Manet's portrait of *Madame Michel-Lévy* depicts the wife of the publisher and collector Lévy. It was painted in 1882 and reveals an Impressionist approach to the subject in the vibrant brushwork and the handling of light.

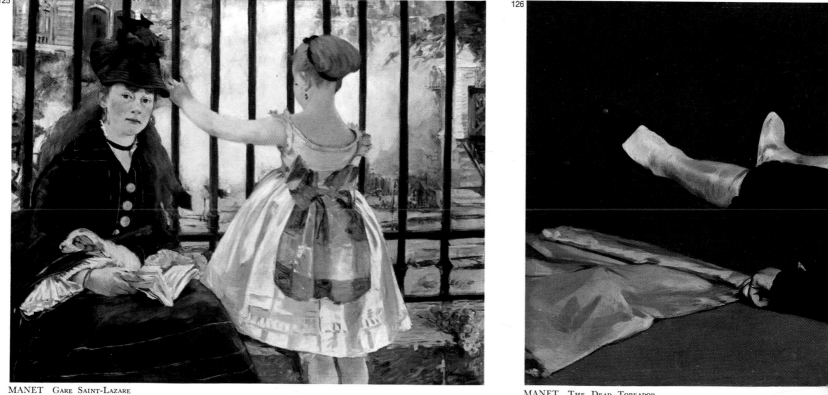

MANET Gare Saint-Lazare

MANET The Dead Toreador

MONET Palazzo da Mula, Venice

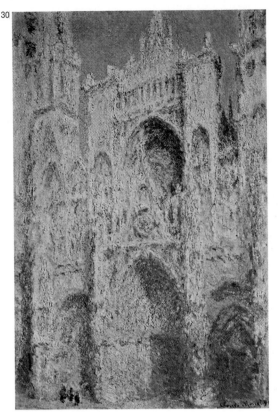

MONET Rouen Cathedral, West Façade, Sunlight

128 – 130. The most representative of the Impressionist painters is Claude **Monet**. He discovered Venice in 1908 when he was already sixty-eight, and it was here that he was inspired to paint his imaginative vision of *Palazzo da Mula, Venice*, which seems to constitute a poetic manifesto of Impressionism. *Rouen Cathedral, West Façade, Sunlight* is one of a series of studies of Rouen's cathedral at different times of day. The midday sunshine has here caused the stonework to lose its solidity, and the intricate Gothic decorative work has molted into a shimmer of light. By contrast, the picture of *Boulevard des Italiens, Morning, Sunlight* which Camille **Pissarro** painted in 1897 displays a more meditative and constructive kind of Impressionism.

PISSARRO Boulevard des Italiens, Morning, Sunlight

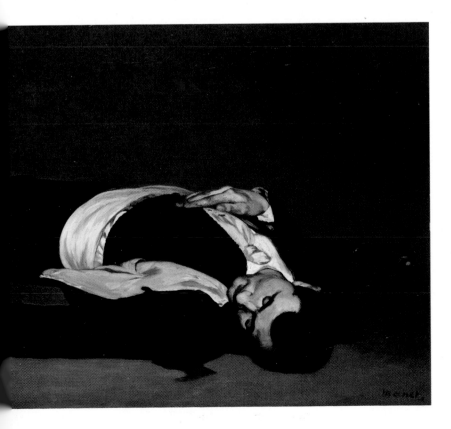

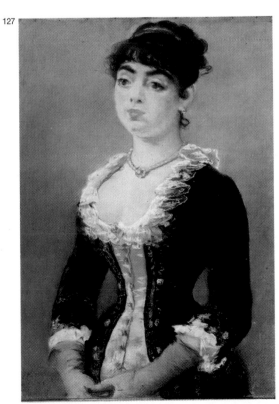

MANET Madame Michel-Lévy

DEGAS Achille De Gas in the Uniform of a Cadet

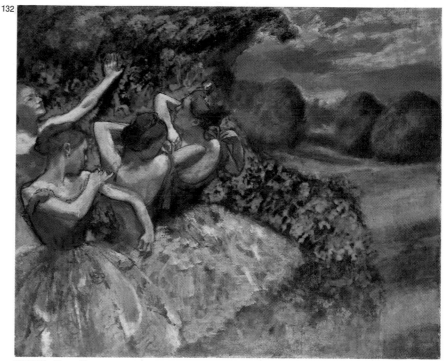

DEGAS Four Dancers

131 – 132. Like Manet and Renoir, Edgar **Degas** was not a strictly orthodox Impressionist. He painted this portrait of his younger brother *Achille De Gas in the Uniform of a Cadet* when he was about twenty-three. It recalls the great Realist school of painting, but has at the same time a sense of elevated melancholy which shows that Degas had studied the work of Renaissance artists and of Ingres. *Four Dancers*, on the other hand, depicts the theatrical world which fascinated Degas from the age of forty until his death, because it afforded him endless opportunities to study the poetry of movement. It is one of his last paintings in oils, and can be dated about 1899. Failing eyesight in fact caused him to adopt pastel as his medium in his later years, since it was more manageable than oils. His concern to catch a fleeting movement as though in a photographic snapshot (he was also an accomplished photographer) in such a way as to suggest that the scene goes beyond the confines of the picture, is typically Impressionist. But his technique of modeling and his incisive pictorial language has a harsh kind of stylization which, together with his creation of a magical sense of space, places his art outside Impressionism. Nevertheless, he shared the Impressionists' interest in investigating color-light relationships, and in this picture he showed four dancers standing in

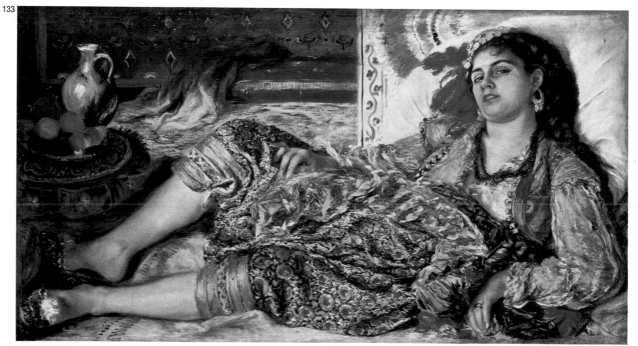

RENOIR Odalisque

the wings of a naturalistic stage set, with the yellows, blues and reds of the stage lights reflected on their flesh and hair.

133 – 134. **Renoir** was an Impressionist painter whose work displays joyousness and a spontaneous sensuality which is as innocent as a child's greed. Life for him was a delightful succession of children, women and flowers. His color range is richer than that of orthodox Impressionists like Monet, for he was not satisfied simply by the investigation of the qualities of light and complementary colors. He was also fascinated by the richly colored paintings of the great Venetian artists like Titian, as well as by the work of Delacroix and Rubens. His *Odalisque* bears the date 1870 and pays homage to the art of Delacroix and his magnificently flowing brushwork. At the same time the reclining figure conveys a sense of reality which was to recur in Renoir's work after his visit to Italy and after his Impressionist period was over, when he revived the plastic values and the classical interpretation of forms which Impressionism had abandoned. *A Girl with a Watering Can* is dated 1876 and is a masterly example of the work Renoir produced during his Impressionist period, from 1872 until about 1883.

135 – 136. Of all the Impressionist painters, Henri de **Toulouse-Lautrec** was the one who proved most sensitive to the charm of Japanese decorative prints. They were then very fashionable, and provided a source of inspiration for Impressionism on account of their succinct representation of the real world. His synthesis of reality is harsh and his style dry and sardonic. He mixed his own special paints from diluted oils, watercolors and pastels, and concentrated his pitiless gaze on the world of night clubs, circuses and dance halls where he spent the unhappy life thrust upon him by nature, which gave a dwarf's body to a man of ancient and aristocratic family. (He was in fact a descendant of the Counts of Toulouse.) *A Corner of the Moulin de la Galette* depicts one of the most famous theatres of Montmartre, which used one of the old windmills of the "butte" as its sign. The figures in this scene are genuine portraits of the theatre's habitués, and the artist has painted their flesh in the crude, flat fashion that one would expect to find in a print or a poster. This is the genre for which Toulouse-Lautrec is most famous and in which he extolled the fleeting glories of the idols of the boulevards. *Quadrille at the Moulin Rouge*, like the preceding picture, was painted in 1892. It catches the moment when the "naturalist quadrille" – a reincarnation of the frenzied can-can – is about to begin on the most famous dance floor in Montmartre. A dancer called Gabrielle is about to perform the first figure, while the elegant spectators have retired from the dance floor, as was the custom. The lady on the left has been identified as Lucie Bellanger, while the man beside her, seen from behind, is a dancer called Valentin-le-Désossé.

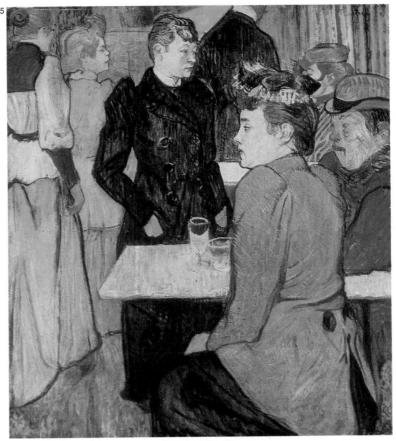

TOULOUSE-LAUTREC A CORNER OF THE MOULIN DE LA GALETTE

63

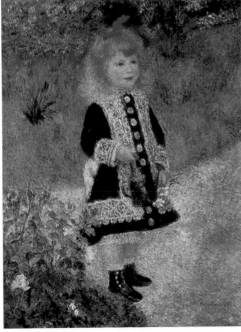

RENOIR A GIRL WITH A WATERING CAN

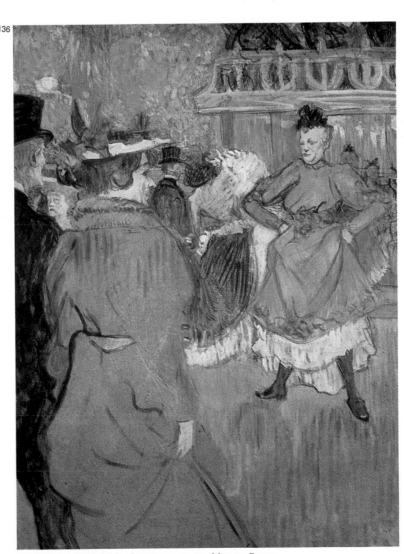

TOULOUSE-LAUTREC QUADRILLE AT THE MOULIN ROUGE

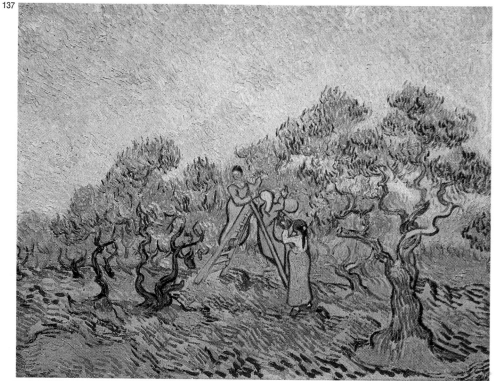

VAN GOGH THE OLIVE ORCHARD

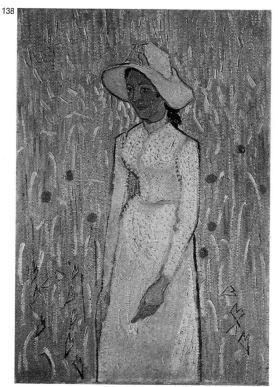

VAN GOGH GIRL IN WHITE

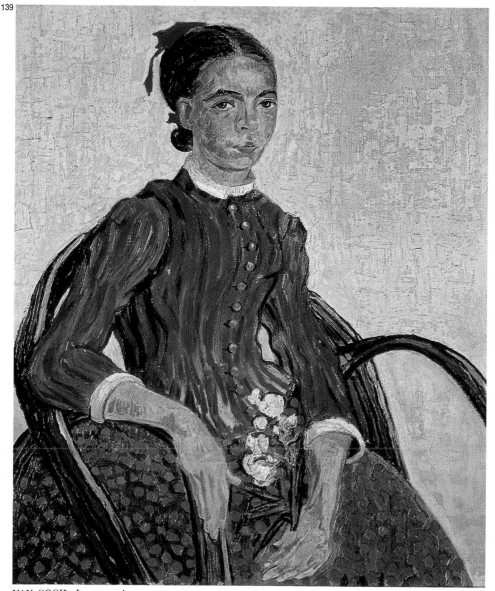

VAN GOGH LA MOUSMÉ

137 – 139. Together with Cézanne and Gauguin, Vincent **van Gogh** was a leader of the reaction against Impressionism, and the revolution he helped bring about was valuable in that it taught artists to draw in paint and to use bright, melodic colors. These new artists, however, also felt the need to restore to objects their intrinsic value and not to limit themselves to what the eye sees. Van Gogh began his artistic career as a selftaught painter and draftsman in his native Holland, and moved to Paris in 1886 at the age of thirty-three. His paintings use vibrant brushstrokes and have a forceful graphic framework combined with a masterly grasp of essential forms in simplified masses and basic color contrasts which derive from his study of Japanese prints. *The Olive Orchard* was painted in 1889, the year when he was in an asylum at Saint-Rémy in Provence, and *Girl in White* was painted in June 1890, a month before he committeed suicide at Auver-sur-Oise. In his struggle against the mental disease which was to destroy him, periods of madness alternated with others of sanity, during which he could continue his search for a new kind of art. As he did so, he used more and more delicate and poetic tones, and at the same time he invigorated his pictorial language by the use of swift, crowded brushstrokes which were extremely decorative as well as profoundly expressionist. The *Girl in White*, with its cornfield background, is an extremely subtle painting, and gives the impression of a vision which is about to condense into solid form. His style here has affinities with Symbolism and the flowing rhythms of Art Nouveau, and already looks forward to the Fauves and Expressionism. *La mousmé* is an earlier work, painted in 1888, when van Gogh was living at Arles in Provence. It is not a young Japanese girl who is depicted here, but a local girl of twelve or fourteen (as van Gogh himself wrote in a letter), and the painting reflects the artist's attempt to achieve forcefully modeled but simplified forms, using highly expressive brushstrokes.

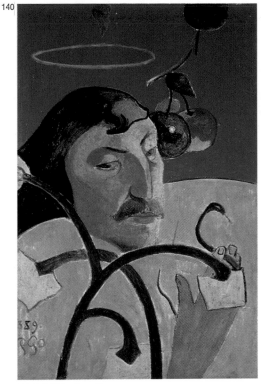

GAUGUIN SELF-PORTRAIT

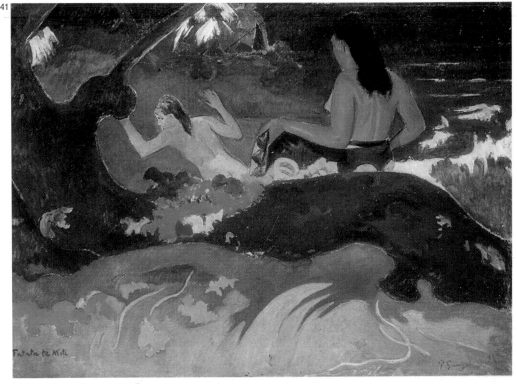

GAUGUIN "FATATA TE MITI"

140 – 141. Paul **Gauguin** contributed much to the style of painting known as symbolism, which involved giving symbolic value to an image conveyed in a language that was decorative and expressive at the same time. This *Self-Portrait* was painted in 1889 – the year when he worked alongside van Gogh at Arles. It shows him at the culmination of his "synthetist" period. The reality he conceives is expressed in a style known as Cloisonnism, which involved laying on the paint in large areas of glossy color within heavily drawn outlines. Gauguin had derived this from the brilliant immediacy of effect found in the cloisonné ware of the past, where areas of enamel were enclosed in thin metal bands. "*Fatata te miti*" reveals a development of his style towards more plastic, monumental forms. He painted it in 1892, a few months after his arrival at Tahiti in the Southern Pacific, where he had withdrawn from civilization in order to seek out the primordial sources of life and art. The woman who is taking off her sarong is thought to be Tehura, a beautiful Polynesian girl who became Gauguin's *wahine*. The yellows, violets, reds, greens, oranges and brilliant blues of Tahiti are arranged to create a broad decorative symphony of color, which symbolizes the basic life force of nature and man.

142. Edouard **Vuillard** painted *The Visit* in 1931, at a very late stage in his career. He was one of the most outstanding members of the *Nabis* group of symbolists (the word derives from a Hebrew term meaning "prophet"), whose aim was to "give ideas a tangible form" – in other words, to convey the ideal essence of reality. To achieve this, Vuillard made continual use of delicate color tones and effects of light which he had learned from the Impressionists. This particular painting is a typical example of his liking for tranquil indoor scenes of middle-class life, conveyed in a rich and intimate manner.

VUILLARD THE VISIT

143

CÉZANNE THE ARTIST'S FATHER

143 – 145. The reaction against Impressionism was deeply influenced by the work of the great artist Paul **Cézanne,** who lived in isolation in Provence. As a young man in Paris he had belonged to the Impressionist group, with the result that his reassessment of artistic values came gradually from within himself, and hence proved much more fruitful than that of van Gogh and Gauguin, for his geometrical organization of the world led to Cubism. *The Artist's Father* is one of his earliest works. It was probably painted in 1866 – the year when the novelist Zola (whom Cézanne had taken to see the Salon des Refusés three years earlier) published a violent attack on the accademicians of the official Salon in the magazine *Événement.* In fact the artist's father, Louis-Auguste Cézanne, is shown reading *Événement* with the title well in evidence. Even though Cézanne painted this portrait when he was only twenty-four, it is clear that he was already trying to establish his own personal manner, which here takes the form of a forcefully arranged composition in a style related to that of Manet in his pre-Impressionist period. The *House of Père Lacroix* was painted in 1873. It depicts an old peasant's cottage at Auvers-sur-Oise near Paris, where Cézanne lived for two years, and belongs to his Impressionist period. Nevertheless, one can already discern a tendency to apply paint in adjacent areas at different angles and in different planes, and an attempt to find a strictly architectural form in a universe defined in terms of volumes and planes. Both these qualities are characteristic of his work after 1878, when he had abandoned Impressionism. A magnificent example of this later style is *The Artist's Son, Paul,* which he painted in 1885, when his son was thirteen. This was the central period of his attempt to work out his new art form. He sought in his subject matter (whether a human figure, some aspect of nature, or open space) an underlying idea of geometrical order, which he conveyed by means of static, monumental images arranged in blocks of color. This was what he meant when he said he "wanted to do Poussin again, from Nature". In other words, he wanted to find an immutable rational standard in nature, to reestablish the classical qualities of the world.

145

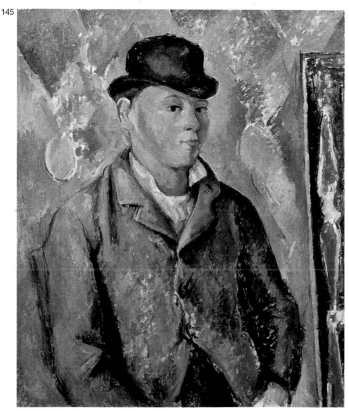

CÉZANNE THE ARTIST'S SON, PAUL

144

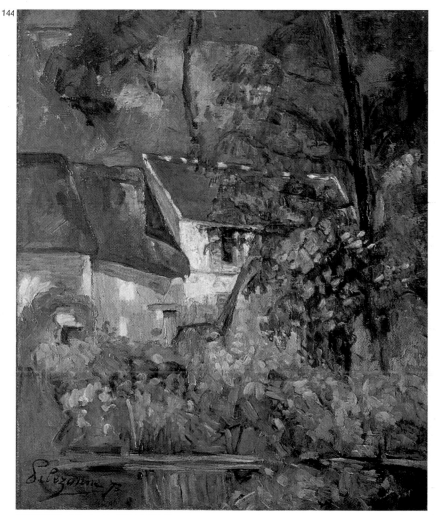

CÉZANNE HOUSE OF PÈRE LACROIX

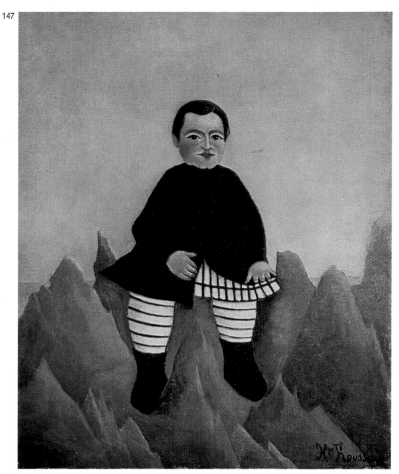

H. ROUSSEAU BOY ON THE ROCKS

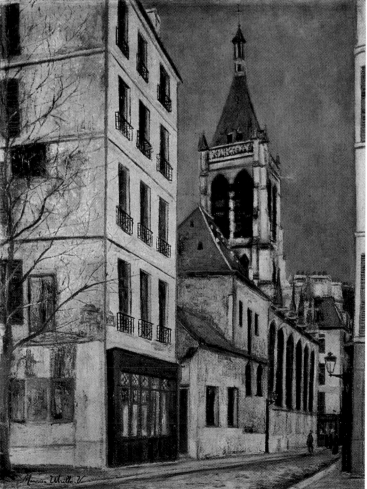

UTRILLO THE CHURCH OF SAINT-SÉVERIN

146. It was Maurice **Utrillo**'s mother, Suzanne Valadon, herself a painter and a model for the Impressionists, who made her son take up painting at the age of eighteen, hoping that this would distract him from his early alcoholism. It is well known that he often worked from picture postcards when he painted views, but the roots of his art, unlike that of Rousseau, are to be found in the logic of design, structure and color, with the result that he was able to convey a melancholy, lyrical quality which sought to define the basic essence of Paris in terms of its drab surburban streets. *The Church of Saint-Séverin* is set in the dreary district of the same name on the left bank of the Seine. It belongs to his "white period," when he used a mixture of white lead and powdered gesso to obtain poetic effects from drabness.

147. Henri **Rousseau** is the most famous of the "Sunday painters." He was a minor customs official who nevertheless exhibited regularly at the Salon des Indépendants and enjoyed the friendship of men like Picasso and the poet Apollinaire. He painted *Boy on the Rocks* about 1895-7, when he was just over fifty. The figure of the child has the reality of a portrait and seems strikingly ill-at-ease in the fantasy setting of sharp rocks, which suggest a child's nightmare vision of the seaside rather than the seaside as we know it. He stresses whatever strikes his imagination, whether it be the podgy and ungainly figure of a growing boy, or seaside rocks. But his logical view of the world has a stark forcefulness which was to prove attractive to his Cubist and Fauvist friends, as well as a magical charm which influenced the Surrealists.

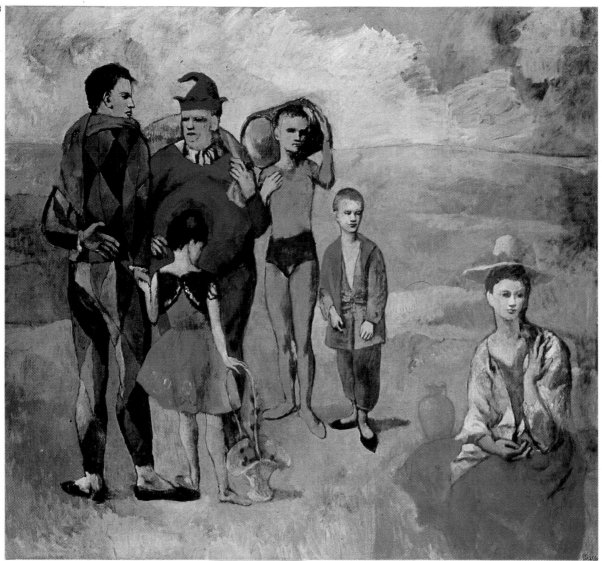

PICASSO FAMILY OF SALTIMBANQUES

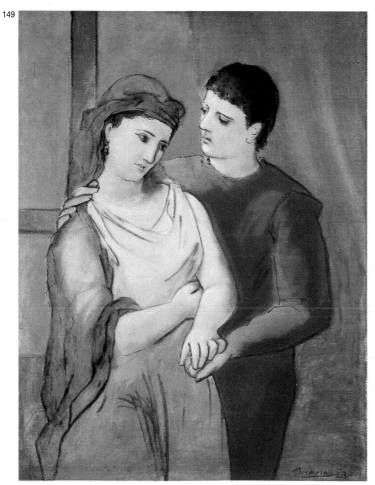

PICASSO THE LOVERS

THE FAUVES AND CUBISTS

The Fauves and Cubists were essentially twentieth century artists. The Fauves caused a furor at the Salon d'Automne in 1905, when a critic described the room containing paintings by Matisse, Rouault, Vlaminck, Derain and Marquet as a "cage aux fauves" ("cage of wild beasts"). Under the leadership of Matisse, they tried to convey the essence of reality by means of violent color, and hence they revived Impressionist investigations into the nature of pure colors, as well as van Gogh's expressionist fire and the compelling and magical quality of Gauguin's decorative style. The Cubists took their name from a phrase used by Matisse in referring to some landscapes exhibited by Braque in 1910, which included houses painted as cubes. The chief exponents of Cubism were Picasso and Braque. Their point of departure was Cézanne's attempt to synthesize reality in plastic terms and the rudimentary arrangement of frontal planes in negro sculpture which had recently attracted their attention. Thus they dismantled reality and reassembled it in its archetypal geometric forms. The color tones they used were as subdued as those of the Fauves were gay and bright; and their view of the world was as static and intellectual as that of the Fauves was full of movement and instinctive vitality. Their aim was to reconstruct the world, and so they sometimes even attached a variety of materials to their paintings in the form of collages in an attempt to reproduce the individual tone of the objects they were depicting.

148 – 150. These three paintings are examples of three important stages in the development of the art of Pablo **Picasso**. He painted *Family of Saltimbanques* in 1905. This work is a pre-Cubist masterpiece of his "rose period." Picasso was particularly attracted by the world of the circus at that time, and he has expressed its essence here in delicate shapes which harmonize outline and volume, and with a color range dominated by pinks and other warm tones. *The Lovers* was painted in 1923 and belongs to Picasso's "neoclassical" period. He had visited Rome, Naples and Pompeii in 1917, and had been deeply affected by the traditional

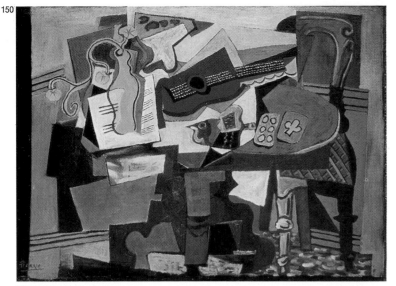

PICASSO STILL LIFE

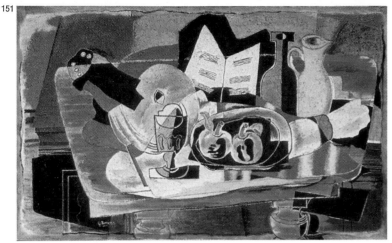

BRAQUE STILL LIFE: THE TABLE

values which he found there; he had taken a fresh look at the work of Ingres. Hence in this painting he conveys a strong sense of solidity, with a particular delicacy of line which is influenced by the magnificent precision of the figures drawn on Greek vases. His *Still Life* of 1918 shows the Cubist attempt to reconstruct objects in geometrical form. Cubism is now at a late stage of development, however, with the result that there is now not only more color and movement than before, but in addition the flat arrangement of objects has been abandoned. They are no longer removed from three-dimensional space and set in an abstract two-dimensional world where all their basic structures can be seen simultaneously.

151. Georges **Braque** was another great Cubist painter whose genius was yet quite different from the exuberant and many-sided genius of Picasso, and he remained faithful to the principles of Cubism throughout his life. He painted *Still Life: The Table* in 1928. He uses carefully controlled color relationships here, and dismantles and reassembles the various parts of objects in a refined manner. He is always in complete control of his art, and thus exemplifies very well the Cubist principle that art is "a discipline which controls emotion." Nevertheless, in mature works like this one, as in later paintings, his emotion leads to the creation of rich, serene forms which seem gradually to wean Cubism away from its austere concentration on fundamentals.

152 – 153. Henri **Matisse** painted this *Odalisque with Raised Arms* in 1923. In other words, almost twenty years separate it from the exhibition in the Salon d'Automne where he had made his powerful profession of faith as a Fauvist. There are still Fauvist characteristics to be found here, however, in the artist's complete confidence in the possibility of defining form purely by means of color, in his love of visually attractive arabesques and curving lines (which relate his work to the Art Nouveau rhythms of the same early years of the century), and in that feeling of primitive joy before the spectacle of life which he never lost. The gay images, and vibrant, calligraphic use of color in the work of Raoul **Dufy** also derive from Fauvism. Dufy did not exhibit any paintings in the 1905 "cage aux fauves," but he did do so the following year, contributing a taste for the witty use of linear flourishes. Later on he abandoned the Fauves' violent dissonances, with the result that in a painting like this *Reclining Nude* of 1930, one can appreciate to the full his own personal style.

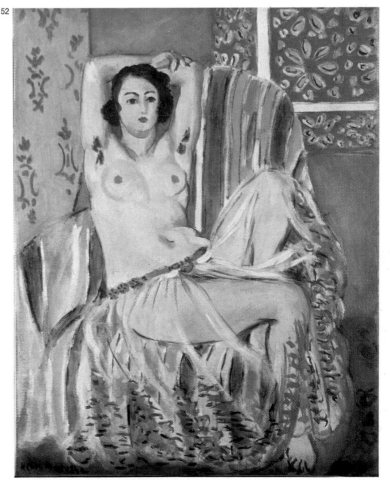

MATISSE ODALISQUE WITH RAISED ARMS

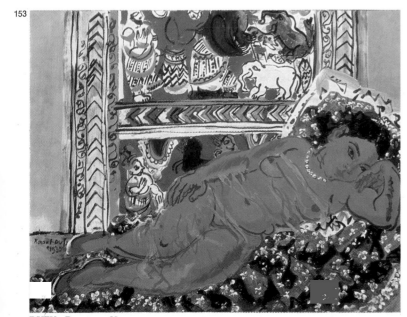

DUFY RECLINING NUDE

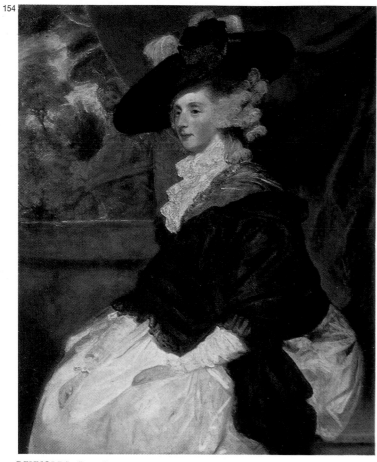

154

70

REYNOLDS Lady Cornewall

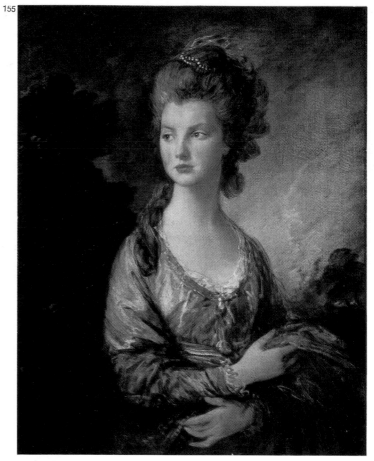

155

GAINSBOROUGH The Honorable Mrs. Graham

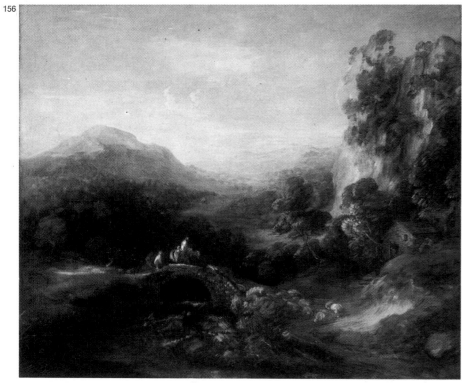

156

GAINSBOROUGH Landscape with a Bridge

ENGLISH ARTISTS

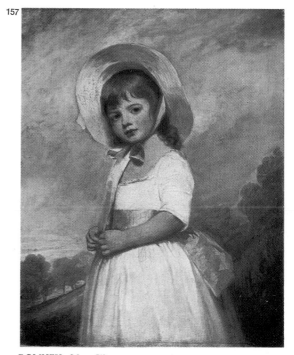

157

ROMNEY Miss Willoughby

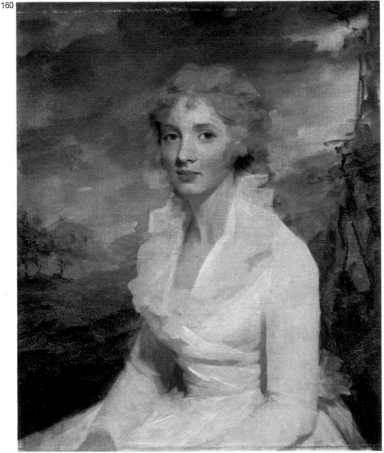

RAEBURN Miss Eleanor Urquhart

and who championed classical ideals in all his writings, was in reality a precursor of Romantic portraiture.

155 – 156. This portrait of *The Honorable Mrs. Graham* is a mature work by Thomas **Gainsborough.** He probably painted it in 1755, a year after he moved from his native Suffolk to London, where he became one of the most highly regarded portrait painters of Georgian times. In addition he was one of the founders of the English school of landscape painting. *Landscape with a Bridge* was painted about 1785. Typical of his work is its nervous energy and a certain feeling of unreality which comes from his practice of reassembling landscapes within the confines of his studio by using all kinds of odds and ends to set up a primitive landscape of trees, soil and rocks, as a stimulus to his memory and imagination.

157. George **Romney** developed his style during a long visit to Italy and by studying the work of Reynolds and Gainsborough. He became a skillful painter of children, as one can see in this picture of *Miss Willoughby* (1781-3). At the time when he painted this portrait, his ability to concentrate solely on problems of composition and color was at its height.

158. John **Hoppner** was George III's favorite artist and specialized in history paintings. Thus his portrait of *The Hoppner Children* shows the sitters in an English style park and treats them as though they were historical characters set down in paint for the benefit of posterity. He also shows great skill, however, in conveying the charm of children, and this family group has an unusual dignity as well as a natural air.

159. *Colonel Pocklington with His Sisters* (1769) bears witness to George **Stubbs'** skill in depicting animals. Stubbs was a selftaught artist, but also a considerable scholar and the author of works on animal anatomy, his particular interest being horses, which played such an important part in the life of the English country gentleman. His paintings of horses are so lifelike that art galleries often describe them as "portraits." He was less successful at painting the human figure, with the result that the affected and faintly ridiculous inhabitants of his pictures were described as "stable boys" by contemporary wits.

160. Sir Henry **Raeburn** was the most modern of the British portraitists. He did not paint in accordance with conventional ideas of what an aristocratic portrait ought to look like, but drew his inspiration straight from nature. Nevertheless, he evidently did not impose long and tiring sittings on his subjects, for his free and direct handling of paint shows that he must have worked rapidly. His masterly portrait of *Miss Eleanor Urquhart* has compositional force which looks forward to modern art, but there is also a suggestion of the mystery and agitation of Romanticism which is typical of British portraiture in the closing years of the eighteenth century. This portrait is one of the finest examples of the series of portraits of Scottish gentry which he painted after his final return to Scotland from a long visit to Italy.

154. Sir Joshua **Reynolds** was responsible for founding the eighteenth century English school of portraiture, which brought to fruition van Dyck's work in England and sought fresh inspiration in Italian art and especially in the work of Venetian painters. Reynolds derived from Titian, Tintoretto and Veronese a subtle magic in the use of color which enabled him to convey a broad and elevated kind of realism in paintings like this portrait of *Lady Cornewall*, in which the sitter is shown on the terrace of her stately home. It dates from about 1785 and therefore belongs to that group of portraits painted when Reynolds was over sixty, in which one notices in particular a striking freedom of approach. Thus the man who dominated the eighteenth century in England both as a practicing painter and as a writer on art theory,

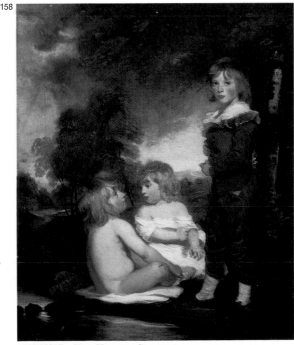

HOPPNER The Hoppner Children

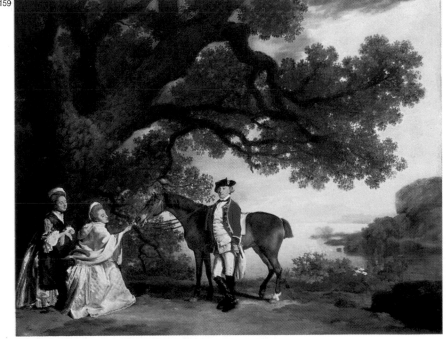

STUBBS Colonel Pocklington with His Sisters

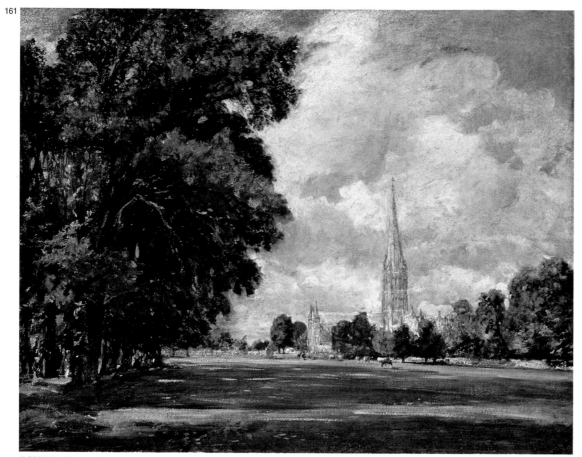

CONSTABLE A View of Salisbury Cathedral

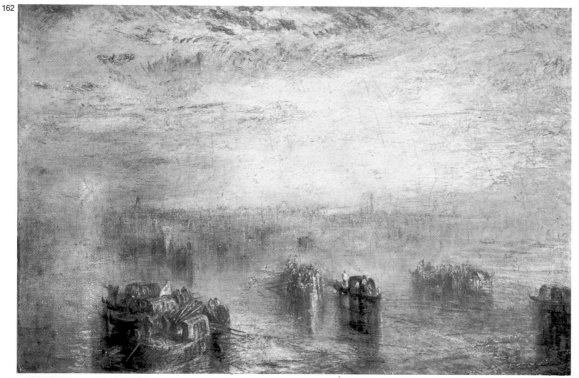

TURNER Approach to Venice

161 – 162. Constable and Turner took British art out of the eighteenth century and made it truly modern in conception. Turner was born in 1775 and Constable only a year later, and their magnificent landscapes dominated British art in the first half of the nineteenth century. *A View of Salisbury Cathedral* (c 1825) shows John **Constable** as the founder of realistic landscape painting, for his fresh observation and sense of the imposing presence of nature take him beyond the Romantic view of the world. But Constable included in his paintings far more than normal vision would allow. His original, almost extravagant compositions allowed him to depict a breadth of landscape beyond the scope of the human eye, and the grandiose effects he thereby obtained went beyond what was realistic. Joseph Mallord William **Turner** was a "painter of sunshine" whom the Impressionists saw as their spiritual father, and indeed his studies of the effect of light at different times of day preceded Monet's work by fifty years. The way landscape dissolves into the luminosity of the atmosphere makes his *Approach to Venice* a prodigious accomplishment. When he was about fifty and at his full maturity as an artist, he concentrated his attention entirely on an attempt to render atmospheric effects, and the highly visionary landscapes of his final years reveal a continuation of this investigation, as is clear in this particular work, painted about 1843. He has obtained effects suggestive of watercolor by superimposing a number of thin layers of paint over a white ground. The last time Turner had been to Venice was in 1840, and so this landscape was worked out in his studio from rapid sketches made on the spot, thus enabling him to create an unreal, dreamlike Venice.

AMERICAN ARTISTS

American painting from the eighteenth century to the present day offers an extraordinary variety of forms, because America was sensitive to influences from Europe and at the same time developed its own art. Close contacts with British art (West and Copley, two major American artists, worked mostly in England) had their chief effect in portrait painting – for example, in the work of an important artist like Stuart. It was the Impressionists, however, who proved most influential in the late nineteenth century, and American awareness of the new artistic problems then being tackled produced two artists of European stature in Whistler and Mary Cassatt, as well as two purely American realists in Homer and Eakins. But the upheavals in Paris, Dresden and Munich which changed the face of European art were most influential in America in the early twentieth century, when they produced original artists like Bellows and Du Bois. In addition to the orthodox history of American art, however, one has also to consider the unique contribution of "primitive" American painting, of which there are almost two hundred examples in the National Gallery, ranging in time from the eighteenth to the mid-nineteenth century. For the most part the artists concerned were genuine self-taught professionals, who supplied paintings to the provincial middle classes and to modest rural patrons.

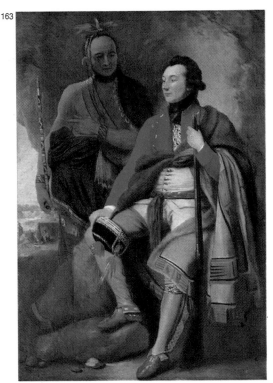

WEST COLONEL GUY JOHNSON

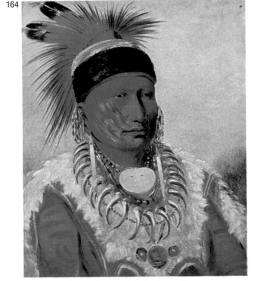

CATLIN THE WHITE CLOUD, HEAD CHIEF OF THE IOWAS

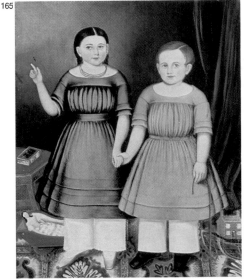

STOCK MARY AND FRANCIS WILCOX

163 – 164. Benjamin **West** was a favorite painter of George III and succeeded Reynolds as second President of the Royal Academy. He was a late eighteenth century history painter, as we see in his *Colonel Guy Johnson*, which depicts the English Superintendent of Indian Affairs in the American Colonies, with an Indian chief beside him holding a pipe of peace. The picture has certain neoclassical refinement, which West gained from a visit to Italy, together with a primitive ability to simplify – qualities which differentiate West from the artists of the British School. In the mid-nineteenth century the world of the Indians had a blunt and very realistic commentator in George **Catlin**, who journeyed from camp to camp among the northern and southern Indian tribes after 1830, observing and sketching. By 1870 his "Indian Gallery" was ready for the exhibition held in Brussels in that year. *The White Cloud, Head Chief of the Iowas* depicts the leader of one of the great northern tribes of Indians, and is characterized by free brushwork and a precise kind of realism.

165 – 166. "Primitive" painting provides an imaginative equivalent of the real world, and emphasizes what strikes the artist most, irrespective of orthodox rules about composition, color and perspective. As in the case of the language of children, its description of reality does not proceed in a logical sequence. It provides instead a vivid representation of the salient features of the world and at the same time crowds the canvas with material in an attempt to avoid forgetting something. Joseph Whiting **Stock**'s portrait of *Mary and Francis Wilcox* shows brother and sister with objects which indicate their pastimes, and was painted in 1845. *Leaving the Manor House* is the work of an unknown artist of the **American School**, and was painted about 1860 – a date confirmed by the costumes. That the family was a wealthy one is shown by the setting: a grandiose neoclassical home, a well-kept garden, dogs and horses, and guests in a sailing boat. The artist displays a particular delicacy of line.

AMERICAN SCHOOL LEAVING THE MANOR HOUSE

167. *The Copley Family* is one of John Singleton **Copley**'s finest works. He, West and Stuart were in fact the three greatest American artists of the eighteenth century. He moved from Boston to London in 1775, studied with West, who was the same age as he, and became a member of the Royal Academy. This group portrait was painted the year after he arrived in London, and displays a freedom of style and an elevated manner derived from Reynolds and West. It depicts his wife, their four children and his father-in-law Richard Clarke (a Tory merchant who returned to England with his family after the setback of the Boston Tea Party), while the artist himself appears behind the others.

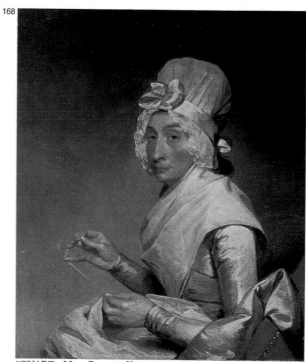

STUART Mrs. Richard Yates

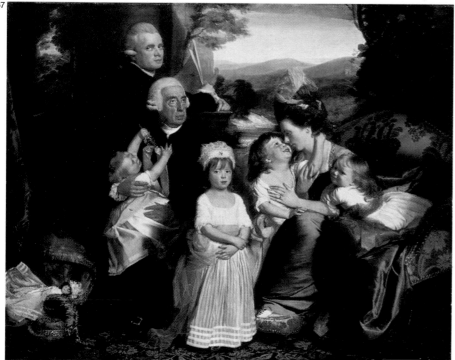

COPLEY The Copley Family

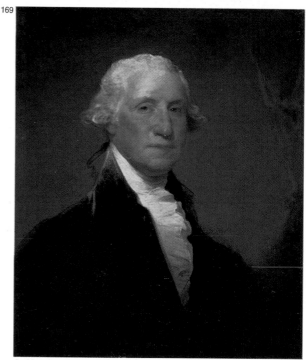

STUART George Washington 492

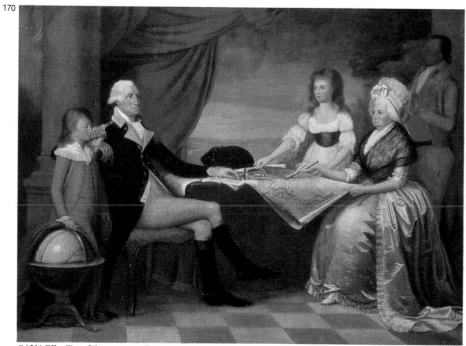

SAVAGE The Washington Family

170. Edward **Savage**'s *The Washington Family* is more in the tradition of the official portrait, the figures being arranged in a splendid setting with the Potomac River in the background. George Park Curtis, Washington's adopted nephew, stands next to his uncle, whose left hand is resting on a map showing Washington, the new American capital on the Potomac. The painting was based on sketches made from life in New York in 1789 and was completed in Philadelphia in 1796.

168 – 169. The work of Gilbert **Stuart** justifies the description of American art as international. This "portraitist of the young Republic" came to London in 1775 at the age of twenty, and trained in West's studio. In order to throw off the conventions of the English aristocratic portrait, he returned to America in 1793 and practiced in New York, Philadelphia and Boston. Those of his patrons who were not tied to tradition gave him the opportunity of painting pictures which displayed a subtle understanding of humanity and a very free technique. His uncompromising portrait of *Mrs. Richard Yates*, the wife of a New York merchant, was painted the year he returned to America. In it he anticipated the Impressionists by applying his discovery that flesh colors were "not mingled but shone out against one another, like blood through the human skin." Mrs. Yates was an elderly citizen of young America with a squint. Stuart disguised the squint, but conveyed her business-like and stubborn personality quite openly. The portrait of *George Washington* which he painted a few later (1795-6) is one of the replicas (known as the "Vaughan-Sinclair portrait") of his first portrait of Washington, painted in 1795. Though his sitter was the man who created the American democratic spirit, Stuart painted him with vivid realism, avoiding any kind of exaltation.

EAKINS THE BIGLEN BROTHERS RACING

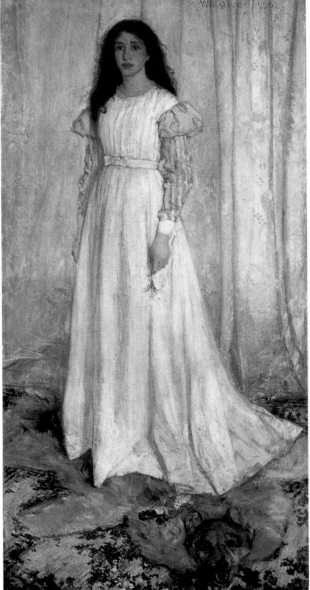

WHISTLER THE WHITE GIRL

CHASE A FRIENDLY CALL

171 – 173. These three works are excellent examples of the way American art grew to maturity and became really modern in the second half of the nineteenth century. James Abbott McNeill **Whistler** painted *The White Girl* in Paris in 1862 and exhibited it at the Salon des Refusés in 1863. In it he realized his ambition to create a supreme stylistic harmony involving elements not only of the realism of Courbet, his prime source of inspiration, but also of the basic tonal effects in Japanese prints and of the investigations of his friends Degas and Manet. The girl depicted is Whistler's mistress Joanna Heffernan, and in painting her he has produced one of the first of those variations on a theme of whites and half tones in pale blue and grey of which he was to become a master. *The Biglen Brothers Racing* is in the quite different idiom of indigenous American realism, which here has all the vitality of nature itself. It was painted by Thomas **Eakins**, and can probably be dated 1873, the year he returned to America from Paris. He had been taught the principles of realist drawing and perspective by Gérôme, but worked towards a vigorous immediacy of vision in which he was assisted by his keen interest in photography. *A Friendly Call* was painted by William Merritt **Chase** in 1895, and exemplifies an extreme development from Impressionism involving the use of an intimate, rapid and decorative style, whose greatest exponents in France were Bonnard and Vuillard.

DU BOIS "CAFÉ DU DÔME"

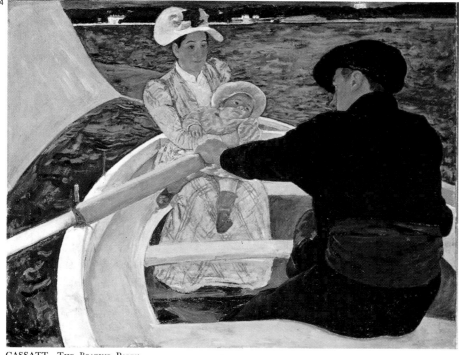

CASSATT The Boating Party

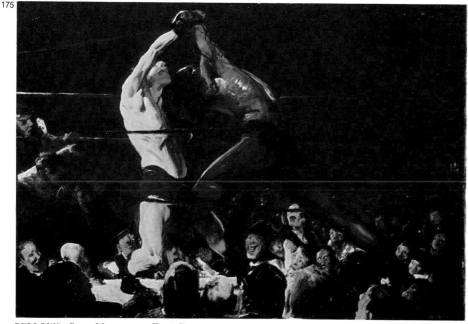

BELLOWS Both Members of This Club

174. *The Boating Party* is one of Mary **Cassatt**'s most famous paintings. She moved to Europe from America at the age of twenty-two, visited all the art galleries and made a particular study of the handling of color by Rubens, Velázquez and Correggio. Then she settled in Paris, became a friend of the Impressionists, and worked out her own personal style in contact with them. Her paintings are highly original in their firm composition, confident drawing and almost crudely forceful color relationships, which she got from Impressionist investigations into primary colors. This particular picture was painted at Antibes in 1893-4 when Mary Cassatt's artistic ability had reached its height. The "American" component of her art is discernible in the instinctive vigor which tempers her refinement. It was not many years now until 1914, when she was forced by blindness to give up painting and retire from the world. She shared this affliction with Degas, the artist whom she most admired.

175 – 176. *Both Members of This Club* was painted by George **Bellows** in 1909, and is striking evidence of the complete revolution in artistic expression which occurred in the early years of the twentieth century. Those canons of beauty and harmony which had held sway in art up to and including the time of the Impressionist revolution were now abandoned, and interest was firmly centered instead on the expressive value of the relationship between color and form. In Europe this led to Expressionism. This picture by Bellows conveys a powerful impression of a society in transition in the climate of cruelty and violence which came with the increased wealth of the industrial age and the greed it imposed on those who belonged to it. The members of the club were in fact poor boxers who fought for money (this was against the law) under the pretence of taking part in the activities of a sports club. Bellows had firsthand experience of this sordid section of society, since he had been an athlete before taking up painting. He belonged to the group of New York artists known as the *Ash-Can School*, whose members found inspiration in the life of the poorest districts of the richest city in the world. Guy Pène **Du Bois** was about the same age as Bellows, but in paintings like his *"Café du Dôme"* (1925-6) he looks at the sad cruelty of life through scenes in Parisian cafés.

Other Important Paintings
in the National Gallery of Art

AGNOLO DEGLI ERRI
A Dominican Preaching

ALBRECHT ALTDORFER
The Fall of Man

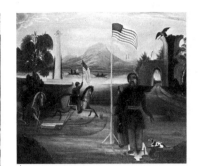

AMERICAN SCHOOL
Allegory of Freedom

AMERICAN SCHOOL
Liberty

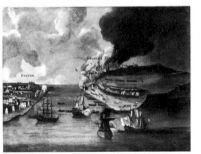

AMERICAN SCHOOL
*Attack on Bunker's Hill,
with the Burning of Charles Town*

AMERICAN SCHOOL
A City of Fantasy

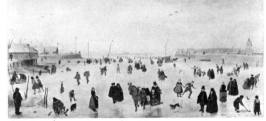

HENDRICK AVERCAMP
A Scene on the Ice

AMERICAN SCHOOL
Civil War Battle

AMERICAN SCHOOL
Twenty-two Houses and a Church

AMERICAN SCHOOL
*General Washington
on a White Charger*

ANDREA DEL CASTAGNO
Portrait of a Man

BALDASSARE D'ESTE
(attr)
*Francesco II
Gonzaga, Fourth
Marquis of Mantua*

FRA ANGELICO
*The Madonna
of Humility*

AMICO ASPERTINI
Saint Sebastian

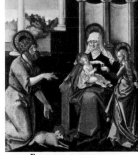

HANS BALDUNG GRIEN
*Saint Anne with the Christ
Child, the Virgin, and Saint
John the Baptist*

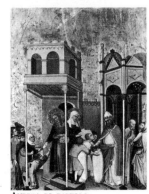

ANDREA DI BARTOLO
Joachim and the Beggars

BACCHIACCA
The Gathering of the Manna

BARTOLOMEO VENETO
Portrait of a Gentleman

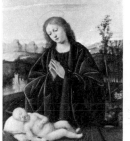

MARCO BASAITI
Madonna Adoring the Child

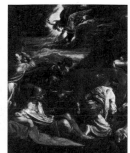

JACOPO BASSANO
The Annunciation to the Shepherds

FRÉDÉRIC BAZILLE
Edouard Blau

BERNARDO BELLOTTO
View of Munich

LEILA T. BAUMAN
U. S. Mail Boat

GIOVANNI BELLINI
Portrait of a Man 293

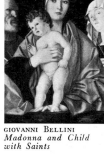

GIOVANNI BELLINI
Portrait of a Condottiere

GIOVANNI BELLINI
Madonna and Child with Saints

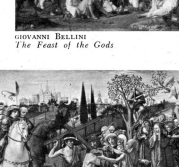

GIOVANNI BELLINI
The Feast of the Gods

GEORGE BELLOWS
Blue Morning

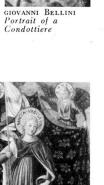

FRANCESCO BENAGLIO
Saint Jerome

BENOZZO GOZZOLI
Saint Ursula with Angels and Donor

BERGOGNONE
The Resurrection

BENVENUTO DI GIOVANNI
Christ Carrying the Cross

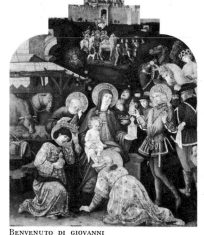

BENVENUTO DI GIOVANNI
The Adoration of the Magi

WILLIAM BLAKE
Job and his Daughters

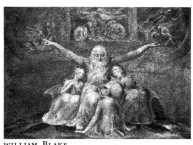

LOUIS-LÉOPOLD BOILLY
A Painter's Studio

LOUIS-LÉOPOLD BOILLY
Mademoiselle Mortier de Trévise (facing right)

GIOVANNI ANTONIO BOLTRAFFIO
Portrait of a Youth

PIERRE BONNARD
The Letter

FRANCESCO BONSIGNORI
Francesco Sforza

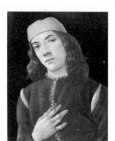

PARIS BORDONE
The Baptism of Christ

BOTTICELLI
Portrait of a Youth

BOTTICELLI
Madonna and Child

HIERONYMUS BOSCH
Death and the Miser

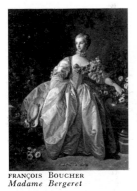

FRANÇOIS BOUCHER
Madame Bergeret

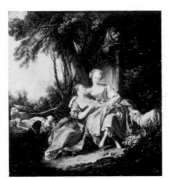

FRANÇOIS BOUCHER
The Love Letter

EUGÈNE BOUDIN
The Beach at Villerville

SÉBASTIEN BOURDON
The Finding of Moses

GEORGES BRAQUE
Nude Woman with Fruit
1753

GEORGES BRAQUE
Still Life: Le Jour

EUGÈNE BOUDIN
*Yacht Basin at
Trouville-Deauville*

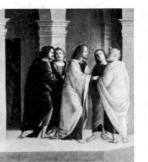

BRAMANTINO (attr)
*The Apparition of Christ
among the Apostles*

SÉBASTIEN BOURDON
Countess Ebba Sparre

79

DIERIC BOUTS
Portrait of a Donor

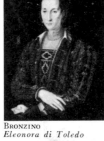

BRONZINO
Eleonora di Toledo

MATHER BROWN
William Vans Murray

GIULIANO BUGIARDINI
Portrait of a Young Woman

PIETER BRUEGHEL THE ELDER (attr)
The Temptation of Saint Anthony

BYZANTINE SCHOOL
*Enthroned Madonna and
Child 1*

BYZANTINE SCHOOL
*Enthroned Madonna and
Child 1048*

W.H. BROWN
Bareback Riders

ANNIBALE CARRACCI
Venus Adorned by the Graces

LUDOVICO CARRACCI
*The Dream of Saint
Catherine of Alexandria*

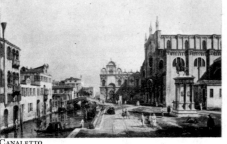

CANALETTO
View in Venice

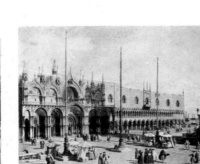

CANALETTO
The Square of Saint Mark

CARAVAGGIO (attr)
Still Life

VITTORE CARPACCIO
Madonna and Child

ROSALBA CARRIERA
Sir John Reade, Bart.

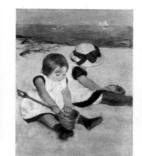

MARY CASSATT
Children Playing on the Beach

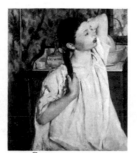

MARY CASSATT
Girl Arranging Her Hair

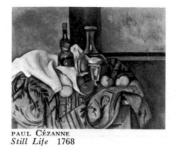

PAUL CÉZANNE
Still Life 1768

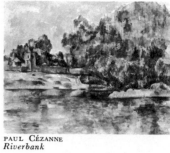

PAUL CÉZANNE
Riverbank

GEORGE CATLIN
See-non-ty-a, an Iowa Medicine Man

THOMAS CHAMBERS
The Connecticut Valley

PAUL CÉZANNE
Landscape in Provence

PAUL CÉZANNE
Le Château Noir

WINTHROP CHANDLER
Mrs. Samuel Chandler

JOOS VAN CLEVE
Portraits of Joris W. Vezeler and *His Wife*

PAUL CÉZANNE
The Sailor

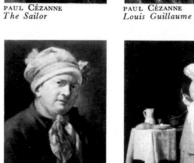

PAUL CÉZANNE
Louis Guillaume

PAUL CÉZANNE
Antony Valabrègue

JEAN-BAPTISTE CHARDIN
Étienne Jeaurat

JEAN-BAPTISTE CHARDIN
The Attentive Nurse; The Kitchen Maid

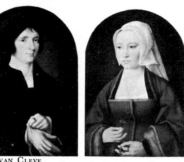

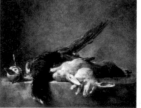

PETRUS CHRISTUS
The Nativity

PETRUS CHRISTUS
A Donor and *His Wife*

JEAN-BAPTISTE CHARDIN
Still Life 1115

CIMA DA CONEGLIANO
Madonna and Child with Saint Jerome and Saint John the Baptist

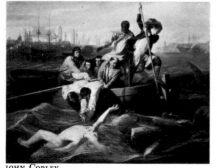

JOHN COPLEY
Watson and the Shark

JOHN CONSTABLE
The White Horse

JOHN CONSTABLE
Wivenhoe Park, Essex

80

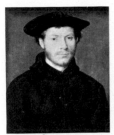

CLAUDE CORNEILLE
DE LYON
Portrait of a Man

JEAN-BAPTISTE COROT
Portrait of a Young Girl

JEAN-BAPTISTE COROT
The Artist's Studio

JEAN-BAPTISTE COROT
*Rocks in the Forest
of Fontainebleau*

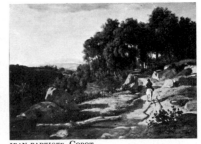

JEAN-BAPTISTE COROT
A View near Volterra

CORREGGIO
"Salvator Mundi"

FRANCIS COTES
Miss Elizabeth Crewe

JEAN-BAPTISTE COROT
The Forest of Coubron

JEAN-BAPTISTE COROT
Ville d'Avray

CORREGGIO
*The Mystic Marriage
of Saint Catherine*

FRANCESCO DEL COSSA
The Crucifixion

FRANCESCO DEL COSSA
Saint Florian

GUSTAVE COURBET
The Stream

GUSTAVE COURBET
Beach at Étretat

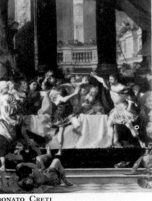

DONATO CRETI
The Quarrel

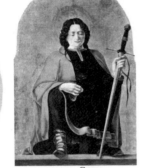

LUCAS CRANACH THE ELDER
A Prince and a Princess of Saxony

LUCAS CRANACH THE
ELDER
Portrait of a Man

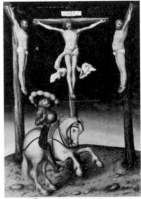

LUCAS CRANACH THE ELDER
The Crucifixion with Longinus

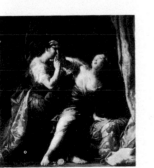

GIUSEPPE MARIA CRESPI
Lucretia threatened by Tarquin

CARLO CRIVELLI
*Madonna and
Child Enthroned
with Donor*

AELBERT CUYP
Herdsmen Tending Cattle

AELBERT CUYP
The Maas at Dordrecht

BERNARDO DADDI
Saint Paul

CHARLES-FRANÇOIS DAUBIGNY
The Farm

HONORÉ DAUMIER (follower)
The Beggars

HONORÉ DAUMIER (follower)
French Theater

HONORÉ DAUMIER (follower)
Wandering Saltimbanques

CHARLES DAVID
*Portrait of a Young
Horsewoman*

GERARD DAVID
The Saint Anne Altarpiece

EDGAR DEGAS
The Races

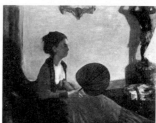

EDGAR DEGAS
Madame Camus

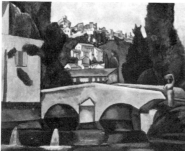

ANDRÉ DERAIN
The Old Bridge

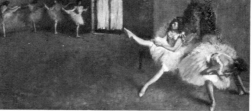

EDGAR DEGAS
Before the Ballet

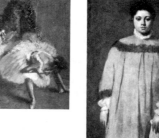

EDGAR DEGAS
Girl in Red

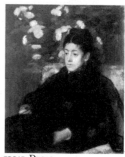

EDGAR DEGAS
Mademoiselle Malo

ANDRÉ DERAIN
Harlequin

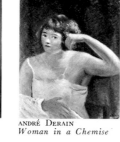

ANDRÉ DERAIN
Woman in a Chemise

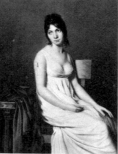

JACQUES-LOUIS DAVID
Madame Hamelin

EUGÈNE DELACROIX (follower)
Algerian Child

EUGÈNE DELACROIX (follower)
Michelangelo in his Studio

ROBERT DELAUNAY
Political Drama

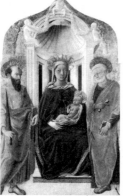

DOMENICO DI BARTOLO
*Madonna and Child
Enthroned with Saint Peter
and Saint Paul*

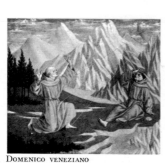

DOMENICO VENEZIANO
*Saint Francis Receiving the
Stigmata*

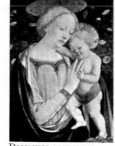

DOMENICO VENEZIANO
Madonna and Child

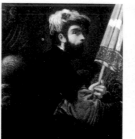

DOSSO DOSSI (attr)
The Standard Bearer

DOSSO DOSSI
Circe and Her Lovers in a Landscape

82

GERARD DOU
The Hermit

FRANÇOIS-HUBERT DROUAIS
Group Portrait

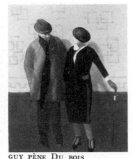

GUY PÈNE DU BOIS
Hallway, Italian Restaurant

GUY PÈNE DU BOIS
The Politicians

RAOUL DUFY
Saint-Jeannet

ANTHONIS VAN DYCK
Susanna Fourment and Her Daughter

ANTHONIS VAN DYCK
Marchesa Balbi

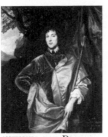

ANTHONIS VAN DYCK
Philip, Lord Wharton

ANTHONIS VAN DYCK
William II of Nassau and Orange

ANTHONIS VAN DYCK
Paola Adorno, Marchesa Brignole Sale, and Her Son

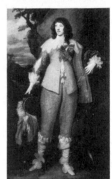

ANTHONIS VAN DYCK
Henri II de Lorraine, Duc de Guise

THOMAS EAKINS
Mrs. Louis Husson

RALPH EARL
Thomas Earle

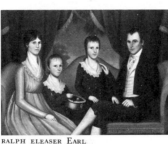

RALPH ELEASER EARL
Family Portrait

JACOB EICHHOLTZ
The Ragan Sisters

LYONEL FEININGER
Zirchow VII

PAOLO FEI
The Presentation of the Virgin

DOMENICO FETTI
The Parable of Dives and Lazarus

ERASTUS FIELD
Mrs. Harlow A. Pease

HENRI FANTIN-LATOUR
Portrait of Sonia

HENRI FANTIN-LATOUR
Still Life

VINCENZO FOPPA
Saint Bernardine

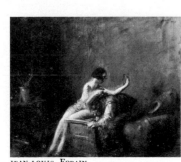

JEAN-LOUIS FORAIN
Artist and Model

JEAN-LOUIS FORAIN
Behind the Scenes

JEAN-HONORÉ FRAGONARD
A Game of Horse and Rider and *of Hot Cockles*

JEAN-HONORÉ FRAGONARD
Hubert Robert

FRANCESCO DI GIORGIO MARTINI
God the Father Surrounded by Angels and Cherubim

JEAN-HONORÉ FRAGONARD
Blindman's Buff; The Swing

FRANCESCO FRANCIA
Bishop Altobello Averoldo

FRENCH SCHOOL
Portrait of an Ecclesiastic

FREDERICK CARL FRIESEKE
The Basket of Flowers

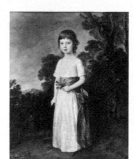

THOMAS GAINSBOROUGH
Master John Heathcote

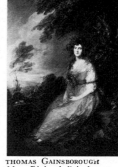

THOMAS GAINSBOROUGH
Mrs. Richard Brinsley Sheridan

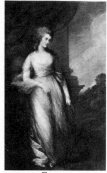

THOMAS GAINSBOROUGH
Georgiana, Duchess of Devonshire

FRENCH SCHOOL
The Expectant Madonna with Saint Joseph

FRENCH SCHOOL
Prince Hercule-François, Duc d'Alençon

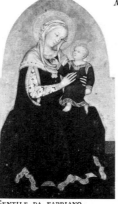

GENTILE DA FABRIANO
Madonna and Child

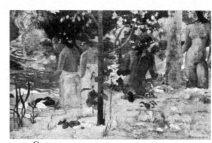

PAUL GAUGUIN
The Bathers

PAUL GAUGUIN
Madame Alexandre Kohler

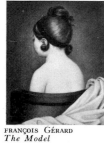

FRANÇOIS GÉRARD
The Model

THÉODORE GÉRICAULT
Nude Warrior with a Spear

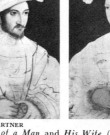

PETER GERTNER
Portraits of a Man and His Wife (?)

DOMENICO GHIRLANDAIO
Madonna and Child

VITTORE GHISLANDI
Portrait of a Young Man

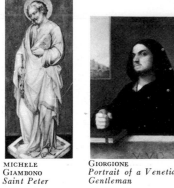

MICHELE GIAMBONO
Saint Peter

GIORGIONE
Portrait of a Venetian Gentleman

GIROLAMO DA CARPI
The Assumption of the Virgin

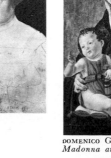

GIROLAMO DI BENVENUTO
Portrait of a Young Woman

GOYA
Carlos IV of Spain as Huntsman and Maria Luisa, Queen of Spain

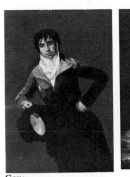
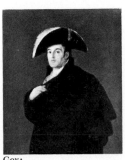
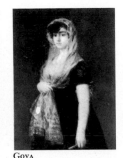

GOYA
Portraits of Don Bartolomé Sureda and *His Wife*

GOYA
Don Antonio Noriega

GOYA
The Duke of Wellington

GOYA
The Bookseller's Wife

MARCEL GROMAIRE
Vendor of Ices

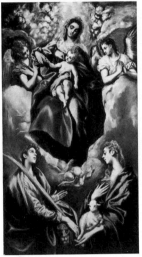

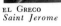
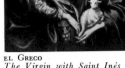

EL GRECO
*The Virgin with Saint Inés
and Saint Tecla*

EL GRECO
Saint Jerome

EL GRECO
Saint Ildefonso

JEAN-BAPTISTE GREUZE
*Ange-Laurent de Lalive
de Jully*

JEAN-BAPTISTE GREUZE
Girl with Birds

ANTOINE-JEAN GROS
Dr. Vignardonne

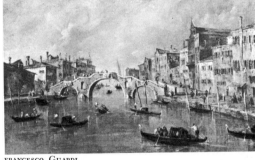
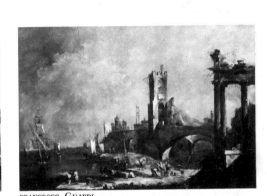

FRANCESCO GUARDI
View of the Cannaregio, Venice

FRANCESCO GUARDI
A Seaport and Classic Ruins in Italy

JEAN-BAPTISTE GUILLAUMIN
The Bridge of Louis Philippe

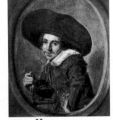

GUERCINO
*Cardinal Francesco
Cennini*

FRANS HALS
Balthasar Coymans

FRANS HALS
*Portrait of a Young
Man 71*

FRANS HALS
*A Young Man in a
Large Hat*

JUAN VAN DER HAMEN Y LEON
Still Life

WILLIAM M. HARNETT
My Gems

MARSDEN HARTLEY
Landscape No. 5

CHILDE HASSAM
Allies Day, May 1917

MARTIN HEADE
Rio de Janeiro Bay

JAN DAVIDSZ. DE HEEM
Vase of Flowers

JAN SANDERS VAN HEMESSEN
"Arise, and Take Up Thy
Bed, and Walk"

JEAN-JACQUES HENNER
Alsatian Girl

JAN VAN DER HEYDEN
An Architectural Fantasy

EDWARD HICKS
The Cornell Farm

86

MEINDERT HOBBEMA
A View on a High Road

MEINDERT HOBBEMA
Village near a Pool

JOSEPH HIGHMORE
A Scholar of Merton
College, Oxford

HANS HOLBEIN THE
YOUNGER
Sir Brian Tuke

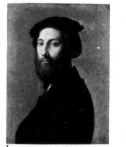

PIETER DE HOOCH
A Dutch Courtyard

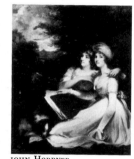

PIETER DE HOOCH
The Bedroom

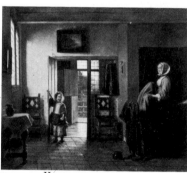

JOHN HOPPNER
The Frankland Sisters

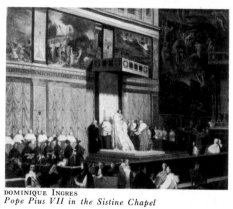

DOMINIQUE INGRES
Pope Pius VII in the Sistine Chapel

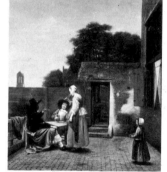

ITALIAN SCHOOL
Baldassare Castiglione

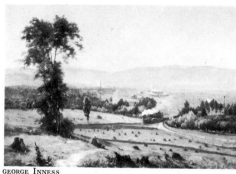

WINSLOW HOMER
Breezing Up

GEORGE INNESS
The Lackawanna Valley

DOMINIQUE INGRES
Monsieur Marcotte

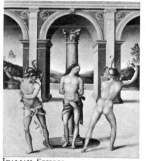

ITALIAN SCHOOL
The Flagellation of Christ

EASTMAN JOHNSON
The Early Scholar

JUAN DE FLANDES
The Annunciation; The Nativity

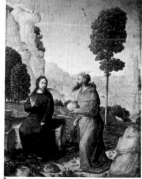

JUAN DE FLANDES
The Temptation of Christ

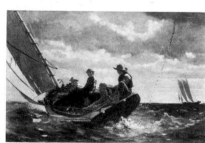

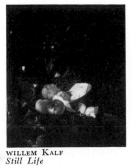

WILLEM KALF
Still Life

ANGELICA KAUFFMANN
Franciska Krasinska,
Duchess of Courland

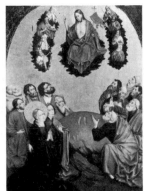

JOHANN KOERBECKE
The Ascension

ROGER DE LA FRESNAYE
Nude

A. A. LAMB
Emancipation Proclamation

NICOLAS LANCRET
The Picnic after the Hunt

NICOLAS DE LARGILLIÈRE
Elizabeth Throckmorton

MAURICE-QUENTIN DE LA TOUR
Claude Dupouch

FERNAND LÉGER
Woman with Mirror

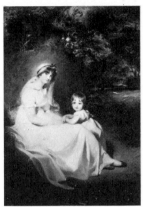

THOMAS LAWRENCE
Lady Templetown and Her Son

MARIE LAURENCIN
In the Park

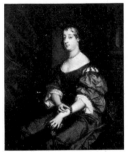

PETER LELY
Barbara Villiers,
Duchess of Cleveland

LOUIS LE NAIN
A French Interior

JUDITH LEYSTER
Self-Portrait

FILIPPO LIPPI
Saint Benedict Orders Saint Maurus to
the Rescue of Saint Placidus

FILIPPINO LIPPI
Pietà

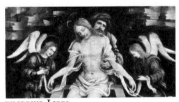

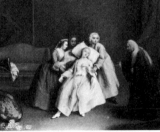

PIETRO LONGHI
The Simulated Faint

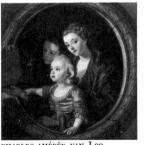

CHARLES-AMÉDÉE VAN LOO
The Magic Lantern

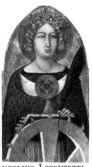

UGOLINO LORENZETTI
Saint Catherine of
Alexandria

FILIPPINO LIPPI
Tobias and the Angel

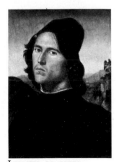

LORENZO DI CREDI
Self-Portrait

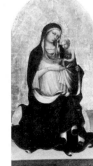

LORENZO MONACO
Madonna and Child

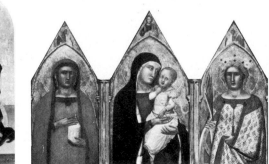

PIETRO LORENZETTI
Madonna and Child with Saint Mary Magdalen
and Saint Catherine

CLAUDE LORRAIN
Landscape with Merchants

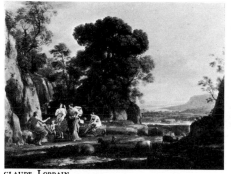

CLAUDE LORRAIN
The Judgment of Paris

LORENZO LOTTO
Allegory

BERNARDINO LUINI
Portrait of a Lady

BERNARDINO LUINI
Procris' Prayer to Diana; The Illusion of Cephalus

LOUIS MORRIS
Beta Kappa

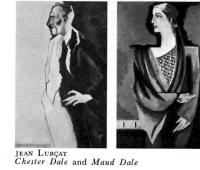

GEORGE LUKS
The Bersaglieri

JEAN LURÇAT
Chester Dale and Maud Dale

MABUSE
Saint Jerome Penitent

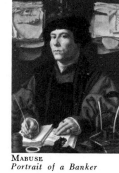

MABUSE
Portrait of a Banker

JAN LYS
The Satyr and the Peasant

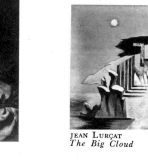

JEAN LURÇAT
The Big Cloud

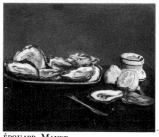

NICOLAES MAES
An Old Woman Dozing
over a Book

MACKAY
Catherine Brower

ALESSANDRO MAGNASCO
Christ at the Sea of Galilee

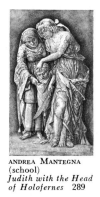

ANDREA MANTEGNA
(school)
Judith with the Head
of Holofernes 289

ANDREA MANTEGNA
The Christ
Child Blessing

ÉDOUARD MANET
Oysters

ÉDOUARD MANET
The Old Musician

ÉDOUARD MANET
The Tragedian
(Rouvière as Hamlet)

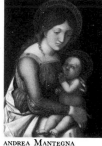

ANDREA MANTEGNA
(school)
Madonna and Child

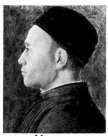

ANDREA MANTEGNA
Portrait of a Man

LOUIS MARCOUSSIS
The Musician

GEORGE MARK
Marion Feasting the British Officer on Sweet Potatoes

SIMON MARMION (st)
A Miracle of Saint Benedict

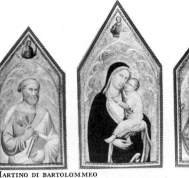

MARTINO DI BARTOLOMMEO
Madonna and Child with Saint Peter and Saint Stephen

ALBERT MARQUET
The Pont Neuf

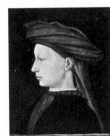

MASACCIO (attr)
Profile Portrait of a Young Man

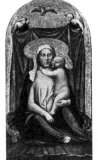

MASACCIO (attr)
The Madonna of Humility

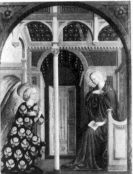

MASOLINO
The Annunciation

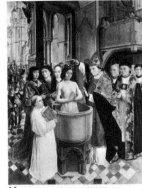

MASTER OF SAINT GILLES
The Baptism of Clovis

MASTER OF THE BARBERINI PANELS
The Annunciation

MASTER OF THE SAINT BARTHOLOMEW ALTAR
The Baptism of Christ

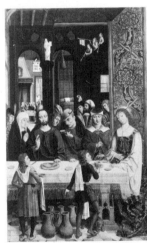

MASTER OF THE RETABLE OF THE REYES CATÓLICOS
The Marriage at Cana; Christ among the Doctors

MASTER OF THE SAINT LUCY LEGEND
Mary, Queen of Heaven

MATTEO DI GIOVANNI
Madonna and Child with Saints and Angels 408

GARI MELCHERS
The Sisters

HENRI MATISSE
Lorette

HENRI MATISSE
The Plumed Hat

HENRI MATISSE
Still Life: Apples on Pink Tablecloth

HENRI MATISSE
Pot of Geraniums

HANS MEMLING
The Presentation in the Temple

LIPPO MEMMI
Madonna and Child with Donor

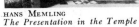

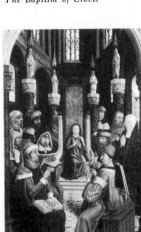

JEAN-FRANÇOIS MILLET
The Bather

JEAN-FRANÇOIS MILLET
Portrait of a Man

JOAN MIRÓ
L'Etoile

AMEDEO MODIGLIANI
Madame Amédée

AMEDEO MODIGLIANI
Léon Bakst

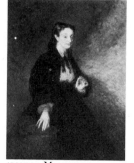

AMEDEO MODIGLIANI
Madame Kisling

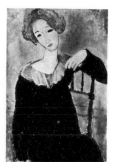

AMEDEO MODIGLIANI
Woman with Red Hair

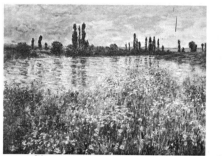

CLAUDE MONET
Banks of the Seine, Vétheuil

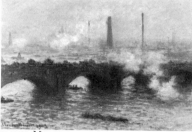

CLAUDE MONET
Waterloo Bridge, Gray Day

ADOLPHE MONTICELLI
Madame Cahen

ANTHONIS MOR
Portrait of a Gentleman

CLAUDE MONET
Ships at Anchor on the Seine

BERTHE MORISOT
*The Artist's Daughter
with a Parakeet*

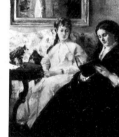

BERTHE MORISOT
*The Mother and Sister
of the Artist*

BERTHE MORISOT
*Girl in a Boat with
Geese*

GIOVANNI BATTISTA MORONI
"Titian's Schoolmaster"

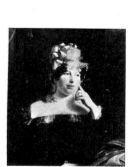

SAMUEL MORSE
Portrait of a Lady

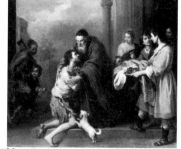

MURILLO
The Return of the Prodigal Son

JEAN-MARC NATTIER
*Joseph Bonnier de la
Mosson*

JOHN NEAGLE
Thomas W. Dyott

GIOVANNI BATTISTA MORONI
Gian Federico Madruzzo

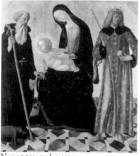

NEROCCIO DE' LANDI
*Madonna and Child with Saint
Anthony Abbot and Saint
Sigismund*

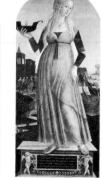

NEROCCIO DE' LANDI
Claudia Quinta

ADRIAEN VAN OSTADE
The Cottage Dooryard

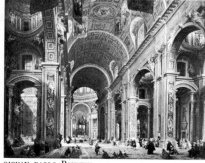

GIOVAN PAOLO PANNINI
Interior of Saint Peter's, Rome

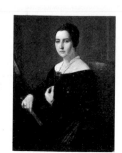

JOHN PARADISE
*Mrs. Elizabeth Oakes
Smith*

LINTON PARK
Flax Scutching Bee

JEAN-BAPTISTE PATER
Fête Champêtre 883

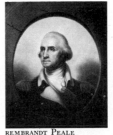

REMBRANDT PEALE
George Washington 596

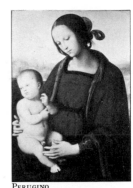

PERUGINO
Madonna and Child

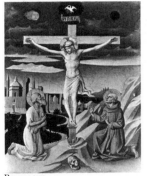

PESELLINO
*The Crucifixion with
Saint Jerome and Saint Francis*

AMMI PHILLIPS
Lady in White

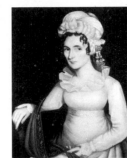

PABLO PICASSO
Le Gourmet

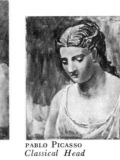

PABLO PICASSO
Classical Head

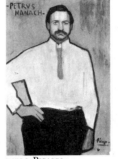

PABLO PICASSO
Pedro Mañach

PABLO PICASSO
The Tragedy

PIERO DI COSIMO
*The Visitation with Saint Nicholas
and Saint Anthony Abbot*

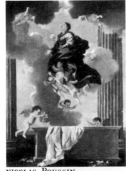

PIERO DI COSIMO
*The Nativity with the Infant
Saint John*

PIERIN DEL VAGA
The Nativity

CAMILLE PISSARRO
Place du Carrousel, Paris

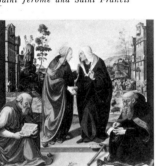

CHARLES POLK
Anna Maria Cumpston

NICOLAS POUSSIN
*The Assumption of the
Virgin*

NICOLAS POUSSIN
The Baptism of Christ

CAMILLE PISSARRO
*Peasant Girl with a
Straw Hat*

CAMILLE PISSARRO
The Bather

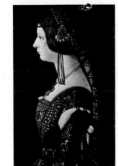

PAULUS POTTER
A Farrier's Shop

GIOVANNI DE' PREDIS
Bianca Maria Sforza

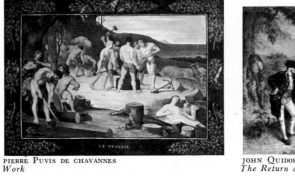

PIERRE PUVIS DE CHAVANNES
Work

JOHN QUIDOR
The Return of Rip Van Winkle

HENRY RAEBURN
Colonel Francis James Scott

HENRY RAEBURN
John Tait and his
Grandson

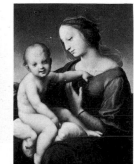

RAPHAEL
The Niccolini-Cowper
Madonna

RAPHAEL
Bindo Altoviti (?)

ODILON REDON
Wildflowers

ODILON REDON
Evocation of Roussel

JEAN-FRANÇOIS RAFFAËLLI
The Flower Vendor

HENRY RANGER
Spring Woods

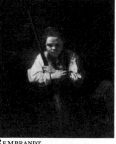

REMBRANDT
Self-Portrait 666

REMBRANDT
A Girl with a Broom

REMBRANDT
A Woman Holding a Pink

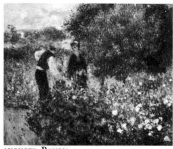

AUGUSTE RENOIR
Picking Flowers

REMBRANDT
Lucretia

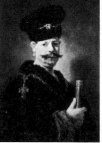

REMBRANDT
A Polish Nobleman

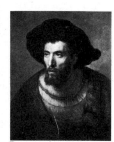

REMBRANDT
The Philosopher

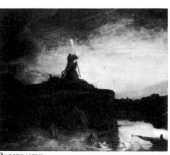

REMBRANDT
The Mill

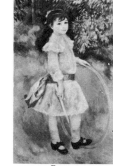

AUGUSTE RENOIR
Girl with a Hoop

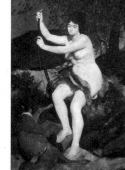

AUGUSTE RENOIR
Diana

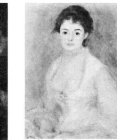

AUGUSTE RENOIR
Madame Henriot

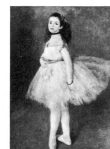

AUGUSTE RENOIR
The Dancer

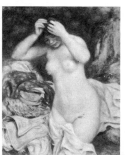

AUGUSTE RENOIR
Bather Arranging her Hair

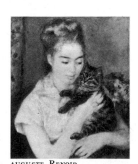

AUGUSTE RENOIR
Woman with a Cat

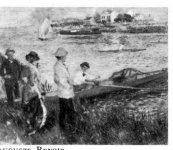

AUGUSTE RENOIR
Oarsmen at Chatou

JOSHUA REYNOLDS
Lady Caroline Howard

JOSHUA REYNOLDS
Lady Betty Hamilton

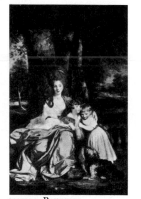

JOSHUA REYNOLDS
Lady Elizabeth Delmé and
Her Children

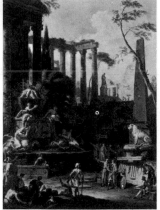

SEBASTIANO RICCI
Memorial to Admiral
Sir Clowdisley Shovell

92

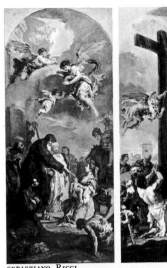

SEBASTIANO RICCI
A Miracle of Saint Francis of Paula and *The
Finding of the True Cross*

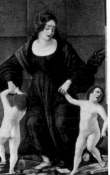

ERCOLE DE' ROBERTI
*The Wife of Hasdrubal
and her Children*

GEORGE ROMNEY
Sir Archibald Campbell

PIETRO ROTARI
*A Girl with a Flower
in her Hair*

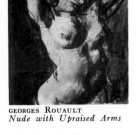

GEORGES ROUAULT
Nude with Upraised Arms

93

THÉODORE ROUSSEAU
Landscape with Boatman

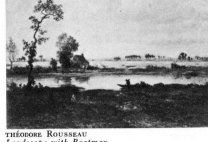

GEORGES ROUAULT
Christ and the Doctor

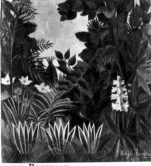

HENRI ROUSSEAU
The Equatorial Jungle

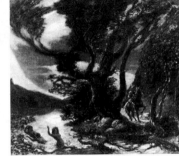

ALBERT RYDER
Siegfried and the Rhine Maidens

JACOB VAN RUISDAEL
Forest Scene

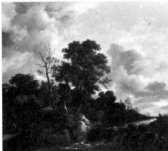

JACOB VAN RUISDAEL
Landscape

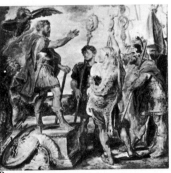

RUBENS
Decius Mus Addressing the Legions

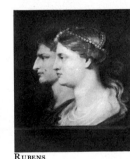

RUBENS
Tiberius and Agrippina

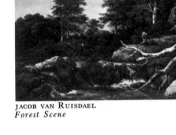

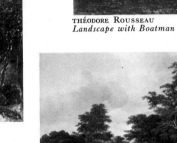

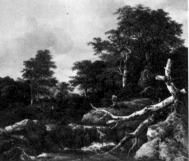

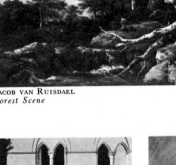

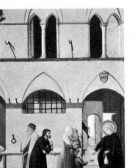

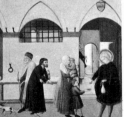

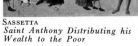

SASSETTA
*Saint Anthony Distributing his
Wealth to the Poor*

JOHN SARGENT
Mrs. Adrian Iselin

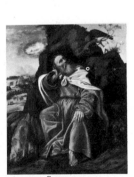

GIOVANNI SAVOLDO
Elijah Fed by the Raven

RUBENS
Daniel in the Lions' Den

LAMBERT SACHS
The Herbert Children

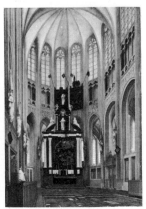

SANO DI PIETRO
The Crucifixion

SEBASTIANO DEL PIOMBO
*Cardinal Bandinello Sauli,
His Secretary and Two Geographers*

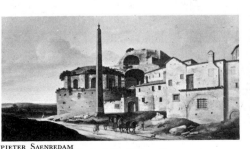

PIETER SAENREDAM
Church of Santa Maria della Febbre, Rome

PIETER SAENREDAM
*Cathedral of Saint John
at 's-Hertogenbosch*

JACOPO DEL SELLAIO
Saint John the Baptist

GEORGES SEURAT
Study for "La Grande Jatte"

LUCA SIGNORELLI
*Madonna and Child with Saints
and Angels*

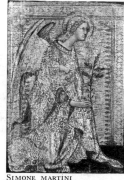

SIMONE MARTINI
*The Angel
of the Annunciation*

T. SKYNNER
Portrait of a Woman

94

ALFRED SISLEY
The Banks of the Oise

MIGUEL SITHIUM
The Assumption of the Virgin

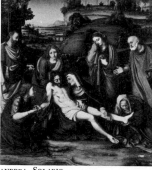

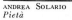

ANDREA SOLARIO
Pietà

CHAIM SOUTINE
Portrait of a Boy

CHAIM SOUTINE
The Pastry Chef

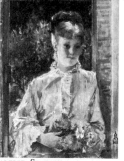

ALFRED STEVENS
*Young Woman in White
Holding a Bouquet*

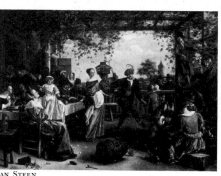

JAN STEEN
The Dancing Couple

BERNHARD STRIGEL
*Saint Mary Cleophas and Saint Mary Salome
and Their Families*

BERNARDO STROZZI
Bishop Alvise Grimani

THOMAS SULLY
Andrew Jackson

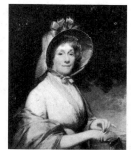

GILBERT STUART
Lady Liston

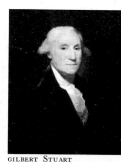

GILBERT STUART
*George Washington
(Vaughan portrait)* 580

TANZIO DA VARALLO
Saint Sebastian

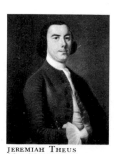

JEREMIAH THEUS
Mr. Motte

GIAMBATTISTA TIEPOLO
*A Young Lady in
Domino and Tricorne*

GIAMBATTISTA TIEPOLO
*Timocleia and the Thracian
Commander*

GIAMBATTISTA TIEPOLO
Madonna of the Goldfinch

TINTORETTO
The Conversion of Saint Paul

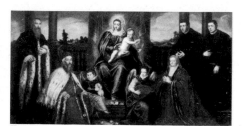

TINTORETTO
*Doge Alvise Mocenigo and Family before
the Madonna and Child*

TITIAN
Portrait of a Lady

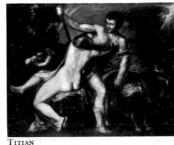

TITIAN
Venus and Adonis

TITIAN
Doge Andrea Gritti

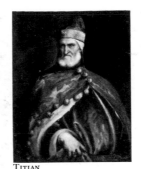

HENRI DE TOULOUSE-LAUTREC
Rue des Moulins, 1894

HENRI DE TOULOUSE-LAUTREC
Alfred La Guigne

JOSEPH TURNER
Keelmen Heaving Coals by Moonlight

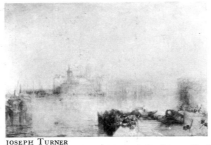

JOSEPH TURNER
The Dogana and Santa Maria della Salute, Venice

HENRI DE TOULOUSE-LAUTREC
Maxime Dethomas

HENRI DE TOULOUSE-LAUTREC
Jane Avril

95

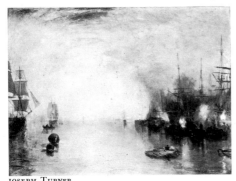

JOSEPH TURNER
Mortlake Terrace

JOSEPH TURNER
The Junction of the Thames and the Medway

MAURICE UTRILLO
Marizy-Sainte-Geneviève

HENRI DE
TOULOUSE-LAUTREG
The Artist's Dog, Flèche

VAN GOGH (attr)
Self-Portrait

VAN GOGH
Roulin's Baby

JOHN TRUMBULL
Alexander Hamilton 494

ANTONIO VASSALLO
The Larder

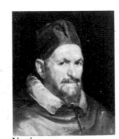

VELÁZQUEZ
Pope Innocent X

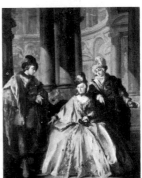

VENETIAN SCHOOL
Before the Masked Ball

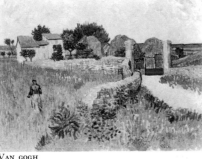

VAN GOGH
Farmhouse in Provence, Arles

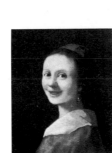

JAN VERMEER (follower)
The Smiling Girl

JAN VERMEER
A Lady Writing

VERONESE
Saint Lucy and a Donor

VERONESE
The Annunciation

ELISABETH VIGÉE-LEBRUN
Portrait of a Lady

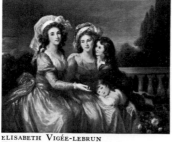

ELISABETH VIGÉE-LEBRUN
*The Marquise de Pezé and the
Marquise de Rouget with Her Two
Children*

ALVISE VIVARINI
Saint Jerome Reading

BARTOLOMEO VIVARINI
Madonna and Child

ANTONIO VIVARINI
*Saint Catherine Casting
Down a Pagan Idol*

MAURICE DE VLAMINCK
The Old Port of Marseille

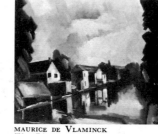

MAURICE DE VLAMINCK
The River

SIMON VOUET
Saint Jerome and the Angel

BENJAMIN WEST
The Battle of La Hogue

ÉDOUARD VUILLARD
Repast in a Garden

ÉDOUARD VUILLARD
Théodore Duret

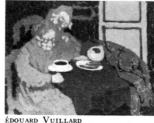

ÉDOUARD VUILLARD
Two Women Drinking Coffee

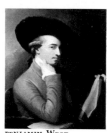

ANTOINE WATTEAU
Ceres

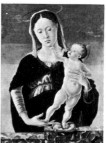

BENJAMIN WEST
Self-Portrait

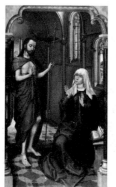

ROGIER VAN DER WEYDEN
*Christ Appearing to the
Virgin*

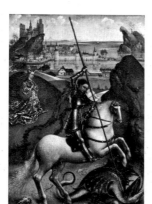

ROGIER VAN DER WEYDEN
Saint George and the Dragon

JAMES WHISTLER
*Chelsea Wharf:
Grey and Silver*

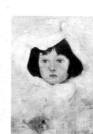

JAMES WHISTLER
Little Girl in White

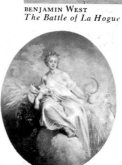

JOHN WOLLASTON
*Lieutenant Archibald
Kennedy (?)*

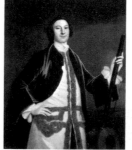

MARCO ZOPPO
Madonna and Child

Catalogue of the Paintings
in the National Gallery of Art

AGNOLO DEGLI ERRI
second half Fifteenth Century, Emilia
A Dominican Preaching *
pn 16.9×13.4 (43×34 cm)
c 1470 mutilated

ALBRIGHT Ivan Le Lorraine
Chicago 1897 –
There Were no Flowers Tonight
cv 48.4×30.3 (123×77 cm)
sg c 1928

ALEXANDER Francis
Killingly 1800 – Florence 1880
Ralph Wheelock's Farm
cv 25.2×48.0 (64×122 cm)
c 1822
GR

ALTDORFER Albrecht
Regensburg c 1480 – 1538
The Fall of Man *
trp; panels; centr pn 15.4×13.8 (39×35 cm); wings 15.4×6.3 (39×16 cm) c 1525 ins
KR

AMERICAN SCHOOL
Eighteenth Century
Christ and the Woman of Samaria
cv 20.5×26.0 (52×66 cm)
c 1720-40
GR
Christ on the Road of Emmaus
cv 25.2×30.5 (64×77,5 cm)
c 1720-40
GR
Jonathan Bentham
cv 45.9×35.0 (116,5×89 cm)
c 1725
GR
Young Man on Terrace
cv 20.1×26.0 (51×66 cm)
c 1730
GR
Catharine Hendrickson
cv 46.1×38.0 (117×96,5 cm)
c 1770
GR
Attack on Bunker's Hill, with the Burning of Charles Town*
cv 21.3×28.0 (54×71 cm)
c 1783
GR
Girl in Pink Dress
cv 40.0×28.3 (101,5×72 cm)
c 1790
GR
A View of Mount Vernon
cv 37.6×43.3 (95,5×110 cm)
c 1790
simulated frame
GR
The Cheney Family
cv 25.2×31.3 (64×79,5 cm)
c 1795
GR

Nineteenth Century
The Sargent Family
cv 38.4×50.4 (97,5×128 cm)
1800
GR
Young Man Wearing White Vest
cv 25.2×22.4 (64×57 cm)
c 1810
GR
Jane L. Van Reid

Wellington Van Reid
Husband and wife portraits
panels c 9.8×c 7.9
(c 25×c 20 cm) c 1810
GR
Little Girl with Doll
pn 20.5×16.3 (52×41,5 cm)
c 1815
GR
Sophia Burpee
cv 22.0×16.9 (56×43 cm)
c 1815
GR
General Washington on a White Charger *
pn 38.2×29.3 (97×74,5 cm)
c 1820
GR
Portrait of a Young Lady 1206
pn 11.8×9.8 (30×25 cm)
c 1820
GR
New England Village
pn 12.6×25.6 (32×65 cm)
c 1820
GR
Liberty *
cv 29.9×20.1 (76×51 cm)
c 1820
GR
Five Children of the Budd Family
cv 47.8×41.7 (121,5×106 cm)
c 1820
GR
Portrait of a Lady 706
cv 30.1×25.0 (76,5×63,5 cm)
c 1825
DL
Portrait of a Man 1219
pn 19.5×13.4 (49,5×34 cm)
1829 (?)
GR
Miss Ryan (?)
cv 29.9×25.2 (76×64 cm)
c 1830
ML
Young Man on Terrace
cv 20.1×26.0 (51×66 cm)
c 1830
ML
Junius Bruthus Booth
crt 20.1×14.6 (51×37 cm)
c 1830
ML
Aphia Salisbury Rich and Baby Edward
pn 29.9×24.2 (76×61,5 cm)
c 1833
GR
Martha
cv 35.8×36.2 (91×92 cm)
c 1835
GR
Little Girl with Flower Basket
pn 14.0×10.2 (35,5×26 cm)
c 1835
GR
Family Burying Ground
cv 19.7×24.0 (50×61 cm)
c 1835
GR
Profile Portrait of a Lady
Profile Portrait of a Man
Husband and wife profile portraits
panel c 8.7×c 6.7 (c 22×c 17)
c 1840
GR
The Hobby Horse
cv 40.8×40.0 (103,5×101,5 cm)
c 1840
GR
Fruit and Flowers
cv 34.3×41.3 (87×105 cm)
c 1850
GR

The Dog
cv 35.2×41.3 (89,5×105 cm)
c 1850
GR
Stylized Landscape
cv 27.8×41.3 (70,5×105 cm)
c 1850
GR
Twenty-two Houses and a Church *
cv 24.0×29.5 (61×75 cm)
c 1850
GR
A City of Fantasy *
cv 28.7×40.6 (73×103 cm)
c 1850
GR
Aurora
pn 24.0×32.3 (61×82 cm)
c 1850
GR
Little Girl with Pet Rabbit
crt 12.2×9.6 (31×24,5 cm)
c 1845
GR
Little Girl with Slate
cv 27.0×22.0 (68,5×56 cm)
c 1845
GR
Henry L. Wells 1244
cv 30.1×25.2 (76,5×64 cm)
c 1845
GR
Henry L. Wells 1426
cv 40.1×28.3 (101,5×72 cm)
1845
GR
Boy with Toy Horse and Wagon
cv 30.3×25.0 (77×63,5 cm)
c 1845
GR
Brothers
cv 44.1×35.0 (112×89 cm)
c 1845
GR
Mounting of the Guard
cv 26.8×39.4 (68×100 cm)
c 1850
GR
Lexington Battle Monument
cv 27.8×30.7 (70,5×78 cm)
c 1853
GR
Burning of Old South Church, Bath, Maine
cv 18.5×24.0 (47×61 cm)
1854 (?)
GR
"We go for the Union"
cv 17.9×24.0 (45,5×61 cm)
c 1855
GR
Portrait of a Lady 966
oval pn 29.9×25.2 (76×64 cm)
false sg and d ("Henry Imman 1844") c 1855
ML
Leaving the Manor House
→ no 166
cv 27.0×34.1 (68,5×86,5 cm)
c 1860
GR
Civil War Battle *
cv 36.0×44.1 (91,5×112 cm)
c 1861
GR
Allegory of Freedom *
cv 37.0×42.9 (94×109 cm)
c 1863
GR

Cat and Kittens
crt 12.0×13.8 (30,5×35 cm)
c 1872-83
GR
Imaginary Regatta of America's Cup Winners
cv 26.8×46.9 (68×119 cm)
c 1889
GR
Village by the River
oilcloth 20.1×33.5
(51×85 cm) c 1890
GR
Northwestern Town
cv 27.8×41.7 (70,5×106 cm)
c 1890
GR
Blacksmith Shop
cv 23.2×32.1 (59×81,5 cm)
c 1890
GR
Mahantango Valley Farm 1322
pn 28.0×35.4 (71×90 cm)
c 1890
window shade
GR
Farmhouse in Mahantango Valley 1323
cv 29.5×28.3 (75×72 cm)
c 1890
GR

AMES Ezra
Framingham 1768 –
Albany 1836
Maria Gansevoort Melville
pn 29.9×23.6 (76×60 cm)
c 1815
ML

AMES Joseph Alexander
Roxbury 1816 – New York 1872
George Southward
pn 29.9×24.4 (76×62 cm)
c 1835
ML

Amiens School see
FRENCH SCHOOL

ANDREA DEL CASTAGNO
Castagno or San Martino a Corella c 1420 – Florence 1457
Portrait of a Man *
pn 21.3×15.9 (54×40,5 cm)
c 1455
ML
The Youthful David → no 11
leather 45.5×16.1
(115,5×41 cm) c 1450
ornamental coat of arms
WD

ANDREA DEL SARTO
(A. d'Agnolo)
Florence 1486 – 1530
Charity
pn 47.2×36.6 (120×93 cm)
c 1530
KR

ANDREA DI BARTOLO
Siena ... – 1428
Madonna and Child (on rv Crucifixion)
pn 11.4×7.1 (29×18 cm)
c 1415
on obv gold ground;
rv mutilated
KR

Joachim and the Beggars *
The Nativity of the Virgin
The Presentation of the Virgin
 wings of a polyptych;
 panels 17.3×12.6 (44×32 cm)
 gold ground c 1400
 KR

ANGELICO
(Fra Giovanni da Fiesole)
Vicchio di Mugello (?) c 1400 –
Rome 1455
The Madonna of Humility *
 pn 24.0×17.9 (61×45,5 cm)
 c 1440 ins
 ML
The Healing of Palladia by
 Saint Cosmas and Saint Da-
 mian → no 8
 pn of a pred 14.4×18.5
 (36,5×47 cm) c 1438-43
 KR
The Adoration of the Magi
 → no 9
 pn; td 53.9 (137 cm) c 1445
 in collaboration with Filippo
 Lippi
 KR
The Entombment
 pn 35.0×21.6 (89×55 cm)
 c 1445 attr
 KR

Circle of
ANTHONISSEN Hendrik van
act c 1606 – 1654-60 Holland
Ships in the Scheldt Estuary
 cv 48.2×58.3 (122,5×148 cm)

ANTONELLO DA MESSINA
Messina c 1430 – 1479
Madonna and Child → no 30
 pn 23.2×17.3 (59×44 cm)
 c 1475
 ML
Portrait of a Young Man
 pn 13.0×9.8 (33×25 cm)
 c 1475
 ML

ASPERTINI Amico
Bologna c 1474 – 1552
Saint Sebastian *
 pn 45.3×26.8 (115×68 cm)
 c 1505
 KR

AUDUBON John James
Les Cayes 1785 – New York 1851
Arctic Hare
 tmp on crt 24.4×34.3
 (62×87 cm) c 1841
Farmyard Fowls
 cv 28.3×40.9 (72×104 cm)
 sg c 1827

AUDUBON John Woodhouse
Henderson 1812 –
New York 1862
Black-Footed Ferret
 cv 22.0×27.2 (56×69 cm)
 1840-6
Long-Tailed Red Fox
 cv 22.0×27.2 (56×69 cm)
 1848-54

AVERCAMP Hendrick
Amsterdam 1585 – Kampen 1634
A Scene on the Ice *
 pn 15.4×30.3 (39×77 cm)
 sg c 1625

BACCHIACCA
(Francesco Ubertini)
Florence 1494 – 1557
The Gathering of the Manna *
 pn 44.1×37.4 (112×95 cm)
 c 1545-55
 KR

BADGER Joseph
Charlestown 1708 –
Boston (?) 1765
Captain Isaac Foster
Mrs. Isaac Foster
 Husband and wife portraits
 canvases 35.8 and 36.2×28.0
 (91 and 92×71 cm) sg d 1755
 GR

BAER George
Chicago 1895 – ...
Masouba
 cv 21.6×13.0 (55×33 cm)
 sg d 1927
 DL

BALDASSARE D'ESTE
second half Fifteenth Century,
Ferrara
Francesco II Gonzaga, Fourth
 Marquis of Mantua *
 pn 10.4×8.3 (26,5×21 cm)
 c 1476-8 ins
 KR

BALDUNG GRIEN Hans
Schwäbisch-Gmünd 1484-5 –
Strasbourg 1545
Saint Anne with the Christ
 Child, the Virgin and Saint
 John the Baptist *
 pn/masonite 34.3×29.9
 (87×76 cm) sg
 c 1511 ins
 KR

BARD James
Chelsea 1815 –
White Plains 1897
Steamer St. Lawrence
 cv 28.7×48.0 (73×122 cm)
 sg d 1850
 GR

BAROCCI Federico
Urbino 1526 – 1612
Quintilia Fischieri
 cv 48.8×37.4 (124×95 cm)
 c 1580
 KR

BARTOLOMEO VENETO
act 1502-46 Ferrara,
Lombardy and Venetia
Portrait of a Gentleman *
 pn/cv 30.3×22.8 (77×58 cm)
 c 1520
 KR

BASAITI Marco
act 1496-1530 Venice
Madonna Adoring the Child *
 pn 8.3×6.7 (21×17 cm)
 sg 1520-30
 KR

BASSANO Jacopo
(J. da Ponte)
Bassano 1516-9 – 1592
The Annunciation to the Shep-
 herds *
 cv 41.7×32.7 (106×83 cm)
 c 1575
 KR

BASTIEN-LEPAGE Jules
Damvillers 1848 – Paris 1884
Simon Hayem
 cv 15.7×13.0 (40×33 cm)
 sg 1875 ins
 DL

BAUMAN Leila T.
Nineteenth Century, U.S.A.
Geese in Flight
U.S. Mail Boat *
 canvases 20.1×26.4
 (51×67 cm) c 1870
 GR

BAZILLE Frédéric
Montpellier 1841 –
Beaune-la-Rolande 1870
Edouard Blau *
 cv 23.6×17.1 (60×43,5 cm)
 sg d 1866
 DL

BECCAFUMI Domenico
Montaperti c 1485 – Siena 1551
The Holy Family with Angels
 → no 44
 pn 31.9×24.4 (81×62 cm)
 c 1545
 KR

BEECHEY Sir William
Burford 1753 – London 1839
General Sir Thomas Picton
 cv 30.3×25.2 (77×64 cm) 1815

Beke see **CLEVE**

BELLINI Giovanni
Venice 1426 (?) – 1516
Portrait of a Young Man in Red
 → no 29
 cv 12.6×10.4 (32×26,5 cm)
 1480-90
 ML
Portrait of a Young Man 293 *
 pn 12.2×9.8 (31×25 cm)
 sg c 1500
 KR
Saint Jerome Reading
 pn 19.3×15.4 (49×39 cm)
 sg d 1505
 KR

Portrait of a Condottiere *
 pn/cv/pn 19.3×13.8
 (49×35 cm) c 1484-1500
 KR
Portrait of a Venetian Gentle-
 man
 pn 11.8×7.9 (30×20 cm)
 sg c 1500
 KR
Madonna and Child in a Land-
 scape
 pn 29.5×23.0 (75×58,5 cm)
 sg c 1500 in collaboration
 with st assistants, res
 KR
Madonna and Child 445
 pn 20.9×16.9 (53×43 cm)
 c 1464-75
 KR
Madonna and Child 894
 pn 28.3×20.9 (72×53 cm)
 c 1480-90 ins
 BTH
Madonna and Child with
 Saints *
 pn/cv 29.9×20.1 (76×51 cm)
 sg c 1490
 KR
The Feast of the Gods *
 cv 66.9×74.0 (170×188 cm)
 sg d 1514
 changes by Titian
 WD
Orpheus
 pn/cv 15.6×31.9 (39,5×81 cm)
 c 1515
 WD
An Episode from the Life of
 Publius Cornelius Scipio
 cv 29.5×140.2 (75×356 cm)
 c 1506 ins
 KR
The Infant Bacchus
 pn/cv 18.9×14.6 (48×37 cm)
 c 1510-14
 KR
Portrait of a Man 1553
 pn 10.4×7.5 (26,5×19 cm)
 c 1490-1500 attr
 TM

BELLINI Jacopo
Venice ... – 1470-1
Profile Portrait of a Boy
 pn 9.3×7.1 (23,5×18 cm)
 c 1470 attr
 KR

BELLOTTO Bernardo
Venice 1720 – Warsaw 1780
The Castle of Nymphenburg
 → no 63
 cv 26.8×47.2 (68×120 cm)
 c 1761
 KR
View of Munich *
 cv 27.2×47.2 (69×120 cm)
 c 1761
 KR

BELLOWS George
Columbus 1882 – New York 1925
Blue Morning *
 cv 31.5×43.3 (80×110 cm)
 sg 1909
 DL
Both Members of This Club
 → no 175
 cv 45.3×63.2 (115×160,5 cm)
 sg 1909
 DL
Chester Dale
 cv 44.9×34.6 (114×88 cm)
 sg 1922
 DL
Maud Dale
 cv 40.2×33.5 (102×85 cm)
 sg 1919
 DL
The Lone Tenement
 cv 36.2×48.0 (92×122 cm)
 sg 1909
 DL
Nude with Red Hair
 cv 44.1×34.3 (112×87 cm)
 1920 later sg

BENAGLIO Francesco
Verona 1432 – c 1492
Madonna and Child
 pn/cv 31.9×22.0 (81×56 cm)
 c 1460-70
 WD
Saint Jerome *
 pn 54.7×26.4 (139×67 cm)
 sg c 1450-55 ins
 KR

BENBRIDGE Henry
Philadelphia 1743 – ... 1812
Portrait of a Man
 cv 30.1×25.2 (76.5×64 cm)
 sg d 1771
 ML

BENOZZO GOZZOLI
(B. di Lese)
Florence 1420 – Pistoia 1497
Saint Ursula with Angels and
 Donor *
 pn 18.5×11.4 (47×29 cm)
 c 1455 ins
 KR
The Raising of Lazarus
 cv 25.8×31.5 (65,5×80,5 cm)
 1497 (?)
 WD
The Dance of Salome → no 16
 pn of a pred 9.4×13.9
 (24×34 cm) 1461-2
 KR

BENSON Ambrosius
... – Bruges 1550
Niclaes de Hondecoeter
Wife of Niclaes de Hondecoe-
 ter
 Husband and wife portraits
 panels 10.1 and 10.2×7.9
 (25,5 and 26×20 cm)
 the first d 1543 ins

BENVENUTO DI GIOVANNI
Siena 1436 – c 1518
The Adoration of the Magi *
 cusped pn 52.0×53.9
 (132×137 cm) c 1470
 ML
Passion of our Lord
The Agony in the Garden
Christ Carrying the Cross *
The Crucifixion
Christ in Limbo
The Resurrection
 panels c 16.9×19.1
 (c 43×48,5 cm); the third
 16.7×21.5 (42,5×54,5 cm)
 c 1490
 KR
Madonna with Saint Jerome
 and Saint Bernardine
 ar pn 27.8×18.9 (70,5×48 cm)
 gold ground c 1475 ins
 WD

BERGOGNONE
(Ambrogio da Fossano)
act 1481-1522 Lombardy
The Resurrection *
 pn 45.3×24.2 (115×61,5 cm)
 c 1510
 KR

BESNARD Albert
Paris 1849 – ... 1934
Nude
 pastel 31.8×28.0 (91×71 cm)
 sg c 1875

BIAGIO D'ANTONIO
DA FIRENZE
act 1476-1504 Florence
The Triumph of Scipio Africa-
 nus
 pn 23.6×60.6 (60×154 cm)
 1465 ins
 KR
Portrait of a Boy
 pn 16.5×14.2 (42×36 cm)
 c 1475-80
 KR

BIRLEY Oswald
Auckland 1880 – ... 1952
Andrew Mellon
 cv 52.4×41.3 (133×105 cm)
 sg d 1933

BLAKE William
London 1757 – 1827
Job and his Daughters *
 cv 10.6×15.0 (27×38 cm)
 c 1823
 RS
The Last Supper
 cv 12.0×18.9 (30,5×48 cm)
 1799
 RS

BLAKELOCK Ralph Albert
New York 1847 –
Adirondack 1919
The Artist's Garden
 cv 16.1×24.0 (41×61 cm)
 sg c 1880
 DL

BOILLY Louis-Léopold
La Bassée 1761 – Paris 1845
A Painter's Studio *
 cv 28.9×23.4 (73,5×59,5 cm)
 sg c 1800
 DL
Mademoiselle Mortier de Tré-
 vise (facing right) *
Mademoiselle Mortier de Tré-
 vise (facing left)
 canvases c 87.4×65.0
 (c 222×165 cm) c 1800
 DL

BOLTRAFFIO
Giovanni Antonio
Milan 1467 – 1516
Portrait of a Youth *
 pn 18.5×13.8 (47×35 cm)
 c 1500
 BTH

BONNARD Pierre
Fontenay-aux-Roses 1867 –
Le Cannet 1947
The Letter *
 cv 21.6×18.7 (55×47,5 cm)
 sg c 1906
 DL
Two Dogs in a Deserted Street
 cv 13.8×10.6 (35×27 cm) sg
 ML
The Cab Horse
 cv 11.6×15.7 (29,5×40 cm) sg
 ML
Children Leaving School
 crt/cv 11.4×17.3 (29×44 cm)
 sg
 ML
The Artist's Sister and Her Chil-
 dren
 crt/cv 12×10 (30,5×25,5 cm)
 sg d 1898
 ML
The Green Table
 cv 20.1×25.6 (51×65 cm)
 sg 1910?
 ML
Table Set in a Garden
 cv 19.5×25.4 (49,5×64,5 cm)
 sg
 ML
Bouquet of Flowers
 cv 27.8×18.7 (70.5×47.5 cm)
 sg
 ML
A Spring Landscape
 cv 26.6×40.6 (67,5×103 cm) sg
 ML
Stairs in the Artist's Garden
 cv 25×28.7 (63,5×73 cm)
 sg d 1943
 ML

BONSIGNORI Francesco
Verona c 1455 –
Caldiero di Verona 1519
Francesco Sforza *
 pn 28.5×24.4 (72,5×62 cm)
 false sg and d
 ("An. Mantinia Pinx. Anno
 MCCCCLV") c 1490
 WD

BORCH Gerard ter
Zwolle 1617 – Deventer 1681
The Suitor's Visit → no 89
 cv 31.5×29.5 (80×75 cm)
 c 1658
 ML
The Concert
 cv 27.2×21.6 (69×55 cm)
 school
 TM

BORDONE or **BORDON Paris**
Treviso 1500 – Venice 1571
The Baptism of Christ *
 cv 51.0×52.0 (129,5×132 cm)
 c 1535-40
 WD

BOSCH Hieronymus
's-Hertogenbosch c 1450-60 –
1516
Death and the Miser *
 pn 36.6×12.2 (93×31 cm)
 c 1490
 KR

BOTTICELLI (Sandro Filipepi)
Florence c 1445 – 1510
Portrait of a Youth *
 pn 16.1×12.6 (41×32 cm)
 c 1483-4
 ML
Madonna and Child *
 pn 29.9×21.8 (76×55,5 cm)
 c 1470
 ML
The Adoration of the Magi
 → no 19
 pn 27.6×40.9 (70×104 cm)
 c 1481-2
 ML
The Virgin Adoring the Child
 pn, td 23.4 (59,5 cm) c 1480-90
 KR
Giuliano de' Medici → no 20
 pn 29.7×20.7 (75,5×52,5 cm)
 c 1478
 KR
Madonna and Child with Angels
 pn 35.0×23.6 (89×60 cm)
 c 1465-70 attr
 KR

BOUCHER François
Paris 1703 – 1770
Venus consoling Love → no 112
cv 42.1×33.5 (107×85 cm)
sg d 1751
DL
Allegory of Painting
cv 40.0×51.2 (101,5×130 cm)
sg d 1765
KR
Allegory of Music
cv 40.8×51.2 (103,5×130 cm)
sg d 1764
KR
Madame Bergeret *
cv 56.3×41.3 (143×105 cm)
sg d 1746
KR
Diana and Endymion
cv 37.4×53.9 (95×137 cm)
c 1765
TM
The Love Letter *
cv 31.9×29.1 (81×74 cm)
sg d 1750
TM

BOUDIN Eugène
Honfleur 1824 – Deauville 1898
The Beach at Villerville *
cv 18.1×29.9 (46×76 cm)
sg d 1864
DL
On the Beach, Trouville
pn 7.1×13.0 (18×33 cm)
sg d 1887
DL
On the Beach
pn 5.5×9.4 (14×24 cm)
sg d 1894 ins
DL
Return of the Terre-neuvier
cv 28.9×39.8 (73,5×101 cm)
sg d 1875 ins
DL
The Beach at Trouville
cv 10.2×18.9 (26×48 cm) sg
ML
On the Jetty
pn 7.3×10.8 (18,5×27,5 cm)
false sg and d 1870
ML
The Beach
pn 4.3×10 (11×25,5 cm)
sg 1877 (?)
ML
Women on the Beach at Berck
pn 9.8×14.2 (25×36 cm)
sg d 1881
ML
Yacht Basin at Trouville-Deau-
ville *
pn 18.1×14.6 (46×37 cm) sg
ML
Washerwomen on the Beach of
Etretat
pn 14.6×21.6 (37×55 cm)
sg d 1894
ML
The Beach at Deauville
pn 6.1×9.6 (15,5×24,5 cm)
false sg attr
ML

BOURDON Sébastien
Montpellier 1616 – Paris 1671
Countess Ebba Sparre *
cv 41.7×35.4 (106×90 cm)
c 1653
KR
The Finding of Moses *
cv 47.1×68.1 (119,5×173 cm)
c 1650
KR

**BOUTS Dieric,
Dirk or Thierry**
Haarlem c 1432 – Louvain 1475
Portrait of a Donor *
pn 10.0×8.1 (25,5×20,5 cm)
c 1455
KR

BRADLEY John
act 1832-47 New York
Little Girl in Lavender
cv 33.9×27.4 (86×69,5 cm)
sg c 1840
GR

BRADSHAW J. W.
Eighteenth Century, U.S.A.
Plains Indian (possibly Sitting
Bull)
cv 20.1×16.1 (51×41 cm)
sg 1780 (?)
GR

**BRAMANTINO
(Bartolomeo Suardi)**
Milan (?) c 1465 – Milan 1530
The Apparition of Christ among
the Apostles *
pn 9.4×7.7 (24×19,5 cm)
c 1500 attr
KR

BRAQUE Georges
Argenteuil 1882 – Paris 1963
Nude Woman with Basket of
Fruit 1752
cv 63.8×29.1 (162×74 cm)
sg d 1926
DL
Nude Woman with Fruit 1753 *
cv 39.4×31.9 (100×81 cm)
sg d 1925
DL
Peonies
pn 22.0×27.2 (56×69 cm)
sg d 1926
DL
Still Life: Le Jour *
cv 45.3×57.9 (115×147 cm)
sg d 1929
DL
Still Life: The Table → no 151
cv 31.9×51.6 (81×131 cm)
sg d 1928
DL

BRITISH SCHOOL
Sixteenth Century
The Earl of Essex
pn 45.3×34.6 (115×88 cm)
c 1597

Eighteenth Century
Portrait of a Man 957
cv 50.0×40.0 (127×101,5 cm)
false sg and d
("R.F. Pinx 1748") c 1750
ML
The Earl of Beverly
The Countess of Beverly
Husband and wife portraits
canvases 36.2 and 36.0×28.2
(92 and 91,5×71,5 cm) 1750-75
ML
Portrait of a Little Girl
cv 46.5×33.1 (118×84 cm)
ML
Honorable Sir Francis N.P. Bur-
ton (?)
cv 29.9×25.2 (76×64 cm)
c 1790
ML
James Dawson (?)
pn 29.1×23.2 (74×59 cm)
c 1790
ML

Nineteenth Century
Portrait of a Man 984
cv 48.4×36.2 (123×92 cm)
c 1830
ML

**BRONZINO
(Agnolo di Cosimo di Mariano)**
Florence 1503 – 1572
A Young Woman and Her Little
Boy → no 40
pn 39.2×29.9 (99,5×76 cm)
c 1540
WD
Eleonora di Toledo *
pn 33.1×25.6 (84×65 cm)
c 1560
KR
see also Pontormo

BROWN Mather
Boston 1761 – London 1831
Thomas Dawson, Viscount Cre-
morne
cv 29.9×25.0 (76×63,5 cm)
sg c 1788
ML
William Vans Murray *
cv 30.1×25.0 (76,5×63,5 cm)
sg d 1787
ML

BROWN W. H.
Nineteenth Century, U.S.A.
Bareback Riders *
crt 18.5×24.4 (47×62 cm)
sg d 1886
GR

**BRUEGHEL THE ELDER
Pieter**
*Brueghel or Breda c 1525-30 –
Brussels 1569*
The Martyrdom of Saint Cather-
ine
pn 24.4×46.5 (62×118 cm)
c 1553-4 attr
KR
The Temptation of Saint Antho-
ny *
pn 22.8×33.9 (58×86 cm)
c 1555-8 attr
KR

BRUYN THE ELDER Barthel
... 1493 – Cologne c 1555
Portrait of a Man
pn 13.6×9.3 (34,5×23,5 cm)
c 1535

BUGIARDINI Giuliano
Florence 1475 – 1554
Portrait of a Young Woman *
pn 22.8×19.3 (58×49 cm)
c 1525
KR

BUNDY Horace
Hardwick 1814 – Concord 1883
Vermont Lawyer
cv 44.1×35.4 (112×90 cm)
d 1841
GR

BYZANTINE SCHOOL
Thirteenth Century
Enthroned Madonna and
Child 1 *
pn 32.1×19.3 (81,5×49 cm)
gold ground
ML
Enthroned Madonna and Child
1048 *
pn 51.6×30.3 (131×77 cm)
gold ground
ML

Calvaert see under
Niccolò dell'Abate

**CANALETTO
(Giovanni Antonio Canal)**
Venice 1697 – 1768
View in Venice *
cv 28.0×44.1 (71×112 cm)
c 1740
WD
The Square of Saint Mark *
Venice, the Quay of the Piaz-
zetta
canvases c 45.3×60.6
(c 115×154 cm) sg c 1735-40
The Portello and the Brenta Ca-
nal at Padua → no 62
cv 24.6×43.3 (62,5×110 cm)
c 1735-40
KR
Landscape Capriccio with Co-
lumn
Landscape Capriccio with Pa-
lace
canvases 52.0×40.9 and 42.1
(132×104 and 107 cm) c 1754
KR

Follower of CANALETTO
late Eighteenth Century
The Courtyard, Doge's Palace,
with the Procession of the
Papal Legate
A Fete Day, Venice
canvases 63.4×87.2
(161×221,5 cm)

**CARAVAGGIO
(Michelangelo Merisi)**
*Caravaggio 1573 –
Porto Èrcole 1610*
Still Life *
cv 20.1×28.3 (51×72 cm)
c 1600 attr
KR

CARIANI (Giovanni Busi)
*Venice (?) c 1480-5 –
Venice c 1547*
Portrait of a Man with a Dog *
cv 26.4×21.3 (67×54 cm)
c 1520 ins
KR

CARPACCIO Vittore
Venice 1460-5 – 1525-6
The Flight into Egypt
pn 28.3×43.9 (72×111,5 cm)
c 1500
KR
The Virgin Reading
→ no 28
pn/cv 30.7×20.1
(78×51 cm) c 1505 mutilated
KR
Madonna and Child *
pn 33.5×26.8 (85×68 cm)
c 1505
KR

CARRACCI Annibale
Bologna 1560 – Rome 1609
Landscape
cv 34.8×58.3 (88,5×148 cm)
c 1600
KR
Venus Adorned by the Graces *
pn/cv 52.4×67.1
(133×170,5 cm) c 1595
KR

CARRACCI Ludovico
Bologna 1555 – 1619
The Dream of Saint Catherine
of Alexandria *
cv 54.7×43.5 (139×110,5 cm)
c 1590
KR

CARRIERA Rosalba
Venice 1675 – 1757
Sir John Reade, Bart. *
pastel 22.8×18.1
(58×46 cm) 1739
on rv ins
KR
Allegory of Painting → no 60
pastel 17.7×13.8 (45×35 cm)
c 1720-30
KR
Countess Orzelska
pastel 24.8×20.1 (63×51 cm)
copy

CASSATT Mary
Pittsburgh 1844 – Paris 1926
The Boating Party → no 174
cv 35.4×46.1 (90×117 cm)
1893-4
DL
Miss Mary Ellison
cv 33.5×25.8 (85×65,5 cm)
sg c 1880
DL
Girl Arranging Her Hair *
cv 29.5×24.4 (75×62 cm)
1886
DL
The Loge
cv 31.5×25.2 (80×64 cm)
sg 1882
DL
Mother and Child
cv 36.2×28.9 (92×73,5 cm)
sg c 1905
DL
Portrait of an Elderly Lady
cv 28.7×23.6 (73×60 cm)
c 1887
DL
Woman with a Red Zinnia
cv 28.9×23.6 (73,5×60 cm)
sg 1891
DL
Children Playing on the Beach *
cv 39×29.1 (97,5×74 cm)
sg c 1885
ML

Castagno see **ANDREA
DEL CASTAGNO**

CATLIN George
*Wilkes-Barre 1794-6 –
Jersey City 1872*
Apache Chief and Three War-
riors
crt 18.5×24.4 (47×62 cm)
Antelope Shooting – Assiniboin
cv 17.5×23.6 (44,5×60 cm)
A Whale Ashore - Clayoquot
crt 18.5×24.4 (47×62 cm)
Comanche Chief, His Wife and
a Warrior
crt 18.5×24.8 (47×63 cm)
sg d 1861
See-non-ty-a, an Iowa Medicine
Man *
cv 28.0×22.8 (71×58 cm)
The White Cloud, Head Chief
of the Iowas → no 164
cv 27.8×22.8 (70,5×58 cm)
Mandan War Chief with his Fa-
vorite Wife
crt 18.5×24.4 (47×62 cm)
Three Mandan Warriors Armed
for War
crt 18.5×24.4 (47×62 cm)
sg d 1861
Buffalo Dance-Mandan
crt 18.5×24.4 (47×62 cm)
sg d 1861
A Pawnee Warrior Sacrificing
His Favorite Horse
crt 18.5×24.4 (47×62 cm)
Three Celebrated Ball Players -
Sioux, Ojibwa and Choctaw
crt 18.5×24.4 (47×62 cm)
sg d 1861
Buffalo Lancing in the Snow
Drifts - Sioux
cv 17.5×23.6 (44,5×60 cm)

SOUTH AMERICAN INDIANS
Ostrich Chase, Buenos Ayres -
Auca
cv 18.5×26.0 (47×66 cm)
sg 1852-70
Lengua Indians Ascending the
Rapids of the Rio Uruguay
crt 18.5×24.4 (47×62 cm)
1852-70
Pont de Palmiers and Tiger
Shooting
crt 18.5×24.4 (47×62 cm)

**VOYAGES OF DISCOVERY
BY LA SALLE**
Portage around the Falls of
Niagara
La Salle Claiming Louisiana
for France
canvases 15.0×22.2
(38×56,5 cm) sg 1847-8

CAZIN Jean-Charles
Samer 1841 – Lavandou 1901
The Windmill
pn 15.9×12.6 (40,5×32 cm)
c 1884
Paris Scene with Bridge
pn 9.6×8.3 (24,5×21 cm) sg
ML

CÉZANNE Paul
Aix-en-Provence 1839 – 1906
Le Château Noir *
cv 29.1×38.0 (74×96,5 cm)
c 1904
Vase of Flowers 1509
cv 39.8×32.3 (101×82 cm)
1902-3
Vase of Flowers 1769
cv 28.7×23.6 (73×60 cm)
sg c 1876
DL
The Sailor *
cv 42.1×29.3 (107×74,5 cm)
1904-5
Still Life with Apples and Pea-
ches
cv 31.9×39.6 (81×100,5 cm)
c 1895
The Artist's Son, Paul → no 145
cv 25.6×21.3 (65×54 cm)
DL
Louis Guillaume *
cv 22.0×18.5 (56×47 cm)
1879-82
DL
House of Père Lacroix → no 144
cv 24.0×19.9 (61×50,5 cm)
sg d 1873
DL
Landscape in Provence *
cv 19.7×23.6 (50×60 cm)
1878-83
DL
Still Life 1768 *
cv 26.0×32.3 (66×82 cm)
c 1890
DL
Still Life
cv 18.3×21.6 (46,5×55 cm)
1895-1900
The Artist's Father → no 143
cv 78.0×47.1 (198,5×119,5 cm)
1866 (?)
ML
"La Lutte d'Amour"
cv 15.0×18.1 (38×46 cm)
1875-6
"Le Mont Sainte-Victoire, Envi-
rons de Gardanne"
cv 26.4×36.0 (67×91,5 cm)
1885-6
"Au bord de l'eau"
cv 28.7×36.4 (73× 92,5 cm)
1888-90
Man with Pipe
cv 10.2×8.1 (26×20,5 cm)
1890-2
Antony Valabrègue *
cv 45.7×38.8 (116×98,5 cm)
d 1866
ML
Riverbank *
cv 28.7×36.4 (73×92,3 cm)
ML

CHAMBERS Thomas
act 1807-8 – c 1866 U.S.A.
The Connecticut Valley *
cv 18.1×27.6 (46×70 cm)
c 1850
GR
Felucca off Gibraltar
cv 22.0×29.9 (56×76 cm)
c 1850
GR
The Hudson Valley, Sunset
cv 22.0×29.9 (56×76 cm)
c 1850
GR
Mount Auburn Cemetery
cv 14.0×18.1 (35,5×46 cm)
c 1850
GR

CHAMPAIGNE Philippe de
Brussels 1602 – Paris 1674
Omer Talon → no 107
cv 88.6×63.6 (225×161,5 cm)
sg d 1649
KR

CHANDLER Joseph Goodhue
*South Hadley 1813 –
Hubbardstown 1884*
Charles H. Sisson
cv 48.0×25.2 (122×64 cm)
1850
GR

CHANDLER Winthrop
Woodstock 1747 – 1790
Captain Samuel Chandler

99

Mrs. Samuel Chandler *
Husband and wife portraits
canvases 54.7×47.8
(139×121,5 cm) c 1780
GR

**CHARDIN
Jean-Baptiste-Siméon**
Paris 1699 – 1779
The House of Cards → no 113
cv 32.3×26.0 (82×66 cm)
sg c 1735
ML
The Young Governess → no 114
cv 22.8×29.1 (58×74 cm)
sg c 1739
ML
Soap Bubbles
cv 36.6×29.3 (93×74,5 cm)
sg c 1745
Étienne Jeaurat *
cv 20.1×16.1 (51×41 cm)
sg c 1770
Still Life 741
cv 13.2×16.9 (33,5×43 cm)
c 1755
DL
Still Life 1115 *
cv 19.5×23.4 (49,5×59,5 cm)
sg 1760-5
KR
Portrait of an old Woman
cv 31.7×25.4 (80,5×64,5 cm)
c 1745
KR
The Attentive Nurse *
The Kitchen Maid *
canvases 18.1×14.6 and 14.8
(46×37 and 37,5 cm)
the second sg d 1738
KR
Still Life with a White Mug
cv 13.0×16.1 (33×41 cm)
c 1756

CHASE William Merritt
Franklin 1849 – New York 1916
Chrysanthemums
cv 26.8×44.7 (68×113,5 cm)
sg c 1878
DL
A Friendly Call → no 173
cv 30.1×48.2 (76,5×122,5 cm)
sg d 1895
DL

**CHRISTUS or
CHRISTI Petrus**
Baerle ... – Bruges 1472-3
The Nativity *
pn 51.2×38.2 (130×97 cm)
c 1445
ML
A Donor and his Wife *
portraits of donors
wings of a trp; panels
16.5×8.5 (42×21,5 cm) c 1455
KR

CHURCH Frederic Edwin
Hartford 1826 – New York 1900
Morning in the Tropics
cv 54.3×84.1 (138×213,5 cm)
sg d 1877

CIMABUE (Cenni di Pepo)
Florence ... – Pisa 1302
Christ between Saint Peter and
Saint James Major
trp, shaped panels, centr pn
31.1×21.6 (79×55 cm);
wings 26.4×14.2 (67×36 cm)
gold ground c 1270 ins attr
ML
Madonna and Child with the
Baptist and Saint Peter
pn 13.4×9.8 (34×25 cm)
gold ground c 1290
KR

**CIMA DA CONEGLIANO
Giambattista**
*Conegliano 1459-60 –
Venice c 1518*
Madonna and Child with Saint
Jerome and Saint John the
Baptist *
pn 41.3×57.5 (105×146 cm)
sg c 1510
ML
Saint Jerome in the Wilderness
cv 18.9×15.7 (48×40 cm)
sg c 1495
KR
Saint Helena → no 27
pn 15.7×12.6 (40×32 cm)
c 1495
KR

CLARK Alvan
*Ashfield 1804 –
Cambridge (Mass.) 1887*

Barnabus Clark
cv 27.4×22.2 (69,5×56,5 cm)
c 1838
ML
Lovice Corbett Whittemore
Thomas Whittemore
Husband and wife portraits
canvases 30.3×25.0
(77×63,5 cm) 1845 and 1844

Claude Lorrain see
LORRAIN

CLEVE or der BEKE Joos van
*Cleve (?) c 1495 –
Antwerp 1540-1*
Joris W. Vezeler *
Margaretha Boghe, Wife of Jo-
ris W. Vezeler *
Husband and wife portraits
ar panels c 22.8×15.7
(c 58×40 cm) c 1520

CLOUET François
... – Paris 1572
Diane de Poitiers (?) → no 106
pn 36.2×31.9 (92×81 cm)
sg c 1571
KR

COE Elias V.
act 1829-37 U.S.A.
Henry W. Houston
Mrs. Phebe Houston
Husband and wife portraits
canvases 28.0×22.0
(71×56 cm) 1837
GR

COLE Thomas
*Bolton-le-Moor 1801 –
Catskill 1848*
The Notch of the White Moun-
tains (Crawford Notch)
cv 40.1×61.4 (101,5×156 cm)
sg d 1839
ML
The Voyage of Life:
Childhood
Youth
Manhood
Old Age
canvases c 52.8×77.6, 76.8,
78.5, 77.2
(c 134×197, 195, 199, 196 cm)
1841-2

CONSTABLE John
*East Bergholt 1776 –
London 1837*
A View of Salisbury Cathedral
→ no 161
cv 28.7×35.8 (73×91 cm)
c 1825
ML
The White Horse *
cv 50.0×72.0 (127×183 cm)
c 1819
WD
Wivenhoe Park, Essex *
cv 22.0×39.8 (56×101 cm) 1816
WD

COOKE L. M.
Nineteenth Century, U.S.A.
Salute to General Washington
in New York Harbor
cv 27.0×40.2 (68,5×102 cm)
sg c 1890
GR

COPLEY John Singleton
Boston 1738 – London 1815
Mrs. Metcalf Bowler
cv 50.0×40.2 (127×102 cm)
c 1763
Jane Browne
cv 30.1×25.2 (76,5×64 cm)
sg d 1756
ML
The Copley Family → no 167
cv 72.4×90.4 (184×229,5 cm)
1776-7
ML
The Death of the Earl of Cha-
tham
cv 20.9×25.2 (53×64 cm)
sg d 1779
Colonel Fitch and his Sisters
cv 101.6×133.9 (258×340 cm)
1800-1
Baron Graham
cv 56.3×46.9 (143×119 cm)
sg 1804 ins
The Red Cross Knight
cv 83.9×107.5 (213×273 cm)
1793
Epes Sargent
cv 49.8×40.0 (126×101,5 cm)
c 1760
Eleazer Tyng
cv 49.6×40.2 (126×102 cm)
sg d 1772

Watson and the Shark *
cv 71.7×91.5 (182×232,5 cm)
sg d 1778

**CORNEILLE DE LYON or
DE LA HAYE Claude**
*The Hague 1500-10 –
Lyons c 1574*
Portrait of a Man *
pn 6.5×5.5 (16,5×14 cm)
c 1540

COROT Jean-Baptiste-Camille
Paris 1796 – 1875
The Artist's Studio *
pn 24.4×15.7 (62×40 cm)
sg c 1855-60
WD
The Forest of Coubron *
cv 37.8×29.9 (96×76 cm)
sg d 1872
WD
View near Épernon
cv 12.8×21.1 (32,5×53,5 cm)
sg 1850-60
WD
The Eel Gatherers
cv 23.8×32.1 (60,5×81,5 cm)
sg c 1860-5
River View
pn 12.6×16.5 (32×42 cm)
sg c 1870
Gipsy Girl with Mandolin
cv 25.2×20.1 (64×51 cm)
sg c 1870-5
Italian Girl
cv 25.6×20.7 (65×52,5 cm)
sg c 1871-2
Ville d'Avray *
cv 19.3×25.6 (49×65 cm)
sg c 1867-70
Saint Sebastian Succored by
the Holy Women
cv 51.2×33.9 (130×86 cm)
sg c 1874
TM
Italian Peasant Boy
cv 10.0×12.8 (25,5×32,5 cm)
sg 1825-6
DL
Portrait of a Young Girl *
cv 10.6×9.1 (27,5×23 cm)
sg d 1859
DL
Agostina → no 120
cv 52.2×38.4 (132,5×97,5 cm)
sg 1866 (?)
DL
Forest of Fontainebleau
→ no 121
cv 69.1×95.5 (175,5×242,5 cm)
sg c 1830
DL
Rocks in the Forest of Fontai-
nebleau *
cv 18.1×23.0 (46×58,5 cm)
sg c 1860-5
DL
A View near Volterra *
cv 27.4×37.4 (69,5×95 cm)
sg d 1838
DL
River Scene with Bridge
cv 9.8×13.4 (25×34 cm)
ML
Madame Stumpf and Her
Daughter
cv 41.7×29.1 (106×74 cm)
sg 1873
ML

**CORREGGIO
(Antonio Allegri)**
Correggio 1489 – 1534
The Mystic Marriage of Saint
Catherine *
pn 11.0×8.3 (28×21 cm)
c 1515
KR
"Salvator Mundi" *
pn 16.5×13.0 (42,5×33 cm)
c 1515
KR
Madonna and Child with the
Infant Saint John
pn 27.2×20.1 (69×51 cm)
c 1515 attr
TM
see also Pratt

COSSA Francesco del
Ferrara c 1435 – Bologna c 1477
Saint Florian *
Saint Lucy → no 21
ar panels 31.1×21.6 and 22.0
(79×55 and 56 cm) c 1470
KR
The Crucifixion *
pn; td 25.2 (64 cm) c 1470
KR
Madonna and Child with An-
gels
pn 21.1×14.2 (53,5×36 cm)
c 1465
KR

COTES Francis
London 1725 – 1770
Portrait of a Lady 1558, 1559
oval canvases 7.9×6.3
(20×16 cm) 1765-70
TM
Miss Elizabeth Crewe *
cv 30.7×24.8 (78×63 cm)
1765-70

COURBET Gustave
*Ornans 1819 – La Tour de Peilz
(Switzerland) 1877*
The Stream *
cv 40.9×53.9 (104×137 cm)
sg d 1855
La Grotte de la Loue
cv 38.8×51.4 (98,5×130,5 cm)
sg c 1865
Beach at Étretat *
cv 24.0×35.4 (61×90 cm)
sg c 1869
DL
Portrait of a Young Girl
cv 23.8×20.7 (60,5×52,5 cm)
sg d 1857
DL
The Promenade
cv 33.7×28.5 (85,5×72,5 cm)
sg d 1866
DL
A Young Woman Reading
→ no 122
cv 23.6×28.7 (60×73 cm)
sg 1868-72
DL

**CRANACH THE ELDER Lucas
(L. Sunder or Müller de C.)**
Kronach 1472 – Weimar 1553
A Prince of Saxony *
A Princess of Saxony *
panels 17.3×c 13.4
(44×c 34 cm) c 1517
BTH
Madonna and Child
pn 28.0×20.5 (71×52 cm)
c 1535
Portrait of a Man *
Portrait of a Woman → no 95
Husband and wife portraits
panels 22.4×c 15.0
(57×c 38 cm) the first
sg d 1522
KR
The Nymph of the Spring
pn 19.1×28.7 (48,5×73 cm)
sg c 1537 ins
The Crucifixion with Longinus *
pn 20.1×13.8 (51×35 cm)
sg d 1536 ins
KR

CRESPI Giuseppe Maria
Bologna 1665 – 1747
Cupids with Sleeping Nymphs
copper 20.9×29.9
(53×76 cm) c 1700
KR
Lucretia threatened by Tar-
quin *
cv 76.8×67.7 (195×172 cm)
c 1700-10
KR

CRETI Donato
Cremona 1671 – Bologna 1749
The Quarrel *
cv 47.2×67.5 (120×171,5 cm)
c 1739
KR

CRIVELLI Carlo
Venice c 1431 – ... c 1493
Madonna and Child → no 25
pn 15.4×12.2 (39×31 cm)
c 1490
KR
Madonna and Child Enthroned
with Donor *
ar pn 51.0×21.5
(129,5×54,5 cm) c 1470 ins
KR

**Follower of
CROME John (Old C.)**
Norwich 1768 – 1821
Harling Gate, near Norwich
cv 48.4×39.0 (123×99 cm)
c 1817
WD

CROPSEY Jasper Francis
*Rossville 1823 –
Hastings-on-Hudson 1900*
Autumn - On the Hudson River
cv 60.1×107.9 (152,5×274 cm)
sg d 1860

CUITT THE YOUNGER George
Richmond 1779 – Masham 1854
Easby Abbey, near Richmond
cv 26.0×36.0 (66×91,5 cm)
c 1829

CUYP Aelbert
Dordrecht 1620 – 1691
Herdsmen Tending Cattle *
cv 26.0×34.6 (66×88 cm)
sg c 1650
ML
The Maas at Dordrecht *
cv 45.3×66.9 (115×170 cm)
sg c 1660
ML
Lady and Gentleman on Horse-
back
cv 48.4×67.7 (123×172 cm)
sg c 1660
WD
Horsemen and Herdsmen with
Cattle
cv 47.2×67.5 (1206×171,5 cm)
sg c 1660-70
WD

DADDI Bernardo
act c 1312-48 Florence
Saint Paul *
cusped pn 92.1×35.0
(234×89 cm) d 1333 ins
ML
Madonna and Child with Saints
and Angels
lobate pn 19.7×9.4
(50×24 cm) gold ground
1330-40
KR
The Crucifixion
pn 14.2×9.3 (36×23,5 cm)
c 1335
KR

DALI Salvador
Figueras 1904 –
The Sacrament of the Last Sup-
per → no 105
cv 65.7×105.1 (167×267 cm)
sg d 1955
DL

**DAUBIGNY
Charles-François**
Paris 1817 – 1878
Landscape with Figures
pn 9.6×18.1 (24,5×46 cm)
sg d 1865
The Farm *
cv 20.3×31.9 (51,5×81 cm)
sg d 1855
DL

DAUMIER Honoré
*Marseilles 1808 –
Valmondois 1879*
Advice to a Young Artist
→ no 124
cv 16.1×13.0 (41×33 cm)
sg 1860 (?)
RS
In Church
pn 5.9×8.7 (15×22 cm)
1860 (?)
RS

Follower of DAUMIER
The Beggars *
cv 23.6×29.1 (60×74 cm)
sg c 1845
DL
French Theater *
pn 10.2×13.8 (26×35 cm)
sg c 1857-60
DL
Wandering Saltimbanques *
pn 12.8×9.8 (32,5×25 cm)
c 1847-50
DL
Feast of the Gods
pn 11.4×15.4 (29×39 cm)
c 1850
RS
Hippolyte Lavoignat
cv 18.3×15.0 (46,5×38 cm)
c 1860
DL

DAVID Charles
Cadenet 1797 – Avignon 1869
Portrait of a Young Horse-
woman *
cv 29.3×23.8 (74,5×60,5 cm)
sg d 1839
DL

DAVID Gerard
Oudewater 1450-60 – Bruges 1523
The Rest on the Flight into
Egypt → no 72
pn 17.7×17.5 (45×44,5 cm)
c 1510
ML
The Saint Anne Altarpiece *
trp; panels, centr pn
94.1×38.0 (239×96,5 cm);
wings 94.1×28.0 (239×71 cm)
c 1500-10 ins
WD

100

DAVID Jacques-Louis
Paris 1748 – Brussels 1825
Madame David → no 118
portrait of the artist's wife
cv 28.7×23.4 (73×59,5 cm)
sg d 1813
KR
Napoleon in his Study
→ no 117
cv 80.3×49.2 (204×125)
sg d 1812 ins
KR
Madame Hamelin *
cv 49.4×37.4 (125,5×95 cm)
c 1800 st
DL

DAVIES Arthur B.
Utica 1862 – Italy 1928
Sweet Tremulous Leaves
cv 30.3×18.1 (77×46 cm)
sg 1922-3
DL

DEARTH Henry Golden
Bristol 1864 – New York 1918
Flecks of Foam
pn 17.7×21.6 (45×55 cm)
sg 1911-2
DL

DE CHIRICO Giorgio
Volo (Greece) 1888 –
Conversation among the Ruins
→ no 66
cv 51.4×38.2 (130,5×97 cm)
sg 1927
DL

DEGAS Hilaire-Germain-Edgar
Paris 1834 – 1917
The Races *
cv 10.4×13.8 (26,5×35 cm)
sg c 1873
WD
Before the Ballet *
cv 15.7×35.0 (40×89 cm)
sg 1888
WD
Madame Dietz-Monin
pastel 23.6×17.7 (60×45 cm)
c 1879
Ballet Scene
pastel 30.3×43.7 (77×111 cm)
1906-8
or rv atelier stamp
DL
Girl in red *
cv 39.0×31.9 (99×81 cm)
1873-5
DL
Mademoiselle Malo *
cv 31.9×25.6 (81×65 cm)
c 1877
on rv atelier stamp
DL
Madame Camus *
cv 28.7×36.2 (73×92 cm)
1870
like the prec work
DL
Four Dancers → no 132
cv 59.4×70.9 (151×180 cm)
1896-9
like the prec work
DL
Achille De Gas in the Uniform
of a Cadet → no 131
cv 25.4×20.1 (64,5×51 cm)
c 1856-7
DL
Madame René De Gas
portrait of the artist's wife
cv 28.7×36.2 (73×92 cm)
1872-3
on rv atelier stamp
DL
Duke and Duchess of Morbilli
cv 46.1×35.4 (117×90 cm)
c 1865
DL
Roses
cv 6.9×5.1 (17,5×13 cm)
sg 1921
Horses
pn 7.3×9.4 (18,5×24 cm) sg
Girl Drying Herself
pastel 31.1×20.3
(79×51,5 cm) sg d 1885
Dancers Backstage
cv 9.4×7.5 (24×19 cm)
sg 1882 (?)
Dancers at the Old Opera
House
cv 8.7×6.7 (22×17 cm) sg
ML
Ballet Dancers
past 11.6×10.6 (29,5×27 cm)
sg
ML

DELACROIX Eugène
Charenton-Saint-Maurice 1798 – Paris 1863
Columbus and his Son at La
Rabida
cv 35.6×46.5 (90,5×118 cm)
sg d 1838
DL
The Arab Tax → no 123
cv 36.2×29.3 (92,5×74,5 cm)
sg d 1863
DL

Follower of DELACROIX
Michelangelo in his Studio *
pn 9.4×7.3 (24×18,5 cm)
1849 (?)
on rv "ED" stamp
DL
Algerian Child *
cv 18.3×15.0 (46,5×38 cm)
sg c 1832

DELAUNAY Robert
Paris 1885 – Montpellier 1941
Political Drama *
crt 35.0×26.0 (89×66 cm) 1914
collage

De Predis see PREDIS

DERAIN André
Chatou 1880 – Paris 1954
Head of a Woman
cv 14.2×13.0 (36×33 cm)
sg 1926
DL
Portrait of a Girl
cv 24.0×18.3 (61×46,5)
sg 1923-4
DL
Woman in an Armchair
cv 36.4×29.1 (92,5×74 cm)
sg 1920-5
DL
Woman in a Chemise *
cv 30.7×23.8 (78×60,5 cm)
sg c 1928
DL
Flowers in a Vase
cv 29.5×37.0 (75×94 cm)
sg 1932
DL
Harlequin *
cv 29.1×24.0 (74×61 cm)
sg 1919
DL
The Old Bridge *
cv 31.9×39.4 (81×100 cm)
sg 1910
DL
Still Life 1795
cv 28.7×36.4 (73,5×92,5 cm)
sg 1913
DL
Road in Provence
cv 13.2×16.3 (33,5×41,5 cm)
sg
ML
Abandoned House in Provence
cv 13.6×16.9 (34,5×43 cm) sg
ML
Still Life
cv 36.4×29.1 (92,5×74 cm)
1913
The Kitchen Table
cv 38.6×46.5 (98×118 cm)
sg 1923
Mediterranean Landscape
cv 29.5×37.0 (75×94 cm)
sg 1926
Portrait of Marie Harriman
cv 43.5×44.5 (110,5 113 cm)
sg 1935
La Route d'Ollières
cv 24.4×20.1 (62×51 cm)
sg 1930
Le Mont Olympe
cv 13.0×16.5 (33×42 cm)
sg 1930
Landscape
cv 13.0×15.9 (33×40,5 cm)
sg 1929
Head of a Girl
pn 16.7×11.0 (42,5×28 cm)
sg 1918
The Green Scarf
cv 6.9×9.3 (17,5×23,5 cm)
sg 1935
Portrait of Eve Curie
cv 18.5×15.0 (47×38 cm)
sg 1938

DEVIS Arthur
Preston 1711 – London 1787
Lord Brand of Hurndall Park
cv 27.6×38.6 (70×98 cm)
sg d 1756
Conversation Piece, Ashdon
House
cv 54.5×77.0 (138,5×195,5 cm)
c 1760

DIANA Benedetto
(B. Rusconi)
Venice ... – 1525
The Presentation and Marriage
of the Virgin, The Annuncia-
tion
frm of a pred; pn 14.6×64.6
(37×164 cm) c 1520-5
KR

DIAZ DE LA PEÑA
Narciso Virgilio
Bordeaux 1808 – Menton 1876
Forest Scene
pn 12.6×17.3 (32×44 cm)
sg d 1874

DOMENICO DI BARTOLO
act c 1428-46 Siena
Madonna and Child Enthroned
with Saint Peter and Saint
Paul *
pn 20.9×12.2 (53×31 cm)
c 1430
KR

DOMENICO VENEZIANO
Venice ... – Florence 1461
Matteo Olivieri → no 12
pn/cv 18.7×13.4 (47,5×34 cm)
1440 ins
attr also to Paolo Uccello
(Florence 1397-1475)
ML
Saint Francis Receiving the
Stigmata *
Saint John in the Desert → no
13
panels of a pred; 10.6×12.0
and 11.2×12.8 (27×30,5 cm
and 28,5×32,5 cm) c 1445
KR
Madonna and Child *
pn 32.7×22.4 (83×57 cm)
c 1445
KR

DOOD Lamar
... 1909 –
Winter Valley
cv 38.0×50.0 (96,5×127 cm)
d 1944

DOORNIK F. V.
Eighteenth Century, U.S.A.
Anna de Peyster (?)
Isaac de Peyster (?)
Husband and wife portraits
oval canvases 30.1×c 24.0
(76,5×c 61 cm)
d 1731 the first sg
DL

DOSSO DOSSI
(Giovanni Luteri)
Ferrara 1489-90 – 1542
The Standard Bearer *
cv 33.1×28.0 (84×71 cm)
c 1520 attr
KR
Scene from a Legend → no 48
cv 23.6×35.4 (60×90 cm)
c 1520
mutilated (?)
KR
Saint Lucretia
pn 20.9×16.5 (53×42 cm)
c 1520 ins
KR
Circe and Her Lovers in a Land-
scape *
cv 39.8×53.5 (101×136 cm)
c 1515
KR

DOU Gerard
Leiden 1613 – 1675
The Hermit *
pn 18.1×13.6 (46×34,5 cm)
sg d 1670
TM

DOUGHTY Thomas
*Philadelphia 1793 –
New York 1856*
Fanciful Landscape
cv 30.1×39.8 (76,5×101 cm)
sg d 1834

DOVE Arthur G.
*Canandaigua 1880 –
Centerfort 1946*
Moth Dance
cv 20.1×26.0 (51×66 cm)
sg 1929

DROUAIS François-Hubert
Paris 1727 – 1775
Group Portrait *
cv 96.1×76.8 (244×195 cm)
sg d 1756
KR

Madame du Barry
oval cv 28.0×23.2 (71×59 cm)
c 1770 (?)
TM
Marquis d'Ossum
cv 85.8×64.6 (218×164 cm)
1762 (?)

DROUAIS Hubert
La Roque 1699 – Paris 1767
Portrait of a Lady
cv 46.5×37.4 (118×95 cm)
c 1750

DU BOIS Guy Pène
Brooklyn 1884 – Boston 1958
"Café du Dôme" → no 176
pn 21.6×18.1 (55×46 cm)
sg d 1925-6
DL
Hallway, Italian Restaurant *
cv 25.2×20.1 (64×51 cm)
sg d 1922
DL
The Politicians *
cv 16.1×12.2 (41×31 cm)
sg 1912 (?)
DL
La Rue de la Santé
cv 36.2×28.7 (92×73 cm)
sg d 1928 (?)
DL

DUCCIO DI BUONINSEGNA
Siena ... – 1318-9
Nativity with the Prophets
Isaiah and Ezekiel → no 2
The Calling of the Apostles
Peter and Andrew → no 3
panels; the first is a trp;
centr pn 17.3×17.5
(44×44,5 cm) side panels
17.3×6.5 (44×16,5 cm) the
second 17.1×18.1 (43,5×46
cm) 1308-11
panels of pred from the Mae-
stà at Siena, Museo dell'Ope-
ra del Duomo
ML; KR

**Follower of
DUCCIO DI BUONINSEGNA**
early Fourteenth Century
Madonna and Child Enthroned
with Angels
cusped pn 90.8×55.9
(230,5×142 cm)
KR

DUFRESNE Charles
Millemont 1876 – ... 1938
Judgment of Paris
cv 51.6×64.0 (131×162,5 cm)
sg 1925
DL
Still Life
cv 32.1×39.4 (81,5×100 cm)
sg 1927-8
DL

DUFY Raoul
Le Havre 1877 – Forcalquier 1953
The Basket
cv 21.3×25.6 (54×65 cm)
sg 1926
DL
Reclining Nude → no 153
cv 25.8×31.9 (65,5×81 cm)
sg d 1930
DL
Saint-Jeannet *
cv 31.9×39.4 (81×100 cm)
sg 1910
DL
Regatta at Cowes
cv 32.1×39.6 (81,5×100,5 cm)
sg d 1934
ML
Regatta at Henley
cv 35.0×63.8 (89×162 cm)
1937 (?)
ML
The Basin at Deauville
cv 32.1×39.6 (81,5×100,5 cm)
sg
ML

DUPRÉ Jules
Nantes 1811 – L'Isle-Adam 1889
The Old Oak
cv 12.6×16.5 (32×42 cm)
c 1870

DURAND Asher Brown
*Maplewood 1796 –
New Jersey 1886*
Gouverneur Kemble
cv 34.3×26.8 (87×68 cm)
sg d 1853
ML
Portrait of a Man
cv 34.1×27.2 (86,5×69 cm)
c 1840
ML

Madame du Barry
Madame du Barry

DÜRER Albrecht
Nuremberg 1471 – 1528
Madonna and Child
(on rv Lot and his daughters)
pn 19.7×15.7 (50×40 cm)
on r sg c 1505
KR
Portrait of a Clergyman → no 94
parchment on cv 16.9×13.0
(43×33 cm) sg d 1516
KR
see also Schäufelein

DUTCH SCHOOL
Seventeenth Century
Portrait of a Man 1006
cv 21.5×16.5 (54,5×42 cm)
c 1655 false ins
ML
Eighteenth Century
Portrait of a Man 1000
cv 29.9×25.6 (76×63,5 cm)
false sg and d
("J. Smibert fecit 1734")
ML

DUVENECK Frank
Covington 1848 – Cincinnati 1919
Leslie Pease Barnum
cv 22.0×18.1 (56×46 cm) 1876
ML
William Gedney Bunce
cv 30.5×26.0 (77,5×66 cm)
1878 (?)
ML

DYCK Anthonis van
Antwerp 1599 – London 1641
Susanna Fourment and Her
Daughter *
cv 68.1×46.1 (173×117 cm)
c 1620
ML
Marchesa Balbi *
cv 72.0×48.0 (183×122 cm)
1622-7
ML
Philip, Lord Wharton *
cv 52.4×41.7 (133×106 cm)
sg d 1632 ins
ML
William II of Nassau and Oran-
ge *
cv 41.3×34.3 (105×87 cm)
c 1640 attr
ML
Portrait of a Flemish Lady
cv 48.4×35.4 (123×90 cm)
1618-21
ML
The Assumption of the Virgin
cv 46.5×40.2 (118×102 cm)
c 1627
WD
Giovanni Vincenzo Imperiale
cv 50.0×41.5 (127×105,5 cm)
1625 ins
WD
The Prefect Raphael Racius
cv 51.6×41.5 (131×105,5 cm)
c 1625 ins
WD
Paola Adorno, Marchesa Bri-
gnole Sale, and Her Son *
cv 74.4×55.1 (189×140 cm)
c 1625
WD
Marchesa Elena Grimaldi, Wife
of Marchese Nicola Cattaneo
→ no 76
cv 87.1×68.1 (246,5×173 cm)
1623 (?)
WD
Filippo Cattaneo, Son of Mar-
chesa Elena Grimaldi
Clelia Cattaneo, Daughter of
Marchesa Elena Grimaldi
→ no 77
canvases c 48.0×33.1
(c 122×84 cm) d 1623 ins
WD
Lady D'Aubigny
cv 41.9×33.5 (106,5×85 cm)
c 1638 ins
WD
Henri II de Lorraine, Duc de
Guise *
cv 80.5×48.8 (204,5×124 cm)
c 1634
KR
Queen Henrietta Maria with Her
Dwarf
cv 86.2×53.1 (219×135 cm)
1633 (?)
KR
Portrait of a Man
pn 20.1×16.1 (51×41 cm)
KR
Doña Polyxena Spinola Guz-
mán de Leganés
cv 43.3×38.2 (110×97 cm)
c 1630-3
KR

101

Group of Four Boys
cv 50.0×39.8 (127×101 cm)
school
TM
see also Rubens

EAKINS Thomas
Philadelphia 1844 – 1916
The Biglin Brothers Racing
→ no 172
cv 24.0×36.2 (61×92 cm)
c 1873
Dr. John H. Brinton
cv 78.3×57.1 (199×145 cm)
sg d 1876 ins
Monsignor Diomede Falconio
cv 72.0×54.3 (183×138 cm)
1905
Louis Husson
Mrs. Louis Husson *
Husband and wife portraits
canvases 24.0×20.1
(61×51 cm) sg
the first d 1899 ins the second
c 1905

EARL Ralph
*Worcester County 1751 –
Bolton 1801*
Daniel Boardman
cv 81.5×55.1 (207×140 cm)
sg d 1789
Thomas Earle *
cv 37.4×33.9 (95×86 cm)
sg d 1800
ML
Dr. David Rogers
Martha Tennent Rogers and
Daughter
Husband and wife portraits
with their daughter
canvases 34.1×28.8
(86,5×73,3 cm) sg d 1788
GR

**EARL Ralph
Eleaser Whiteside**
*England 1788 –
Hermitage (Nashville) 1838*
Family Portrait *
cv 46.5×63.4 (118×161 cm)
sg d 1804
GR

EICHHOLTZ Jacob
Lancaster 1776 – 1842
Robert Coleman
Mrs. Robert Coleman
Husband and wife portraits
canvases 36.2×28.0
(92×71 cm) c 1820
William Clark Franzer
cv 29.9×25.0 (76×63,5 cm)
c 1830
ML
Phoebe Cassidy Freeman
cv 27.6×22.2 (70×56,5 cm)
c 1830
ML
Julianna Hazlehurst
cv 29.5×24.8 (75×63 cm)
false sg "T. S."
(Thomas Sully) c 1820
ML
Mr. Kline
oval pn 9.1×6.9 (23×17,5 cm)
c 1808
GR
Henry Eichholtz Leman
cv 29.9×25.2 (76×64 cm)
c 1835
ML
Mr. Leman
Joseph Leman
Miss Leman
portraits of father and chil-
dren
oval panels 9.1×6.7
(23×17 cm) the third
sg d 18.. (c 1808)
GR
The Ragan Sisters *
cv 59.1×49.2 (150×109 cm)
c 1820
James P. Smith
cv 59.1×42.9 (150×109 cm)
c 1835
ML

ELLIOTT Charles Loring
Scipio 1812 – Albany 1868
Captain Watten Delano
oval cv 35.8×28.3 (91×72 cm)
sg 1852
William Sidney Mount
cv 30.3×25.0 (77×63,5 cm)
sg c 1850
ML

Erri see **AGNOLO DEGLI E.**

EYCK Jan van
Bruges c 1385 – 1441
The Annunciation → no 67
pn/cv 36.6×14.4 (93×36,5 cm)
c 1425-30 ins
ML

FANTIN-LATOUR Henri
Grenoble 1836 – Buré 1904
Duchess de Fitz-James
Mademoiselle de Fitz-James
portraits of mother and
daughter
canvases c 20.1×c 16.5
(c 51×c 42 cm)
sg the second d 1867
DL
Self-Portrait
cv 16.1×13.0 (41×33 cm)
sg 1858
DL
Portrait of Sonia *
cv 42.9×31.9 (109×81 cm)
sg d 1890 ins
DL
Still Life *
cv 24.4×29.5 (62×75 cm)
sg d 1866
DL

FEI Paolo di Giovanni
act 1369-1411 Siena
The Presentation of the Virgin *
pn/masonite 57.9×55.3
(147×140,5 cm) c 1400
KR
The Assumption of the Virgin
pn 26.4×15.0 (67×38 cm)
c 1385
KR

FEININGER Lyonel
New York 1871 – 1956
Storm Brewing
cv 19.1×30.7 (48,5×78 cm)
sg 1939
Zirchow VII *
cv 31.7×39.6 (80,5×100,5 cm)
sg d 1918

FEKE Robert
*Oyster Bay 1706 –
Bermuda or Barbados c 1751*
Captain Alexander Graydon
cv 39.8×35.4 (101×90 cm)
1746 (?)
GR

FETTI Domenico
Rome c 1589 – Venice 1623
The Parable of Dives and Laz-
arus *
cv 23.6×16.9 (60×43 cm)
1615-20
KR
The Veil of Veronica
pn 32.1×26.6 (81,5×67,5 cm)
1613-21 (?)
KR

FIELD Erastus Salisbury
Leverett 1805 – Sunderland 1900
Ark of the Covenant
cv 20.1×24.0 (51×61 cm)
c 1865-80
GR
"He Turned Their Waters into
Blood"
cv 30.3×40.6 (77×103 cm)
c 1865-80
GR
Man with Vial
Wife of Man with Vial
canvases 29.5×c23.2
(75×c 59 cm) c 1827
GR
Mr. Pease
Mrs. Harlow A. Pease *
Husband and wife portraits
canvases 35.0×29.1
(89×74 cm) c 1835
GR

FLEMISH SCHOOL
Sixteenth Century
Goosen van Bonhuysen
pn 33.3×25.0 (84,5×63,5 cm)
1542 ins

FLORENTINE SCHOOL
Sixteenth Century
Apollo and Marsyas
pn 22.0×46.1 (56×117 cm)
c 1540
KR
Allegorical Portrait of Dante
→ no 42
pn 50.0×47.2 (127×120 cm)
c 1530
KR

FOPPA Vincenzo
Brescia 1427-30 – 1515-6
Saint Bernardine *
Saint Anthony of Padua
panels of a polyptych;
c 58.7×c 22.4 (c 149×c 57 cm)
the first ins c 1500
KR

FORAIN Jean-Louis
Reims 1852 – Paris 1931
Artist and Model *
cv 21.5×25.8 (54,5×65,5 cm)
sg d 1925
RS
Behind the Scenes *
cv 18.3×15.2 (46,5×38,5 cm)
sg c 1880
RS
The Stockade
cv 29.9×26.0 (76×66 cm)
sg c 1908 (?)
RS
The Petitioner
cv 24.2×20.1 (61,5×51 cm)
sg c 1910
RS
The Charleston
cv 23.6×28.9 (60×73,5 cm)
sg d 1926
DL

FRAGONARD Jean-Honoré
Grasse 1732 – Paris 1806
A Game of Horse and Rider *
A Game of Hot Cockles *
oval canvases 45.3×34.5 and
45.5×36.0 (115×87,5 cm and
115,5×91,5 cm) 1767-73
KR
The Visit to the Nursery
cv 28.7×36.2 (73×92 cm)
c 1784
KR
Love as Folly
Love as Conqueror
canvases 22.0×18.3
(56×46,5 cm) c 1775
Blindman's Buff *
The Swing *
canvases c 85.0×78.0 and 73.0
(c 216×198 cm and 185,5 cm)
c 1765 (?)
KR
Hubert Robert *
cv 25.6×22.5 (65×54,5 cm)
c 1760
KR
The Happy Family
oval cv 21.3×25.6 (54×65 cm)
c 1769
TM
A Young Girl Reading → no 116
cv 31.9×25.6 (81×65 cm)
c 1776
Love as Jester
Love as Sentinel
oval canvases 21.3×17.7
(54×45 cm) sg
ML

**FRANCESCO
DI GIORGIO MARTINI**
Siena 1439 – 1502
God the Father Surrounded by
Angels and Cherubim *
oval pn 14.4×20.5
(36,5×52 cm) c 1470
frm of the Nativity, New York,
Metropolitan Museum
KR

**FRANCIA Francesco
(F. Raibolini)**
Bologna c 1450 – 1517
Bishop Altobello Averoldo *
pn 20.9×15.7 (53×40 cm)
1505 (?) ins
KR

FRANCO-FLEMISH SCHOOL
early Fifteenth Century
Profile Portrait of a Lady
→ no 68
pn 20.5×14.4 (52×36,5 cm)
c 1410
ML

FRENCH SCHOOL
*early Fifteenth Century,
Amiens*
The Expectant Madonna with
Saint Joseph *
ar pn 27.6×13.4 (70×34 cm)
gold ground c 1437
KR

late Fifteenth Century
Portrait of an Ecclesiastic *
pn 11.4×8.7 (29×22 cm) c 1480
KR

A Knight of the Golden Fleece
pn 26.8×21.1 (68×53,5 cm)
c 1495

Sixteenth Century
Portrait of a Nobleman
pn 12.8×9.3 (32,5×23,5 cm)
c 1570
Prince Hercule-François, Duc
d'Alençon *
cv 74.2×40.2 (188,5×102 cm)
1572 ins
KR

Seventeenth Century
Portrait of a Man
cv 23.0×18.5 (58,5×47 cm)
c 1650
ML

Eighteenth Century
The Adoration of the Skulls
cv 20.9×25.0 (53×63,5 cm)
Singerie:
The Concert
The Dance
The Fishermen
The Picnic
The Painter
The Sculptor
canvases c 35.4×59.4, 56.7,
56.3, 58.7; the last two
c 32.3×c 46.9 (c 90×151 cm,
144 cm, 143 cm, 149 cm; the
last two c 82×c 119 cm)
The Rape of the Sabine Women
cv 22.4×43.7 (57×111 cm)
c 1635 formerly attr to Rubens
WD

Nineteenth Century
Portrait of a Lady
cv 12.8×9.6 (32,6×24,5 cm)
false sg ("E. G. Malbone")
c 1810
ML

FRIESEKE Frederick Carl
Oworso 1874 – ... 1939
The Basket of Flowers *
cv 31.9×32.1 (81×81,5 cm)
sg c 1913
DL
Memories
cv 51.8×51.2 (131,5×130 cm)
sg d 1915

FROTHINGHAM James
*Charlestown 1786 –
Brooklyn 1864*
Ebenezer Newhall
cv 26.0×20.1 (66×51 cm)
c 1810
ML

FULLER George
Deerfield 1822 – Brookline 1884
Agnes Gordon Higginson, Wife
of George Fuller
portrait of the artist's wife
cv 27.2×22.0 (69×56 cm)
c 1877
Mrs. Stephen Higginson
cv 27.2×22.0 (69×56 cm) 1876
Violet
cv 27.0×22.0 (68,5×56 cm)
d 1882 ins

GADDI Agnolo
Florence ... – 1396
Madonna Enthroned, with
Saints and Angels
pn 80.7×96.5 (205×245 cm)
c 1390
ML
The Coronation of the Virgin
→ no 6
pn 64.0×31.3 (162,5×79,5 cm)
c 1370
KR

GAINSBOROUGH Thomas
Sudbury 1727 – London 1788
Mrs. Richard Brinsley Sheri-
dan *
cv 86.6×60.6 (220×154 cm)
1785-6 (?)
ML
Georgiana, Duchess of Devon-
shire *
cv 92.7×57.7 (235,5×146,5 cm)
1783 (?) copy
ML
George IV as Prince of Wales
oval cv 29.9×24.8 (76×63 cm)
1780-8 st
ML
Miss Catherine Tatton
cv 29.9×25.2 (76×64 cm)
1785 (?)
ML

Mrs. John Taylor
cv 29.9×25.2 (76×64 cm)
c 1778
ML
Landscape with a Bridge
→ no 156
cv 44.5×52.4 (113×133 cm)
c 1785
ML
Mrs. Methuen
cv 33.1×28.0 (84×71 cm)
c 1776
WD
The Honorable Mrs. Graham
→ no 155
cv 35.2×27.2 (89,5×69 cm)
1775 (?)
WD
The Earl of Darnley
cv 29.9×25.0 (76×63.5 cm)
1785 (?)
ML
Master John Heathcote *
cv 50.0×39.8 (127×101 cm)
c 1770-4
William Yelverton Davenport
cv 50.2×40.2 (127,5×102 cm)
1780-90
William Pitt
pn 6.1×4.9 (15,5×12,5 cm)
copy
ML
Seascape
cv 40.2×50.4 (102×128 cm)
ML

GAUGUIN Paul
*Paris 1848 –
Atuana (Dominica) 1903*
The Bathers *
cv 23.8×36.8 (60,5×93,5 cm)
sg d 1898
Madame Alexandre Kohler (Ma-
rie Henry of Pouldu) *
cv 18.1×15.0 (46×38 cm)
sg 1887-8
DL
Brittany Landscape
cv 28.0×35.2 (71×89,5 cm)
sg d 1888
DL
"Fatata te miti" → no 141
cv 26.8×36.0 (68×91,5 cm)
sg d 1892 ins
DL
Self-Portrait → no 140
pn 31.1×20.1 (79×51 cm)
sg d 1889
DL
Words of the Devil
cv 37.0×27.6 (94×70 cm)
sg d 1892

GENTILE DA FABRIANO
Fabriano 1370 (?) – Rome 1427
Madonna and Child *
pn 37.8×22.4 (96×57 cm)
gold ground c 1422 ins
KR
Miracle of Saint Nicholas
→ no 7
pn of a pred 14.2×13.8
(36×35 cm) 1425
KR

**GENTILESCHI Orazio
Lomi de**
Pisa 1563 – London 1639
Saint Cecilia and an Angel
→ no 56
cv 34.6×42.5 (88×108 cm)
c 1610
KR
The Lute Player
cv 56.5×50.8 (143,5×129 cm)
c 1626

GÉRARD François
Rome 1770 – Paris 1837
The Model *
cv 24.0×19.7 (61×50 cm)
c 1800
DL

GÉRICAULT Théodore
Rouen 1791 – Paris 1824
Nude Warrior with a Spear *
cv 36.8×29.7 (93,5×75,5 cm)
1810-2
DL
Trumpeters of Napoleon's Im-
perial Guard
cv 23.8×19.5 (60,5×49,5 cm)

GERMAN SCHOOL
Sixteenth Century
The Crucifixion
Christ in Limbo
panels c 42.9×c 16.1
(c 109×c 41 cm) c 1570
KR

Nineteenth Century
An Artist and his Family
cv 29.9×25.0 (76×63,5 cm)
c 1820
ML

GERTNER Peter
act 1530-40 Germany
Portrait of a Man *
Portrait of a Lady *
Husband and wife portraits (?)
crt 17.5×12.6 (44,5×32 cm)
ins unfinished

GHIRLANDAIO (Domenico Bigordi)
Florence 1449 – 1494
Lucrezia Tornabuoni → no 18
pn 20.9×15.7 (53×40 cm)
c 1475
on rv ins
KR
Madonna and Child *
pn/masonite 28.9×20.1 (73,5×51 cm)
gold ground c 1470 res
KR

GHIRLANDAIO (Ridolfo Bigordi)
Florence 1483 – 1561
Lucrezia Sommaria
pn 24.8×18.1 (63×46 cm)
c 1510 ins
WD

GHISLANDI Vittore (Fra Galgario)
Bergamo 1655 – 1743
Portrait of a Young Man *
cv 28.7×22.2 (73×56,5 cm)
c 1690
KR

Giambellino see BELLINI Giovanni

GIAMBONO Michele (M. di Taddeo Bono)
act 1420-62 Venice
Saint Peter *
pn of a polyptych 33.9×13.8 (86×35 cm) c 1440

GIORGIONE (Giorgio da Castelfranco)
Castelfranco Veneto c 1477 – Venice 1510
The Adoration of the Shepherds → no 45
pn 35.8×43.7 (91×111 cm)
c 1510
perhaps in collaboration with Titian
KR
The Holy Family → no 46
pn/masonite 14.6×17.9 (37×45,5 cm) c 1500-5
KR
Portrait of a Venetian Gentleman *
cv 29.9×25.2 (76×64 cm)
c 1510 ins
in collaboration with Titian
KR

Follower of GIORGIONE
Venus and Cupid in a Landscape
pn 4.3×7.9 (11×20 cm) c 1505
KR

GIOTTO
Colle di Vespignano 1267 (?) – Florence 1337
Madonna and Child → no 4
centr pn of a polyptych 33.7×24.4 (85,5×62 cm)
gold ground c 1320-30 res
KR

GIOVANNI DI PAOLO
Siena c 1399 – 1482
The Adoration of the Magi
pn 10.2×17.7 (26×45 cm)
c 1450
ML
The Annunciation → no 15
pn of a pred 15.7×18.1 (40×46 cm) c 1445
KR

GIROLAMO DA CARPI (G. Sellari)
Ferrara 1501 – c 1557
The Assumption of the Virgin *
pn 78.3×51.6 (199×131 cm)
c 1530
KR

GIROLAMO DI BENVENUTO
Siena 1470 – 1524
Portrait of a Young Woman *
pn 23.6×17.7 (60×45 cm)
c 1505
KR

Giulio Romano see under **Raffaello Sanzio**

GLACKENS William James
Philadelphia 1870 – Westport 1938
Family Group
cv 72.0×84.1 (183×213,5 cm)
1910-11

Gogh see VAN GOGH

Gossart or **Gossaert** see MABUSE

GOYA Y LUCIENTES Francisco José de
Fuendetodos 1746 – Bordeaux 1828
The Marquesa de Pontejos → no 103
cv 83.1×49.6 (211×126 cm)
1786 (?)
ML
Carlos IV of Spain as Huntsman *
Maria Luisa, Queen of Spain *
canvases 18.1×11.8 (46×30 cm) c 1799
ML
Señora Sabasa García → no 102
cv 28.0×22.8 (71×58 cm)
1806-7
ML
Don Bartolomé Sureda *
Doña Teresa Sureda *
Husband and wife portraits
canvases 47.2×31.3 (120×79,5 cm) c 1805
Victor Guye *
cv 42.1×33.5 (107×85 cm) 1810
Don Antonio Noriega *
cv 40.4×31.9 (102,5×81 cm)
sg d 1801 ins
KR
The Duke of Wellington *
cv 41.5×33.1 (105,5×84 cm)
1812 (?) ins
The Bookseller's Wife *
cv 43.3×30.7 (110;78 cm)
sg c 1805
The Bullfight
cv 29.1×43.3 (74×110 cm)
c 1827 attr
Condesa de Chinchón
cv 53.0×46.3 (134,5×117,5 cm)
ML

Gozzoli see BENOZZO G.

Granacci see under **Master of the Kress Landscapes**

GRECO El (Doménicos Theotocópoulos or Theotocópuli)
Candia 1540 – Toledo 1614
Saint Ildefonso *
cv 44.1×25.6 (112×65 cm)
1603-5 repl
ML
Saint Martin and the Beggar 621 → no 98
The Virgin with Saint Inés and Saint Tecla *
canvases 76.2×40.6 (193,5×103 cm) sg 1597-9
WD
Saint Martin and the Beggar 84
cv 40.9×23.6 (104×60 cm)
1604-14
repl of the prec work
ML
Saint Jerome *
cv 66.1×43.5 (168×110,5 cm)
1610-14
KR
Laocoön → no 99
cv 54.1×67.9 (137,5×172,5 cm)
c 1610
KR
Christ Cleansing the Temple
pn 25.8×32.7 (65,5×83 cm)
sg c 1570
KR
The Holy Family
sketch (?); cv 20.9×13.6 (53×34,5 cm) 1590-1600
KR

GREUZE Jean-Baptiste
Tournus 1725 – Paris 1805
Ange-Laurent de Lalive de Jully *
cv 46.1×34.8 (117×88,5 cm)
1759 (?)
KR

Girl with Birds *
oval cv 24.2×20.5 (61,5×52 cm)
TM
Girl with Folded Arms
cv 22.0×18.5 (56×47 cm)
TM
Benjamin Franklin
cv 28.5×22.6 (72,5×57,5 cm)
attr

GROMAIRE Marcel
Noyelles-sur-Sambre 1892 –
Vendor of Ices *
cv 31.9×25.6 (81×65 cm)
sg d 1928
DL

GROS Antoine-Jean
Paris 1771 – Meudon 1835
Dr. Vignardonne *
cv 31.9×25.2 (81×64 cm)
sg d 1827
DL

GRÜNEWALD Matthias (M. Gothardt Neithardt)
Würzburg c 1475-83 – Halle 1528
The Small Crucifixion → no 93
pn 24.2×18.1 (61,5×46 cm)
sg c 1510
KR

GUARDI Francesco
Venice 1712 – 1793
View of the Cannaregio, Venice *
cv 18.9×29.1 (48×74 cm)
c 1770
KR
Campo San Zanipolo → no 61
cv 14.8×12.4 (37,5×31,5 cm)
1782
KR
View of the Rialto 623
cv 27.0×36.0 (68,5×91,5 cm)
c 1775 (?)
KR
A Seaport and Classic Ruins in Italy *
cv 48.0×70.1 (122×178 cm)
c 1760
KR
The Rialto Bridge 1038
pn 7.5×11.8 (19×30 cm)
c 1775-80
Castel Sant'Angelo *
cv 18.5×29.9 (47×76 cm)
1760-70 (?)
Carlo and Ubaldo Resisting the Enchantments of Armida's Nymphs
cv 98.4×181.0 (250×460 cm)
1755-60
in collaboration with Gian Antonio Guardi
(Vienna 1699 - Venice 1760)
Erminia and the Shepherds
cv 98.8×174.0 (251×442 cm)
1755-60
in collaboration with Gian Antonio Guardi
Piazza San Marco
cv 19.1×33.1 (48,5×84 cm)
school

GUERCINO (Giovanni Francesco Barbieri)
Cento 1591 – Bologna 1666
Cardinal Francesco Cennini *
cv 46.3×37.8 (117,5×96 cm)
c 1625
KR

GUILLAUMIN Jean-Baptiste-Armand
Paris 1841 – 1927
The Bridge of Louis Philippe *
cv 18.1×23.8 (46×60,5 cm)
sg d 1875
DL

HALS Frans
Antwerp or Malines 1580-1 – Haarlem 1666
Portrait of an Elderly Lady → no 78
cv 40.6×34.1 (103×86,5 cm)
d 1633 ins
ML
Portrait of an Officer → no 79
cv 33.9×27.2 (86×69 cm)
c 1640
ML
Balthasar Coymans *
cv 30.3×25.2 (77×64 cm)
d 1645 ins
ML
Portrait of a Man 70
oval cv 37.0×29.5 (94×75 cm)
c 1652-4
ML

Portrait of a Man 624
cv 25.0×21.1 (63,5×53,5 cm)
sg c 1640-5
WD
Portrait of a Young Man 71 *
cv 26.8×22.0 (68×56 cm)
sg c 1645
ML
A Young Man in a Large Hat *
cv 11.4×9.1 (29×23 cm)
c 1626-7
ML
Portrait of a Gentleman 625
cv 44.9×33.5 (114×85 cm)
1650-2
WD

HAMEN Y LEON Juan van der
Madrid 1596 – 1631
Still Life *
cv 33.1×44.5 (84×113 cm)
sg d 1627
KR

HARDING Chester
Conway 1792 – Boston 1866
Charles Carroll of Carrollton
cv 35.8×28.0 (91×71 cm)
1828 (?)
Amos Lawrence
cv 84.6×53.9 (215×137 cm)
c 1845
John Randolph
cv 30.1×25.0 (76,5×63,5 cm)
1829
ML
Self-Portrait
cv 29.9×25.0 (76×63,5 cm)
c 1825
ML

HARNETT William M.
Philadelphia 1848 – New York 1892
My Gems *
pn 18.1×14.0 (46×35,5 cm)
sg d 1888

HARPIGNIES Henri-Joseph
Valenciennes 1819 – St. Privé 1916
Landscape
cv 19.7×24.2 (50×61,5 cm)
sg 1896

HARTLEY Marsden
Lewiston 1877 – Ellsworth 1943
Landscape No. 5 *
cv 23.0×35.4 (58,5×90 cm)
1922-3
The Aero
cv 39.6×32.1 (100,5×81,5 cm)
Mt. Katahdin
cv 29.9×40.2 (76×102 cm)

HARTUNG Hans
Leipzig 1904 –
Composition
cv 39.4×9.4 (100×24 cm)
sg d 1952

HASELTINE William Stanley
Philadelphia 1835 – Rome 1900
Marina Piccola, Capri
pp on cv 12.0×18.5 (30,5×47 cm) 1856

HASHAGEN A.
Nineteenth Century, U.S.A.
Ship Arkansas Leaving Havana
cv 22.0×28.7 (56×73 cm)
sg d 1847 ins
GR

HASSAM Childe
Boston 1859 – New York (?) 1935
Allies Day, May 1917 *
cv 36.6×30.3 (93×77 cm)
sg d 1917
Nude Seated
cv 24.0×22.0 (61×56 cm)
sg d 1912
DL

Haye see CORNEILLE DE LYON

HEADE Martin Johnson
Lumberville 1819 – St. Augustine 1904
Rio de Janeiro Bay *
cv 17.7×35.8 (45×91 cm)
sg d 1864

HEALY George P. A.
Boston 1813 – Chicago 1894
Roxanna Wentworth
cv 30.3×25.0 (77×63,5 cm)

HEEM Jan Davidsz. de
Utrecht 1606 – Antwerp 1683-4
Vase of Flowers *
cv 27.4×22.2 (69,5×56,5 cm)
sg c 1645

HEMESSEN Jan Sanders van
Hemixen c 1500 – Haarlem 1564-6
"Arise, and Take Up Thy Bed, and Walk" *
pn 42.5×29.9 (108×76 cm)
c 1555

HENNER Jean-Jacques
Bernviller 1829 – Paris 1905
Reclining Nude
cv 10.8×16.3 (27,5×41,5 cm)
sg
TM
Alsatian Girl *
pn 10.6×7.5 (27×19 cm)
sg d 1873
Madame Uhring
pn 10.6×7.5 (27×19 cm) 1890
DL

HENRI Robert
Cincinnati 1865 – New York 1929
Catherine
cv 24.0×20.1 (61×51 cm)
sg 1913
Edith Reynolds
cv 76.0×37.2 (193×94,5 cm)
sg 1908
Snow in New York
cv 35.8×25.8 (91×65,5 cm)
sg d 1902
DL
Young Woman in White
cv 78.3×38.2 (199×97 cm)
sg 1904

HEYDEN Jan van der
Gorinchem 1637 – Amsterdam 1712
An Architectural Fantasy *
pn 19.5×27.8 (49,5×70,5 cm)
c 1670

HICKS Edward
Attleboro 1780 – Newtown 1849
The Cornell Farm *
cv 36.6×49.0 (93×124,5 cm)
sg d 1848 ins
GR

HIGHMORE Joseph
London 1692 – Canterbury 1780
A Scholar of Merton College, Oxford *
cv 50.4×40.2 (128×102 cm)
c 1750

HISPANO-DUTCH SCHOOL Fifteenth Century
The Adoration of the Magi
pn 73.0×65.4 (185,5×166 cm)
KR

HOBBEMA Meindert
Amsterdam 1638 – 1709
A Farm in the Sunlight
cv 31.9×26.0 (81×66 cm)
1660-70
A Wooded Landscape
cv 37.4×51.2 (95×130 cm)
sg d 1663
ML
A View on a High Road *
cv 36.6×50.4 (93×128 cm)
sg d 1665
ML
Hut among Trees
cv 38.0×42.5 (96,5×108 cm)
sg c 1665
WD
The Travelers
cv 39.8×57.1 (101×145 cm)
sg d 1663
WD
Village near a Pool *
cv 31.9×42.1 (81×107 cm)
c 1665
WD

HOFMANN Charles C.
act 1820-82 U.S.A.
Berks County Almshouse, 1878
metal 31.9×38.8 (81×98,5 cm)
sg d 1878 ins
GR
View of Benjamin Reber's Farm
cv 25.2×34.8 (64×88,5 cm)
sg d 1872 ins
GR

HOGARTH William
London 1697 – Leicester Fields 1764
The Singing Party
cv 28.7×36.2 (73×92 cm)
c 1760

HOLBEIN THE YOUNGER
Augsburg 1497-8 – London 1543
Edward VI as a Child → no 97
pn 22.4×17.3 (57×44 cm)
1538 (?) ins
ML
Sir Brian Tuke *
pn 19.3×15.4 (49×39 cm)
c 1527 ins
ML
Portrait of a Young Man
→ no 96
pn 8.7×6.7 (22×17 cm)

HOMER Winslow
Boston 1836 – Prout's Neck 1910
Breezing Up *
cv 24.0×38.2 (61×97 cm)
sg d 1876
Hound and Hunter
cv 28.3×48.0 (72×122 cm)
sg d 1892
Right and left
cv 28.3×48.4 (72×123 cm)
sg d 1909
Sunset
cv 15.4×22.4 (39×57 cm)
sg 1875 (?)

HOOCH or HOOGH Pieter de
*Rotterdam 1629 –
Amsterdam c 1683*
A Dutch Courtyard *
cv 26.8×23.2 (68×59 cm)
c 1660
ML
The Bedroom *
cv 20.1×23.6 (51×60 cm)
c 1660
WD
Woman and Child in a Court-
yard → no 91
cv 28.9×26.0 (73,5×66 cm)
sg c 1660
WD

HOPPNER John
Whitechapel 1758 – London 1810
The Frankland Sisters *
cv 61.0×49.2 (155×125 cm)
sg 1795 ins
ML
The Hoppner Children → no 158
portrait of the artist's chil-
dren
cv 60.0×50.0 (152,5×127 cm)
c 1790
WD
Portrait of a Man
cv 30.1×24.8 (76,5×63 cm)
1790-1800 attr

HUMPHREYS Charles S.
act c 1854-70 U.S.A.
The Trotter
cv 20.1×36.0 (51×91,5 cm)
c 1860 attr
GR

HUNTINGTON Daniel
New York 1816 – 1906
Dr. James Hall
cv 29.9×25.0 (76×63,5 cm)
c 1856
ML
Dr. John Edwards Holbrook
cv 28.3×23.2 (72×59 cm)
c 1856-7
ML
Henry Theodor Tuckerman
cv 27.0×22.2 (68,5×56,5 cm)
sg d 1866
ML

INGHAM Charles Cromwell
Dublin 1796 – New York 1863
Coralie Livingston (?)
cv 36.0×28.0 (91,5×71 cm)
c 1833
ML

**INGRES
Jean-Auguste-Dominique**
Montauban 1780 – Paris 1867
Madame Moitessier → no 119
cv 57.7×39.4 (146,5×100 cm)
sg d 1851 ins
KR
Pope Pius VII in the Sistine
Chapel *
cv 29.3×36.4 (74,5×92,5 cm)
sg d 1810
KR
Monsieur Marcotte *
cv 36.8×27.2 (93,5×69 cm)
sg d 1810
KR
Ulysses
cv/pn 9.8×7.3 (25×18,5 cm)
sg c 1827
DL

INMAN Henry
Utica 1801 – New York (?) 1846
George Pope Morris
cv 29.9×23.8 (76×60,5 cm)
c 1836
ML

INNESS George
*Newburgh 1825 –
Bridge of Allan 1894*
The Lackawanna Valley *
cv 33.9×50.2 (86×127,5 cm)
sg 1855
Lake Albano, Sunset
cv 30.1×44.9 (76,5×114 cm)
1872-4

ITALIAN SCHOOL
early Sixteenth Century
Baldassare Castiglione *
pn 24.8×18.5 (63×47 cm)
c 1510
WD

Sixteenth Century, Umbria
The Flagellation of Christ *
pn 22.0×18.9 (56×48 cm)
c 1505
KR

**Jacopo del Sellaio see
SELLAIO**

**Jacopo di Cione see under
Orcagna**

JARVIS John Wasley
England 1781 – New York 1840
Thomas Paine
cv 25.8×20.1 (65,5×51 cm)
1806-7 (?)
Commodore John Rodgers
cv 37.2×28.0 (94,5×71 cm)
c 1814

JENNYS William
act 1795-1807 U.S.A.
Asa Benjamin
Mrs. Asa Benjamin
Everard Benjamin
Husband, wife and son por-
traits
canvases c 29.9×25.0
(c 76×63,5 cm) 1795
GR

JOHN Augustus
Tenby 1878 – ... 1961
Joseph E. Widener
cv 49.0×40.2 (124,5×102 cm)
sg d 1921
WD

JOHNSON David
New York 1827 – Walden 1908
Edwin Forrest
cv 24.0×20.1 (61×51 cm)
sg d 1871
ML

JOHNSON Eastman
Lowell 1824 – New York 1906
The Early Scholar *
board on cv 16.9×21.1
(43×53,5 cm) sg 1865 (?)
DL
Joseph Wesley Harper, Jr.
cv 27.2×22.2 (69×56,5 cm)
sg c 1885
ML

JOHNSTON John
Boston 1752 – 1818
John Peck
cv 25.0×18.9 (63,5×48 cm)
c 1795
ML

JOHNSTON Joshua
act 1796-1824 Baltimore
The Westwood Children
cv 41.1×46.1 (104,5×117 cm)
c 1870
GR

JORDAENS Jacob
Antwerp 1593 – 1678
Portrait of a Man
pn 41.5×28.9 (105,5×73,5 cm)
c 1624

JORDAN Samuel
... 1803-4 – ...; act U.S.A.
Eaton Family Memorial
cv 21.8×15.4 (55,5×39 cm)
sg d 1831
GR

JOUETT Matthew Harris
*Harrodsburg 1787 –
Lexington 1827*
Augustus Fielding Hawkins
pn 27.2×20.9 (69×53 cm)
c 1820
ML

**JUAN DE FLANDES
(Juan Sallaert ?)**
... c 1475 – Palencia (?) 1519
The Annunciation *
The Nativity *
The Adoration of the Magi
The Baptism of Christ
panels of a polyptych
43.3×31.3; 43.5×32.7;
49.2×31.3; 49.6×31.9
(110×79,5 cm; 110,5×83 cm;
125×79,5 cm; 125×81 cm)
c 1510
KR
The Temptation of Christ *
pn 8.3×6.3 (21×16 cm) c 1500

KALF Willem
*Rotterdam 1619 –
Amsterdam 1693*
Still Life *
cv 25.4×21.3 (64,5×54 cm)
c 1665
DL

KAUFFMANN Angelica
Chur 1741 – Rome 1807
Franciska Krasinska, Duchess
of Courland *
cv 24.8×19.5 (63×49,5 cm)
c 1785

KEMMELMEYER Frederick
act 1788-1805 Baltimore
First Landing of Christopher
Columbus
cv 27.6×36.6 (70×93 cm)
sg d 18.. (1800-5) ins
GR

KENSETT John Frederick
Cheshire 1816 – New York 1872
Beacon Rock, Newport Harbor
cv 22.4×36.0 (57×91,5 cm)
sg d 1857
Landing at Sabbath Day Point,
Lake George
cv 10.0×15.7 (25,5×40 cm)
sg c 1850

KIDD Joseph Bartholomew
*Scotland 1808 (?) –
U.S.A. 1889 (?)*
Black-Backed Three-Toed
Woodpecker
cv 26.2×20.5 (66,5×52 cm)
1832-3
Orchard Oriole
cv 26.0×20.5 (66×52 cm)
1831
Sharp-Tailed Sparrow
crt 18.9×11.9 (48×30 cm)
1832-3
Yellow Warbler
crt 18.9×11.8 (48×30 cm)
1831-2

KLINE Franz
*Wilkes-Barre 1910 –
New York 1962*
C & O
cv 77.0×110.0
(195,5×279,5 cm) 1958
Four Square
cv 78.3×50.8 (199×129 cm)
sg d 1956

KOERBECKE Johann
act 1453-91 Münster
The Ascension *
pn 36.4×25.6 (92,5×65 cm)
1457
KR

KREMER Nicolaus
*... c 1500 – Ottersweier 1533;
act Strasbourg*
Portrait of a Nobleman
pn 23.6×17.5 (60×44,5 cm)
sg d 1529
BTH

KUHN Walt
New York 1877 – 1949
Pumpkins
cv 40.0×50.2 (101,5×127,5 cm)
sg d 1941
Wisconsin
cv 20.1×15.9 (51×40,5 cm)
sg d 1936
Hare and Hunting boots
cv 28.9×27.0 (73,5×68,5 cm)
sg d 1926
Pine on a Knoll
cv 25.0×29.9 (63,5×76 cm)
sg d 1929

Red Apples and Pineapple
cv 25.0×29.9 (63,5×76 cm)
sg d 1933
The White Clown
cv 40.0×29.9 (101,5×76 cm)
sg d 1929
Zinnias
cv 25.0×29.9 (63,5×76 cm)
sg d 1933
Green Apples and Scoop
cv 29.9×40.0 (76×101,5 cm)
sg d 1939
Dryad
cv 34.1×23.0 (86,5×59,5 cm)
sg d 1935

LA FARGE John
*New York 1835 –
Providence 1910*
Afterglow, Tautira River, Tahiti
cv 53.5×60.1 (136×152,5 cm)
1891 (?)

LA FRESNAYE Roger de
Le Mans 1885 – Grasse 1925
Nude *
crt 34.3×24.4 (87×62 cm)
sg d 1910
DL

LAMB A. A.
Nineteenth Century, U.S.A.
Emancipation Proclamation *
cv 32.3×53.9 (82×137 cm)
sg c 1863
GR

LANCRET Nicolas
Paris 1690 – 1743
La Camargo Dancing
cv 29.9×42.1 (76×107 cm)
c 1730
ML
The Picnic after the Hunt *
cv 24.2×29.5 (61,5×75 cm)
c 1740
KR

LARGILLIÈRE Nicolas de
Paris 1656 – 1746
A Young Man with his Tutor
cv 57.5×45.3 (146×115 cm)
sg d 1685
KR
Elizabeth Throckmorton *
cv 31.9×25.8 (81×65,5 cm)
ins; on rv sg d 1729

LA TOUR Maurice-Quentin de
Saint-Quentin 1704 – 1788
Claude Dupouch *
pastel 23.4×19.5
(59,5×49,5 cm) 1739 (?)
KR

LAURENCIN Marie
Paris 1885 – 1956
Girl with a Dove
cv 18.1×15.2 (46×38,5 cm)
sg d 1928
DL
In the Park *
cv 36.2×25.8 (92×65,5 cm)
sg d 1924
DL

LAWRENCE Thomas
Bristol 1769 – London 1830
Lady Templetown and Her
Son *
cv 84.6×58.7 (215×149 cm)
c 1801
ML
Lady Robinson
cv 50.0×40.0 (127×101,5 cm)
c 1827
WD

LAWSON Thomas Bailey
Newburyport 1807 – Lowell 1888
William Morris Hunt
cv 18.1×14.2 (46×36 cm)
sg d 1879
ML

LÉGER Fernand
*Argentan 1881 –
Gif-sur-Yvette 1955*
Maud Dale
cv 39.6×31.3 (100,5×79,5 cm)
sg d 1935
DL
Woman with Mirror *
cv 36.4×23.6 (92,5×60 cm)
sg d 1929
DL

LEGROS Alphonse
Dijon 1837 – London 1911
Portrait of an Old Man
cv 18.3×15.2 (46,5×38,5 cm)
sg

Head of a Man with Upturned
Eyes
cv 15.9×11.2 (40,5×28,5 cm)
sg
Memory Copy of Holbein's
Erasmus
pn 17.5×15.6 (44,5×39,5 cm)
Hampstead Heath
cv 15.9×24.0 (40,5×61 cm) sg
Portrait of a Woman
cv 21.1×17.3 (53,5×44 cm)
sg d 1875

**LELY Peter
(Pieter van der Faes)**
*Soest or Utrecht 1618 –
London 1680*
Barbara Villiers, Duchess of
Cleveland *
cv 49.6×40.0 (126×101,5 cm)
c 1662
TM

LE NAIN Louis
Laon c 1593 – Paris 1648
Landscape with Peasants
→ no 108
cv 18.3×22.4 (46,5×57 cm)
c 1640
KR
A French Interior *
cv 21.8×25.4 (55,5×64,5 cm)
c 1645
KR

LEONARDO DA VINCI
*Vinci 1452 –
Cloux (Amboise) 1519*
Ginevra de' Benci (?) → no 36
pn 15.0×14.4 (38×36,5 cm)
c 1474-6 mutilated (?) on rv
plants and scroll with ins
Portrait of a Young Lady
pn/masonite 18.5×25.6
(47×65 cm) st
KR
see also Verrocchio (circle)

LÉONID (L. Berman)
*Saint Petersburg 1896 –
act U.S.A.*
Faraduro
cv 40.0×31.9 (101,5×81 cm)
sg d 1952

LERMOND C. C. E.
Nineteenth Century, U.S.A.
Landscape with Churches
pn 35.0×40.2 (89×102 cm) sg
trapezoidal sleigh back
GR

LEYSTER Judith
*Haarlem 1609 –
Heemstede 1660*
Self-Portrait *
cv 28.3×25.6 (72×65 cm)
c 1635

LIPPI Filippino
Prato 1457 – Florence 1504
The Adoration of the Child
pn 31.9×22.0 (81×56 cm)
c 1480
ML
Portrait of a Youth → no 17
pn 20.1×14.0 (51×35,5 cm)
c 1485
ML
Tobias and the Angel *
pn 16.7×9.3 (42,5×23,5 cm)
c 1480
KR
The Coronation of the Virgin
lunette; pn 35.4×87.4
(90×222 cm) c 1480
KR
Pietà *
pn 6.9×13.4 (17,5×34 cm)
c 1490
KR

LIPPI Filippo
Florence 1406 – Spoleto 1469
Madonna and Child → no 10
pn 31.5×20.1 (80×51 cm)
1440-5
KR
The Annunciation
lunette; pn 40.6×64.2
(103×163 cm) c 1440
KR
Saint Benedict Orders Saint
Maurus to the Rescue of Saint
Placidus *
pn of a pred 16.3×28.0
(41,5×71 cm) c 1445
KR
The Nativity
pn of a pred 9.4×22.8
(24×58 cm) c 1445
with assistance
KR
see also Angelico

LONGHI Pietro (P. Falca)
Venice 1702 – 1785

The Simulated Faint *
cv 19.3×24.0 (49×61 cm)
c 1760
KR

Blindman's Buff
cv 19.3×24.0 (49×61 cm)
c 1760
KR

LOO Charles-Amédée-Philippe van
Turin 1719 – Paris 1795

The Magic Lantern *
Soap Bubbles
canvases 34.8×34.8
(88,5×88,5 cm)
sg d 1764

LOO Louis-Michel van
Toulon 1707 – Paris 1771

Portrait of a Lady
cv 22.0×18.3 (56×46,5 cm)
school

LORENZETTI Pietro
Siena ... – 1348 (?)

Madonna and Child with Saint
Mary Magdalen and Saint Ca-
therine *
trp; cusped panels/canvases;
centr pn 43.5×23.2
(110,5×59 cm); wings
40.0×19.5 (101,5×49,5 cm)
sg d 1321 (?); c 1330

LORENZETTI Ugolino
act c 1320-60 Siena

Saint Catherine of Alexandria *
pn of a polyptych 29.1×16.5
(74×42 cm) gold ground
c 1335 mutilated
KR

LORENZO DI CREDI
Florence c 1458 – 1537

Self-Portrait *
pn/cv 18.1×12.8 (46×32,5 cm);
on rv sg d 1488
WD

**LORENZO MONACO
(Pietro di Giovanni)**
*Siena (?) c 1370 –
Florence 1422-4*

Madonna and Child *
pn 46.1×21.6 (117×55 cm)
d 1413
KR

**LORRAIN or LORENA Claude
(C. Gellée)**
Chamagne 1600 – Rome 1682

The Herdsman → no 110
cv 47.8×63.2 (121,5×160,5 cm)
c 1655-60
KR

Landscape with Merchants *
cv 38.2×56.5 (97×143,5 cm)
sg c 1635
KR

The Judgment of Paris *
cv 44.3×62.8 (112,5×159,5 cm)
1645-6 (?)
KR

Harbor at Sunset
cv 19.3×26.4 (49×67 cm)
school

LOTTO Lorenzo
Venice 1484 – Loreto 1556

Saint Catherine → no 47
pn 22.4×23.6 (57×60 cm)
sg d 1522
KR

A Maiden's Dream *
pn 16.9×13.4 (43×34 cm)
c 1505
covering wing of a portrait
KR

Allegory *
pn 22.2×16.9 (56,5×43 cm)
sg d 1505
like the prec work
KR

The Nativity *
pn 18.1×14.2 (46×36 cm)
sg d 1523
KR

LOUIS Morris
Baltimore 1912 – New York 1962

Beta Kappa *
cv 103.1×173.0 (262×439,5 cm)
1961

LUCAS VAN LEYDEN
Leiden 1494 – 1533

The Card Players → no 74
pn 22.2×24.0 (6,5×61 cm)
c 1520
KR

LUINI Bernardino
Lombardy 1480-90 (?) – 1531-2

Portrait of a Lady *
pn 30.3×22.6 (77×57,5 cm)
c 1525
ML

Venus → no 38
pn 42.1×53.5 (107×136 cm)
c 1530
KR

The Madonna of the Carnation
pn 17.3×15.7 (44×40 cm)
c 1520
KR

Procris' Prayer to Diana *
Cephalus Hiding the Jewels
The Misfortunes of Cephalus
The Despair of Cephalus
Cephalus at the Hunt (The Pu-
nishment of C.)
Procris Pierced by Cephalus'
Javelin
The Illusion of Cephalus (C.
and the Nymphs) *
Cephalus and Pan at the Tem-
ple (The T. of Diana)
Procris and the Unicorn
frescoes/ 90.0×55.1;
87.2×59.1; 69.3×42.1;
71.7×46.7; 83.3×43.3;
56.7×48.4; 89.8×49.0;
89.0×40.8; 90.0×42.5
(228,5×140 cm; 221,5×150 cm;
176×107 cm; 182×118,5 cm;
211,5×110 cm; 144×123 cm;
228×124,5 cm; 226×103,5 cm;
228,5×108 cm) c 1525
formerly in the house Rabia,
Milan
KR

The Magdalen → no 37
pn 23.2×18.9 (59×48 cm)
c 1525
KR

LUKS George Benjamin
*Williamsport 1867 –
New York 1933*

The Bersaglieri *
cv 40.2×59.6 (102×151,5 cm)
sg 1918
The Miner
cv 60.2×50.4 (153×128 cm)
sg 1925
DL

LURÇAT Jean
*Bruyères en Vosges 1892 –
Paris 1966*

Chester Dale *
Maud Dale *
Husband and wife portraits
canvases 57.1×37.8 and
46.9×28.0 (145×96 cm and
119×71 cm) sg d 1928
DL
The Big Cloud *
cv 38.2×57.7 (97×146,5 cm)
sg d 1929
DL

LYS or LISS Jan
Oldenburg c 1600 – Venice 1629

The Satyr and the Peasant *
cv 52.6×65.6 (133,5×166,5 cm)
c 1620
WD

**MABUSE (Jan Gossaert
de Maubeuge)**
*Duurstede or Maubeuge 1480 –
Antwerp c 1534*

Saint Jerome Penitent *
outsides of wings of a trp;
panels 34.1×10.0
(86,5×25,5 cm) grisaille c 1512
KR
Portrait of a Banker *
pn 25.0×18.7 (63,5×47,5 cm)
c 1530

MACKAY
Eighteenth Century, U.S.A.

Catherine Brower *
cv 45.5×27.6 (115,5×70 cm)
sg d 1791
GR

MADER Louis
... 1842 – c 1899; act U.S.A.

Berks County Almshouse, 1895
metal 32.7×39.6 (83×100,5 cm)
sg d 1895
ins
GR

MAES Nicolaes
*Dordrecht 1634 –
Amsterdam 1693*

An Old Woman Dozing over a
Book *
cv 32.3×26.4 (82×67 cm)
sg c 1655
ML

MAGNASCO Alessandro
Genoa 1667 – 1749

The Baptism of Christ → no 57
cv 46.1×57.9 (117×147 cm)
c 1740
KR

Christ at the Sea of Galilee *
cv 46.5×57.9 (118×147 cm)
c 1740
KR

The Choristers
cv 26.8×21.5 (68×54,5 cm)

MANET Édouard
Paris 1832 – 1883

The Dead Toreador → no 126
cv 29.9×60.2 (76×152 cm)
sg 1864 (?)
WD

At the Races
pn 4.9×8.5 (12,5×21,5 cm)
sg c 1875
WD

Portrait of a Lady *
pn 5.9×4.5 (15×11,5 cm)
c 1879

Gare Saint-Lazare → no 125
cv 36.6×45.1 (93×114,5 cm)
sg d 1873

The Tragedian (Rouvière as
Hamlet) *
cv 73.6×42.5 (187×108 cm)
sg c 1866

Still Life with Melon and Pea-
ches
cv 27.2×36.2 (69×92 cm)
sg c 1866

Oysters *
cv 15.4×18.5 (39×47 cm)
sg 1862

Madame Michel-Lévy → no 127
pastel-oil sg cv 29.0×20.1
(74,5×51 cm) sg d 1882
DL

The Old Musician *
cv 73.8×97.6 (187,5×248 cm)
sg d 1862
DL

A King Charles Spaniel
cv 18.5×14.6 (47×37 cm) 1866
ML

Flowers in a Crystal Vase
cv 12.8×9.6 (32,5×24,5 cm) sg
ML

Madame Lépine
cv 12.6×9.6 (32×24,5 cm)
ML

The Plum
cv 29.1×19.3 (74×49 cm) 1877
ML

MANTEGNA Andrea
*Isola di Carturo 1430-1 –
Mantua 1506*

Judith and Holofernes 639
→ no 26
pn 11.8×7.1 (30×18 cm)
on rv sg 1495
WD

Portrait of a Man *
pn/cv 9.4×7.5 (24×19 cm)
c 1460 (?)
KR

The Christ Child Blessing *
cv 27.6×13.8 (70×35 cm)
KR

Saint Jerome in the Wilderness
pn 31.7×21.6 (80,5×55 cm)
c 1460 attr
ML

Judith with the Head of Holo-
fernes 289
drw; pp on cv 13.8×7.9
(35×20 cm) c 1480 school
KR

Madonna and Child *
cv 22.0×16.1 (56×41 cm)
c 1505 school
KR

**MARCOUSSIS Louis
(L. Casimir Ladislas-Markous)**
Warsaw 1883 – Cusset 1941

The Musician *
cv 57.5×44.9 (146×114 cm)
sg d 1914
DL

**MARGARITONE
(Margarito di Magnano)**
*second half Thirteenth Century,
Arezzo*

Madonna and Child Enthroned
→ no 1
pn 38.2×19.5 (97×49,5 cm) sg
silver ground c 1270
KR

MARK George Washington
... – Greenfield 1879

Marion Feasting the British Of-
ficer on Sweet Potatoes *
cv 31.9×37.4 (81×95 cm) 1848
GR

MARMION Simon
*Valenciennes or Amiens 1425 –
Valenciennes 1489*

A Miracle of Saint Benedict *
cv 35.8×30.5 (91×77,5 cm)
c 1480 st
KR

MARQUET Albert
Bordeaux 1875 – Paris 1947

The Pont Neuf *
cv 19.7×24.0 (50×61 cm)
sg d 1906
DL

Martini see SIMONE MARTINI

MARTINO DI BARTOLOMMEO
act 1389-1434 Siena

Madonna and Child with Saint
Peter and Saint Stephen *
trp; cusped panels; centr pn
41.7×21.3 (106×54 cm);
wings c 36.6×c 17.7
(c 93×c 45 cm) 1400-10

**MASACCIO (Tommaso di
Ser Giovanni Guidi)**
*San Giovanni Valdarno 1401 –
Rome 1428*

Profile Portrait of a Young
Man *
pn 16.5×12.6 (42×32 cm)
c 1425 attr
ML

The Madonna of Humility *
pn 41.3×21.3 (105×54 cm)
c 1425 attr
ML

**MASOLINO (Tommaso di
Cristofano di Fino)**
*Panicale di San Giovanni
Valdarno 1383 – ... 1447 (?)*

The Annunciation *
pn 58.3×45.3 (148×115 cm)
1425-30 (?)
ML

The Archangel Gabriel
The Virgin Annunciate
fragments of a pn 29.9×22.4
(76×57 cm)
1420-30 (?)
KR

MASSYS Quentin
Louvain 1465-6 – Antwerp 1530

The Ill-Matched Lovers *
pn 16.9×24.8 (43×63 cm)
ML

**MASTER OF FLÉMALLE
(Robert Campin ?)**
... c 1378 – Tournai 1444

Madonna and Child with Saints
in the Enclosed
Garden → no 69
pn 47.2×58.7 (120×149 cm)
c 1440
with assistance
monogram (of the artist or of
the donor)
KR

MASTER OF HEILIGENKREUZ
*early Fifteenth Century,
Franco-Austrian school*

The Death of Saint Clare
→ no 92
pn 26.2×21.5 (66,5×54,5 cm)
gold ground c 1410
KR

MASTER OF SAINT FRANCIS
*second half Thirteenth Century,
Umbria*

Saint John the Evangelist
Saint James the Minor
panels of a polylptych
19.5 and 19.7×9.4
(49,5 and 50×24 cm)
gold ground ins c 1270-80
KR

MASTER OF SAINT GILLES
*Sixteenth Century,
Fanco-Flemish school*

The Conversion of an Arian by
Saint Rémy
The Baptism of Clovis *
panels of a polylptych
24.2×c 18.1 (61,5×46 cm)
KR

**MASTER OF
SAINT VERONICA**
*early Fifteenth Century,
Cologne*

The Crucifixion
pn 18.1×12.4 (46×31,5 cm)
gold ground c 1400-10
KR

MASTER OF SANTO SPIRITO
late Fifteenth Century, Tuscany

Portrait of a Youth → no 32
pn/cv/novaply 20.5×15.2
(52×38,5 cm) c 1485-90
formerly attr to Pintoricchio
(Perugia c 1454 – Siena 1513)
KR

**MASTER OF THE
BARBERINI PANELS**
*first half Fifteenth Century,
Umbria and Florence*

The Annunciation *
pn 34.6×24.8 (88×63 cm)
c 1450
KR

**Master of the Death of the
Virgin see CLEVE**

**MASTER OF THE
FABRIANO ALTARPIECE**
act c 1335-65 Tuscany

Madonna Enthroned with Saints
trp; panels; centr pn
42.7×23.4 (108,5×59,5 cm)
side panels 35.4×c 13.8
(90×c 35 cm) d 1354 ins
in collaboration with
Allegretto Nuzi (Fabriano ... -
1373-85)
ML

105

**MASTER OF THE
FRANCISCAN CRUCIFIXES**
*second half Thirteenth Century,
Umbria*

The Mourning Madonna
Saint John the Evangelist
panels c 31.9×124.0
(c 81×315 cm) c 1272
end panels of arms of a cross
KR

**MASTER OF THE
GRISELDA LEGEND**
*Fifteenth Century, Tuscany and
Umbria*

Eunostos of Tanagra
pn 34.6×20.7 (88,5×52,5 cm)
1495-1500
formely attr to Luca Signorelli

**MASTER OF THE
KRESS LANDSCAPES**
*early Sixteenth Century,
Tuscany*

Scenes from a Legend
panels 11.0×35.0 and 16.5
(28×89 cm and 42 cm) 1512-20 (?)
formerly attr to Francesco
Granacci (Florence 1469-1543)
KR

**MASTER OF THE LIFE OF
ST. JOHN THE BAPTIST**
*second quarter Fourteenth
Century, Rimini*

Madonna and Child with Angels
The Baptism of Christ
Scenes from the Life of St.
John the Baptist
panels of a polyptych;
centr pn 39.6×18.9
(100,5×48 cm);
side panels c 19.3×15.9
(c 49×40,5 cm)
gold ground c 1340
KR

**MASTER OF THE RETABLE
OF THE REYES CATÓLICOS**
*late Fifteenth Century,
Hispano-Flemish*

The Marriage at Cana *
Christ among the Doctors *
panels of a polyptych
60.4×36.4 and 61.4×37.0
(153,5×92,5 cm and
156×94 cm)
KR

**MASTER OF THE
SAINT BARTHOLOMEW ALTAR**
act c 1470 – c 1510 Cologne

The Baptism of Christ *
pn 41.7×42.3 (106×107,5 cm)
c 1500
KR

**MASTER OF THE
SAINT LUCY LEGEND**
act 1480-90 Flanders

Mary, Queen of Heaven *
pn 85.0×73.0 (216×185,5 cm)
c 1485
KR

106

OSTADE Adriaen van
Haarlem 1610 – 1684
The Cottage Dooryard *
cv 17.3×15.6 (44×39,5 cm)
sg d 1673
WD

OSTADE Isaack van
Haarlem 1621 – 1649
The Halt in the Inn
cv 19.5×26.0 (49,5×66 cm)
sg d 1645
WD

OTIS Bass
Bridgewater 1784 –
Philadelphia 1861
John Smith Warner
cv 30.3×25.0 (77×63,5 cm)
1827

OUDOT Roland
Paris 1897 –
Matador in White
cv 36.2×28.7 (92×73 cm)
sg d 1928
DL
The Market
cv 57.5×44.9 (146,5×114 cm)
sg d 1929
DL

PANNINI Giovan Paolo
Piacenza 1691-2 – Rome 1765
The Interior of the Pantheon
→ no 58
cv 50.4×39.0 (128×99 cm)
c 1740
KR
Interior of Saint Peter's,
Rome *
cv 60.8×77.6 (154,5×197 cm)
1746-54

PAOLO VENEZIANO
act 1324-58 Venice
The Crucifixion
pn 12.6×14.6 (32×37 cm)
gold ground c 1340
KR
The Coronation of the Virgin
→ no 5
centr pn of a polyptych (?)
39.0×30.5 (99×77,5 cm)
gold ground d 1324
KR

PARADISE John Wesley
New Jersey 1809 –
New York 1862
Mrs. Elizabeth Oakes Smith *
cv 34.1×25.6 (86,5×65 cm)
sg c 1845 ins
DL

PARK Linton
... 1826 – ... 1906;
act Pennsylvania
Dying Tonight on the Old Camp
Ground
cv 24.0×33.1 (61×84 cm)
c 1890
GR
Flax Scutching Bee *
cv 31.1×50.2 (79×127,5 cm)
1885
GR

PARMIGIANINO
(Francesco Mazzola)
Parma 1503 – 1540
Allegorical Landscape
cv 25.0×33.1 (63,5×84 cm)
c 1565 school

PATER
Jean-Baptiste-Joseph
Valenciennes 1695 – Paris 1736
Fête Champêtre 883 *
cv 29.3×36.4 (74,5×92,5 cm)
c 1730
KR
Fête Champêtre 1566
cv 15.0×18.5 (38×47 cm)
copy
TM
On the Terrace
cv 28.3×39.4 (72×100 cm)
c 1730-5
The Gift of the Fishermen
cv 15.2×18.9 (38,5×48 cm)
copy

Follower of PATINIR
or PATENIER Joachim
Bouvignes-les-Dinant c 1480 –
Antwerp 1524
The Flight into Egypt
pn 9.4×59.1 (24×150 cm)
c 1550
KR

PEALE Charles Willson
Queen Anne's County 1741 –
Philadelphia 1827
John Philip de Haas
cv 50.0×40.0 (127×101,5 cm)
sg d 1772
ML
Benjamin and Eleanor Ridgely
Laming
cv 41.9×60.2 (106,5×153 cm)
1788

PEALE Rembrandt
Bucks County 1778 –
Philadelphia 1860
Richardson Stuart
cv 20.5×14.6 (52×37 cm)
c 1815
ML
Thomas Sully
cv/pn 23.8×20.1 (60,5×51 cm)
sg d 1859
George Washington 596 *
cv 35.8×28.7 (91×73 cm)
c 1850 ins
George Washington 924
cv 29.9×25.0 (76×63,5 cm)
c 1857 ins
copy from a ptg by R. E. Pine
ML

PERUGINO (Pietro Vannucci)
Città della Pieve c 1448 –
Fontignano 1523
The Crucifixion with the Virgin,
Saint John, Saint Jerome, and
Saint Mary Magdalen → no 31
panels/canvases;
centr pn 39.8×22.2
(101×56,5 cm); ar side panels
37.4×12.0 (95×30,5 cm)
c 1482-5
ML
Madonna and Child *
cv 27.6×20.1 (70×51 cm)
c 1500
KR
Saint Jerome in the Wilderness
pn 24.8×16.5 (63×42 cm)
c 1581-2
KR

PESELLINO
(Francesco di Stefano)
Florence c 1422 – 1457
The Crucifixion with Saint Je-
rome and Saint Francis *
pn 24.4×18.9 (62×48 cm)
c 1440-5
KR

PHILLIPS Ammi
Berkshire County 1788 – ... 1865
Mr. Day
Mrs. Day
Husband and wife portraits
canvases 32.7×28.0
(83×71 cm) c 1835
GR
Lady in White *
cv 32.3×26.0 (82×66 cm)
c 1820
GR
Alsa Slade
Joseph Slade
Husband and wife portraits
canvases 40.2×33.1
(102×84 cm) 1816
GR
Henry Teller
Jane Storm Teller
Husband and wife portraits
canvases 33.1×27.0
(84×68,5 cm) c 1835
GR

PIAZZETTA Giovanni Battista
Venice 1682 – 1754
Elijah Taken up in a Chariot of
Fire
cv 68.7×103.9 (174,5×264 cm)
c 1745
KR
Madonna and Child Appearing
to San Filippo Neri
cv 44.1×25.0 (112×63,5 cm)
c 1724
KH

PICASSO Pablo
Malaga 1881 – Mongins 1973
Le Gourmet
cv 35.4×26.8 (90×68 cm)
sg 1901
DL
Pedro Mañach *
cv 39.6×26.6 (100,5×67,5 cm)
sg 1901 ins
DL
Classical Head *
cv 24.0×19.7 (61×50 cm)
sg d 1922
DL

Family of Saltimbanques
→ no 148
cv 83.9×90.4 (213×229,5 cm)
sg 1905
DL
Juggler with Still Life
gouache 39.4×27.6
(100×70 cm) sg 1905
DL
The Lovers → no 149
cv 51.2×38.2 (130×97 cm)
sg d 1923
DL
Dora Maar
cv 28.7×23.6 (73×60 cm)
sg 1941
DL
Madame Picasso
portrait of the artist's wife
cv 39.4×32.3 (100×82 cm)
sg d 1923
DL
Still Life → no 150
cv 38.2×51.2 (97×130 cm)
sg 1918
DL
The Tragedy *
pn 41.5×27.2 (105,5×69 cm)
sg d 1903
DL
Two Youths
cv 59.6×37.0 (151,5×94 cm)
sg 1905
DL
Mother and Child
cv 39.8×31.9 (101×81 cm)
sg d 1922
DL
Lady with a Fan
cv 39.0×31.5 (99×80 cm)
sg d 1905

PIER FRANCESCO
FIORENTINO
act 1474-97 Florence
Madonna and Child
pn/cv 29.5×21.4 (75×54,5 cm)
damaged
KR

Pseudo
PIER FRANCESCO
FIORENTINO
Fifteenth Century, Tuscany
Madonna and Child
pn 27.2×18.3 (69×46,5 cm)
c 1450
WD

PIERIN or PERIN DEL VAGA
(Pietro Buonaccorsi)
Florence 1501-2 – Rome 1547
The Nativity *
altarpiece; pn/cv 108.1×87.0
(274,5×221 cm)
sg d 1534
pred in Milan, Brera (five pan-
els) and in Genoa, Palazzo
bianco (one pn)
KR

PIERO DELLA FRANCESCA
Borgo Sansepolcro 1410-20 –
1492
Saint Apollonia
pn of a polyptych 15.4×11.0
(39×28 cm)
gold ground c 1460
KR

PIERO DI COSIMO
Florence 1461-2 – 1521
Allegory
wedding-chest (?);
pn 22.0×17.3 (56×44 cm)
c 1500
KR
The Visitation with Saint Nich-
olas and Saint Anthony Ab-
bot *
pn 72.4×74.4 (184×189 cm)
c 1490 (?)
KR
The Nativity with the Infant
Saint John *
cv; td 57.5 (146 cm) c 1500
KR

PINE Robert Edge
London 1730 – Philadelphia 1788
General William Smallwood
cv 29.1×24.0 (74×61 cm)
1788
ML
see also R. Peale

Pintoricchio see under
Master of Santo Spirito

PISSARRO Camille
Saint-Thomas (Antilles) 1830 –
Paris 1903
The Bather *
cv 13.8×10.6 (35×27 cm)
sg d 1895
DL

Boulevard des Italiens, Mor-
ning, Sunlight → no 130
cv 28.7×36.2 (73×92 cm)
sg 1897
DL
Peasant Woman
cv 28.7×23.6 (73×60 cm)
sg d 1880
DL
Orchard in Bloom, Louvecien-
nes
cv 17.7×21.6 (45×55 cm)
sg d 1872
ML
Peasant Girl with a Straw Hat *
cv 28.9×23.4 (73,5×59,5 cm)
sg d 1881
ML
Hampton-Court Green
cv 21.5×28.7 (54,5×73 cm)
sg d 1891
ML
The Artist's Garden at Fragny
cv 28.9×36.4 (73,5×92,5 cm)
sg d 1898
DL
Place du Carrousel, Paris *
cv 21.6×25.8 (55×65,5 cm)
sg d 1900
ML

POLK Charles Peale
Maryland 1767 –
Washington 1822
Anna Maria Cumpston *
cv 57.9×37.6 (147×95,5 cm)
sg c 1790
GR
General Washington at Prince-
ton
cv 36.0×28.0 (91,5×71 cm)
c 1790

Ponte see BASSANO

PONTORMO (Jacopo Carrucci)
Pontormo 1494 – Florence 1557
Ugolino Martelli
pn 35.8×26.8 (91×68 cm)
c 1550
KR
The Holy Family → no 39
pn 39.8×31.1 (101×79 cm)
c 1525
attr also to Bronzino
KR
Portrait of a Young Woman
pn 22.0×16.9 (56×43 cm)
c 1535
WD
Monsignor Della Casa
pn 40.2×31.1 (102×79 cm)
1541-4 (?)
KR

POTTER Paulus
Enkhuizen 1625 –
Amsterdam 1654
A Farrier's Shop *
pn 18.9×18.1 (48×46 cm)
sg d (on the frame) 1648
WD

POUSSIN Nicolas
Les Andelys 1594 – Rome 1665
The Baptism of Christ *
cv 37.6×47.6 (95,5×121 cm)
1641-2
KR
The Feeding of the Child Jupi-
ter
cv 46.3×61.0 (117,5×155 cm)
c 1640
KR
Holy Family on the Steps
→ no 109
cv 27.0×38.6 (68,5×98 cm)
1648
KR
The Assumption of the Virgin *
cv 53.0×38.6 (134,5×98 cm)
c 1626

POWERS Asahel L.
Springfield 1813 – ... c 1850
J. B. Sheldon
Mrs. J. B. Sheldon
Husband and wife portraits
panels 41.3×30.7 (105×78 cm)
c 1835
GR
Hannah Fisher Stedman
pn 36.0×24.8 (91,5×63 cm)
1833
GR

PRATT Matthew
Philadelphia 1734 – 1805
The Duke of Portland
cv 29.9×25.0 (76×63,5 cm)
c 1774

Madonna of Saint Jerome
cv 30.7×23.6 (78×60 cm)
1764-6
copy from ptg by Correggio

PREDIS
Giovanni Ambrogio de'
Milan c 1455 – ... c 1508
Bianca Maria Sforza *
pn 20.1×12.8 (51×32,5 cm)
1493 (?) ins
WD

PRIOR William Matthew
Bath 1806 – Boston 1873
Master Cleeves
crt 15.4×11.4 (39×29 cm)
1850 (?)
GR
The Younger Generation
cv 21.8×27.0 (55,5×68,5 cm)
c 1850
GR

PRUD'HON Pierre-Paul
Cluny 1758 – Paris 1823
David Johnston
cv 21.6×18.3 (55×46,5 cm)
sg d 1808
KR

PUVIS DE CHAVANNES Pierre
Lyons 1824 – Paris 1898
Work *
Rest
canvases 42.7×58.3
(108,5×148 cm)
sg d 1863 ins
WD
The Prodigal Son
cv 41.9×57.9 (106,5×147 cm)
c 1879 (?)
DL

QUIDOR John
Tappan 1801 – Jersey City 1881
The Return of Rip Van Winkle *
cv 36.2×49.6 (92×126 cm)
sg d 1829
ML

RAEBURN Henry
Stockbridge 1756 –
Edinburgh 1823
Miss Eleanor Urquhart → no 160
cv 29.5×24.4 (75×62 cm)
c 1795
ML
Colonel Francis James Scott *
cv 50.4×40.2 (128×102 cm)
c 1800
ML
John Tait and his Grandson *
cv 49.6×39.4 (126×100 cm)
c 1793
ML
The Binning Children
cv 50.8×40.6 (129×103 cm)
c 1811
David Anderson
cv 60.0×42.3 (152,5×107,5 cm)
c 1790 (?)
WD
John Johnstone of Alva, his
Sister and his Niece
cv 40.0×47.2 (101,5×120 cm)
c 1805
Captain Patrick Miller
cv 65.7×52.4 (167×133 cm)
c 1795
Jean Christie
cv 30.3×25.2 (77×64 cm)
c 1820
Mrs. George Hill
cv 38.2×30.1 (97×76,5 cm)
ML
Miss Davidson Reid
cv 29.7×25.2 (75,5×64 cm)
ML

RAFFAËLLI Jean-François
Paris 1850 – 1924
The Flower Vendor *
cv 31.9×25.6 (81×65 cm) sg
DL

RAFFAELLO SANZIO
Urbino 1483 – Rome 1520
The Alba Madonna → no 34
pn/cv; td 37.2 (94,5 cm) 1510-1
ML
The Niccolini-Cowper Madon-
na *
pn 31.9×22.4 (81×57 cm)
sg d 1508
ML
Saint George and the Dragon
→ no 35
pn 11.2×8.5 (28,5×21,5 cm)
sg 1504-6
ML

Bindo Altoviti (?) *
pn 23.6×17.3 (60×44 cm)
c 1515
attr also to Giulio Romano (G.
Pippi, Rome c 1499 - Mantua
1546)
KR
The Small Cowper Madonna
→ no 33
pn 23.4×17.3 (59,5×44 cm)
c 1505
WD
The Annunciation
pn 15.7×14.2 (40×36 cm)
c 1500
KR

**Circle of
RAFFAELLO SANZIO**
Putti with a Wine Press
pn; td 13.0 (33 cm) c 1500
KR

RANGER Henry Ward
... 1858 – ... 1916; act U.S.A.
Spring Woods *
cv 28.0×36.2 (71×92 cm)
sg c 1910 ins
DL

108 Raphael see
RAFFAELLO SANZIO

REDON Odilon
Bordeaux 1840 – Paris 1916
Pansies
pastel 21.5×18.1 (54,5×46 cm)
sg c 1905
Wildflowers *
pastel 24.4×18.9 (62×48 cm)
sg 1905
Pandora
cv 56.5×24.8 (143,5×63 cm)
1910-2
DL
Saint Sebastian
cv 56.7×24.8 (144×63 cm)
sg 1910-2
DL
Evocation of Roussel *
cv 28.7×21.3 (73,5×54 cm)
sg c 1912
DL
Flowers in a Vase
cv 22.0×15.6 (56×39,5 cm) sg
ML

REINHARDT Ad
Buffalo 1913 – New York 1967
Black Painting no 34
cv 60.2×60.0 (153×152,5 cm)
d 1964

**REMBRANDT HARMENSZ.
VAN RIJN**
Leiden 1606 – Amsterdam 1669
Self-Portrait 72 → no 84
cv 33.1×26.0 (84×66 cm)
sg d 1659
ML
Self-Portrait 666 *
cv 36.2×29.7 (92×75,5 cm)
sg d 1650
WD
An Old Lady with a Book
cv 42.9×35.8 (109×91 cm)
sg d 1647
ML
A Girl with a Broom *
cv 42.1×35.8 (107×91 cm)
sg d 1651
ML
A Woman Holding a Pink *
cv 40.6×33.9 (103×86 cm)
sg d 1656
ML
Lucretia *
cv 47.2×39.8 (120×101 cm)
sg d 1664
ML
A Young Man Seated at Table
cv 43.3×35.4 (110×90 cm)
sg d 1662 (or 1663)
ML
A Polish Nobleman *
pn 38.2×26.0 (97×66 cm)
sg d 1637
ML
Joseph Accused by Potiphar's
Wife → no 83
cv 41.7×38.6 (106×98 cm)
sg d 165(5[?])
ML
A Turk
cv 38.6×29.1 (98×74 cm)
sg c 1630-5
ML
Head of Saint Matthew
pn 9.8×7.7 (25×19,5 cm)
1661 (?)
WD

The Apostle Paul → no 85
cv 50.8×40.2 (129×102 cm)
sg 1657 (?)
WD
The Circumcision
cv 22.2×29.5 (56,5×75 cm)
sg d 1661
WD
The Descent from the Cross
cv 56.3×43.7 (143×111 cm)
sg d 165(1[?])
WD
The Mill *
cv 34.5×41.5 (87,5×105,5 cm)
c 1650
WD
Study of an Old Man
pn 11.0×8.5 (28×21,5 cm)
c 1645
WD
Head of an Aged Woman
pn 8.3×6.7 (21×17 cm)
sg d 1657
WD
Philemon and Baucis → no 86
pn 21.5×27.0 (54,5×68,5 cm)
sg d 1658
WD
The Philosopher *
pn 24.2×19.5 (61,5×49,5)
c 1650
WD
Portrait of a Gentleman with
a Tall Hat and Gloves 663
→ no 87
Portrait of a Lady with an
Ostrich-Father Fan → no 88
canvases 39.2×c 32.7
(99,5×c 83 cm) the second
sg d 166... (c 1667)
WD
Portrait of a Man in a Tall Hat
665
cv 47.6×37.0 (121×94 cm)
c 1662
WD
Saskia van Uilenburgh, the
Wife of the Artist
pn 23.8×19.3 (60,5×49 cm)
1633 (?)
WD

Manner of REMBRANDT
Old Woman Plucking a Fowl
cv 52.4×41.3 (133×105 cm)

RENOIR Pierre-Auguste
Limoges 1841 – Cagnes 1919
The Dancer *
pn 56.1×37.2 (142,5×94,5 cm)
sg d 1874
WD
Head of a Young Girl
cv 16.7×13.0 (42,5×33 cm)
sg c 1890
Woman with a Cat *
cv 22.0×18.3 (56×46,5 cm)
sg c 1875
Oarsmen at Chatou *
cv 31.9×39.4 (81×100 cm)
sg d 1879
The Vintagers
cv 21.3×25.8 (54×65,5 cm)
sg d 1879
Girl with a Basket of Fish
Girl with a Basket of Oranges
canvases 51.6×16.5
(131×42 cm) sg c 1889
Madame Henriot *
cv 26.0×19.7 (66×50 cm)
sg c 1876
Girl with a Hoop *
cv 49.6×30.1 (126×76,5 cm)
sg d 1885
DL
Marie Murer
oval cv 26.6×22.4
(67,5×57 cm) sg 1877
DL
Suzanne Valadon
cv 16.1×12.6 (41×32 cm)
sg c 1885
Bather Arranging her Hair *
cv 36.2×29.1 (92×74 cm)
sg 1893
DL
Diana *
cv 78.5×51.0 (119,5×129,5 cm)
sg d 1867
DL
A Girl with a Watering Can
→ no 133
cv 39.4×28.7 (100×73 cm)
sg d 1876
DL
Odalisque → no 134
cv 27.2×48.2 (69×122,5 cm)
sg d 1870
DL
Caroline Rémy ("Séverine")
pastel 24.4×20.1 (62×51 cm)
sg c 1885
DL

Mademoiselle Sicot
cv 45.7×35.2 (116×89,5 cm)
sg d 1865
DL
Mademoiselle Demarsy
cv 24.0×19.7 (61×50 cm)
sg 1884-5
The Blue River
cv 3.2×3.7 (8×9,5 cm)
ML
Young Spanish Woman with a
Guitar
cv 21.8×25.6 (55,5×65 cm)
sg d
ML
White House at Cagnes
cv 5.3×8.9 (13,5×22,5 cm) sg
ML
Woman standing by a Tree
cv 9.8×6.3 (25×16 cm) sg
ML
Woman in a Park
cv 10.2×6.3 (26×16 cm) sg
ML
Child Blond Hair
cv 3.7×3.4 (9,5×8,5 cm) sg
ML
Child Brown Hair
cv 4.7×3.9 (12×10 cm) sg
ML
Young Girl Reading
cv 6.1×4.3 (15,5×11 cm) sg
ML
Regatta at Argenteuil
cv 12.8×17.9 (32,5×45,5 cm)
1890 (?)
ML
Madame Monet and Her Son
cv 19.9×26.8 (50,5×68 cm) ins
ML
Picking Flowers *
cv 21.5×24.4 (54,5×62 cm) sg
ML
Head of a Dog
cv 8.7×7.9 (22×20 cm) sg
ML
The Pont Neuf
cv 29.7×36.8 (75,5×93,5 cm)
sg d 1872
ML
Young Woman Braiding Her
Hair
cv 21.8×18.3 (55,5×46,5 cm)
sg d 1876
ML
Georges Rivière
cv 14.6×11.6 (37×29,5 cm) sg
d 1877
ML
Landscape Between Storms
cv 9.6×12.8 (24,5×32,5 cm) sg
ML
Woman by a Fence
cv 9,8×6.3 (25×16 cm) sg
ML
Madame Hagen
cv 36.2×28.7 (92×73 cm) sg
d 1883
ML
Landscape at Vétheuil
cv 4.5×6.5 (11,5×16,5 cm)
ML
Nude
cv 5.3×4.1 (13,5×10,5 cm) sg
ML
Nude with Figure in Background
cv 5.1×2.2 (13×5,5 cm) sg
ML
Head of a Woman with Red Hair
cv 7.5×7.1 (19×18 cm) sg
ML
Peaches on a Plate
cv 8.7×14.0 (22×35,5 cm) sg
ML

REYNOLDS Joshua
*Plympton-Earl's 1723 –
London 1792*
Lady Elizabeth Delmé and Her
Children *
portrait of mother and chil-
dren
cv 94.1×58.3 (239×148 cm)
1777-80
ML
Lady Elizabeth Compton
cv 94.5×58.7 (240×149 cm)
1781
ML
Lady Caroline Howard *
cv 56.3×44.5 (143×113 cm)
c 1778 ins
ML
Lady Cornewall → no 154
cv 50.0×40.0 (127×101,5 cm)
c 1785
WD
Lady Betty Hamilton *
cv 46.1×33.1 (117×84 cm) 1758
WD
Squire Musters
cv 93.9×57.9 (238,5×147 cm)
1777-80

Follower of REYNOLDS
The Honorable Mrs. Gray
cv 29.9×25.0 (76×63,5 cm)
c 1785
WD

RIBOT Théodule
*S. Nicolas d'Attez 1823 – Colom-
bes 1891*
Portrait of a Man
crt on pn 5.9×4.5 (15×11,5 cm)
sg
DL

Ricci Marco see under
Ricci Sebastiano

RICCI Sebastiano
Belluno 1659 – Venice 1734
A Miracle of Saint Francis of
Paula *
The Finding of the True Cross *
canvases 33.1×13.8
(84×35 cm) 1733-4
KR
The Last Supper
cv 26.4×40.9 (67×104 cm)
c 1715
Memorial to Admiral Sir Clowd-
isley Shovell *
cv 87.4×62.6 (222×159 cm)
c 1725
in collaboration with Marco
Ricci (Belluno 1676 – Venice
1730)
KR

Romano Giulio see under
Raffaello Sanzio

ROMNEY George
*Dalton-in-Furness 1734 – Kendal
1802*
Lady Broughton
cv 94.1×57.9 (239×147 cm)
1770-3
ML
Miss Willoughby → no 157
cv 36.2×28.2 (92×71,5 cm)
1781-3
ML
Mrs. Davenport
cv 30.1×25.2 (76,5×64 cm)
1782-4
ML
Mrs. Blair
cv 50.0×40.0 (127×101,5 cm)
1787-9
WD
Lady Arabella Ward
cv 29.9×25.0 (76×63,5 cm)
1783-8
WD
Mr. Forbes
cv 30.1×25.0 (76,5×63,5 cm)
c 1780-90
DL
Sir Archibald Campbell *
cv 60.4×48.8 (153,5×124 cm)
1792(?)
TM
Sir William Hamilton
cv 30.3×25.6 (77×65 cm)
ML

ROPES George
Salem 1788 – 1819
Mount Vernon
cv 37.0×53.1 (94×135 cm) sg
d 1806
GR

**ROSSO FIORENTINO
(Giovan Battista
di Jacopo di Gaspare)**
*Florence 1495 – Fontainebleau
1540*
Portrait of a Man → no 41
pn 35.0×26.8 (89×68) c 1523
KR

ROTARI Pietro
*Verona 1707 – Saint Petersburg
1762*
A Sleeping Girl
A Girl with a Flower in her
Hair *
canvases 17.3×13.4
(44×34 cm) 1756-62
KR

ROUAULT Georges
Paris 1871 – 1958
Café Scene
gouache 15.2×11.2
(38,5×28,5 cm) sg d 1906
DL
Nude with Upraised Arms *
gouache 24.8×18.7
(63×47,5 cm) sg d 1906
DL
Christ and the Doctor *
cv 3.4×4.3 (8,5×11 cm) sg
ML

ROUGET Georges
Paris 1784 – 1869
Jacques-Louis David
cv 35.0×26.8 (89×68 cm)
c 1815(?)
DL

ROUSSEAU Henri
Laval 1844 – Paris 1910
Boy on the Rocks → no 147
cv 21.8×18.1 (55,5×46 cm)
sg 1895-7
DL
The Equatorial Jungle *
cv 55.1×51.0 (140,5×129, 5 cm)
sg d 1909
DL
Rendezvous in the Forest
cv 36.4×28.7 (92,5×73 cm)
sg 1889

ROUSSEAU Théodore
Paris 1812 – Barbizon 1867
Landscape with Boatman *
pn 7.5×10.6 (19×27 cm)
c 1860

RUBENS Peter Paul
Siegen 1577 – Antwerp 1640
Isabella Brant
cv 60.2×47.2 (153×120 cm)
1623-6(?)
attr also to van Dyck
ML
The Head of one of the Three
Kings
pn/cv 26.2×20.3
(66,5×51,5 cm) c 1615
DL
The Assumption of the Virgin
pn 49.4×37.0 (125,5×94 cm)
c 1626
KR
Decius Mus Addressing the Le-
gions *
pn 31.9×33.3 (81×84,5 cm)
1617(?)
KR
The Meeting of Abraham and
Melchizedek → no 75
pn 26.0×32.5 (66×82,5 cm)
c 1625
Marchesa Brigida Spinola Doria
cv 59.8×39.0 (152×99 cm)
c 1606
KR
Tiberius and Agrippina *
pn 26.2×22.4 (66,5×57 cm)
c 1614
Daniel in the Lions' Den *
cv 88.2×130.1 (224×330,5 cm)
c 1615
Saint Peter
pn 36.2×26.4 (92×67 cm)
c 1612-3 school
TM
Peter Paul Rubens
pn 16.1×13.2 (41×33,5 cm)
c 1615 school
TM
The Gerbier Family
cv 65.4×70.1 (166×178 cm)
ML

RUISDAEL Jacob Isaacksz. van
Haarlem 1628-9 – Amsterdam (?) 1682
Forest Scene *
cv 41.5×51.6 (105,5×131 cm)
sg d c 1660-5
WD
Park with a County House
cv 29.9×38.4 (76×97,5 cm)
sg c 1680
Landscape *
cv 20.9×23.6 (53×60 cm)
sg 1655-60(?)
KR

RYDER Albert Pinkham
New Bedford 1847 – Long Island 1917
Mending the Harness
cv 18.9×22.4 (48×57 cm)
sg c 1875
Siegfried and the Rhine Maidens *
cv 19.9×20.5 (50,5×52 cm)
sg 1888-91
ML

SACHS Lambert
act 1854-64 Philadelphia
The Herbert Children *
cv 25.0×31.5 (63,5×80 cm) sg
d 1857
GR

SAENREDAM Pieter Jansz.
Assendelft 1597 — Haarlem 1665
Cathedral of Saint John at 's-Hertogenbosch *
pn 50.8×34.3 (129×87 cm)
sg d 1646
KR
Church of Santa Maria della Febbre, Rome *
pn 15.0×27.8 (38×70,5 cm)
sg d 1629
KR

SALVIATI Cecchino del (Francesco Rossi)
Florence 1510 – Rome 1563
Portrait of a Lady
pn 26.4×20.5 (67×52 cm)
c 1555

SANO DI PIETRO
Siena 1406 – 1481
The Crucifixion *
pn of a pred (?); pn 9.1×13.0 (23×33 cm) c 1445-50
KR
Madonna and Child with Saints and Angels
pn 25.6×17.3 (65×44 cm)
c 1471 ins
KR

SARGENT John Singer
Florence 1856 — London 1925
Mrs. Joseph Chamberlain
cv 59.3×33.1 (150,5×84 cm)
sg d 1902
Mrs. William Crowninshield Endicott
cv 64.2×45.1 (163×114,5 cm)
sg d 1901
Mrs. Adrian Iselin *
cv 60.4×36.6 (153,5×93 cm)
sg d 1888
Repose
cv 25.2×29.9 (64×76 cm)
sg d 1911
Street in Venice
pn 17.7×21.3 (45×54 cm)
sg 1882
Mathilde Townsend
cv 60.2×40.2 (153×102 cm)
sg d 1907
Peter A. B. Widener
cv 58.7×38.8 (149×98,5 cm)
sg d 1902
WD
Miss Grace Woodhouse
cv 64.2×37.0 (163×94 cm)
sg d 1890

Sarto see **ANDREA DEL S.**

SASSETTA (Stefano di Giovanni)
Siena (?) c 1392 – Siena 1450
Madonna and Child
cusped pn 18.9×8.3 (48×21 cm)
gold ground c 1435
KR
The Meeting of Saint Anthony and Saint Paul → no 14

Saint Anthony Distributing his Wealth to the Poor *
Saint Anthony Leaving His Monastery
The Death of Saint Anthony
panels of a polyptych
c 18.5×c 13.8 (c 47×c 35 cm);
the fourth 14.4×15.0 (36,5×38 cm) c 1440
with assistance
KR
Saint Margaret
Saint Apollonia
panels of a trp (?) 11.4×4.3 (29×11 cm) c 1435 attr

SAVAGE Edward
Princeton 1761 – 1817
George Washington
cv 29.9×24.8 (76×63 cm)
1796(?)
The Washington Family → no 170
cv 83.5×111.8 (212×284 cm)
1796
ML

SAVOLDO Giovanni Girolamo
Brescia c 1480-5 – c 1548
Portrait of a Knight → no 49
cv 34.6×28.9 (88×73,5 cm)
c 1540
KR
Elijah Fed by the Raven *
pn/cv 66.1×53.3 (168×135,5 cm) c 1510
KR
The Adoration of the Child
pn 33.3×47.2 (84,5×120 cm)
c 1527 attr
KR

SCHÄUFELEIN Hans
... 1480-5 – Nördlingen 1539
Portrait of a Man
pn 15.7×12.6 (40×32 cm)
false sg and d (A. Dürer 1507)
formerly attr to Dürer
ML

SCOREL Jan van
Schoorl 1495 – Utrecht 1562
The Rest on the Flight into Egypt → no 73
pn 22.8×29.5 (58×75 cm)
c 1530
KR

SEBASTIANO DEL PIOMBO (S. Luciani or Veneziano)
Venice c 1485 – Rome 1547
Portrait of a Young Woman as a Wise Virgin (Vittoria Colonna?)
pn 21.1×18.1 (53,5×46 cm)
c 1510 ins
KR
Cardinal Bandinello Sauli, His Secretary and Two Geographers *
pn/cv 47.8×59.1 (121,5×150 cm) sg (damaged)
d 1516 ins
KR
Portrait of a Humanist → no 53
pn/masonite 53.1×39.8 (135×101 cm) c 1520
KR

SELLAIO Jacopo del
Florence 1441-2 – 1493
Saint John the Baptist *
pn 20.5×13.0 (52×33 cm)
c 1480
KR

Sellari see **GIROLAMO DA CARPI**

SEURAT Georges-Pierre
Paris 1859 – 1891
Workers
pn 67×10.0 (17×25,5 cm)
Les Grues et la Percée
cv 25.4×31.7 (64,5×80,5 cm)
1888
Study for "Lan Grande Jatte" *
pn 6.3×9.8 (16×25 cm) sg
ML

SEYFFERT Leopold
Colorado 1887 – ... 1956
Rush Harrison Kress
Samuel Henry Kress
brothers' portraits
canvases 50.0×40.2 (127×102 cm) sg d 1953
KR

SHEFFIELD Isaac
Guilford 1798 – Warrenville 1845
Connecticut Sea Captain
Connecticut Sea Captain's Wife
Husband and wife portraits
panels 29.9×24.2 (76×61,5 cm)
1833
GR

SIGNORELLI Luca
Cortona 1445-50 – 1523
Calvary
frm of an altarpiece rv;
pn 28.3×39.6 (72×100,5 cm)
c 1505 with assistance
KR
The Marriage of the Virgin
pn of a pred 8.5×18.9 (21,5×48 cm) c 1491
with assistance
KR
Madonna and Child with Saints and Angels *
pn 61.4×53.3 (156×135,5 cm)
c 1515
with assistance
KR
see also the Master of the Griselda Legend

SIMONE MARTINI
Siena (?) ... – Avignon 1344
The Angel of the Annunciation *
pn 12.2×8.7 (31×22 cm)
gold ground c 1333 res
KR
Saint Matthew
Saint Simon
Saint James Major
Saint Thaddeus
panels of a polyptych
12.2×9.1 (31×23 cm) c 1320
ins with assistance
KR

SIQUEIROS David Alfaro
Chihuahua 1896 – Cuernavaca 1974
Self-Portrait
piroxilene-masonite
47.4×35.8 (120,5×91 cm)

SISLEY Alfred
Paris 1839 – Moret-sur-Loing 1899
The Banks of the Oise *
cv 21.3×25.6 (54×65 cm)
sg c 1878-80
DL
The Road in the Woods
cv 18.1×22.0 (46×56 cm)
sg 1878-80
Street at Sèvres
cv 15.6×23.4 (39,5×59,5 cm)
sg d 1872
ML
Meadow
cv 21.6×28.7 (55×73 cm)
sg d 1875
ML

SITHIUM or SITTOW Miguel or Michel
Reval c 1465-70 – 1525
A Knight of the Order of Calatrava
pn 13.2×9.3 (33,5×23,5 cm)
c 1515
ML
The Assumption of the Virgin *
pn 12.2×6.5 (31×16,5 cm)
c 1500

SKYNNER T.
Nineteenth Century, U.S.A.
Portrait of a Man
Portrait of a Woman *
Husband and wife portraits
canvases 29.9×24.0 (76×61 cm) c 1845
GR

SODOMA (Giovanni Antonio Bazzi)
Vercelli 1477 – Siena 1549
Madonna and Child with the Infant Saint John
pn 31.1×25.6 (79×65 cm)
c 1505
KR
Saint George and the Dragon → no 43
pn 54.3×38.4 (138×97,5 cm)
1518 res
KR

SOLARIO Andrea
Milan (?) c 1470 – Milan 1524
Pietà *
pn 66.3×59.8 (168,5×152 cm)
c 1515
KR

SOULAGES Pierre
Rodez 1919 –
Composition
cv 76.8×51.6 (195×131 cm)

SOUTINE Chaim
Smilovič 1894 – Paris 1943
Portrait of a Boy *
cv 36.2×25.6 (92×65 cm)
sg 1928
DL
The Pastry Chef *
cv 25.4×19.1 (64,5×48,5 cm)
d 1927
DL

SPENCER Frederic R.
Lennox 1806 – Wampoville 1875
Frances Ludlum Morris
cv 35.8×29.1 (91×74 cm) 1838
ML

STANLEY Abram R.
New York 1816 – ... c 1870
Eliza Wells
cv 25.2×23.4 (64×59,5 cm)
1840
GR

STEEN Jan Havicksz.
Leiden 1626 – 1679
The Dancing Couple *
cv 40.4×56.1 (102,5×142,5 cm)
sg d 1663
WD

STEINLEN Théophile Alexandre
Lausanne 1859 – Paris 1923
The Laundresses
cv 32.7×26.8 (83×68 cm)
sg c 1900
DL

STEVENS Alfred
Brussels 1823 – Paris 1906
Young Woman in White Holding a Bouquet *
pn 11.4×8.1 (29×20,5 cm)
sg c 1865-75
DL

STOCK Joseph Whiting
Springfield 1815 – 1855
Mary and Francis Wilcox → no 165
brother and sister portrait
cv 48.0×40.0 (122×101,5 cm)
1845
GR

STRIGEL Bernhard
Memmingen 1460-1 – 1528
Hans Rott, Patrician of Memmingen
Margaret Vöhlin, Wife of Hans Rott
Husband and wife portraits
panels 17.3×12.2 (44×31 cm)
d 1527 ins
BTH
Saint Mary Cleophas and Her Family *
Saint Mary Salome and Her Family *
panels 49.2×24.8 and 26.0 (125×63 and 66 cm) 1520-8 ins
KR

STROZZI Bernardo (Cappuccino or Prete Genovese)
Genoa 1581 – Venice 1644
Bishop Alvise Grimani *
cv 57.9×37.4 (147×95 cm)
c 1633
KR

STUART Gilbert
North Kingstown 1755 – Boston 1828
John Adams
Mrs. John Adams
Husband and wife portraits
canvases 28.9×23.6 (73,5×60 cm) 1815

Captain Joseph Anthony
cv 36.0×28.0 (91,5×71 cm)
1793-4
ML
Mr. Ashe
cv 36.0×28.0 (91,5×71 cm)
c 1800
ML
Ann Barry
Mary Barry
sisters' portraits
canvases 29.1×24.0 (74×61 cm) 1803-5
Herace Binney
cv 28.9×23.6 (73,5×60 cm)
1800
Joseph Coolidge
cv 28.2×22.8 (71,5×58 cm)
1820
ML
Sir John Dick
cv 36.2×28.2 (92×71,5 cm)
sg d (1782) 1783 ins
ML
Counsellor John Dunn
cv 29.1×24.2 (74×61,5 cm)
c 1798
ML
Dr. William Hartigan (?)
Mrs. William Hartigan
Husband and wife portraits
canvases 30.1×25.0 (76,5×63,5 cm) c 1793
ML
Lady Liston *
Sir Robert Liston
Husband and wife portraits
canvases 29.1×24.0 (74×61 cm) 1800
DL
Commodore Thomas Macdonough
pn 28.3×23.0 (72×58,5 cm)
1818(?)
ML
George Pollock
Mrs. George Pollock
Husband and wife portraits
canvases 36.0×12.6 (91,5×32 cm) 1793-4
ML
John Randolph
cv 29.1×24.0 (74×61 cm) 1805
ML
Sir Joshua Reynolds
cv 36.0×29.9 (91,5×76 cm)
1784
ML
John Bill Ricketts
cv 29.5×24.2 (75×61,5 cm)
1793-9 ins
Mrs. William Robinson
pn 28.3×22.8 (72×58 cm)
c 1812
ML
The Skater
cv 96.7×58.1 (245,5×147,5 cm)
1782
ML
Edward Stow
pn 28.9×23.6 (73,5×60 cm)
c 1803
ML
William Thornton
Mrs. William Thornton
Husband and wife portraits
canvases 28.9×28.2 (73,5×71,5 cm) c 1794
ML
George Washington (Vaughan-Sinclair portrait) 492
→ no 169
cv 29.1×24.0 (74×61 cm)
1795-6
ML
George Washington (Vaughan portrait) 580 *
cv 28.9×23.6 (73,5×60 cm)
1795
ML
George Washington 1352
cv 28.9×24.0 (73,5×61 cm)
1803-5(?)
ML
Luke White
cv 29.9×25.0 (76×63,5 cm)
c 1790
ML
Lawrence Reid Yates
cv 30.3×25.2 (77×64 cm)
1793-4
ML
Richard Yates
Mrs. Richard Yates → no 168
Husband and wife portraits
canvases 32.3×27.4 (82×69,5 cm) 1793-4
ML
Benjamin Tappan
Mrs. Benjamin Tappan
Husband and wife portraits
panels 28.5 × c 23.2 (72,5 × c 59 cm)

STUBBS George
Liverpool 1724 – London 1806
Colonel Pockington with His Sisters → no 159
cv 39.4×49.8 (100×126,5 cm)
sg d 1769

SULLY Thomas
Horncastle (England) 1783 – Philadelphia 1872
John Quincy Adams
cv 24.0×20.1 (61×51 cm) 1824
ML
Thomas Alston
cv 30.3×25.2 (77×64 cm)
sg d 1826
ML
The Coleman Sisters
cv 44.1×34.5 (112×87,5 cm)
1844
ML
Joseph Dugan
cv 36.2×28.9 (92×73,5 cm)
1810
Mrs. William Griffin
cv 30.1×25.2 (76,5×64 cm)
sg d 1830
DL
Ann Biddle Hopkinson
Francis Hopkinson
Husband and wife portraits
canvases 20.1×17.1
(51×43,5 cm) the second sg
d 1834
ML
Andrew Jackson *
cv 20.5×17.3 (52×44 cm) 1845
ML
Abraham Kintzing
cv 30.1×25.2 (76,5×64 cm)
1815
ML
Henry Pratt
cv 36.2×28.9 (92×73,5 cm)
1815
Governor Charles Ridgely of Maryland
cv 50.0×40.0 (127×101,5 cm)
sg d 1820
Lady with a Harp: Eliza Ridgely
cv 84.3×56.1 (214×142,5 cm)
sg d 1818
The Sicard-David Children
cv 33.3×44.1 (84,5×112 cm)
sg d 18.. (1826)
DL
Captain Charles Stewart
cv 103.9×58.7 (264×149 cm)
1811-12
The Vanderkemp Children
cv 28.0×36.0 (71×91,5 cm)
sg d 1832
Robert Walsh
cv 30.3×25.2 (77×64 cm) 1814
ML
see also Thomas Wilcocks Sully

SULLY Thomas Wilcocks
Philadelphia 1811 – 1847
Major Thomas Biddle
cv 35.6×27.4 (90,5×69,5 cm)
1832
in collaboration with T. Sully

SUSTERMANS Justus
Antwerp 1597 – Florence 1681
Mattias de' Medici
cv 50.4×40.9 (128×104 cm)
c 1660 attr

SUTHERLAND Graham
London 1903 –
Palm Palisades
cv 42.9×36 (109×91,5 cm) 1947

TAMAYO Ruffino
Oaxaca 1900 –
Clowns
cv 19.7×39.2 (50×99.5 cm)
1942

TANNER J. G.
Nineteenth Century, U.S.A.
Engagement between the Monitor and Merrimac
cv 26.0×36.0 (66×91,5 cm)
sg c 1891 ins
GR

TANZIO DA VARALLO
(Antonio d'Errico)
Riale d'Alagna c 1575 – Varallo Sesia c 1635
Saint Sebastian *
cv 46.5×37.0 (118×94 cm)
c 1620-30
KR

TARBELL Edmund Charles
West Croton 1862 – ... 1938
Mother and Mary
cv 44.1×50.2 (112×127,5 cm)
sg d 1922

TENIERS THE YOUNGER David
Antwerp 1610 – Brussels 1690
Peasants celebrating Twelfth-Night
cv 18.5×27.6 (47×70 cm)
sg d 1635
ML

Ter Borch see BORCH

THEUS Jeremiah
Graubünden (Switzerland) (?) 1719 – Charleston 1774
Mr. Cuthbert
Mrs. Cuthbert
Husband and wife portraits
canvases 30.1×24.8
(75,5×63 cm) c 1765 attr
GR
Mr. Motte *
cv 29.9×25.2 (76×64 cm)
c 1760
ML

TIEPOLO Giambattista
Venice 1696 – Madrid 1770
The Apotheosis of a Poet
sketch; cv 10.6×19.3
(27×49 cm) c 1750
KR
Timocleia and the Thracian Commander *
oval cv 56.3×43.1
(143×109,5 cm) 1765
over-door ptg
KR
The World Pays Homage to Spain
sketch; cv 71.3×41.1
(181×104,5 cm) 1762 (?)
KR
Madonna of the Goldfinch *
cv 24.8×19.7 (63×50 cm)
c 1760
attr also to Giandomenico
Tiepolo (Venice 1727 – 1804)
A Young Lady in Domino and Tricorne *
cv 24.4×19.3 (62×49 cm)
c 1760
KR
Apollo Pursuing Daphne
→ no 59
cv 27.2×34.3 (69×87 cm)
sg c 1758-60
KR
A Scene from Roman History
cv 103.0×144.1 (261,5×366 cm)
c 1735
The Apotheosis of a Saint
cv 16.3×13.4 (41,5×34 cm)
c 1750-60
Bacchus and Ariadne
cv 84.1×91.3 (213,5×232 cm)
c 1738-40
TM

**Tiepolo Giandomenico
see under
Tiepolo Giambattista**

TINELLI Tiberio
Venice 1586 – 1638
Count Lodovico Vidmano
cv 81.1×54.1 (206×137,5 cm)
sg c 1630

**TINTORETTO Jacopo
(J. Robusti)**
Venice 1518 – 1594
The Worship of the Golden Calf
cv 62.6×107.1 (159×272 cm)
c 1545 with assistance
KR
Susanna
cv 59.1×40.6 (150×103 cm)
c 1575
KR
Portrait of a Venetian Senator
cv 43.5×34.6 (110,5×88 cm)
c 1570
DL
Christ at the Sea of Galilee
→ no 54
cv 46.1×66.3 (117×168, 5 cm)
c 1560
KR

The Madonna of the Stars
cv 36.6×28.7 (93×73 cm)
c 1565
BTH
A Procurator of Saint Mark's
cv 54.7×39.8 (139×101 cm)
c 1575-85
KR
The Conversion of Saint Paul *
cv 60.1×92.9 (152,5×236 cm)
c 1545
KR
Doge Alvise Mocenigo and Family before the Madonna and Child *
cv 85.0×164.0 (216×416,5 cm)
1573(?)
KR
Summer
cv 41.7×76.0 (106×193 cm)
c 1555
KR
Apollo and Marsyas (?)
cv 8.9×21.5 (22,5×54,5 cm)
c 1540-5
KR
Portrait of a Man and Boy
cv 44.5×37.0 (113×94 cm)
ins school see also Tiziano

**TINTORETTO Marco
(M. Robusti)**
Venice c 1560(?) – 1637
Pietà
cv 25.6×26.0 (65×66 cm)
TM

**Titian see
TIZIANO VECELLIO**

TIZIANO VECELLIO
Pieve di Cadore c 1488-90 – Venice 1576
Venus with a Mirror → no 51
cv 50.0×41.5 (124,5×105, 5 cm)
c 1555
ML
Andrea dei Franceschi
cv 25.6×20.1 (65×51 cm)
c 1530 ins
ML
Madonna and Child and the Infant Saint John in a Landscape
cv 11.0×22.8 (28×58 cm)
1516-23
ML
Portrait of a Lady *
cv 38.6×29.1 (98×74 cm)
1550-5 damaged
KR
Emilia di Spilimbergo
Irene di Spilimbergo
canvases 48.0×41.9
(122×106,5 cm) c 1560;
the second ins
WD
Venus and Adonis *
cv 42.1×53.5 (107×136 cm)
c 1560
WD
Cardinal Pietro Bembo
cv 37.2×30.1 (94,5×76,5 cm)
c 1540
KR
Ranuccio Farnese → no 52
cv 35.4×28.9 (90×73,5 cm)
sg 1542
KR
Portrait of a Young Lady as Venus Binding the Eyes of Cupid
cv 48.2×38.2 (122,5×97 cm)
c 1555-60
KR
Vincenzo Capello
cv 55.5×46.5 (141×118 cm)
c 1540 attr also to Jacopo Tintoretto
KR
Doge Andrea Gritti *
cv 52.6×40.6 (133,5×103 cm)
sg c 1535-40
KR
Saint John the Evangelist on Patmos
ceiling; cv 93.5×103.5
(237,5×263 cm) c 1540
KR
Allegory (Alfonso d'Este and Laura Diante?)
cv 35.8×32.3 (91×82 cm)
1515-25 st
KR
Cupid with the Wheel of Fortune
cv 26.0×21.6 (66×55 cm)
c 1520 attr
KR

Girolamo and Cardinal Marco Corner Investing Marco, Abbot of Carrara, with His Benefice
cv 52.0×39.4 (132×100 cm)
1520-24 in collaboration with st assistants
TM
Self-Portrait
cv 44.1×37.0 (112×94 cm)
false d and sg (1561)
c 1550 attr
see also Bellini Giovanni and Giorgione

Northern Follower of TIZIANO
Alessandro Alberti with a Page
cv 48.8×40.6 (124×103 cm)
sg (disappeared) d 15.. ins
KR

TOOLE John
... 1815 – ... 1860; act U.S.A.
Skating Scene
cv 14.6×18.1 (37×46 cm)
c 1835
GR

TOULOUSE-LAUTREC Henri de
Albi 1864 – Malromé 1901
Jane Avril *
crt/pn 39.4×35.0
(100×89 cm) sg 1892
DL
A Corner of the Moulin de la Galette → no 135
crt/pn 39.4×35.0 (100×89 cm)
sg 1892
DL
Rue des Moulins, 1894 *
crt/pn 32.9×24.2
(83,5×61,5 cm) sg 1894
DL
Maxime Dethomas *
gouache 26.4×20.9
(67×53 cm) sg d 1896
DL
Alfred La Guigne *
gouache 25.8×19.9
(65,5×50,5 cm) sg 1894 ins
DL
Quadrille at the Moulin Rouge → no 136
gouache 31.5×23.8
(80×60,5 cm) sg 1892
DL
Lady with a Dog
crt 29.7×22.6 (75,5×57,5 cm)
sg d 1891
The Artist's Dog Flèche *
pn 9.3×5.5 (23,5×14 cm) sg
ML
Carmen Gaudin
pn 9.4×5.9 (24×15 cm)
ML

TRUMBULL John
Lebanon 1756 – New York 1843
Alexander Hamilton 494 *
cv 30.3×24.2 (77×61,5 cm)
1806
ML
Alexander Hamilton 1081
cv 30.3×24.0 (77×61 cm)
1792(?)
ML
William Rogers
cv 30.7×25.2 (78×64 cm)
1804-8
ML
Patrick Tracy
cv 91.5×52.6 (232,5×133,5 cm)
1784-6

TUCKER Allen
... 1866 – ... 1939
Bizarre
cv 30.3×25.2 (77×64 cm)
d 1928
Madison Square, Snow
cv 20.1×24.0 (51×61 cm)
d 1904

TURA Cosimo
Ferrara c 1430 – 1495
Madonna and Child in a Garden → no 22
pn 20.9×14.6 (53×37 cm)
c 1455
regilded stucco decoration
KR
The Annunciation with Saint Francis and Saint Maurelius
panels of a diptych or trp (?);
four panels 12.0×4.7
(30,5×12 cm) c 1475
KR

Portrait of a Man
pn 14.0×10.0 (35,5×25,5 cm)
1475-85 attr
KR

TURNER Joseph Mallord William
London 1775 – Chelsea 1851
Mortlake Terrace *
cv 36.2×48.0 (92×122 cm)
c 1826
ML
Approach to Venice → no 162
cv 24.4×37.0 (62×94 cm)
c 1843
ML
Venice: Dogana and San Giorgio Maggiore
cv 36.0×48.0 (91,5×122 cm)
1834(?)
WD
Keelmen Heaving in Coals by Moonlight *
cv 36.2×48.4 (92×123 cm)
sg 1835(?)
WD
The Junction of the Thames and the Medway *
cv 42.9×56.7 (190×144 cm)
c 1805-8
WD
The Rape of Proserpine
cv 36.4×48.8 (92,5×124 cm)
1839
The Evening of the Deluge
cv 29.9×29.9 (76×76 cm)
c 1843
TM
The Dogana and Santa Maria della Salute, Venice *
cv 24.4×36.6 (62×93 cm)
sg 1843(?)
Van Tromps Shallop at the Entrance of the Scheldt
cv 36.4×48.2 (92,5×122,5 cm)
ML

TWACHTMAN John H.
Cincinnati 1853 – Gloucester 1902
Winter Harmony
cv 25.8×31.9 (65,5×81 cm)
sg c 1900

**Unknown American Painters
see AMERICAN SCHOOL**

UTRILLO Maurice
Paris 1883 – Dax 1955
The Church of Saint-Séverin → no 146
cv 28.7×21.3 (73×54 cm)
sg c 1913
DL
Marizy-Sainte-Geneviève *
cv 23.6×31.9 (60×81 cm)
sg c 1910
DL
Row of Houses, Pierrefitte
crt/pn 9.4×13.4 (24×34 cm) sg
ML
Landscape, Pierrefitte
crt/pn 9.8×13.6 (25×34,5 cm)
sg
ML
Rue Cortot, Montmartre
crt 17.9×13.2 (45,5×33,5 cm)
sg d 1909
ML
Street at Corte, Corsica
cv 24.0×31.7 (61×80,5 cm) sg
ML

VALDÉS LEAL Juan de
Seville 1622 – 1690
The Assumption of the Virgin
cv 84.6×61.4 (21×156 cm)
sg c 1670
KR

VALLOTTON Félix
Lausanne 1865 – Paris 1925
Marigolds and Tangerines
cv 25.6×21.3 (65×54 cm)
sg d 1924
DL

VANDERLYN John
Kingston 1775 – 1852
Zachariah Schoonmaker
cv 25.8×22.2 (65,5×56,5 cm)
1815-8
ML

John Sudam
cv 29.9×25.0 (76×63,5 cm)
1830
ML

VAN GOGH Vincent
Zundert 1853 – Auvers-sur-Oise 1890
Girl in White → no 138
cv 26.0×17.7 (66×45 cm) 1890
DL
Roulin's Baby *
cv 13.8×9.4 (35×24 cm) 1888
DL
La mousmé → no 139
cv 28.7×23.6 (73×60 cm) 1888
DL
The Olive Orchard → no 137
cv 28.7×36.2 (73×92 cm) 1889
DL
Self-Portrait *
cv 23.2×19.1 (59×48,5 cm)
1889 attr
DL
Farmhouse in Provence, Arles *
cv 18.1×24.0 (46×61 cm)
ML

VASSALLO Antonio Maria
Seventeenth Century, Genoa
The Larder *
cv 115.0×64.2 (292×163 cm)
c 1640-50
KR

VELÁZQUEZ Diego Rodríguez de Silva y
Seville 1599 – Madrid 1660
Pope Innocent X *
sketch (?); cv 19.3×16.5 (49×42 cm) c 1650
ML
The Needlewoman → no 100
cv 29.1×23.6 (74×60 cm)
c 1640
ML
Portrait of a Young Man
cv 23.2×18.9 (59×48 cm)
c 1635 st
ML

VENETIAN SCHOOL
Sixteenth Century
Portrait of a Young Man
pn 11.0×9.1 (28×23 cm)
c 1505
WD
Allegory
pn 16.9×15.4 (43×39 cm)
c 1530

Eighteenth Century
Before the Masked Ball *
cv 65.6×50.0 (166,5×127 cm)
1750-75
KR

VERMEER Jan
Delft 1632 – 1675
The Girl with a Red Hat → no 80
pn 9.1×7.1 (23×18 cm)
sg c 1660
ML
A Woman Weighing Gold
→ no 82
cv 16.7×15.0 (42,5×38 cm)
c 1657
WD
Young Girl with a Flute → no 81
pn 7.9×7.1 (20×18 cm) 1658-60
WD
A Lady Writing *
cv 17.7×15.7 (45×40 cm)
sg c 1665

Follower of VERMEER
The Lacemaker
cv 17.3×15.7 (44×40 cm)
ML
The Smiling Girl *
cv 16.1×12.6 (41×32 cm)
ML

VERONESE (Paolo Caliari)
Verona 1528 – Venice 1588
The Finding of Moses → no 55
cv 22.8×17.5 (58×44,5 cm)
c 1570
repl of ptg in Madrid, Prado Museum
ML
Rebecca at the Well
cv 57.3×111.4 (145,5×283 cm)
c 1580
KR

Saint Jerome in the Wilderness
cv 42.5×33.1 (108×84 cm)
1570-80(?)
KR
Saint Lucy and a Donor *
cv 80.1×45.3 (180,5×115 cm)
c 1580
KR
The Annunciation *
cv 38.8×29.5 (98,5×75 cm)
c 1580
KR
Agostino Barbaro
cv 40.6×40.4 (103×102,5 cm)
school

Circle of VERROCCHIO
Andrea del (A. di Cione)
Florence 1435 – Venice 1488
Madonna and Child with a Pomegranate
pn 6.3×5.1 (16×13 cm)
c 1475
too drastically cleaned
attr also to Leonardo
KR

Style of VERROCCHIO
Madonna and Child
pn 30.7×21.3 (78×54 cm)
damaged
KR

VIGÉE-LEBRUN Elisabeth
Paris 1755 – 1842
Portrait of a Lady *
pn 42.1×32.7 (107×83 cm)
sg d 1789
KR
The Marquise de Pezé and the Marquise de Rouget with Her Two Children *
cv 49.0×61.4 (123,5×156 cm)
1787
Marie-Antoinette
cv 36.6×28.7 (93×73 cm)
c 1783
TM

VIVARINI Alvise
Venice c 1445 – 1503-5
Saint Jerome Reading *
pn 12.2×9.8 (31×25 cm)
sg c 1475-80
KR
Portrait of a Senator
pn 13.8×12.2 (35×31 cm)
c 1500
KR

VIVARINI Antonio
Murano c 1418 – c 1491
Saint Catherine Casting Down a Pagan Idol *
ar pn 23.6×13.4 (60×34 cm)
c 1450 ins
KR

VIVARINI Bartolomeo
Murano c 1430 – c 1490
Madonna and Child *
pn 20.9×16.5 (53×42 cm)
c 1475
KR

VLAMINCK Maurice de
Paris 1876 – Rueil-la-Gadelière 1958
Carrières-Saint-Denis
cv 28.9×36.2 (73,5×92 cm)
sg 1918-20
DL
The Old Port of Marseille *
cv 28.7×35.6 (73×90,5 cm)
sg 1913
DL
The River *
cv 23.6×28.7 (60×73 cm)
sg c 1910
DL
Still Life with Lemons
cv 23.8×28.7 (60,5×73 cm)
sg 1913-14
DL
Vase of Flowers
cv 28.7×23.8 (73×60,5 cm)
sg c 1910
DL

VOLK Douglas
Pittsfield 1856 – ... 1935
Abraham Lincoln
cv 20.3×16.1 (51,5×41 cm)
sg d 1908
repainted by the author
c 1917
ML

VOUET Simon
Paris 1590 – 1649
Saint Jerome and the Angel *
cv 57.1×70.9 (145×180 cm)
c 1620
KR
The Muses Urania and Calliope
pn 31.5×49.2 (80×125 cm)
c 1634
KR

VUILLARD Édouard
Cuiseaux 1868 – La Baule 1940
Théodore Duret *
crt/pn 37.4×29.5 (95×75 cm)
sg d 1912
DL
Repast in a Garden *
gouache 21.3×20.9 (54×53 cm)
sg 1898
DL
The Visit → no 142
mxt cv 39.4×53.7
(100×136,5 cm) sg 1931
DL
The Artist's Paint Box and Moss Roses
crt/pn 14.2×16.9 (36×43 cm)
sg
ML
Vase of Flowers on a Mantelpiece
crt/pn 14.2×11.6 (36×29,5 cm)
sg
ML
Child Wearing a Red Scarf
crt/pn 11.4×6.9 (29×17,5 cm)
sg
ML
Woman at Her Toilette
crt/pn 8.9×8.3 (22,5×21 cm)
sg
ML
The Conversation
cv 9.4×13.2 (24×33,5 cm) sg
ML
Woman in Black Dress Standing Near a Table
crt 10.6×8.7 (27×22 cm) sg
ML
Two Women Drinking Coffee *
crt/pn 8.5×11.4 (21,5×29 cm)
sg
ML
The Yellow Curtain
cv 13.8×15.4 (35×39 cm) sg
ML
Woman Sitting by the Fireside
crt 8.5×10.2 (21,5×26 cm) sg
ML
Breakfast
crt/pn 10.6×9.1 (27×23 cm) sg
d 1894
ML

WALDO Samuel Lovett
Windham 1783 – New York 1861
Robert G. L. De Peyster
pn 33.1×25.2 (84×64 cm)
sg d 1828 ins
ML

WALTERS Susane
Nineteenth Century, U.S.A.
Memorial to Nicholas M. S. Catlin
cv 39.0×28.7 (99×73 cm) 1852
GR

WARHOL Andy
Philadelphia 1930 –
A Boy for Meg
cv 72.0×52.0 (183×132 cm)

WATTEAU Jean-Antoine
Valenciennes 1684 – Nogent-sur-Marne 1721
Italian Comedians → no 111
cv 25.2×29.2 (64×76 cm)
1720(?)
KR
"Sylvia" (Jeanne-Rose Guyonne Benozzi)
cv 27.2×23.2 (69×59 cm)
c 1720(?) attr
KR
Ceres (Summer) *
oval cv 55.9×45.7
(142×116 cm) c 1712

WEIR Julian Alden
*West Point 1852 –
New York 1919*
Moonlight
cv 26.4×20.1 (67×51 cm)
sg c 1905
DL

WEST Benjamin
Springfield 1738 – London 1820
The Battle of La Hogue *
cv 60.0×84.3 (152,5×214 cm)
1778
ML
Mrs. William Beckford
cv 57.5×45.3 (146×115 cm)
1799(?)
ML
Dr. Samuel Boudé
Mrs. Samuel Boudé
Husband and wife portraits
canvases 35.6×30.1
(90,5×76,5 cm) 1755-6
GR
Elizabeth, Countess of Effingham
cv 57.7×45.7 (146,5×116 cm)
sg 1797(?)
ML
Colonel Guy Johnson → no 163
cv 79.7×54.5 (202,5×138,5 cm)
1776
ML
Self-Portrait *
cv 30.3×25.4 (77×64,5 cm)
c 1770(?)
ML

WEYDEN Rogier van der (R. de la Pasture)
Tournai c 1399 – Brussels 1464
Portrait of a Lady → no 70
pn 14.6×10.6 (37×27 cm)
c 1455
ML
Christ Appearing to the Virgin *
pn 64.2×36.6 (163×93 cm)
c 1460
ML
Saint George and the Dragon *
pn 5.9×4.7 (15×12 cm) c 1432

WHISTLER James Abbott McNeill
Lowell 1834 – London 1903
L'Andalouse, Mother-of-Pearl and Silver
cv 75.4×35.4 (191,5×90 cm) sg
c 1894
Brown and Gold: Self-Portrait
cv 24.4×18.1 (62×46 cm)
c 1900
Chelsea Wharf: Grey and Silver *
cv 24.2×18.1 (61,5×46 cm)
c 1875
WD
Arnold Hannay
pn 8.7×5.1 (22×13 cm) sg
c 1896
RS
Head of a Girl
cv 20.5×15.0 (52×38 cm)
c 1883
Little Girl in White *
cv 14.2×10.2 (36×26 cm)
sg(?) c 1890-1900
DL
Peach Blossom
pn 9.3×5.3 (23,5×13,5 cm)
1881-5
RS
George W. Vanderbilt
cv 82.1×35.8 (208,5×91 cm)
1897-8
The White Girl → no 171
cv 84.5×42.5 (214,5×108 cm)
sg d 1862

WILES Irving R.
Utica 1862 – ... 1948
Miss Julia Marlowe
cv 74.2×55.3 (188,5×140,5 cm)
sg d 1901 ins

WILKIE David
Cults 1785 – Sea of Gibraltar 1841
Camping Gypsies
pn 10.2×7.5 (26×19 cm) sg
d 1841
TM

WILLIAMS Micah
... 1782-3 – ... 1837; act U.S.A.
Miss Sarah Mershon
pastel 25.8×20.9 (65,5×53 cm)
1817
GR
Daniel R. Schenck
pastel 24.4×20.5 (62×52 cm)
1823
GR

WINTERHALTER Franz Xaver
Menzer-Schwand 1805 – Frankfort 1878
Queen Victoria
cv 50.4×37.8 (128×96 cm)
c 1841

WOLLASTON John
act 1736-67 London and America
Lieutenant Archibald Kennedy (?) *
cv 50.5×40.2 (127×102 cm)
c 1750
ML
Lewis Morris (?)
Mary Walton Morris
Husband and wife portraits
canvases 30.1×25.2
(76,5×64 cm) 1749-52
ML
John Stevens
cv 30.1×25.0 (76,5×63,5 cm)
1749-52(?)
ML

WRIGHT OF DERBY Joseph
... 1734 – ... 1797; act U.S.A.
Portrait of a Man
cv 30.1×25.2 (76,5×64 cm)
c 1760
ML
Richard, Earl Howe (?)
cv 50.4×40.2 (128×102 cm)
c 1780
DL
The Widow of an Indian Chief
cv 24.8×29.7 (63×75,5 cm)
c 1785 copy
DL

WYANT Alexander Helwig
Evans Creek 1836 – New York 1892
Peaceful Valley
cv 7.1×12.2 (18×31 cm) sg
c 1860

ZELIFF Amzi Emmons
Eighteenth Century, Essex County and U.S.A.
The Barnyard
cv 24.2×32.1 (61,5×81,5 cm)
sg c 1750
GR

ZOPPO Marco
Cento 1433 – Venice 1478
Saint Peter
pn of a polyptych;
ar pn 19.3×11.8 (49×30 cm)
c 1470
KR
Madonna and Child *
pn 16.1×11.8 (41×30 cm) sg
c 1470
KR

ZORN Anders
Mora 1860 – 1920
Hugo Reisinger
cv 53.3×39.6 (135,5×100,5 cm)
sg d 1907

ZULOAGA Ignacio
Eibar 1870 – Madrid 1945
Achieta
cv 77.0×49.0 (195,5×124,5 cm)
sg 1911-3
DL
Mrs. Philip Lyding
cv 39.0×28.3 (99×72 cm)
sg 1912
DL
Merceditas
cv 77.2×47.8 (196×121,5 cm)
sg 1911-3
DL
Woman in Andalusian Dress
→ no 104
cv 34.3×26.4 (87×67 cm)
sg 1911-3
DL
Sepúlveda
cv 22.8×24.4 (58×62 cm)
sg 1909
DL

ZURBARÁN Francisco
*Fuente de Cantos 1598 –
Madrid 1664*
Santa Lucia
cv 44.9×30.3 (104×77 cm)
c 1625 ins
Saint Jerome with Saint Paula and Saint Eustochium
cv 96.5×68.1 (245×173 cm)
c 1640
KR